I really don't know what to say. There's really nothing special about me or noteworthy, just a simple man. But this book might say a lot about me. Actually, the stars of the book are the wildlife, who have brought me great enjoyment. It is also nice to see others, young and old alike, find the same enjoyment.

I remember when my mother and I were taking photographs of a black bear that had a blonde coloring. We ended up watching the bear for about an hour and it was amazing how many people stopped to take photos. Since there was no place to park along the highway, some drove slow while trying to capture some photos. Simply amazing.

# The Amazing Wildlife in the Prince Albert National Park

by

Michael Holmes

**AUSTIN MACAULEY PUBLISHERS**™
LONDON * CAMBRIDGE * NEW YORK * SHARJAH

Copyright © Michael Holmes (2018)

All rights reserved. No part of this publication may be reproduced, distributed, or transmitted in any form or by any means, including photocopying, recording, or other electronic or mechanical methods, without the prior written permission of the publisher, except in the case of brief quotations embodied in critical reviews and certain other noncommercial uses permitted by copyright law. For permission requests, write to the publisher.

Any person who commits any unauthorized act in relation to this publication may be liable to criminal prosecution and civil claims for damages.

**Ordering Information:**
Quantity sales: special discounts are available on quantity purchases by corporations, associations, and others. For details, contact the publisher at the address below.

**Publisher's cataloging in publishing data**
**Holmes, Michael.**
**The Amazing Wildlife in the Prince Albert National Park**

ISBN 9781641821759 (Paperback)
ISBN 9781641821742 (Hardback)
ISBN 9781641821735 (E-Book)

The main category of the book — Photography/General

www.austinmacauley.com/us

First Published (2018)
Austin Macauley Publishers LLC
40 Wall Street, 28th Floor
New York, NY 10005
USA

mail-usa@austinmacauley.com
+1 (646) 5125767

To the amazing wildlife and all who find great joy in watching these amazing creatures.

There are a few people who I owe a lot of credit to for the privilege of seeing my book in print. First and foremost, my parents, especially my mother, whose amazing passion for photography eventually rubbed off on me, thank goodness. I would also like to express my gratitude to the many personnel that work at the park. They were always interested in the photos that I was able to get and, of course, the stories that went with them that I had to tell.

Of course, one person gets special mention, Marie. It was because of her encouragement that I wrote down my experiences, eventually leading to them being published.

I want to also mention my aunt and uncle, Elaine and Larry Edeen, who always enjoyed looking at my photos and always encouraged me to keep taking photos of these amazing creatures.

I will never forget Austin Macauley Publishers, who saw the value that my manuscript had and that it must be put into print. Words will never be enough for how appreciative I am. Thank you.

And lastly, I would like to mention all those who have the same passion that I have for the many mammals and birds and all the other amazing wildlife.

# CONTENTS

    The Waskesiu River      14

## Mammals      15

    The Black Bear      16
    The Mink      21
    The Wolf Pups      26
    The Otters      29
    The Groundhog      32
    The White-Tailed Deer and Fawn      34
    The Beavers      37
    The Red Fox      45
    The Plains Bison      48

## Birds      49

    The Pileated Woodpecker      50
    The Common Loon      52
    The Gray Jay      55
    The Great Blue Heron      58
    The American White Pelican      62
    The Belted Kingfisher      65
    The Ruffed Grouse      67
    The Birds of Prey      69
    The Evening Grosbeak      71
    The Common Goldeneye      72
    The American Wigeon      73
    The Common Merganser      74
    The Red-Breasted Merganser      75
    The Spotted Sandpiper      76

| | |
|---|---|
| The Stilt Sandpiper | 77 |

# Butterflies — 78

| | |
|---|---|
| The Common or Violet Meadow Blue | 79 |
| The Common Swallowtail | 80 |
| The White Admiral | 81 |
| The Tortoiseshell Butterfly | 82 |
| The Comma Butterfly | 83 |
| The Dark Green Fritillary | 84 |
| The Silver-Bordered Fritillary | 85 |
| The Clouded-Yellow Butterfly | 86 |
| The Small Skipper | 87 |
| The Scotch Argus | 88 |
| The Ringlet Butterfly | 89 |
| The Silver-Bordered Fritillary | 90 |

# Dragonflies — 91

| | |
|---|---|
| The Blue Dragonfly | 92 |
| The Sparkling Jewelwing | 93 |

# Wildflowers — 94

| | |
|---|---|
| The Blue-Eyed Grass | 95 |
| The Prairie Lily or Red Lily | 96 |
| The Yellow Lady's-Slipper | 97 |
| The Hemlock Waterparsnip | 98 |
| The Pitcher Plant and Flower | 99 |
| The Bunchberry | 100 |
| The Western Jewelweed | 101 |
| The Wild Parsnip | 102 |
| The Small-Flowered Columbine | 103 |
| The Hairy Vetch | 104 |
| The Two-Leaved Solomon's-Seal | 105 |
| Wild Lily-of-the-Valley | |

| | |
|---|---:|
| The Starflower | 106 |
| The Butter and Eggs, Toadflax | 107 |
| The Marsh Marigold | 108 |
| The Yarrow | 109 |
| The Common Red Paintbrush | 110 |
| The Yellow Pond Lily | 111 |
| The Canada Anemone | 112 |
| The Western Polemonium | 113 |
| The Northern Bedstraw | 114 |
| The Fireweed | 115 |
| The Philadelphia Fleabane | 116 |
| The Wild Sarsaparilla | 117 |
| The Bog Wintergreen | 118 |
| The Bogbean or Buckbean | 119 |
| The Harebell | 120 |
| The Canada Golden Rod | 121 |
| The Oxeye Daisy | 122 |
| The Golden Groundsel | 123 |
| The Yellow Avens | 124 |
| The Horsetails | 125 |
| Unknown | 126 |
| The Saskatoon | 127 |
| Unknown | 128 |
| The Hairy Hedge-Nettle | 129 |
| The Rhombic-Leaved Sunflower | 130 |
| The Wild Chives | 131 |

# *The Forgotten Animals* — 132

| | |
|---|---:|
| The American Red Squirrel | 133 |
| The Fall at Waskesiu | 136 |
| The Pileated Woodpecker | 139 |
| The Pine Martin | 141 |

| | |
|---|---|
| The Chestnut-Sided Warbler | 151 |
| The Spruce Grouse | 152 |
| The Song Sparrow | 153 |
| The Boreal Chickadee | 154 |
| The Greater Scaup | 155 |
| The Ring-Necked Duck | 156 |
| The Bonaparte's Gull | 157 |
| The Bonaparte's Gull | 158 |
| The Eastern Phoebe | 159 |
| The Common Merganser | 160 |
| The Mallard | 162 |
| The Bufflehead | 163 |
| The Ring-Billed Gull | 164 |
| The Lesser Yellowlegs | 165 |
| The Chipping Sparrow | 166 |
| The Red-Winged Blackbird | 167 |
| The Black-Billed Magpie | 168 |
| The American Crow | 169 |
| The Common Merganser | 170 |
| The Common Goldeneye | 171 |
| The Yellow-Bellied Sapsucker | 172 |
| The Elk | 173 |

# *Flowers* — *174*

| | |
|---|---|
| The Bunchberry | 176 |
| The Lady's Slippers | 177 |
| The Smooth Wild Strawberry | 178 |
| The Wild Rose | 179 |
| The Ferns | 180 |
| The Mealy Primrose | 181 |
| The Water Arum or Wild Calla | 182 |
| The Twinflower | 183 |

| | |
|---|---|
| The Bluebells | 184 |
| The Prairie Buttercup | 185 |
| The Common Silverweed | 186 |
| The Spreading Dogbane | 187 |
| The Round-Leaved Orchis | 188 |
| The Canada Anemone | 189 |
| The Red-Osier Dogwood | 190 |
| The Scorpionweed | 191 |
| The Marsh Skullcap | 192 |
| The Common or Swamp Buttercup | 193 |
| The Honeysuckle | 194 |
| The Wild Chamomile | 195 |
| The Tufted Loosestrife | 196 |
| The Common Loon | 197 |
| The Black Bear | 199 |

# The Waskesiu River

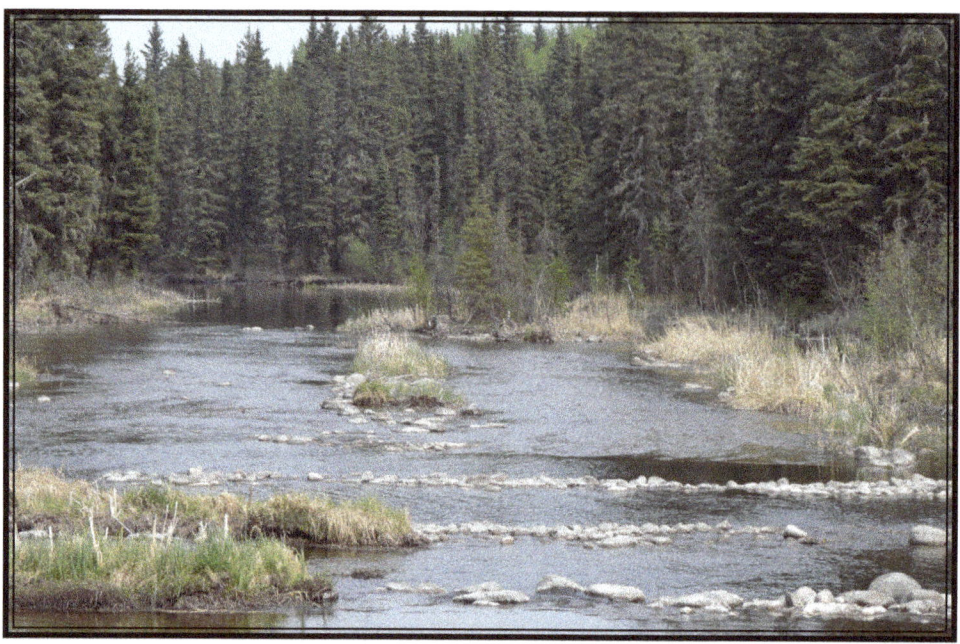

    They say that patience is a virtue. How true is that, especially when it comes to watching and enjoying the amazing wildlife that one can see while at the Prince Albert National Park in Saskatchewan.

    I certainly enjoyed many magical experiences as I watched how amazing the wildlife was. From otters to minks and from beavers and to the black bear, not to mention groundhogs and wolf pups.

    From the birds that one can see, such as American white pelicans to belted kingfishers to the amazing fishing ability of the great blue heron. Even being able to see ospreys, bald eagles, and merlins.

    It was amazing how much wildlife that I was able to see by just being at the Waskesiu River. Even though I had to spend from 1 to almost 3 hours every day, it was certainly worth the time to enjoy animals in their natural surroundings and to see the amazing ability that they possess.

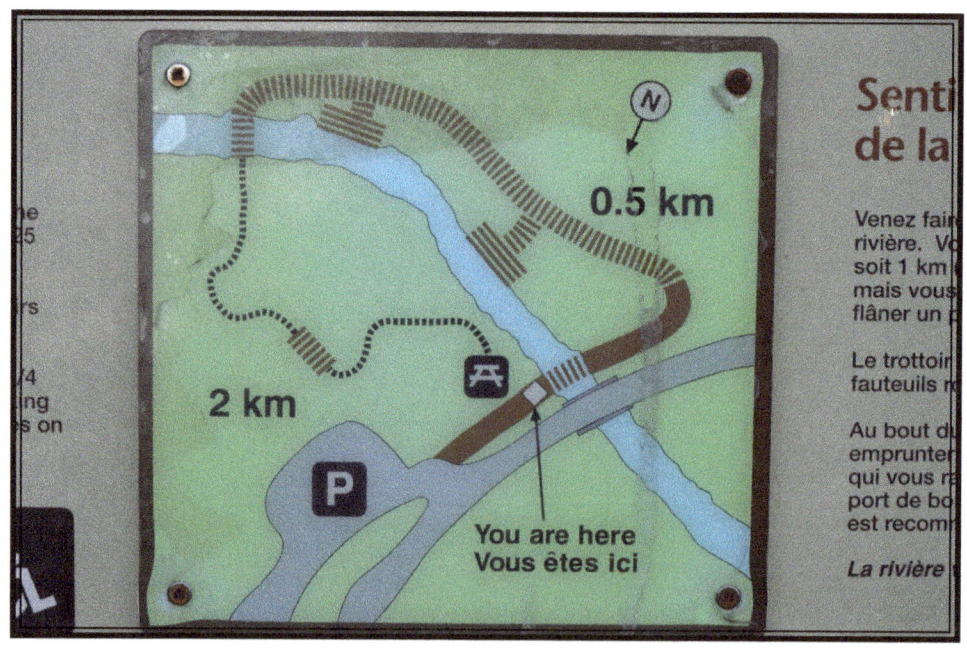

*Mammals*

# The Black Bear

When I first arrived in the park, I was told by a young lady from Parks Canada, that there were lots of black bears in the park. I was really excited as I was expecting to get lots of pictures and I soon realized that this was indeed going to be the case, especially when on just the third day that I was there, I saw a black bear by the river.

While I was there, I noticed a black bear crossing the highway just south of the bridge. I immediately took a picture, then proceeded to cross the bridge for pedestrians, hoping to get a picture of him along the bush.

Well, by the time I got there, he was already in the bush. Because I ran down the bridge, it must have caught the bear's interest as he came up the path to see what was going on, this allowed me to take a few amazing pictures of him. He then, turned around and headed back down the path.

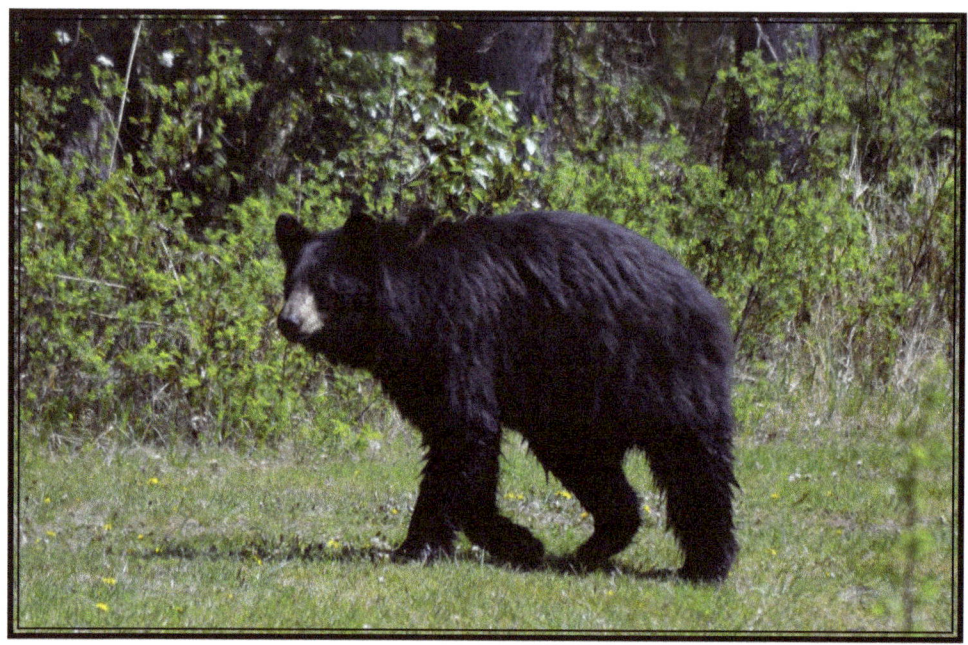

As I was walking across the bridge, I noticed that the bear was heading across the river. Thinking that this would make a nice picture, I headed to where the stones made a path across the river, I probably ran, but by the time I got there, he had already made it across the river.

Missing that opportunity, I started back towards the bridge, but for some reason I looked back and to my surprise, here the bear was, heading down the path on the other side of the river, walking right towards me.

I was able to get some very close and great pictures of the black bear. Then, I thought it was prudent for me to leave the area.

After all, even though the bear just seemed to be curious, seeing what was going on, it was still a wild animal.

Afterwards, I showed two Parks personnel my pictures and one of them made the comment, "You really did get close to the bear."

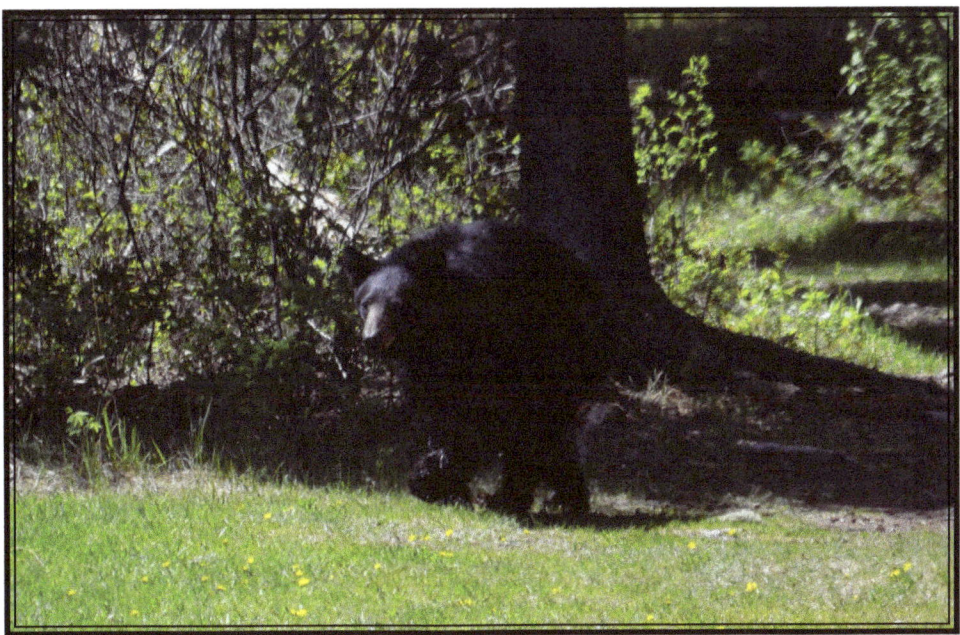

Sadly, even though there were lots of black bears in the park, I only saw bears one more time. This still gave me an amazing opportunity to see something truly unique and exciting to experience.

Even though, I tried many times to find bears in the park, running down every sighting I heard about, I only saw a mama bear with two cubs, a black cub and a cinnamon cub.

Actually, I came across this family of bears by accident, it was a total fluke that I even saw them. Boy, I was certainly glad for the opportunity, as it was an amazing experience, something that I will never forget, but let's start at the beginning.

Every day I would take a trip around the outskirts of the town, to find something that I could take a picture of. I happened to be walking to the kiosk on the 10th hole of the golf course as I heard that pileated woodpeckers were frequently seen in the area and there was lots of evidence to suggest that this was true. Usually, as I came to the library, I would turn around and head back to town, but this time I decided to walk past the library to the next road before I headed back to town. Boy, was I glad that I did, as I noticed a black bear cub.

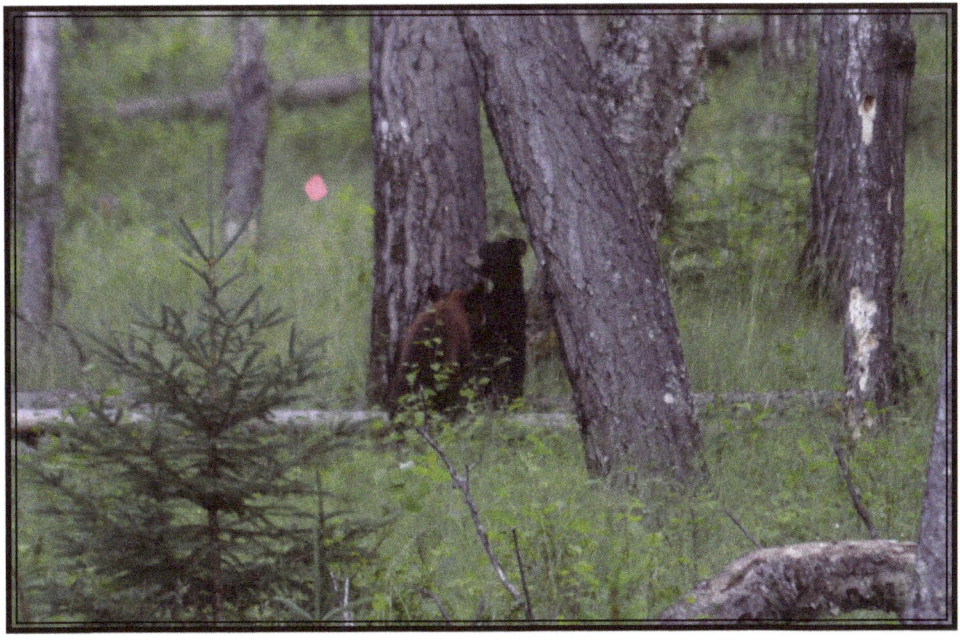

It wasn't very long before there were two cubs. By this time, I had journeyed a fair distance into the bush. But I had

not yet seen where the mother was, being cautious, I kept looking intently to see where she was, but finally I noticed her behind some small bushes. I continued watching them together, but as they continued walking along, I lost sight of them, especially the mother. Not knowing exactly where they were and since it looked like the mother was leading her cubs towards me, I thought it would be the course of wisdom to back up a little bit until I could figure out where they were going, but as I was back tracking I just happened to have stepped on a twig. As soon as the mother bear heard the sound of the branch snapping, she immediately started running away from me leading her cubs to safety.

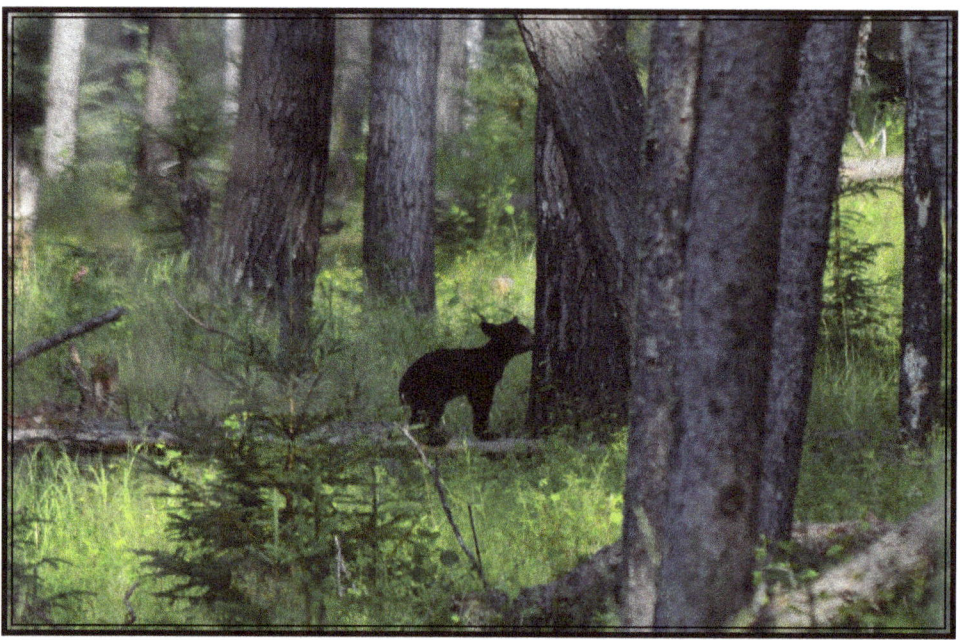

Then, all of a sudden, I saw one cub run up a tree. It happened so fast I didn't even get a picture of him, but I did get a picture of the second cub, the cinnamon one running up the tree. It was unbelievable just how fast they were in climbing up that tree.

Then, to no surprise, the mother bear turned around, stood right behind the tree that her cubs went up and just looked at me.

I realized that I had seen enough and I left. I regret that I was in such a hurry to leave because I should have taken a picture of mama bear guarding the tree that her cubs were in.

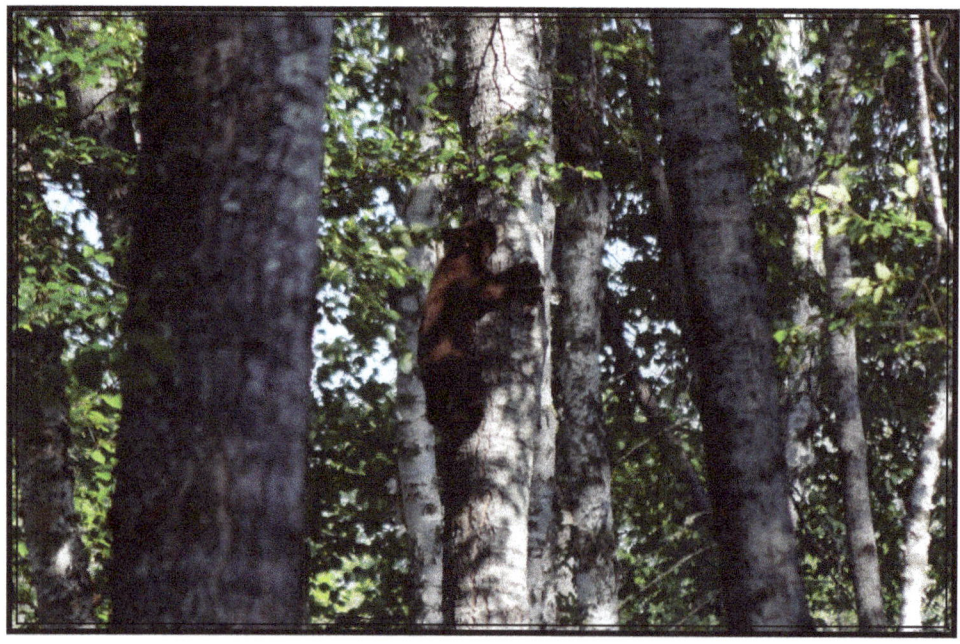

Since I regretted that I was not in my truck, I decided to go back and get my truck, hoping to get some close up pictures of them. As I was heading back, I began to think about the prospects of them heading towards the highway, as it seemed that they were going in that direction.

So I hurried back to see if this was going to be the case. Once I was on the highway, I guessed as to where they might come out. Again patience came into play, as I sat for about 25–30 minutes in my truck but sure enough, they came out just a few yards in front of me and I am pretty sure that they would have crossed the highway but 4 or 5 vehicles just happened to go by at that time, stopping them from going on. They just proceeded along a row of pine trees that were along the highway.

But eventually, the cinnamon cub came out into the open and was busy trying to bust apart a tree stump to get the insects in it.

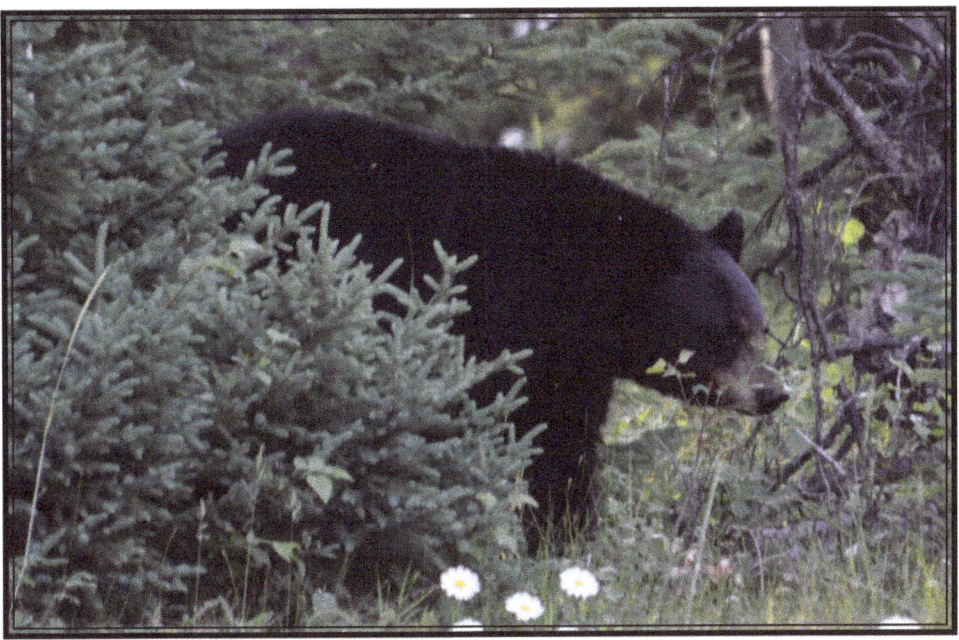

This gave me plenty of time to get lots of pictures of him before he went farther into the bush. This was the last time I saw any bears in the park.

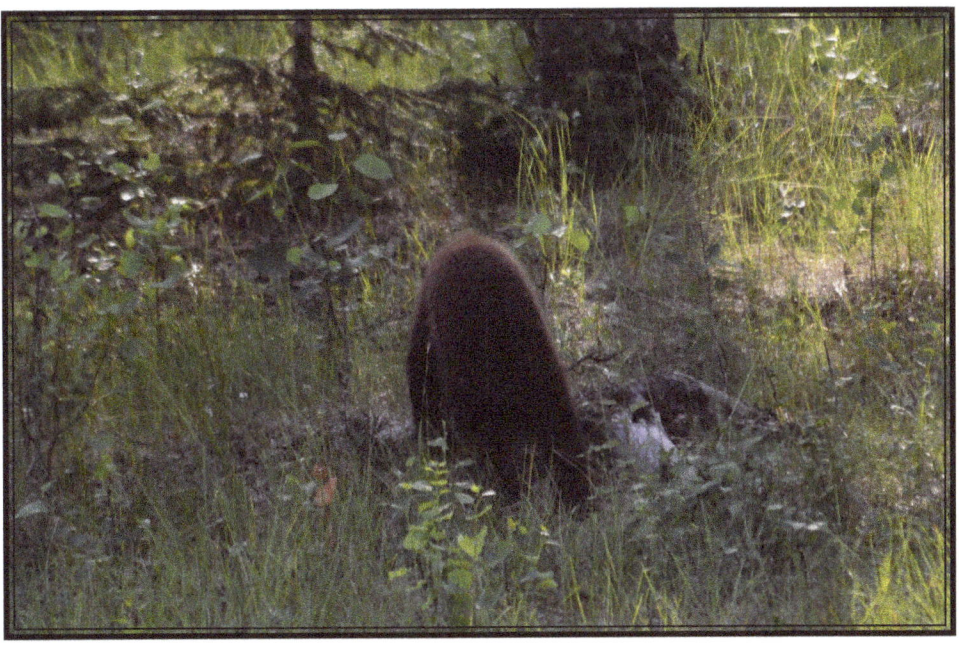

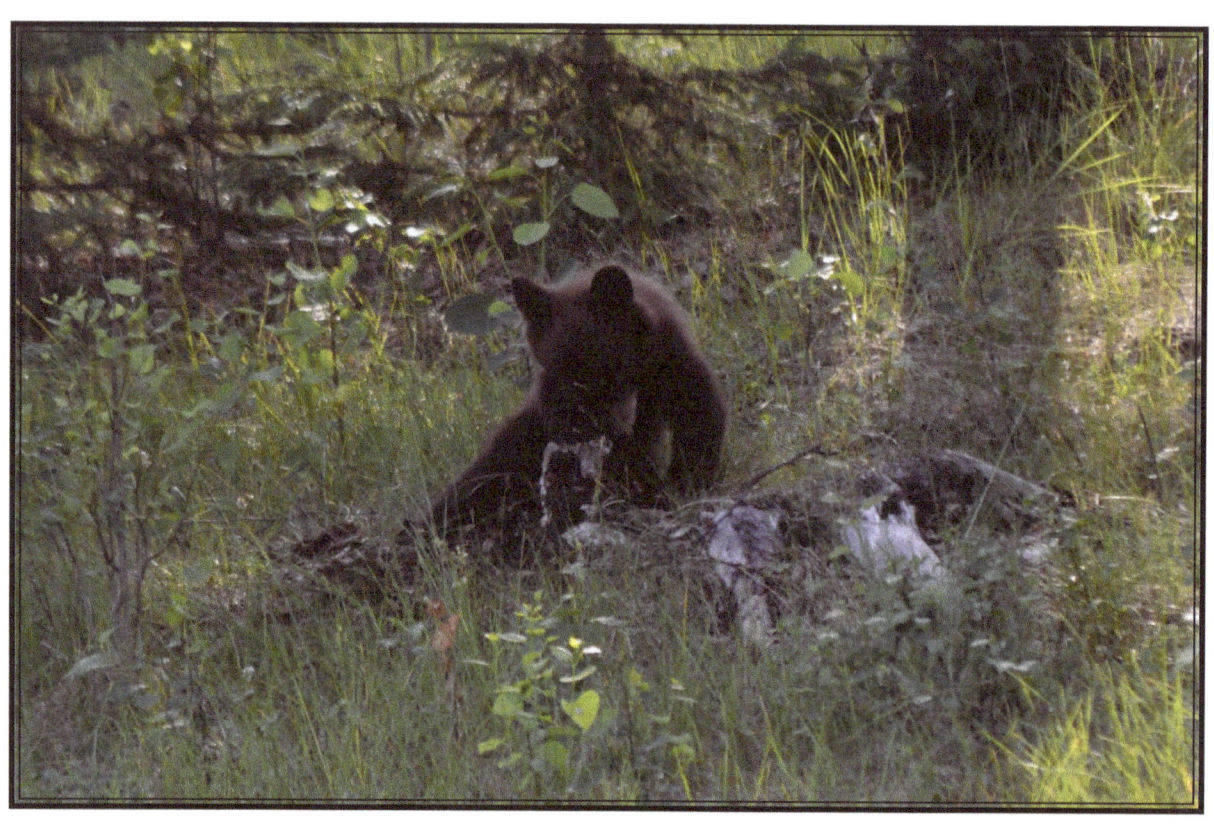

# The Mink

I was very privileged at how many opportunities I had to take many amazing pictures of a mink. But let's start at the beginning again.

It all started last year, I came to the park just for the day on July 14th. While I was at the river, walking along the bridge, all of a sudden something came out of the water and came up onto the bridge right at my feet. I was so dumbfounded by the experience that I was unable to get a picture of him. Thinking it was an otter, needless to say, I was quite disappointed.

I thought I didn't have enough time to get a picture, but I realized later that I had plenty of time to do so. So this year, when I came to the park, I was determined to get a picture of an otter. I came to realize that what I saw last year was not an otter, but rather it was a mink.

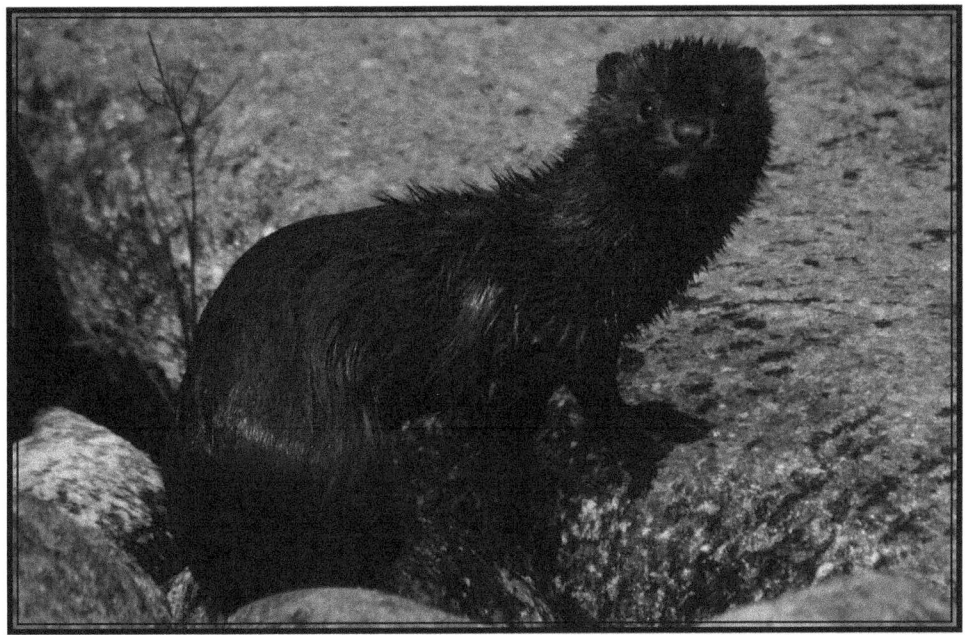

The first time I saw the mink, she had a fish in her mouth, heading towards her home. This served as a two-fold purpose for me. First, it got me what I wanted, a picture of a mink and it also allowed me to find out where her home was, right under the bridge for pedestrians. Knowing this allowed me to get some incredible pictures that I would not otherwise have been able to take.

I remember one time that I saw her, I was standing on the highway bridge and I noticed the mink swimming on the river, heading towards her home. Understanding this, I immediately, headed down the side of the highway and put myself in position to get a picture of the mink as she climbed up the side of the cement foundation of the bridge, before going under the bridge to her home.

I certainly was happy that I beat her to the spot. As I waited for her to come up out of the water, I surprised her as she saw me.

She turned around, I thought she was going to leave, but she didn't. She just poked her head out again, looking at me while I took 5–6 pictures of her.

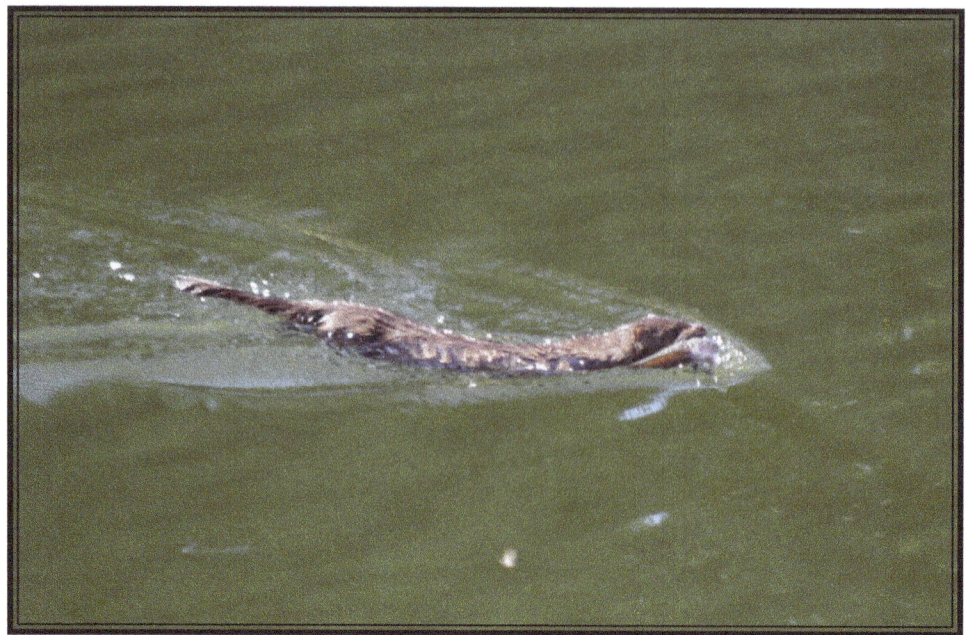

Thankful for the experience, as well as appreciating her willingness to give me the opportunity of getting some amazing pictures, I appropriately left, allowing her to get home.

I am hoping that this had a lasting impression on the mink and by what happened on my next delightful experience with her, this may have just been the case.

Since I was in the habit of going down to the river about 4:30–5:00 every evening, I saw the mink many times. One such time was when I was standing on the bridge, looking down the river towards the highway bridge, to see if anything was coming down the river.

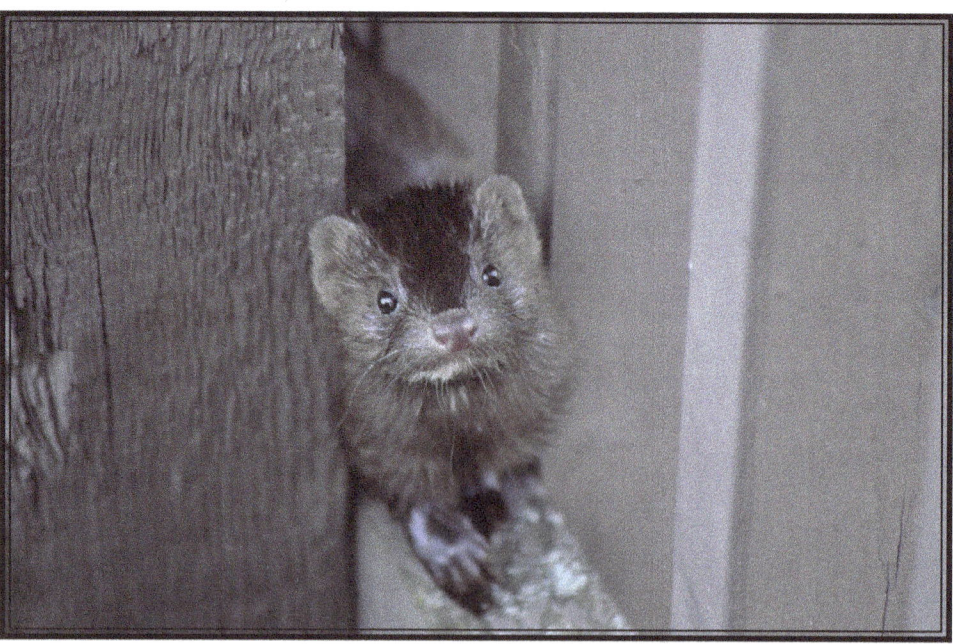

Then, all of a sudden, the mink walked across the bridge just beside me and down the side and was heading towards the river to swim underneath the highway bridge.

Thinking this was a good opportunity for a picture, I immediately headed for the side of the highway, hoping to catch her on the rocks.

When I got to the spot I wanted to, she saw me and turned around. It looked like she was going to go in the opposite direction. Disappointed in a missed opportunity, I went back to where I was on the bridge. For some reason, I looked back to the rocks were the mink was. To my amazement and surprise, she did not head down the river as I thought, a mistake I regret making, as here she was standing on her back legs looking around for me. Since she didn't see me, she went into the water and swam across the river to the other side and then headed down the river. In total awe of her behavior, all I could do was stand there and watch her in amazement, no picture taken, but a permanent picture was taken in my memory that I will never forget. Boy, what a sap, writing this down is bringing a tear to my eye.

Another time that I was able to see the mink, I was standing on the bridge and admiring the river as I noticed the mink swimming along the edge of the river toward were I was standing. I wasn't sure what she was going to do, then all of a sudden, she climbed out of the water and headed up the bank of the river towards the bridge. It seemed that she was going to come up onto the bridge, so I was ready just in case she did. And she did.

The mink walked out onto the bridge, but stopped as soon as she saw me. Hesitated for a while, which gave me an opportunity to get a very good picture of her, and seeing it was just me, proceeded to walk down the full length of the bridge, right past me, and then she went to where the sign sits on the bridge and then went back across the bridge, down the bank and out down the river.

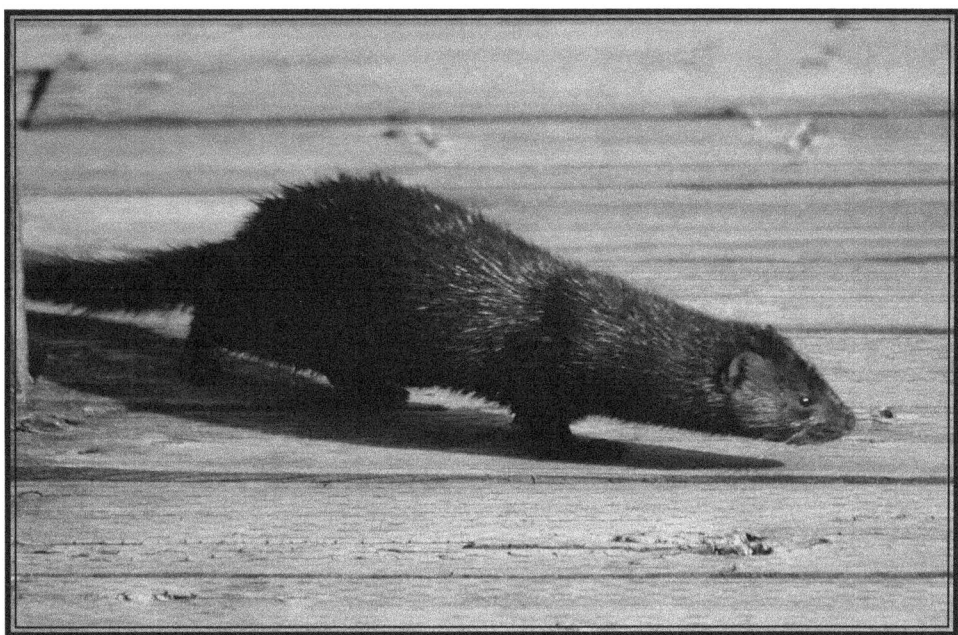

Probably the most amazing experience that I had with the mink was the time when I saw her on the second row of rocks on the river.

As soon as I had seen her, I proceeded to walk down to the river bank and walked across the rocks, trying to get as close to the mink as I can.

This was the second time that I saw her on the rocks, the first time that I had seen her, I tried to do the same thing, get as close as I could, but as soon as she saw me, she headed back and went down the river and was gone.

The reason I mentioned this, is because as I tried to sneak up on her, she sees me and again disappears under the water. I waited for a moment or two and since I hadn't seen her for quite a while, I decided to head back to the river bank, but as I turned around to walk back across the rocks, I immediately noticed her up on the rocks right on the same side as me just 5–6 feet from me. I was totally excited that I was able to get some amazing pictures of her.

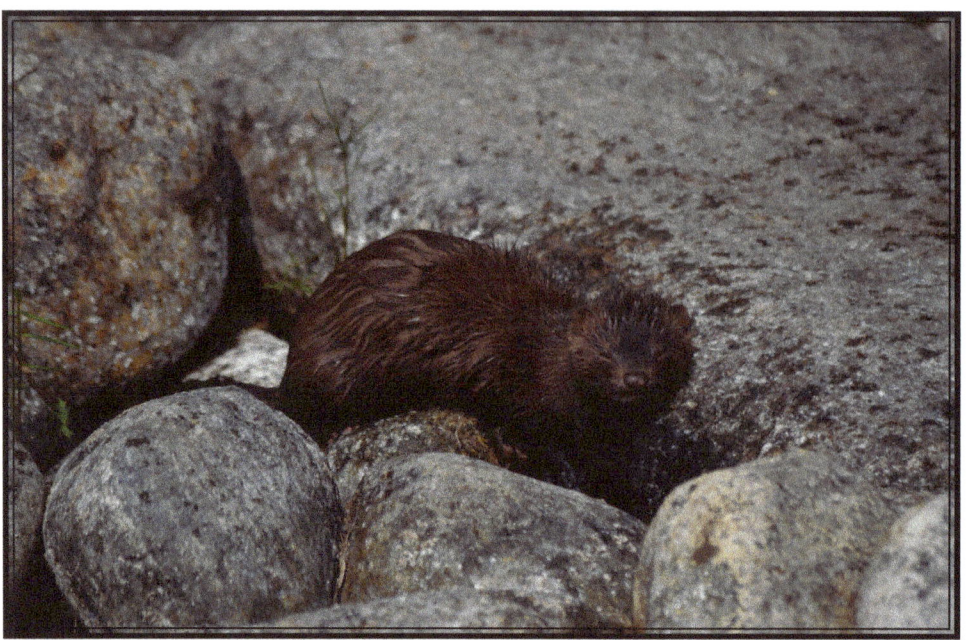

    As she again and again went into the water and back up onto the rocks, even taking a moment once and a while to take a look at me.

    I just had to stand there and watch her in amazement, but what I saw from her so far was nothing in comparison to what I was yet to see.

    I watched her climb up onto the bank of the river and then walk around the rocks. Back to the bank she went, climbed up onto a stump of a tree that was partly showing its roots. She proceeded to rub her back on the roots.

    As she came back onto the rocks, she was now ready for something truly remarkable.

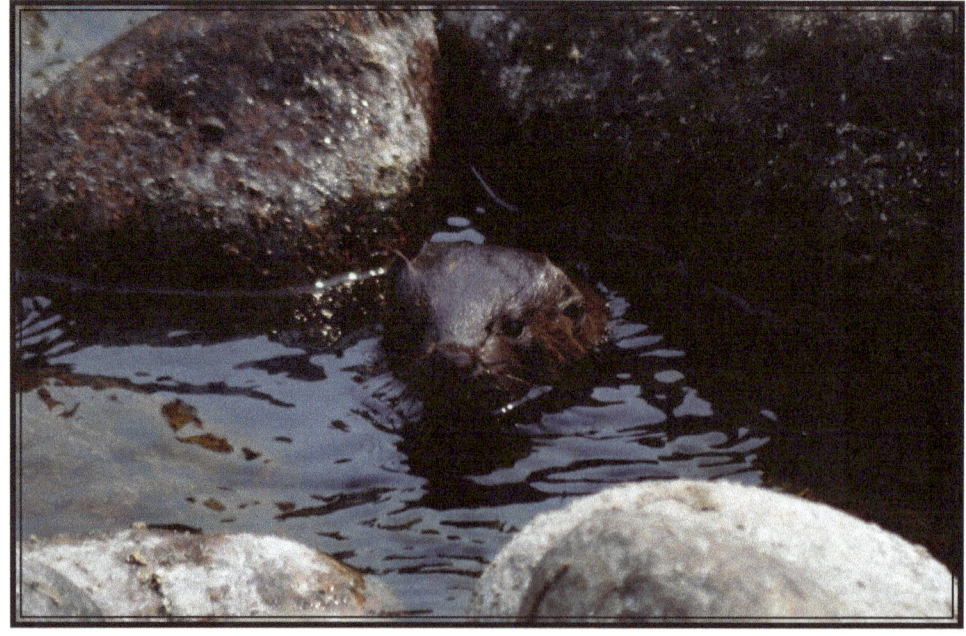

    Since I had so many incredible pictures of the mink, I decided to walk to the bank of the river and from there I continued to watch her. I saw her dive into this one spot in the rocks. She did this about 5–6 times.

    Guess what she came out with?

It was a fish as big as she was. The fish had obviously gotten stuck in the rocks. She worked hard to get it out but she was successful.

I watched as she carried it or should I say more appropriately, she dragged it across the rocks, then along the river bank, up the bank to the bridge, then under the bridge straight to her home. A huge meal for herself as well as for her young ones.

This was the last time that I saw the mink. She was truly an amazing animal. I enjoyed watching her many times and appreciated the incredible pictures that I was able to take of her. She was the one I received the most enjoyment from as I spent hours every night at the Waskesiu River looking for opportunities to photograph this mink.

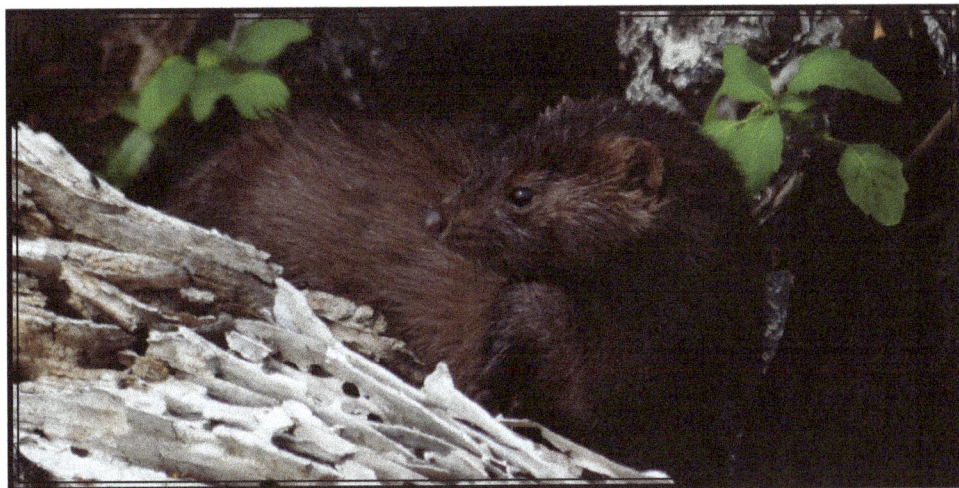

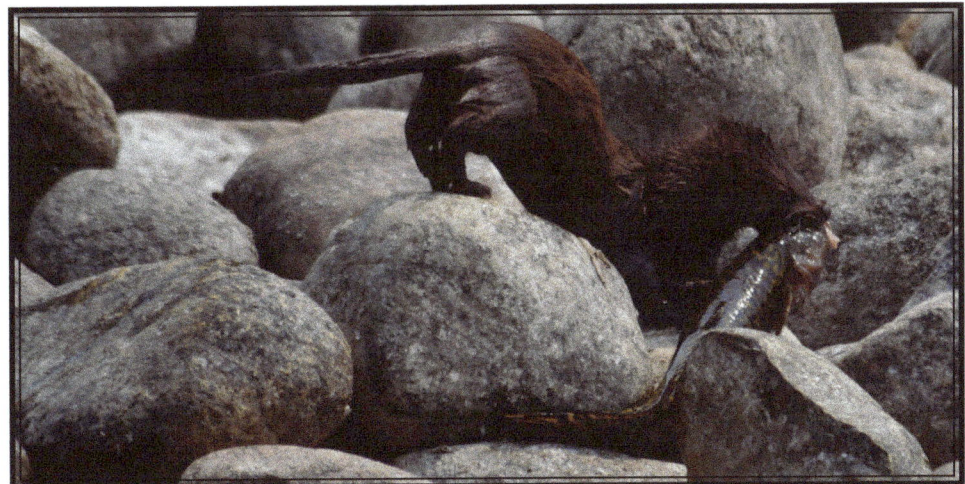

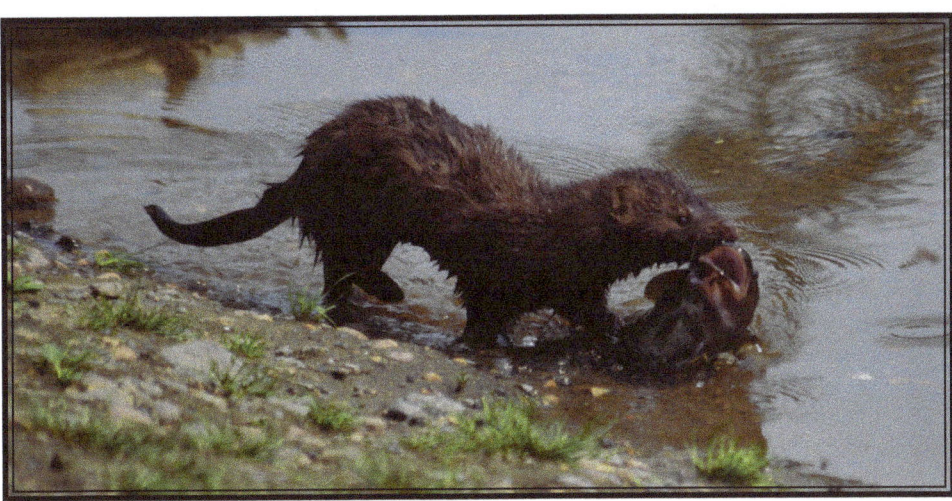

# The Wolf Pups

Another animal on my list of must see, besides an otter, was a wolf. Last year on my way to the park, I saw a wolf but had no camera to get a picture. This year I was determined to get a picture of a wolf.

But I never thought that I would see a wolf pup, let alone four of them.

But this is exactly what happened. When my parents were up for the weekend, we were on our way to the river and I saw a wolf. By the time we stopped and backed the car up, the wolf had disappeared into the bush.

Not realizing that this was a wolf with pups or that their den was so close by, we were totally surprised when we saw three wolf pups playing in the bush. By the time I got myself out of the car so that I could get a picture of them, they were already in their den.

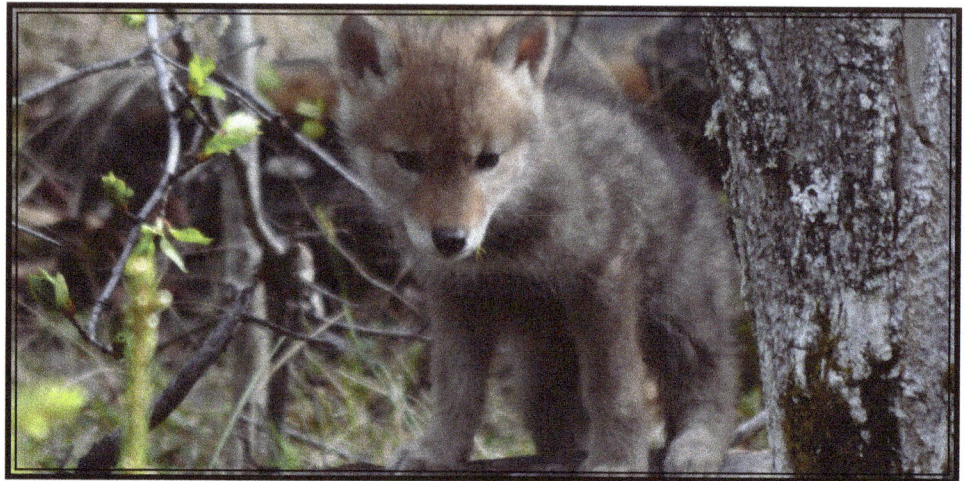

But realizing that not all is lost, I knew I would get another opportunity to take a picture of them because I knew where their den was.

It was in a culvert, of all things, that was just before the stop sign on the road between Red Deer Trailer Park and Beaver Glen that leads to the highway going to the river.

This was about 4:30–4:45 pm. So the next night at the exact same time, I headed to the culvert, hoping to see them again and to ultimately get a picture of these wolf pups. Sure enough, I saw three wolf pups and because the car was parked right on top of their den, they had to come right towards me. I was ready to aim, point and take some amazing pictures.

It is amazing just how cute they really are.

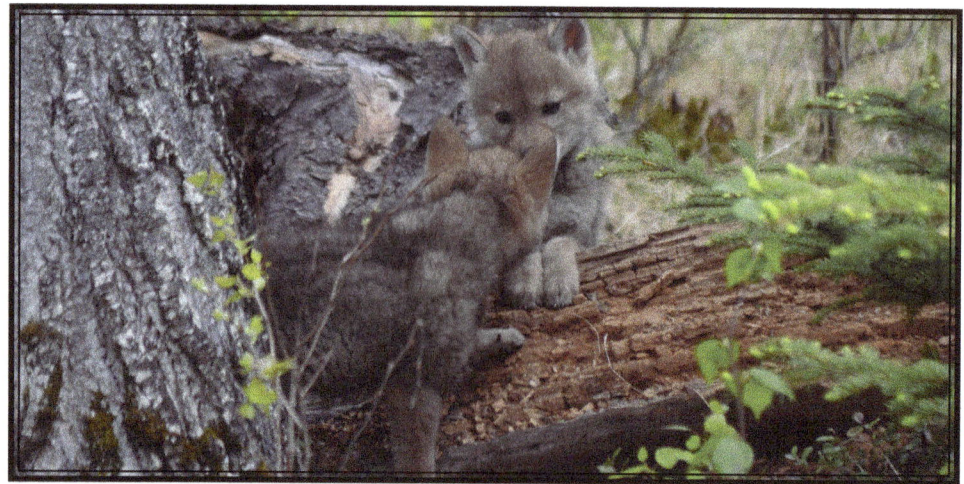

At first, they either didn't notice or were not paying attention to the fact that we were there. I was thankful for that, as I was able to get a few great pictures. That is until they finally came to realize that we were there. Then, each one in turn, cautiously and hesitatingly, headed towards their den.

Of course, always trying to get even better pictures, I headed out at precisely the same time the next night to see if they were outside of their den, again. As I drove slowly past their den, I was disappointed that I did not see any of them.

Since there was nothing to see, I proceeded to go to the river as I always did. After having a very enjoyable evening at the river, I came home for supper. This was about 8:00 pm. How excited I was, to be able to find two wolf pups playing with each other, just outside of their den. What was even more amazing to see was that one of the pups was black in color.

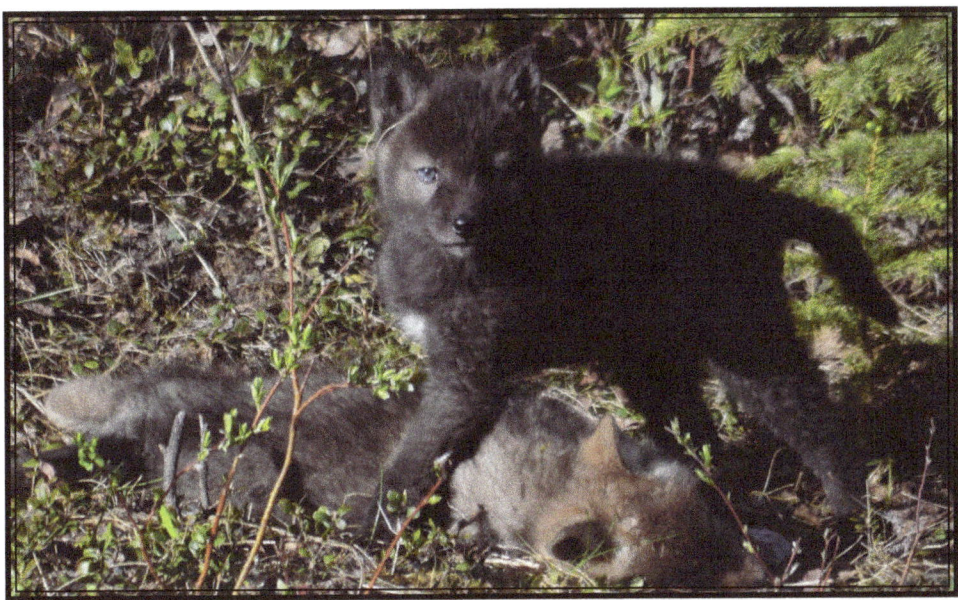

Immediately, I jumped out of my truck and began taking pictures of them playing with each other. Again, it seemed that they were not aware that I was there. I even walked about halfway or even a little further across the highway, to try to get as close as I could to them to get a really great picture of them.

What was really enjoyable to see, was the fact that even when the black wolf pup noticed me, he just looked at me. Showing no concern that I was there, but in time, after taking a number of amazing pictures, I walked back to my truck and by the time I jumped into it, the wolf pups were already back in their den.

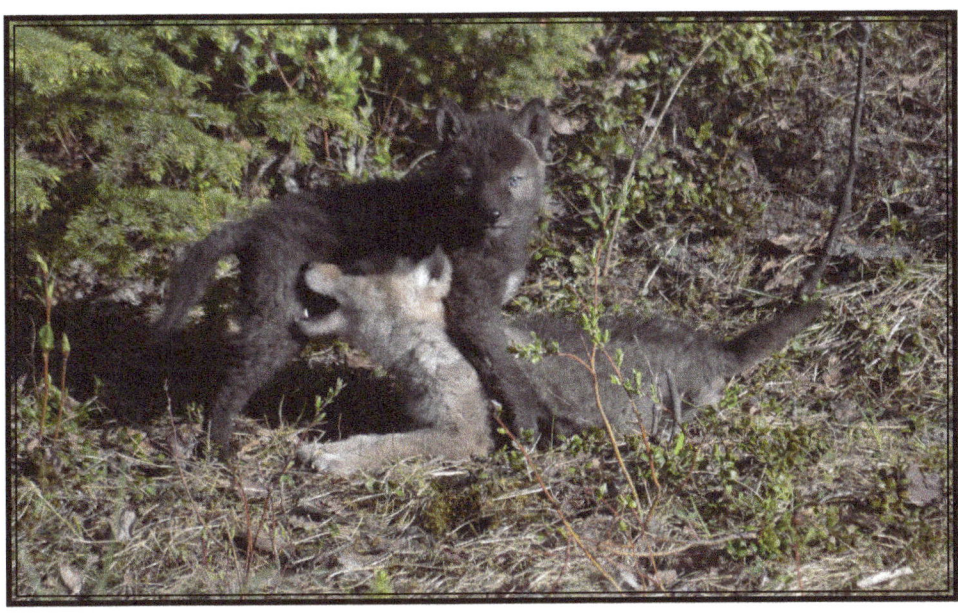

For the next couple of days, I tried to see if I could see them again.

But I was unable to, it wasn't until four days later that I saw just one wolf, she was standing at the entrance to their den, just looking at me.

Then, about three or four weeks later, I saw one of the wolf pups, this was the last time that I saw them again. I was later told by someone that eventually, the mother will move her pups if the den gets too much traffic around it. Even though, I didn't have many opportunities to see them, what I was able to experience was incredible and something one doesn't see very often, especially when it comes to seeing wolf pups and a black one at that.

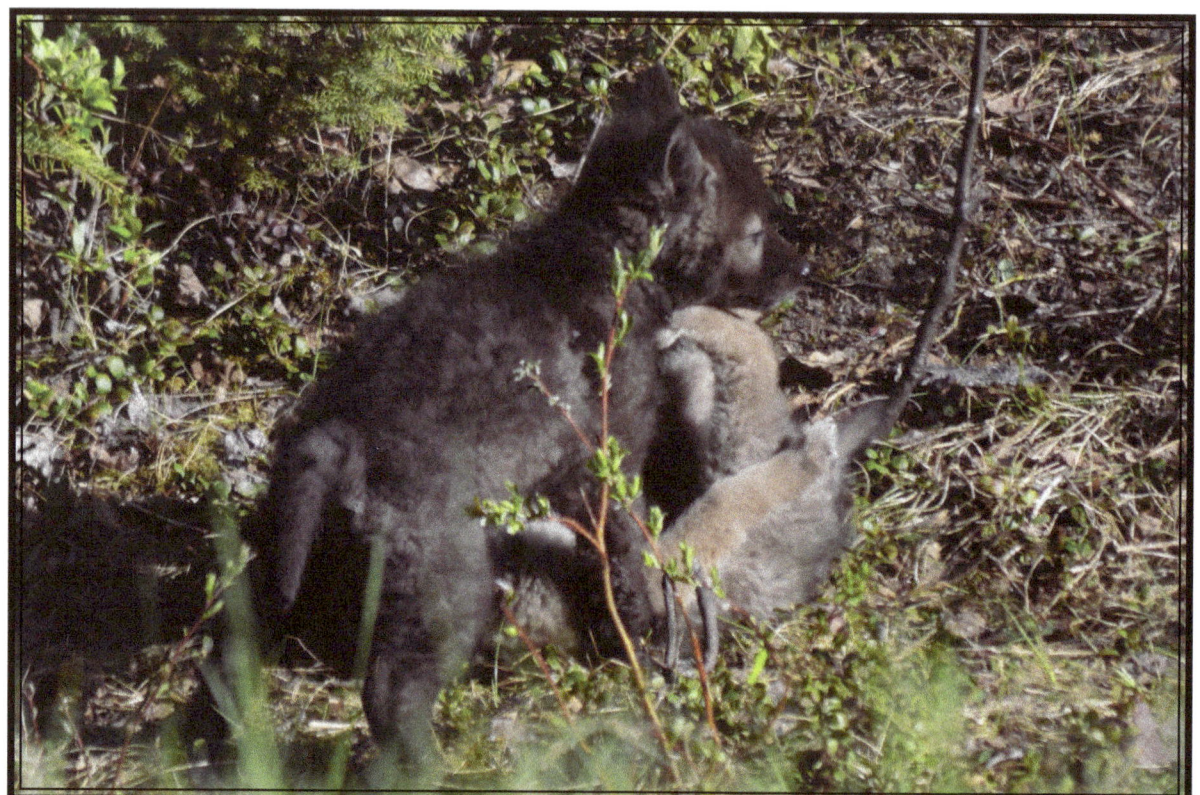

# The Otters

There were four things I was looking forward to seeing while I was at the park. The second thing on my list was otters. I was really hoping to see them and I was really excited for this opportunity.

To say that otters are playful, is an understatement.

One evening while I was at the river, I was standing on the bridge as I did every night. It was around 8:00 pm or so and I was privileged to see from 6–10 otters that came swimming down the river. It was hard to know exactly how many were there, as they were constantly going up and down into the water, but I was able to get a picture of five of them swimming together.

They seemed quite curious when they saw me standing on the bridge. Just down from the bridge, in the middle of the river, is a small island of mud that stands out above the river.

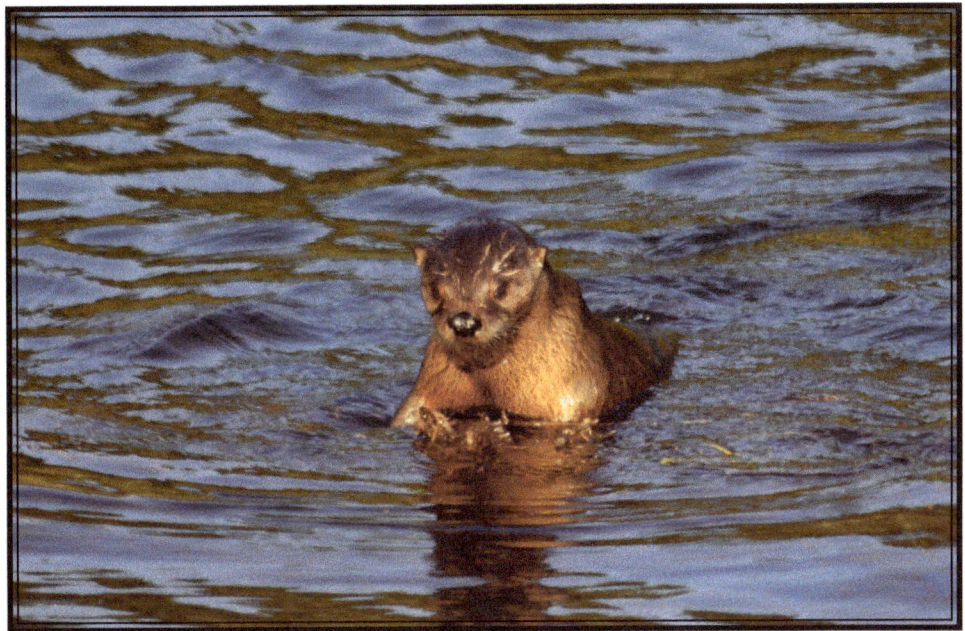

The otters proceeded to swim around this island. One of them even got up onto the mud, looking straight at me while I was on the bridge.

Then, four other otters joined him and began to swim around this spot of mud. It was quite enjoyable to see them playing together.

After, a while, they headed further down the river. Hot on their heels, I followed them down the river as I walked down the boardwalk.

When I came to the first boardwalk that leads us to the edge of the river, I was able to beat the otters to this spot on the river. As they went past me, they would look at me and it seemed that they would push themselves up out of the water as far as they could, hold that position for a while, all the while still looking at me and then slip back into the water. Of course, as they swam down the river, they made a lot of noise, almost like they were snorting or grunting.

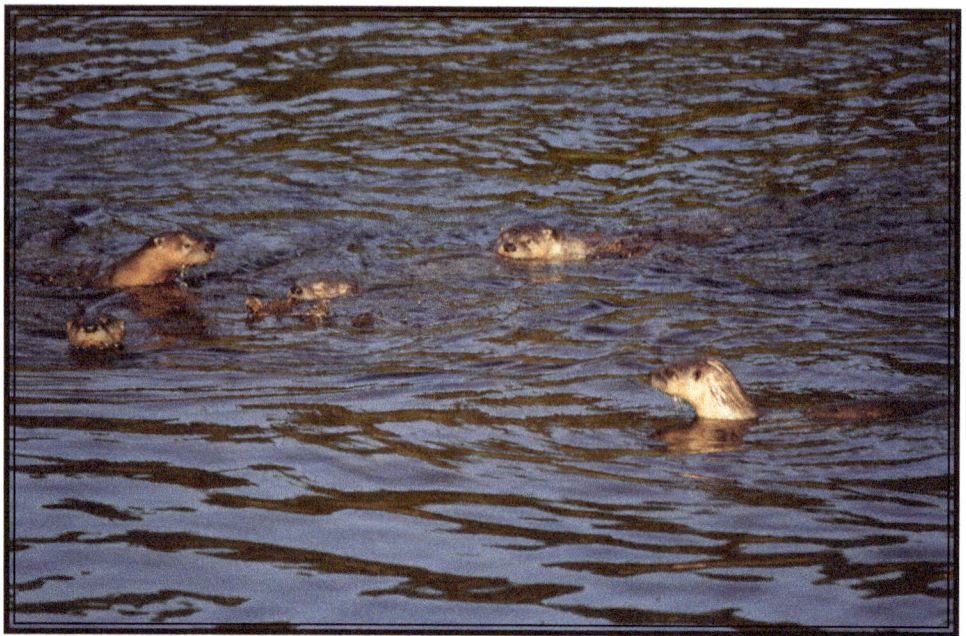

I continued to follow them down the river. I again beat them to the second boardwalk that lead us to the edge of the river. And again the otters acted the same way as they did before.

Once they passed me, I headed to the bridge that crosses the river about a half a kilometer down the river from where I first saw them.

I was also able to beat them to this spot, because I did, the otters climbed up onto the river bank and just sat there. I was able to watch them for quite a while before they headed back up the river towards Waskesiu Lake.

I also followed them as they swam up the river. I was able to get back to the bridge before they did, this allowed me to take even more great pictures of them as they swam towards me as they went under the bridge, back to the lake.

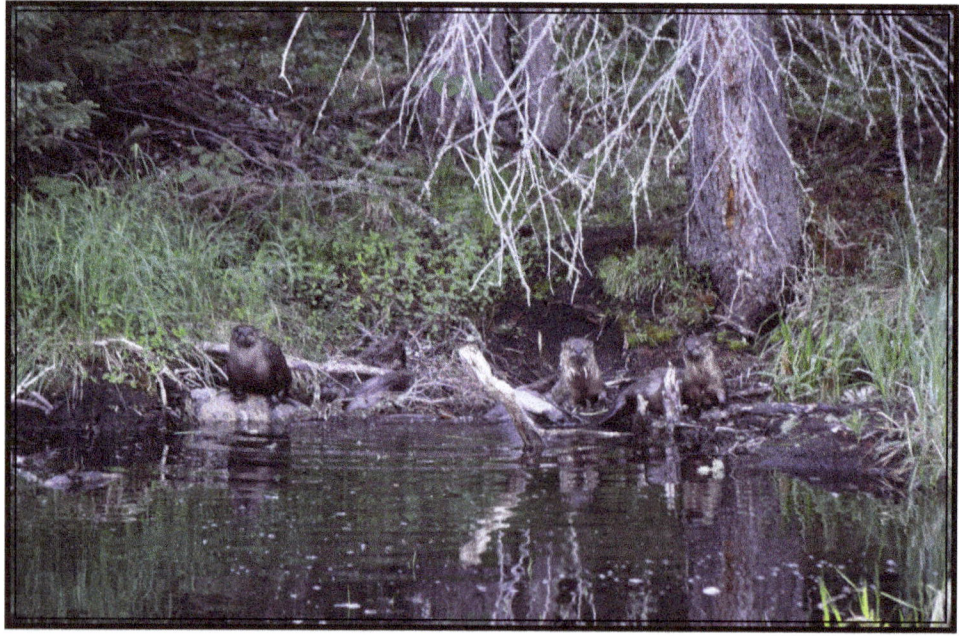

I only saw the otters one more time. Once in a while, I would ride my bike up to Hanging Heart Lakes. It was about a 56-minutes trip for me, one way.

One day as I was on my bike, I came to a small lake that was just before the turn-off to Hanging Heart Lakes. To my surprise, I saw four otters swimming along the shore. I was truly excited that I was able to see these playful otters one more time.

Again, I walked along the shoreline, watching the otters for almost the full length of the lake. I was able to take many pictures of them. As they reached the end of the lake, they went into the cattails and I lost sight of them. I waited for some time, hoping to see if they would cross the highway, to get back into Waskesiu Lake, but sadly they never did, I don't know what happened to them, they probably just stayed in the cattails.

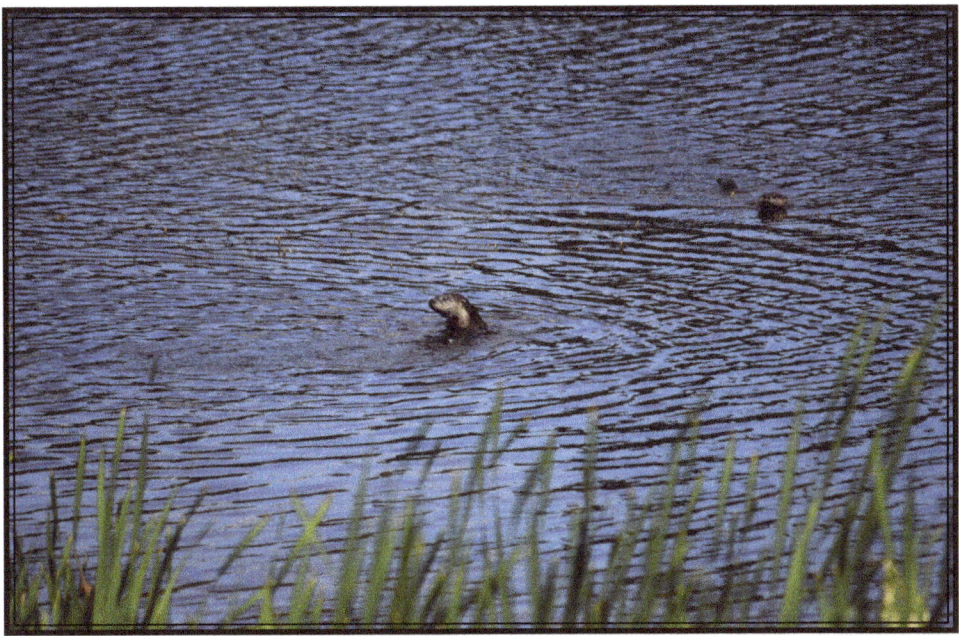

I made another trip to the same lake that I saw the otters in and I was able to clearly see how the otters made it from Waskesiu Lake, crossing the highway and taking a leisurely swim in this other lake. The path they left behind was clear and easy to discern.

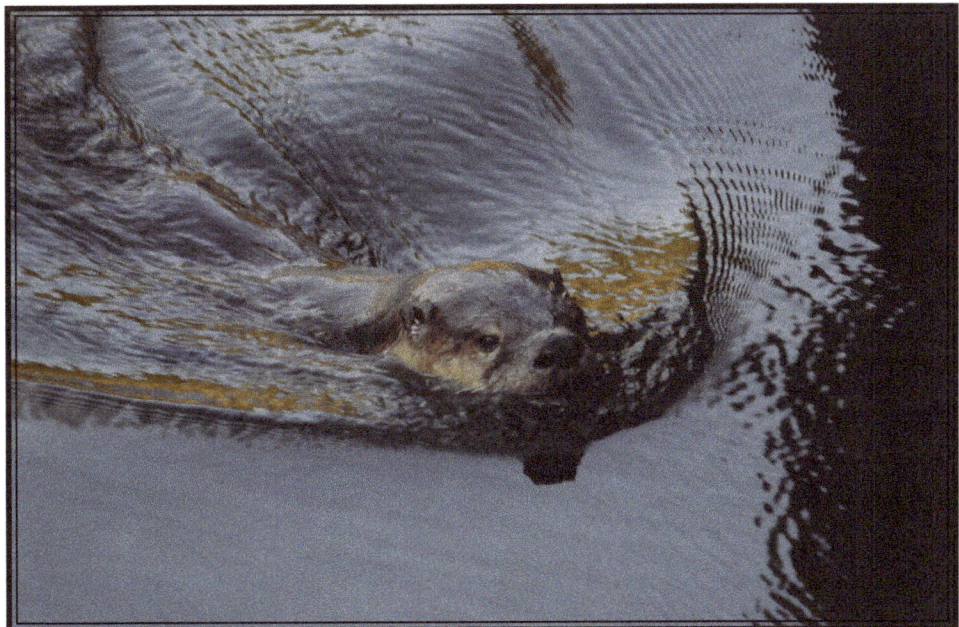

# The Groundhog

The third thing on my list of things to see was a groundhog. Last spring while I was walking on the path that leads to the golf course, I came to the fifteenth green. Beside the green is an open-sided shed and as I came up to this area, a groundhog came from where the shed was and ran right in front of me across the path and into the bush. He tried to hide beside a dead tree that was laying on the ground, but all I had at this time was my phone, I had not yet bought my camera.

So this year I was going to get a picture of a groundhog. I had a basic idea of where to look, since I had seen one here before, I thought that this would be a good place to begin my search. There were also a lot of holes dug into the ground, so I figured that this must be an area that was frequently visited by a groundhog.

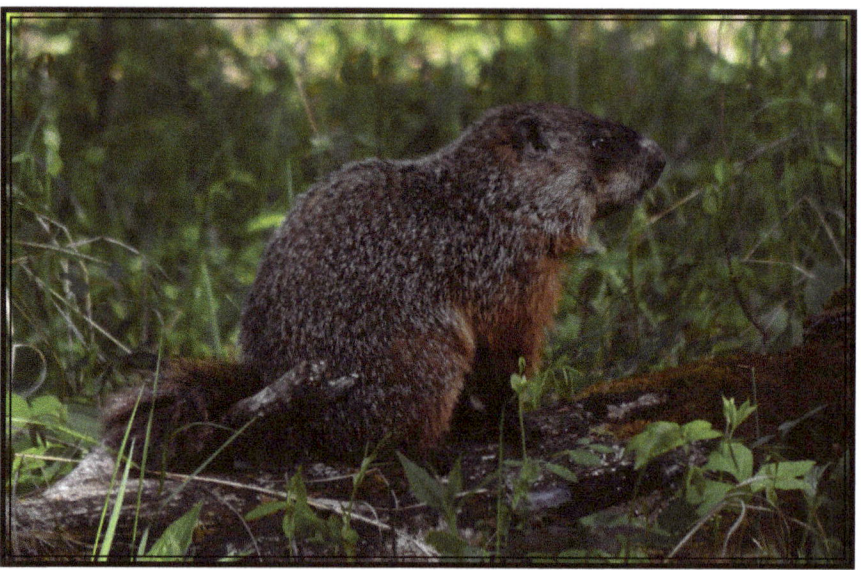

In order to get a picture of a groundhog, I made it a daily routine of walking to the golf course. But I was not successful in my efforts. I was beginning to think that I was not going to get a picture. But, even though, many days passed by, I was determined. I was going to find a groundhog.

Then, one morning as I was walking back from the golf course, I decided to walk through the bush to the fifteenth tee box. For the first few times that I did this, I didn't see anything, but one day while I was walking to the fifteenth tee box, I noticed a couple of Brown Creepers. I tried to get a picture of them, but they were too quick and flew away, I was unable to get a picture of them.

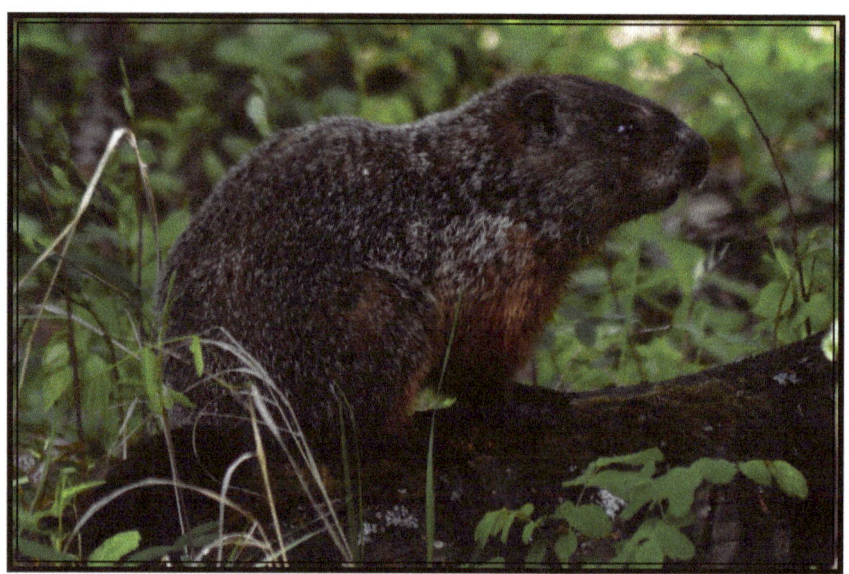

This failure let to great success, because as I turned around to walk back to where I came from, I noticed a groundhog running across the fifteenth tee box.

Off to the races I went.

I proceeded to go where the groundhog had gone. The results were truly amazing. I was able to find the groundhog and immediately began to take some amazing pictures.

After I was able to take a few pictures, the groundhog would move a few yards further into the bush and then stop. Naturally, I would move in closer to the groundhog and again take even more pictures of him.

Then, again, the groundhog would move further into the bush, this time he ended up on top of a tree that was laying on the ground, but the trunk was elevated up off the ground. This gave me even more amazing pictures as I got as close to the groundhog as I dared.

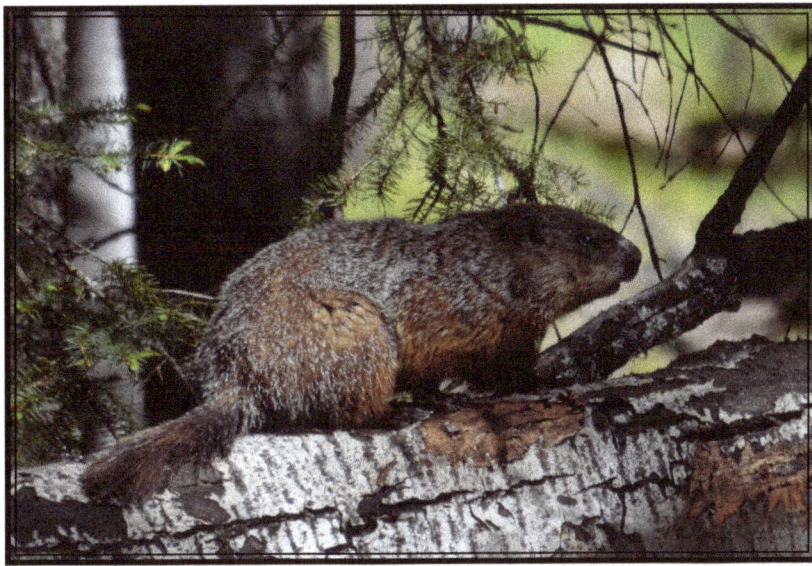

After he moved down the length of the tree trunk, I again moved in closer to get more amazing pictures. After I took these pictures, the groundhog ran toward the water treatment plant on the edge of town, across the road, and underneath a cabin. He certainly had enough of me. I went around the cabin to see if he had come out the other side, but no luck.

But that was alright, as I was able to get some incredible pictures.

This was the one and only time I saw a groundhog. That was okay too, as I was able to complete the third part of my objective. I got some amazing pictures of an incredible mammal – the groundhog.

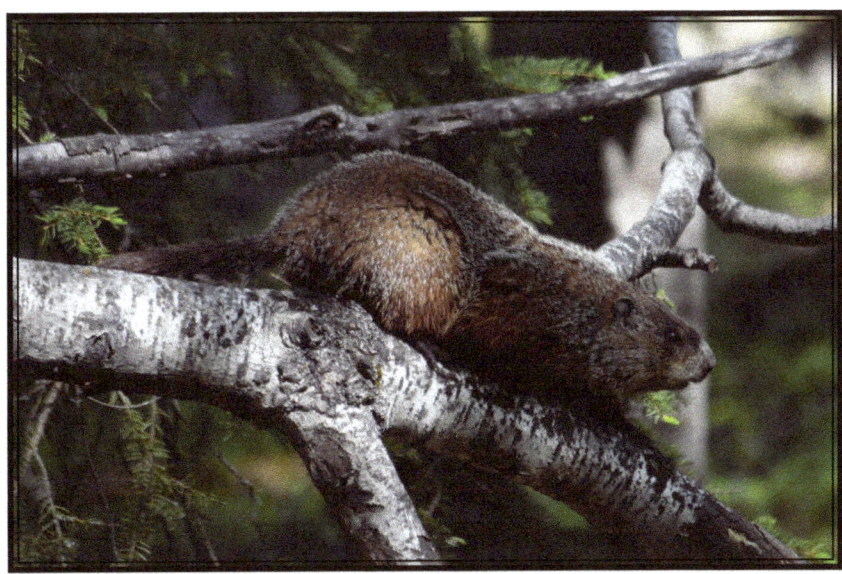

# The White-Tailed Deer and Fawn

One of the prettiest animal, in my opinion, is a fawn. With their white spots on a red carpet of fur, what beauty. So it is no surprise that I wanted a picture of a fawn. But, it took me quite a while before I even saw a fawn, let alone get a picture of one.

One day while I was walking down the path, coming back from the golf course, a lady told me that a deer and her fawn were in between a couple of cabins. I took the round-about way to get where they were hoping to sneak up on them. But by the time I got there, they had seen me and headed into the bush.

Of course, I didn't give up, I took off right after them. By the time I saw them again, the fawn was lingering behind her mother. As soon as the fawn saw me, she stopped, looking right at me. This allowed me to take some pictures. I still tried to get even better pictures and therefore, I followed the fawn further into the bush, but was unsuccessful.

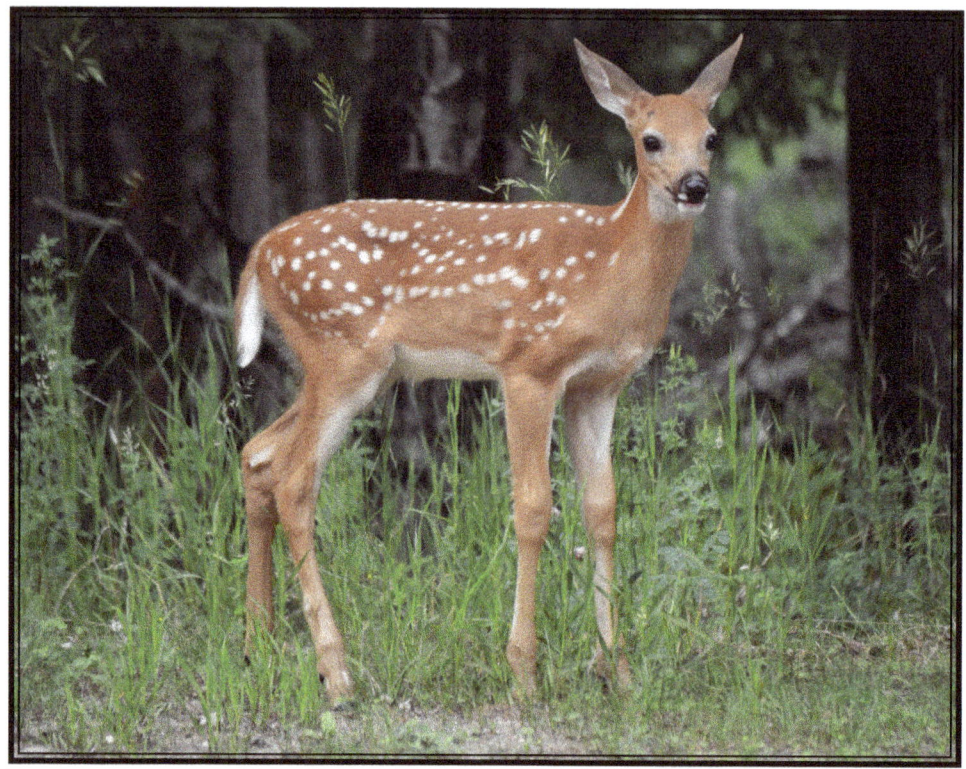

But, now that I had finally seen a fawn. I knew I would have many opportunities to get some amazing pictures. How true this proved to be.

The most amazing experience that I had with a fawn, happened one morning while I was walking to see the beavers, which I did every morning. As I was walking down the road to the beaver lodges, I noticed that across the pond was a deer and a fawn. I took a few pictures of them and then I decided to see if I could get an even better picture.

Just behind the deer, there is an area that has lots of small pine trees, so to get to where the fawn was, I had to walk around these trees.

But by the time I got to where I figured the fawn would come out, an area where there was a clearing because of a path, the deer had already crossed the path into a forest and as I watched the fawn following right behind her mother, there was nothing I could do, it was too late to get an amazing picture.

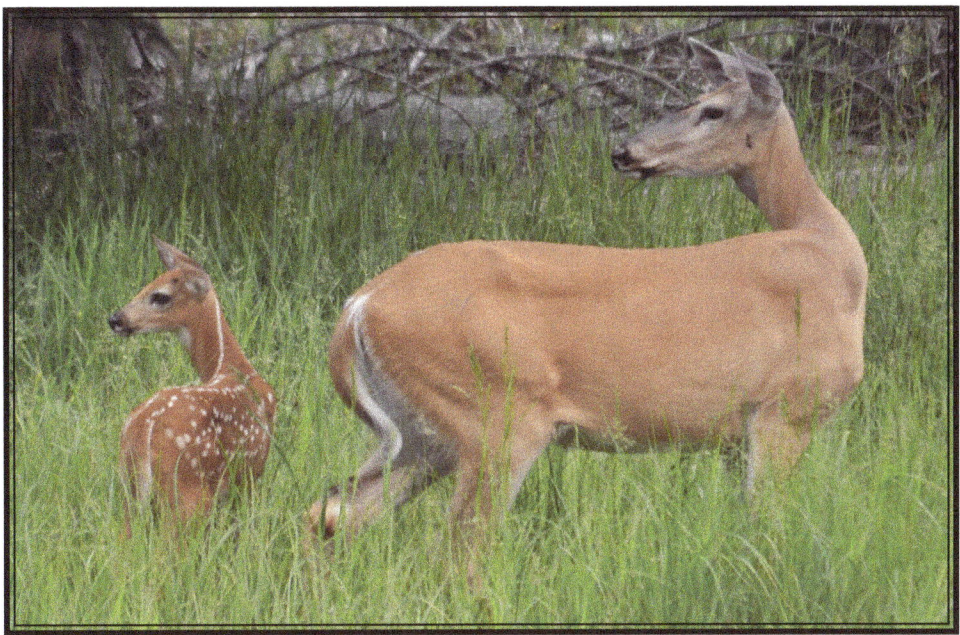

Still, trying to accomplish my goal, I continued to follow them.

To my surprise, I came across them again, when they came up to an apartment building. They were on the southwest corner of the building, while I was on the north side of the building. I decided to see if I could sneak up on them, by walking around a few parked cars, then to the northwest corner of the building, getting as close as I possibly could.

But something truly amazing happened before I could carry out my plan. Unknown to me and which turned out great, was the fact that two Parks personnel walked around the apartment, but they went around the east side of the building first. This action naturally forced the deer to come right to where I was standing.

But what was even more amazing and exciting to see was that they just walked by me, the fawn even stopped right across from me and just looked at me, even though they were just a few yards from where I was standing. Thankfully, the shock didn't prevent me from taking some amazing pictures.

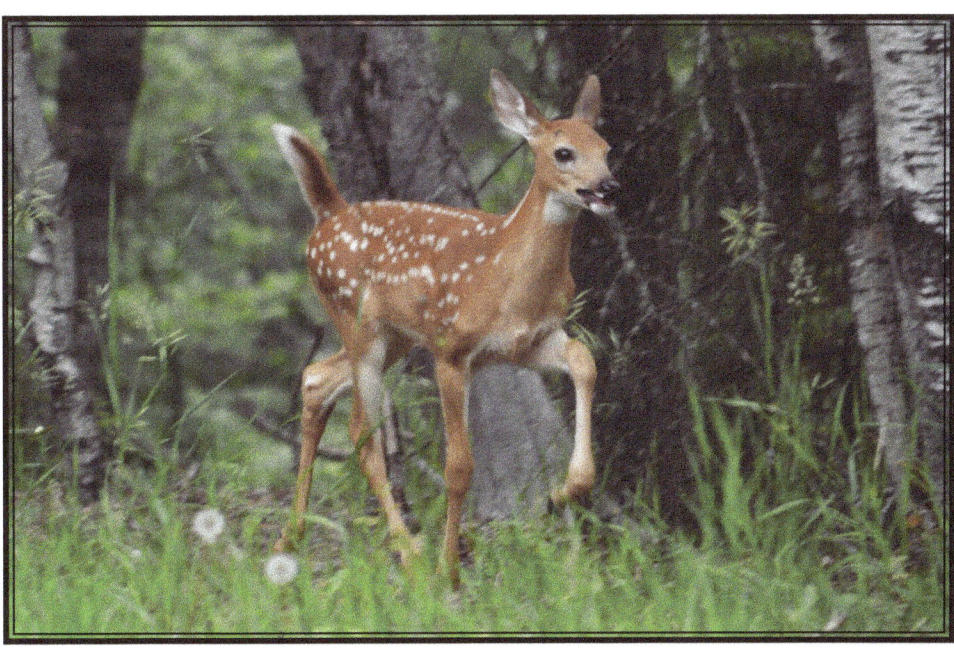

Naturally, I was very thankful for the help I received from the Parks personnel, which I thanked them for.

I also came across them one more time that was memorable for me again. It wasn't really all that amazing of an experience, but it was still exciting to me.

While I was riding my bike down a path along the outside of the town site, I came across a deer and her fawn. As soon as they saw me, they started to walk down the path, away from me. This really didn't give me a very good opportunity to get a real good picture of them, but I still followed them, patiently waiting for the right moment. Finally, that moment came, for some reason they left the path, cutting through the woods. This gave me the chance I needed to get in front of them as they came out from the woods and onto the highway. Again, because they walked right towards me, I was real close to them and was able to get even more amazing pictures of a very pretty looking fawn.

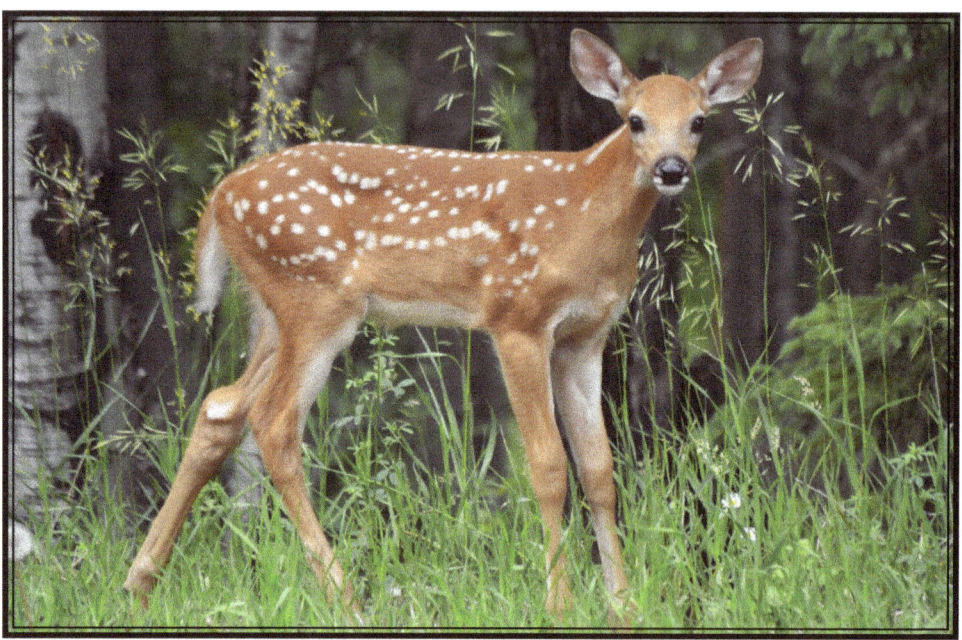

I had one more opportunity to see a fawn and I took a few pictures while the fawn was standing at the edge of a pond. Since I had so many amazing pictures, I really didn't need to see a fawn again, except to enjoy watching these amazing creatures.

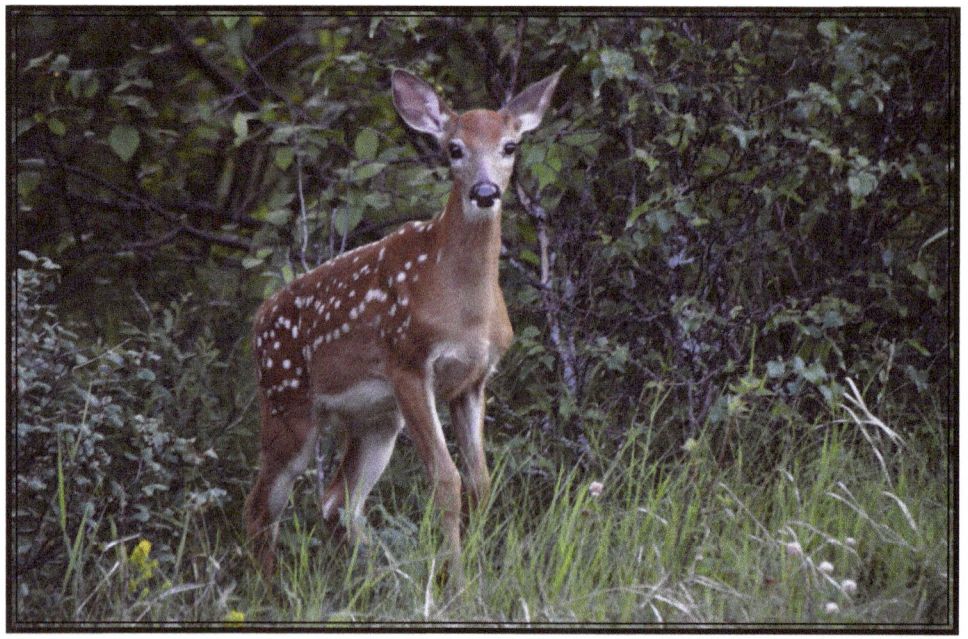

# The Beavers

The animal that I watched the most was undoubtedly, the beaver.

I spent many hours every day just watching and enjoying these amazing creatures. I certainly understand why they are referred to as a busy beaver.

On either the first day or second day of my arrival to the park, I was told by a Parks lady that if I was interested in an active beaver lodge, there was one just on the outskirts of the town site. Naturally, I was. Even though, she gave me directions to where it was, I either was not listening close enough to them or I was easily confused because I had a hard time finding them.

Thankfully, I am persistent and I do not give up easily. I began to reason on how I could find this active beaver lodge. There was a pond that was divided into two by a road and even though, there was a lodge in both ponds, I saw no activity at all.

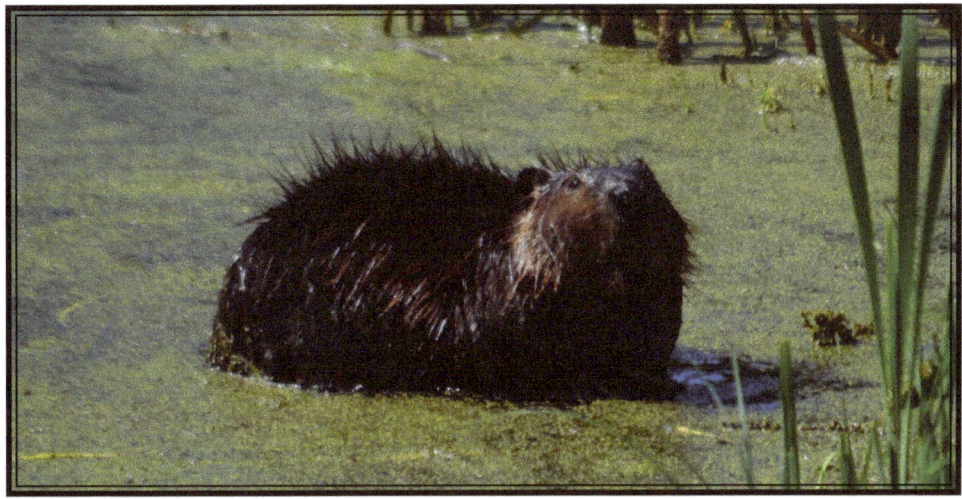

I began to wonder where exactly they could be. I decided that these two ponds were not the ones that the Parks lady was referring to. So I began searching for this elusive second pond that had all the beavers in it.

I probably, spent two days looking for this pond. I walked all over the place and I just could not find out where they were. Well, one day as I was walking back from the ponds towards town, I came across a meadow and for some reason, unknown to me, I decided to walk across it, still trying to find beavers to photograph.

To my surprise, I came across another pond. Guess what I found?

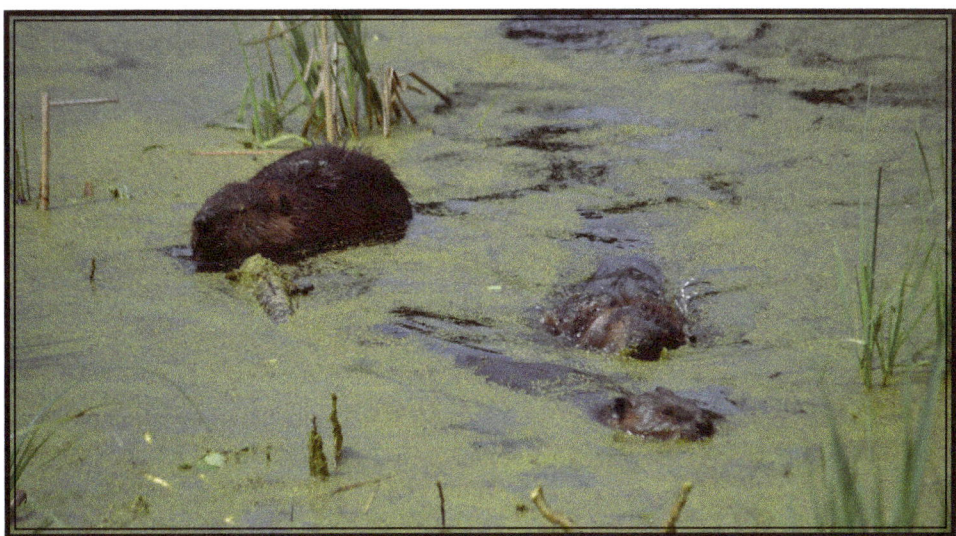

I walked right up to the edge of the pond and just stood there and watched the beavers in action. I saw two beavers by their lodge, but it was not only a little too far away for my liking, but there was also a lot of cattails that would not have allowed me to get a very good picture. But that was okay, as I had finally found them and I knew eventually that I would get an opportunity to get an amazing picture of them.

Still, I was able to enjoy them, by just watching what they were doing.

The next day, I went to see the beavers. I decided to make a habit of going at approximately the same time each day. I wanted to make sure that I saw them. Well, on just the second day of seeing them, something truly amazing happened to me.

When I went to watch them, I tried to get as close to the edge of the pond as I could. As it turned out, I was standing right beside a little ditch. To my surprise, I noticed a few of the cattails moving, could it be a beaver, only a few feet away?

Yes, it was. How exciting to be this close to a beaver. But sadly, it didn't stay there long, as it swam away. But that was okay, as I could watch another beaver swimming out in the middle of the pond. Naturally, as I was watching this beaver swim around, I was startled by a splash right at my feet. Since I was not expecting this, I almost jumped out of my shoes. To my surprise, the beaver had come back to where I was standing and quickly went under the water when it saw me.

Thinking that it was possible that the beaver was a little curious and that it would swim back, I kept my focus on this area. Sure enough, I could see him cautiously swimming back towards me. It was truly amazing how this beaver tried to keep himself hidden by staying behind the cattails. This didn't work as I was still able to get an amazing picture as he sheepishly came to see what I was doing.

I would keep coming back to watch the beavers, but where I was standing wasn't conducive in helping me to get some more amazing pictures of them. So, I decided to go to the opposite side of the pond, straight across from where their lodge was, giving me a clear path so that I could get a better view of the beavers when they were by their lodge.

The next day, I carried out my plan and while I was watching them, I noticed a beaver walking down a path that leads up to a group of trees and that was on the same side of the pond as their lodge.

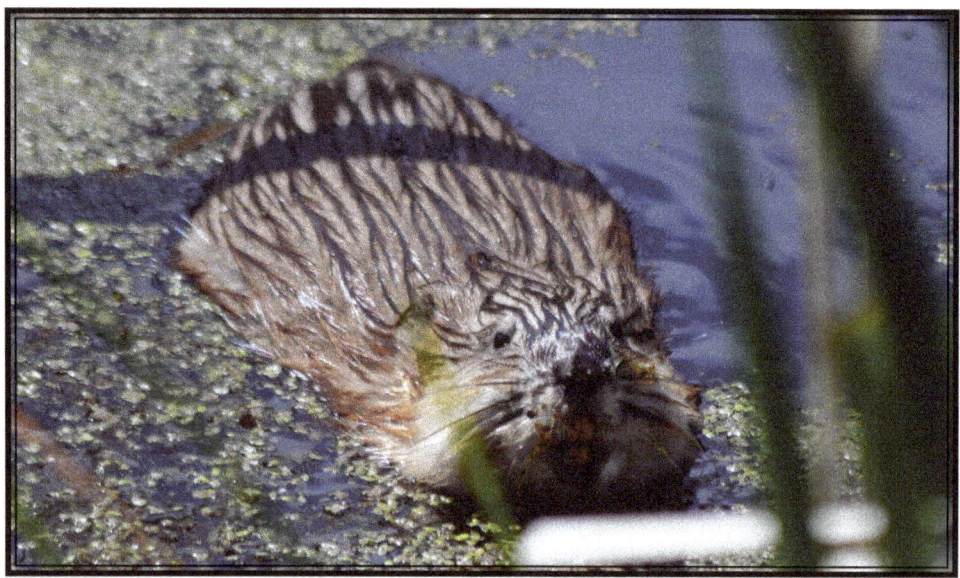

The investigator that I am or snoop, I decided the next day to try and find out where this path leads to and why they were so active on this path.

Since it wasn't such a big area to search, I was able to find the reason why they were frequently on this path. I was able to find their handiwork as they had cut down two large poplar trees.

The path to these trees was well used, so now I found a new favorite place in which to get some amazing pictures of a beaver. I knew that they would be back to the trees that they had just cut down, so all I had to do was just patiently wait for my opportunity.

Sure enough, it came.

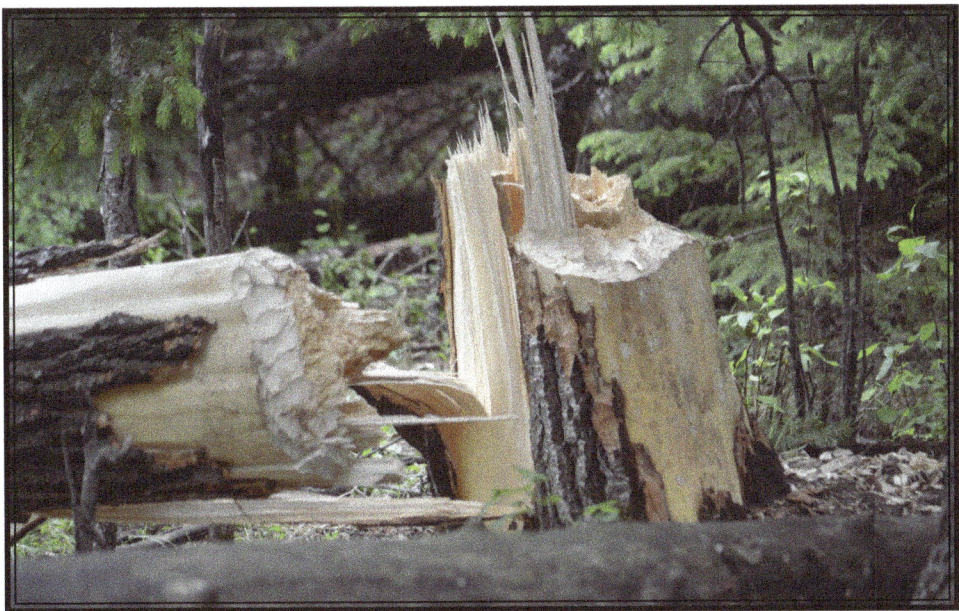

One day, I patiently waited to see if the beavers would make a trip down the path to the trees that they had cut down. I was extremely thrilled to see that they did exactly that.

To my surprise, I saw not just two beavers that day as I had previously seen before, but I saw five beavers. Two were on the path, with another two at the lodge, while I saw still one more swimming in the middle of the pond.

Yes, I had found an active beaver lodge to say the least.

Even though, I was just a few feet from their path, I wasn't really sure if they would continue down the path, I thought I was too close for their liking. But because I was quiet, in stealth mode, the beavers still continued down the path as if I wasn't even there. This allowed me to take some amazing pictures.

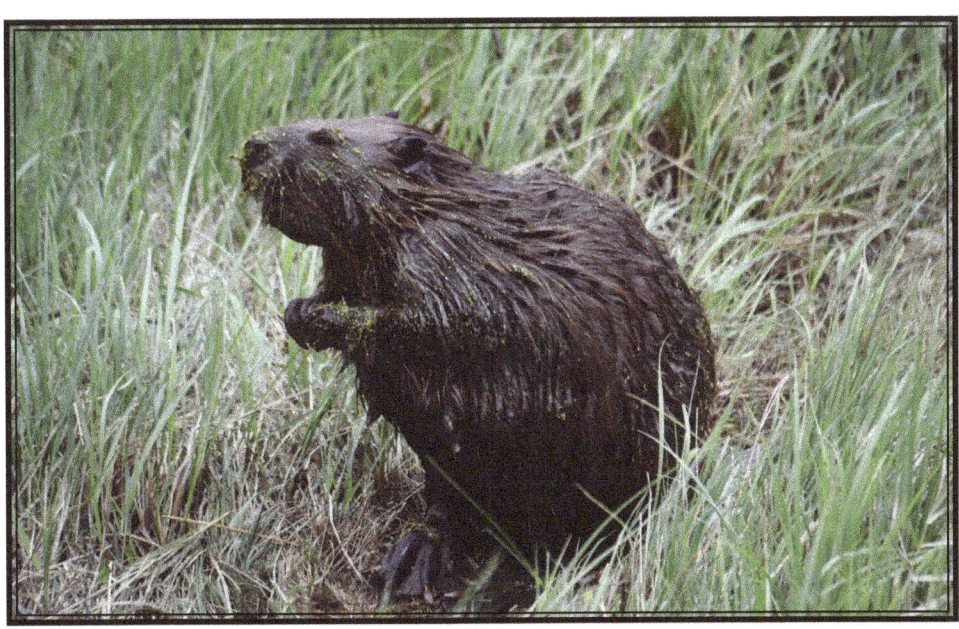

Once they got to the point that they were almost straight across from me, I thought it might be prudent to make some noise as I didn't want them to get pass me and then they might feel like they were trapped.

So what I did was to intentionally step on a twig that was laying just beside me. The noise immediately got their intention as the beaver got up on his two hind feet and began to look around to see what was going on.

*Mammals* | 39

They continued looking around. They didn't go ahead, nor did they go back either. They just stood there. No doubt trying to decide if there was any danger in proceeding further down the path. Again, I thought I should do something, to encourage them to turn around. This time what I decided to do was to take a step or two closer to them, to the path that they were on. Well, that did it, it was enough for the two beavers to turn around and head back to the pond.

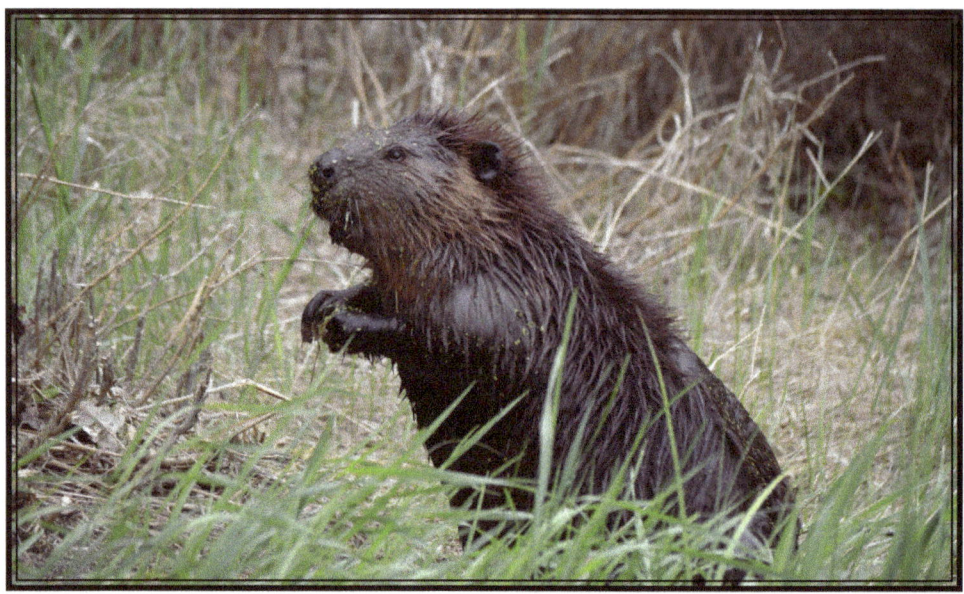

As it turned out, this proved to be a very good opportunity for me to get a picture of them walking down the path away from me. As I was able to get a picture of the beaver's tail. It proved to be a stellar day, a totally awesome and amazing day.

These beavers proved to be totally fascinating creatures in which to watch. Because of my enjoyment, I spend anywhere from 1–2.5 hours every day watching them. One day I can remember quite clearly, was the time that all five of them were eating the bark off the limbs. The noise was almost deafening, well maybe not quite that bad, but it was still surprising just how loud it was as they were busy in having their dinner.

As I watched them, day after day, I started seeing them in all of the four ponds that was strung out in a row. This was very nice to see as it gave me many opportunities to see them in a variety of circumstances, which added to my unique and amazing experiences.

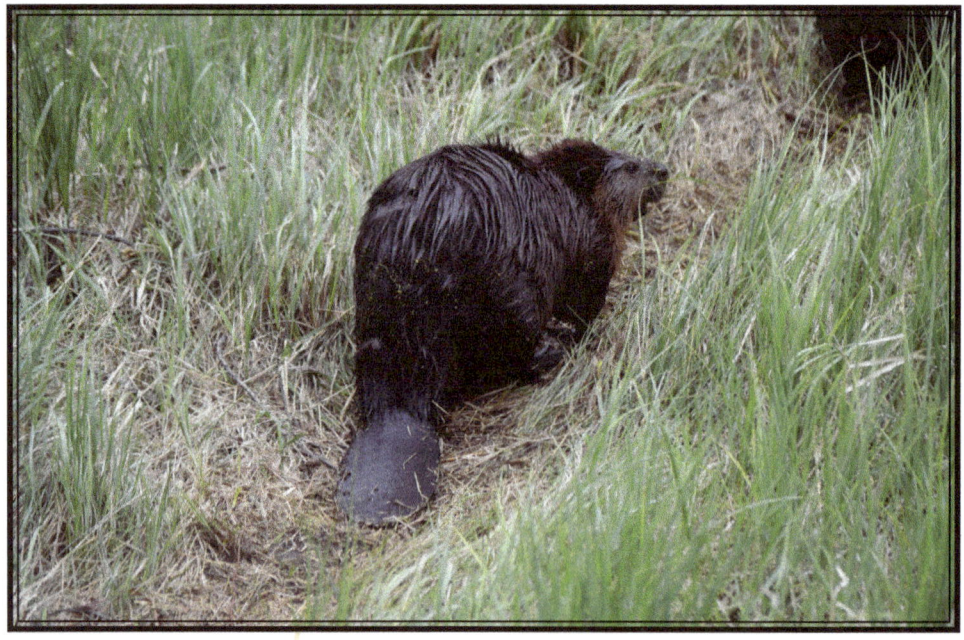

One such time was when I saw four to maybe six Canada geese that were sitting on top of a beaver's lodge. At first I didn't pay much attention to these geese, there was nothing spectacular about that, but all of a sudden, I noticed a beaver that was just below them in the water and was looking at them. I was hoping to get a picture of this, but by the time I got close enough, the beaver turned his attention to three or four other geese that were swimming in the pond and took after them, chasing them away. I was hoping that by the time I got in position to take a picture, the beaver would again turn his attention to the geese on the lodge. For a moment I thought this would happen when the beaver started to swim towards the lodge. But, when he disappeared under the water, I knew that all was lost. The showdown at the O.K. Corral was going to be a lost opportunity for an amazing picture.

I realized then, that he must have went into the lodge. It was not much longer after this that the geese started to walk off the lodge. Did the beaver do something to get them off his lodge?

A beaver can be feisty.

But, as always is the case, what goes around, comes around.

This was the case when I was watching a family of loons. I also noticed in the same lake, a beaver. It didn't take long before one of the adult loons disappeared underneath the water. I didn't know what was going on.

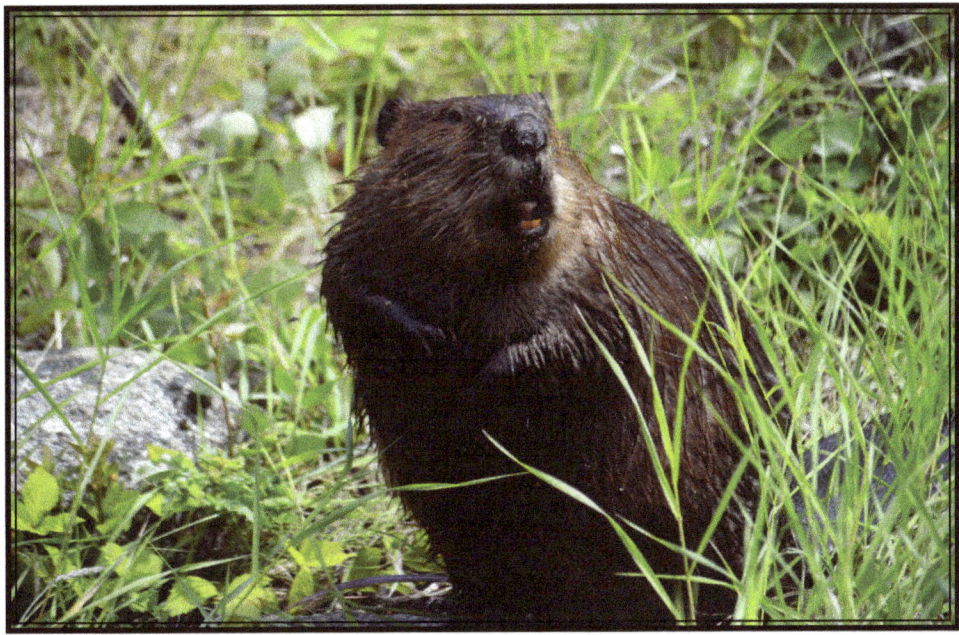

Until all of the sudden, the beaver splashed its tail. The loon had taken after it.

It is amazing how animals protect their territory, especially when it comes to their young ones. But, it is hard to blame them though for acting this way.

Another day, while I was watching a beaver swimming around, I noticed that he was acting in a peculiar way, just swimming in a circle, around and around. I found out later why he was acting this way. By doing a little investigating, I could tell that the beavers were crossing the road by a well-travelled path that went up one side of the road and down the other side. Obviously, because I was standing on the road, between the two ponds, I was an obstruction, in the way of him getting from one pond to the other one.

What the beaver did was the only thing that he could do. I noticed that he went under the water and before long it was in the other pond. It must have went through the culvert that linked the two ponds.

I now wanted a picture of a beaver as they walked across the road, therefore, I decided to stake out this path. Well, one day as I was walking down the road to see if I would be able to get a picture of a beaver, I was surprised to see a beaver walking across the road. Of course, I was too late and too far away to get an amazing picture of this exciting event. I wasn't disappointed that I missed this opportunity, though.

The only thing that really mattered was the fact that I had seen a beaver on the road. I knew, I would get another opportunity, it would just take a little time and patience, which I had plenty of.

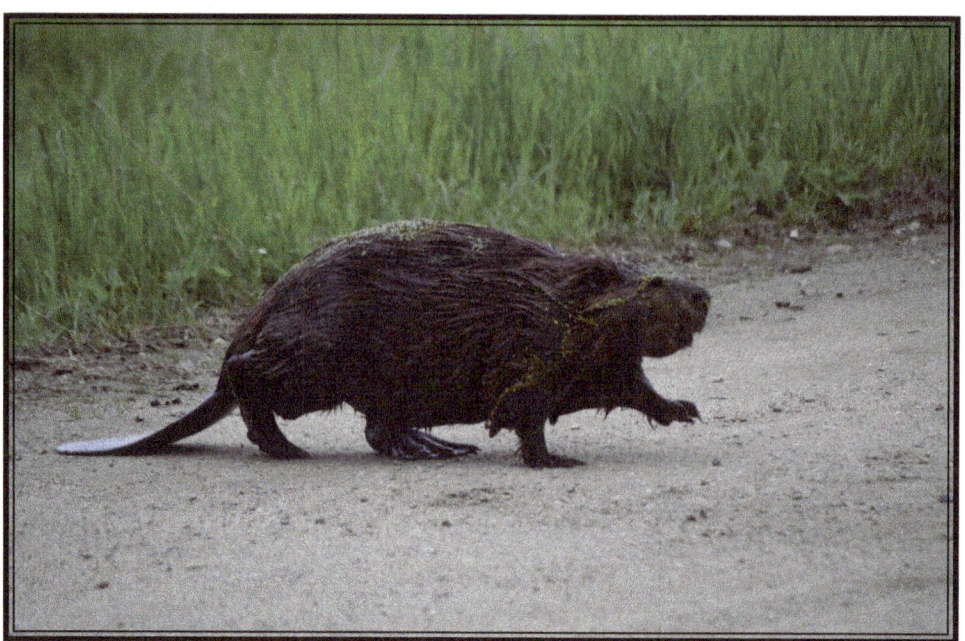

The first time that I saw the beaver about to cross the road, I made the mistake of being too close to the path and on the wrong side of the road. Because as soon as he saw me, the beaver stopped, looked around and then, went back from where he came and swam away.

I learned my lesson well, the next time I went to get a picture of this opportunity, I decided to stand where the beaver would not see me.

Now came the hard part, I just stood there and waited. But, it worked.

Eventually, a beaver did come walking across the road. All the while, I was able to take many amazing pictures of the beaver as he high-stepped it across the road. As always, I tried to get an even better picture. To accomplish this, I went back many times, besides I enjoyed watching them.

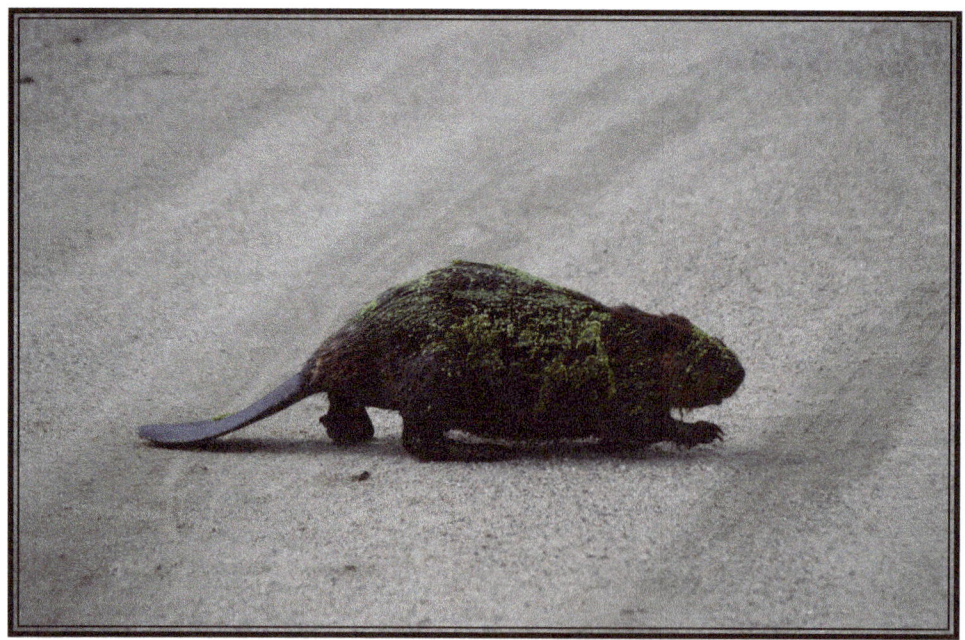

I was certainly glad and worth the time that I did this.

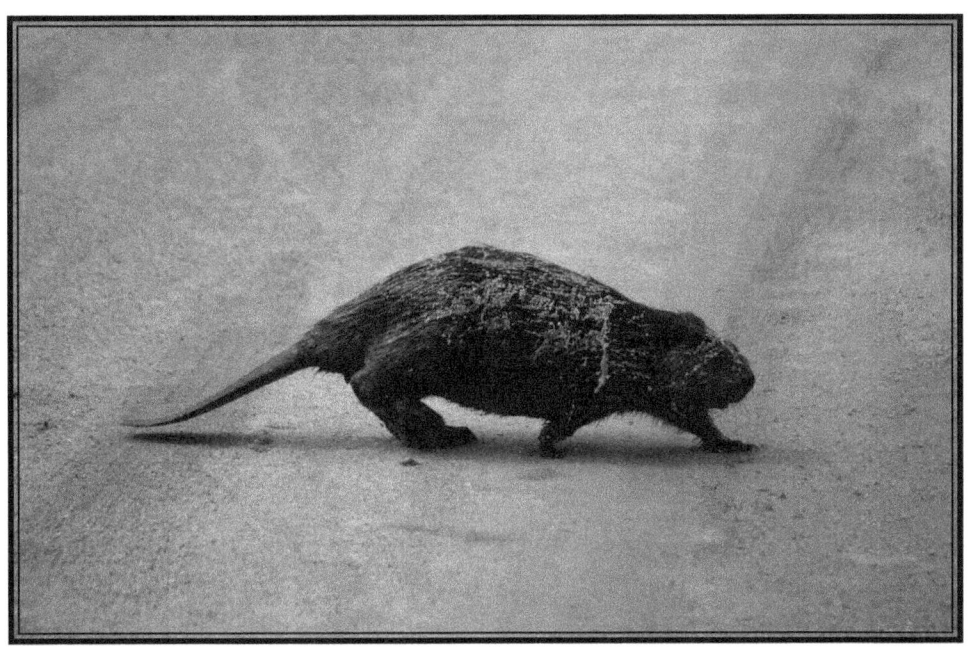

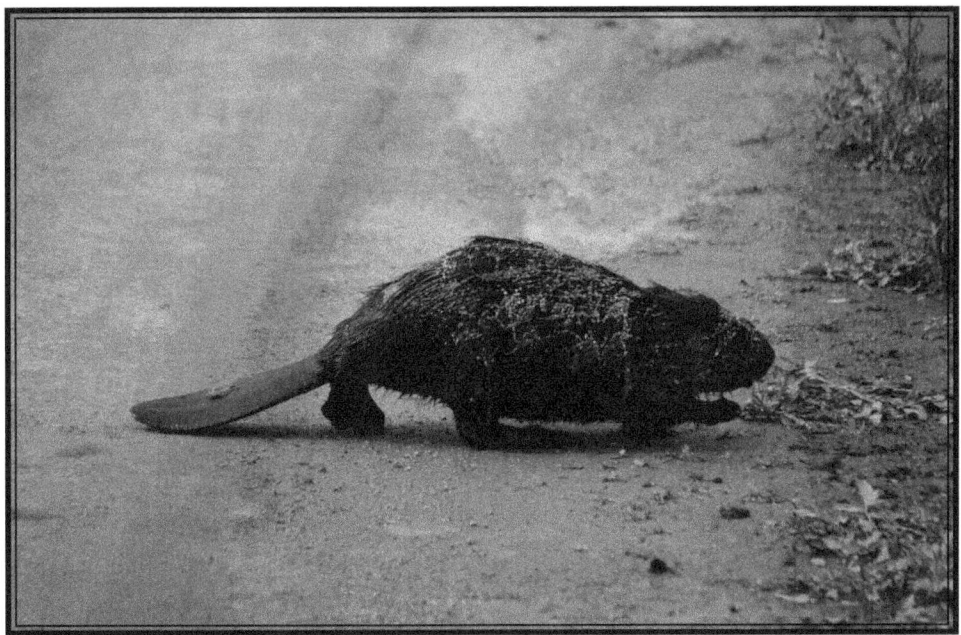

As I was given many opportunities to take some amazing pictures of a beaver in this unique way and was certainly glad to experience it firsthand. Amazing has become a word I use a lot in describing my experiences.

In another attempt to get more amazing pictures, I was totally surprised by what happened to me at another time. I was standing by the side of the road, when I noticed a beaver swimming, but cautiously towards the road. I immediately began to wonder if the beaver was about to cross the road. I patiently waited to see if this would happen. But, here was the surprise.

The beaver did not cross the road where the path was, instead what happened was that I noticed the grass was moving, right in front of me. The beaver was walking right towards me. I was shocked.

I didn't know what to do. To say I was dumbfounded, was an understatement. What was I going to do?

I decided that even though it meant that I would miss an opportunity to have a beaver right at my feet, just a foot or two away, I didn't know how the beaver might react. I decided to back away a few steps.

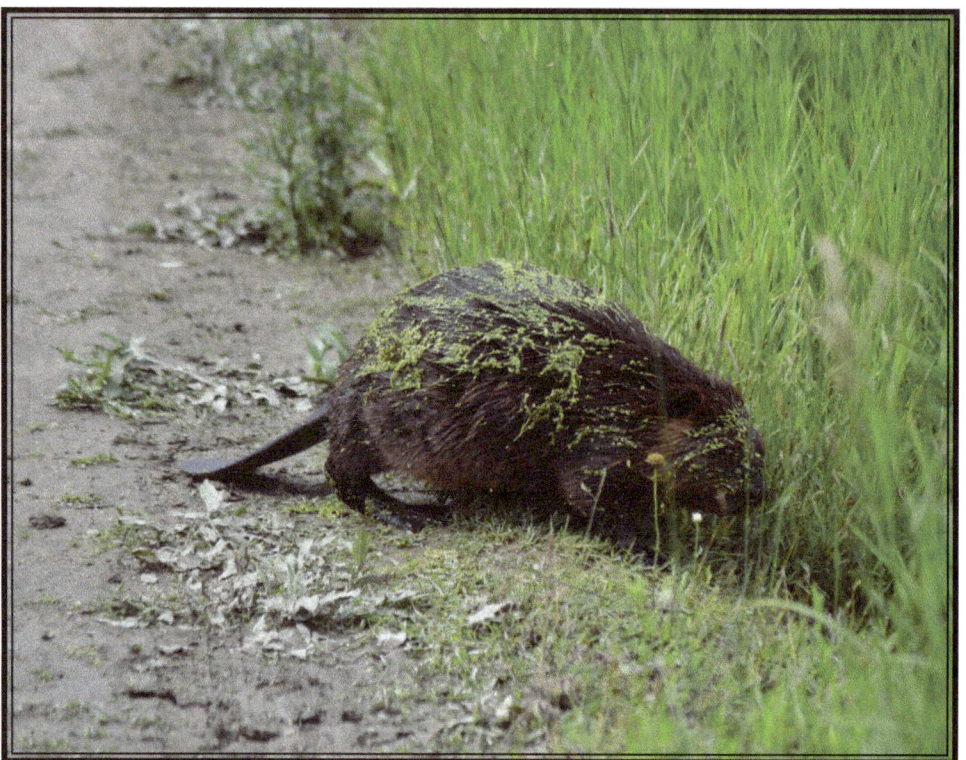

    This action caused me to make some noise and as soon as the beaver heard this, it turned around and headed back into the pond and swam away. I regret not taking the chance, but this was okay too.

    Yes, as it turned out, the beavers were indeed the ones I enjoyed watching the most and was certainly excited to enjoy such amazing experiences.

# The Red Fox

One thing that I was surprised to see or what I didn't see many of were red foxes. Actually, I only saw a family of four foxes besides a mother with just one young one.

The first time I saw this family, I saw just the mother as she was looking for food for her family at the picnic area that is just before the Hanging Heart Lakes turn-off, while a pup was hiding just in the bush.

Up to this point I wasn't too excited about taking a picture of a red fox, as I had so many amazing pictures of them. Not only from last year when I visited the park, but I also had an amazing picture of a very healthy red fox that I took just outside of Birch Hills as it jumped in the air in an attempt to catch a mouse. Which it did. I figured that I could never get a better picture of what I had already taken.

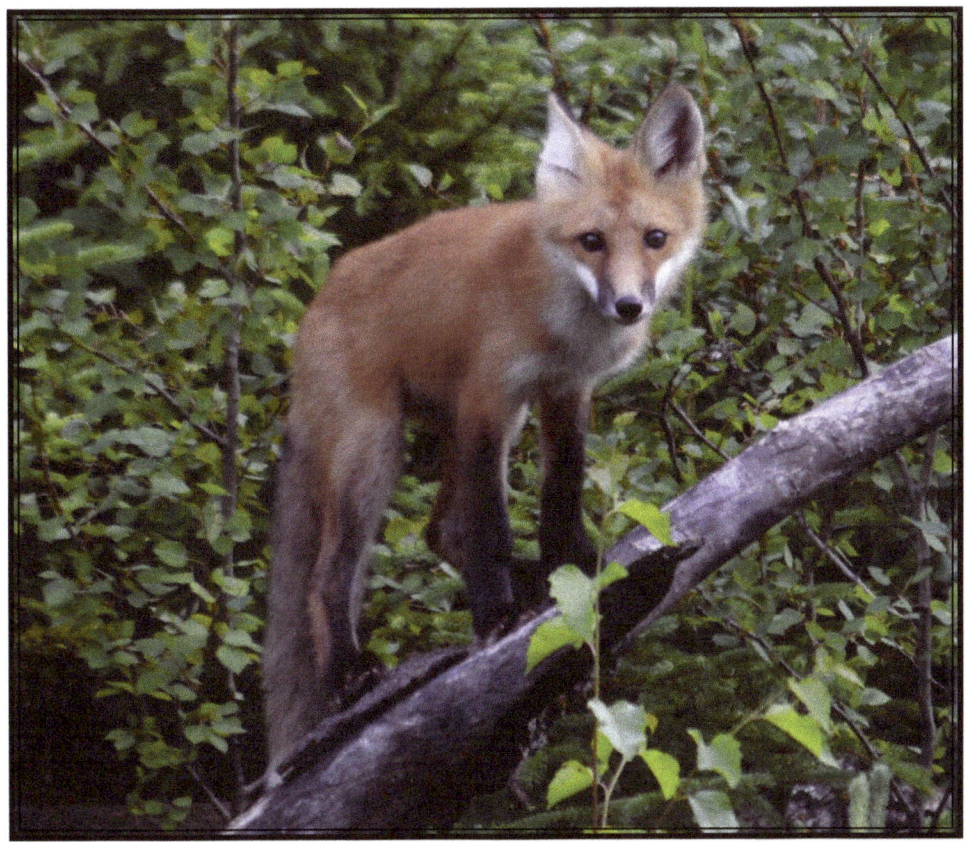

But in time, I had changed my mind. After all, a red fox was still a cute animal to photograph.

So the next time I saw this family, I gave in. My enjoyment for taking pictures of the wildlife found in the park won out. Besides a red fox is also part of the wildlife to be enjoyed. Therefore, I began looking for opportunities to get a photograph of a red fox.

The first couple of times that I had seen them, they ran away from me as soon as I had stopped the truck to get a picture of them, but eventually, I noticed that one of them was not quite as shy. I was able to get out of my truck and one of them didn't run away into the bush. One time, a red fox actually climbed up a dead tree that had fallen over, this gave me a very nice photograph of a red fox.

But the most amazing experience that I had with a red fox was when I noticed a red fox along the side of the road. So, I immediately jumped out of my truck to get a picture. I took a picture and as always in my attempt to get an even better one, I took a few steps closer to him.

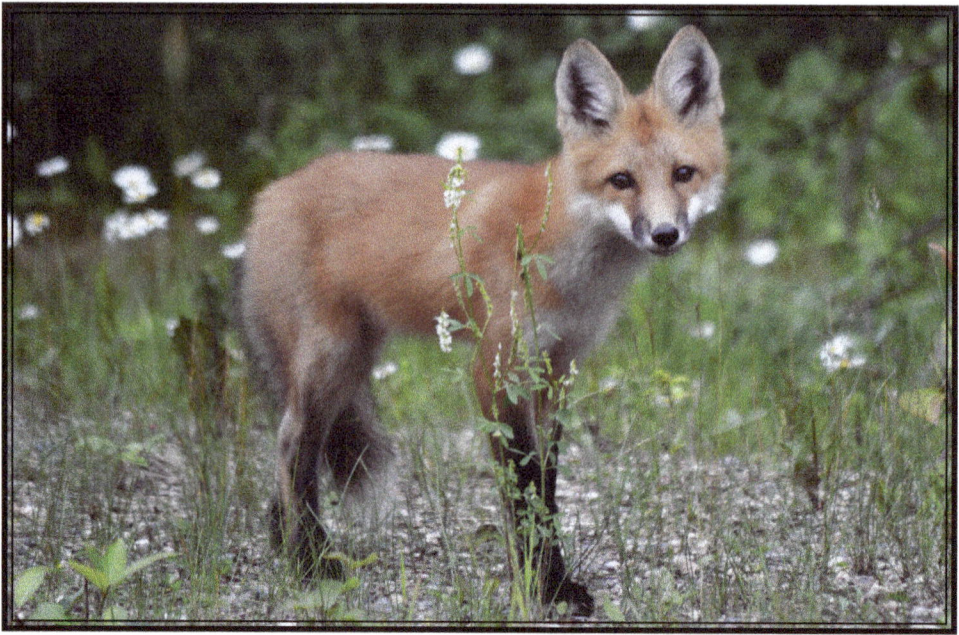

But as I did this, the red fox also took a few steps closer to me.

Finally, the red fox was so close to me that I had to start taking steps backwards. But, the red fox still kept coming closer and closer, until finally I began to wonder if the red fox was going to jump into my truck as I had left the door open.

The red fox was not shy at all, probably because of his youth, the red fox walked all around the truck, first to the back and then, to the front of my truck. As it happened, I noticed later that their den was straight across from where I had just happened to park my truck, this knowledge helped me take many amazing pictures of these cute foxes.

I was able to find out where their den was because as I drove by one time I saw all four of them around a hole in the ground, one was even laying in the mouth of the den. I tried to get a picture of this, but all of them headed farther into the bush. I thought they were gone until I had seen the mother coming up the road with something in her mouth, then her four children came out of the bush and joined their mother on the road. Obviously, looking for something to eat, until they become expert hunters themselves.

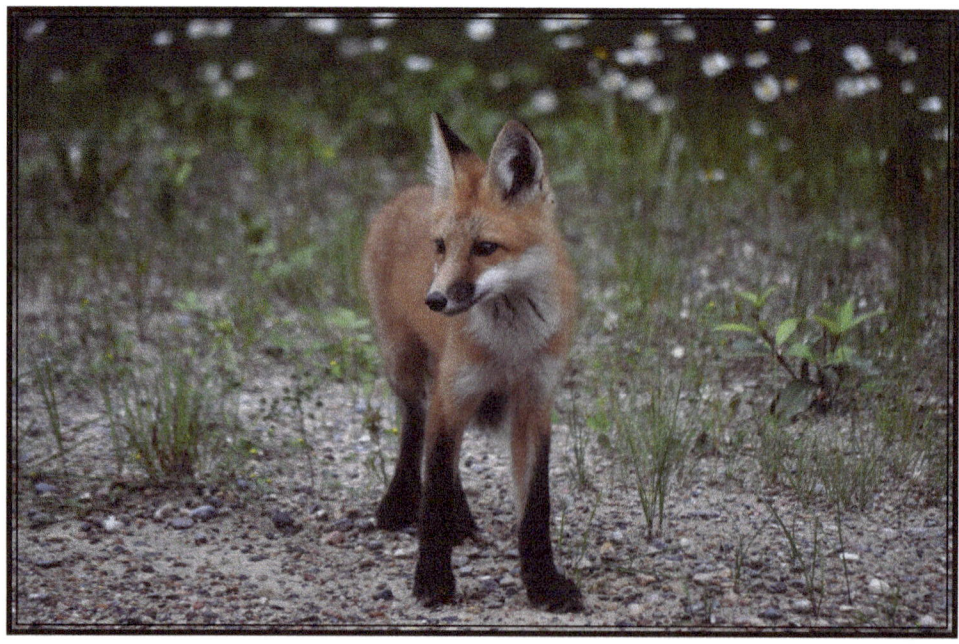

I tried a couple of times after that to see if I could get a picture of the red foxes at their den as this would have made a great picture, but I didn't see them again.

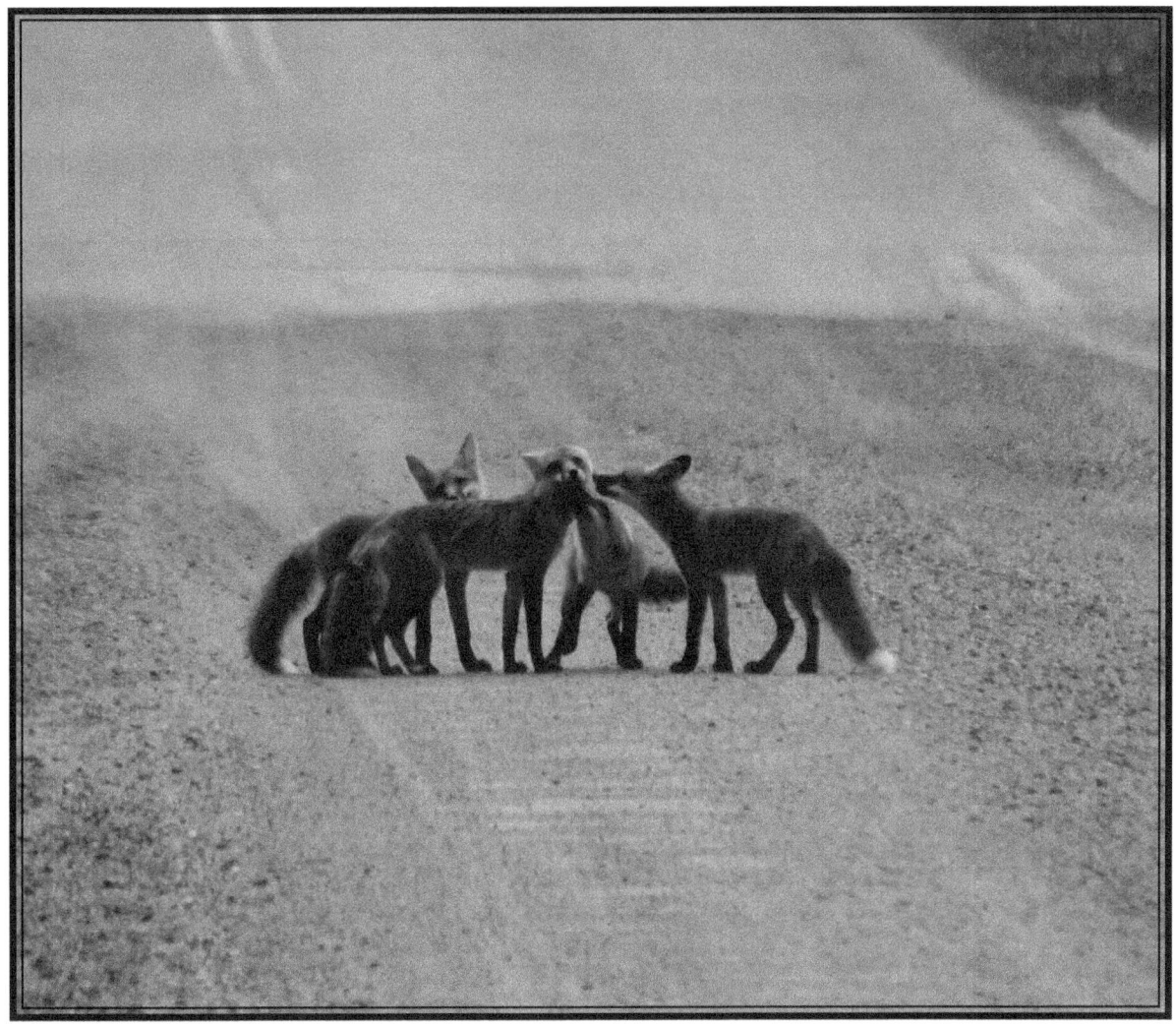

# The Plains Bison

I made only one trip to the Westside of the park this year. On September 13, I made the trip and was expecting to see a bison. But to my disappointment, I saw nothing expect a whole lot of excrement, of which I stepped in because we were led on a trail that only the bison used and I didn't even see it with the tall grass.

Happily though, a very nice Parks lady gave me a toy bison, just in case I didn't see a plains bison on my trip.

*Birds*

# The Pileated Woodpecker

The hardest thing to take pictures of, in my opinion, is the variety of birds that can be seen in the park. From the trees being too tall, to the unfair ability that they have of flying away as soon as they see you.

But that was okay, because of the unnatural ability that I have in being patient and a whole lot of time on my hands, I was still able to take many amazing pictures of common loons, American white pelicans, belted kingfishers, and the great blue heron.

I was even able to take pictures of evening grosbeaks, gray jays and to see the many birds of prey that one can see in the park and to get a picture of an osprey. I also was able to take many pictures of a few ducks that I have never seen before, from American wigeons, common goldeneyes and also a red-breasted merganser. I even was able to get a ruffed grouse mad at me so that I was able to see and get a picture of her as she fanned out her tail feathers, although that wasn't all that hard for me to do.

Yes, I was privileged to get some amazing photographs of a variety of birds. The only thing on my list of must see, that I wanted to get a picture of was a pileated woodpecker. This was the fourth and final thing on my list. Even though, I spent a lot of time trying to get a picture of this remarkable bird, I was unable to finish my list.

Even though, I had seen a pileated woodpecker a number of times, I wasn't able to get a picture of them. The one and only great opportunity I had to get this photograph happened while I was golfing.

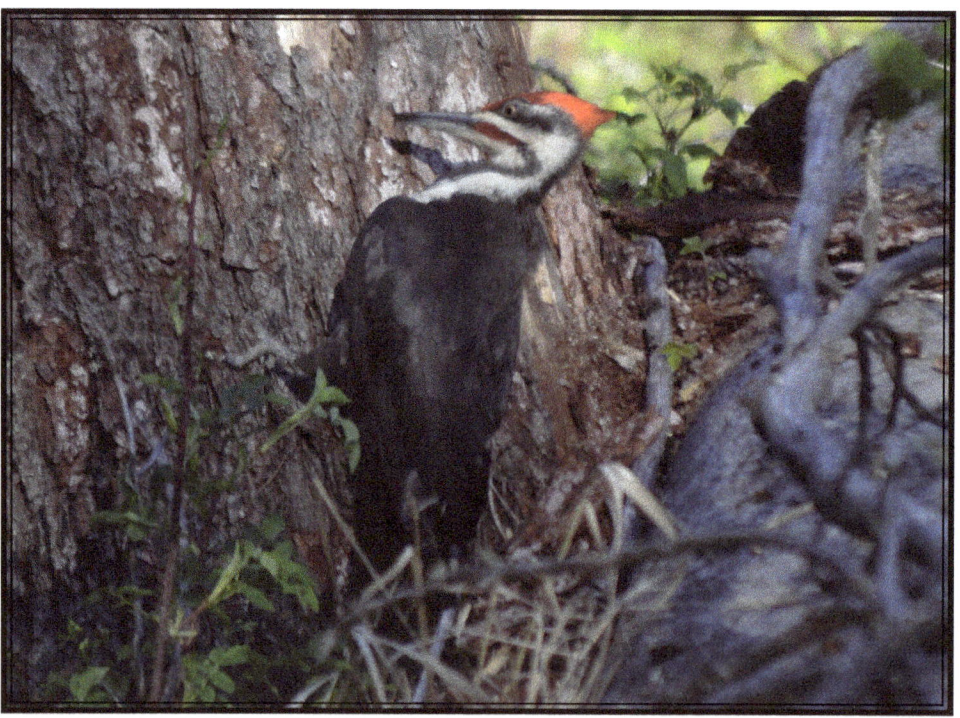

I made the ultimate mistake of foolishly not having my camera. I always made sure that I carried around my camera, wherever I went, just in case I saw something to take a picture of. I even took my camera while I was golfing just in case.

Naturally, the only time I didn't have my camera, was because there was rain in the forecast, so predictably I missed a golden opportunity. Not only did it not rain, but I had an amazing opportunity to get a picture of a pileated woodpecker on the fourteenth hole. Here he was on a pile of wood that was beside the fourteenth green. All I could do was just stand there and watch him. Never again did I get such an amazing opportunity as this. Oh, well there is always next year and I will never make this mistake ever again, even if I have to carry my camera around in a plastic bag.

But, even though it was challenging at times, to get a picture of these amazing birds, I still was able to see some amazing things and was able to still get some amazing photographs from these birds of a feather.

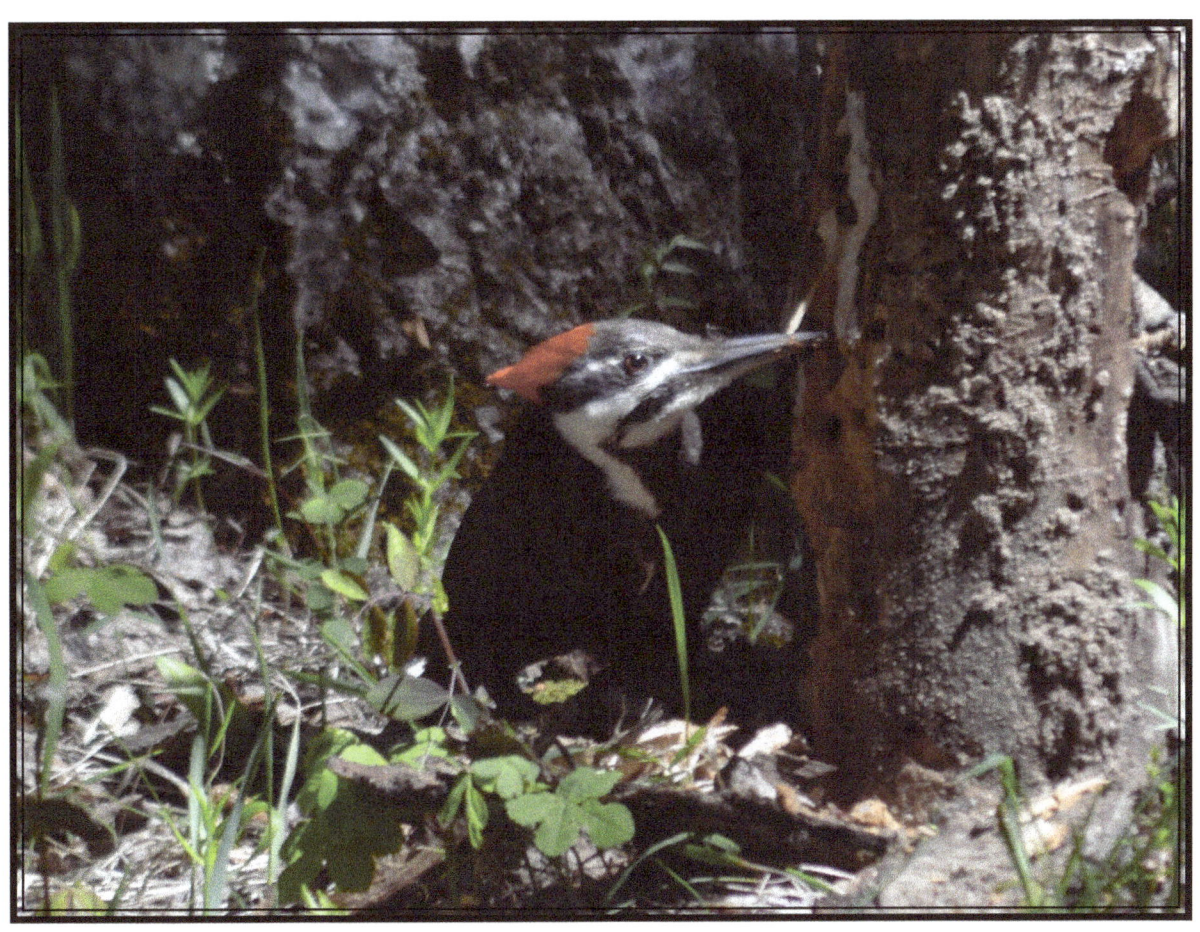

# The Common Loon

The first bird that I had some amazing experiences with was the common loon. I would take a bike ride towards the golf course, around 3:30 pm every day for the first few weeks that I was in the park.

I found it very enjoyable to sit by the lake on the last stairway on the old Kingfisher Trail. I found it so peaceful as the water calmly lapped up against the shoreline. Besides, there was always the chance of seeing something truly amazing.

One day, as I was sitting on the steps, I noticed two loons that were swimming on the lake, but they were too far away for me to get a very good picture of them. But, as always, with a little patience the loons just kept on swimming closer and closer to me. It was truly amazing to see them so close and they were quite content being that close to me.

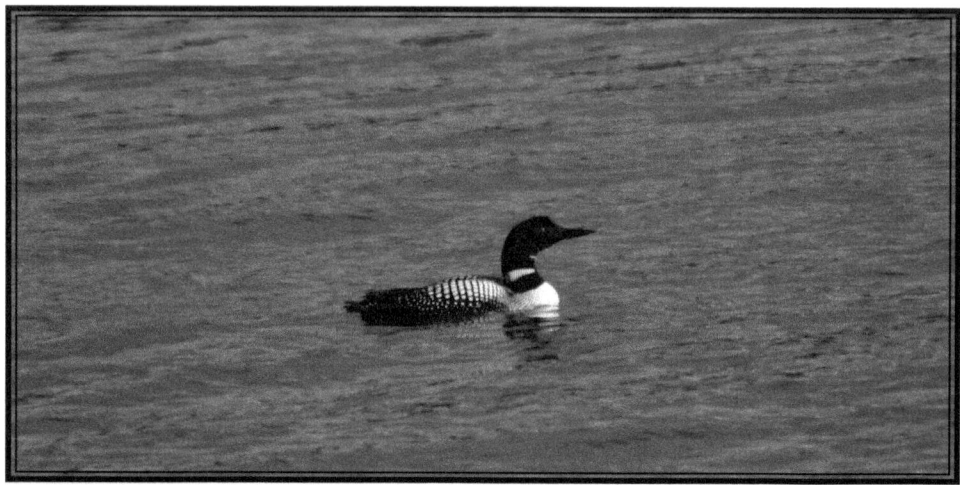

Eventually, they began to fuss with their feathers as I just sat there and watched them.

I certainly enjoyed watching them. The next day, I again made the trip to see if I can see these common loons. Right on time, here they came and this time they even came closer to the shore which allowed me to get even more incredible photographs.

I kept going back to this same spot many times until eventually I could no longer see the common loons. They had obviously moved on.

Another time that I saw the common loons was in the lake that is just before the Hanging Heart Lakes turn-off. As I drove up to this lake, I noticed that there was three common loons that were swimming around. I stopped as I realized that this might be an opportunity for a photograph. What I came to experience was truly remarkable.

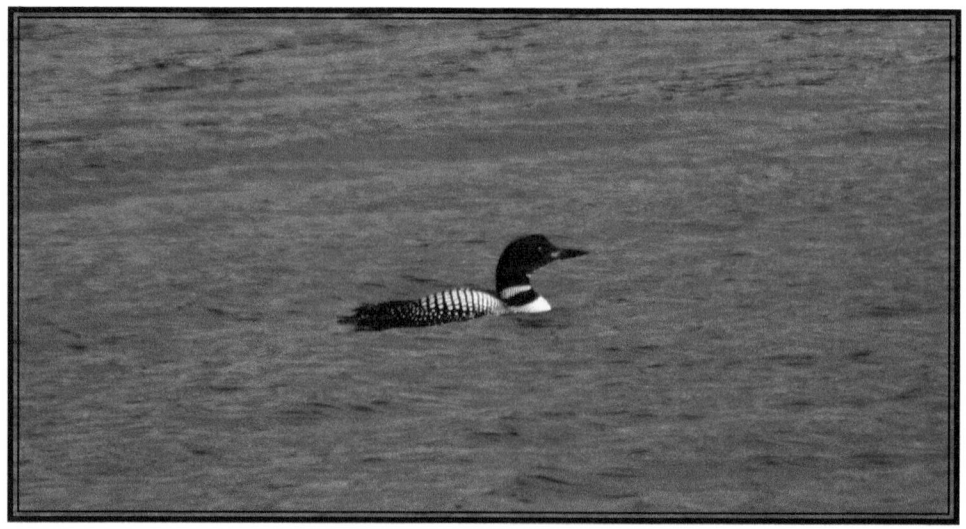

All of a sudden, one of the loons took off after and chased the other loon all over the lake. Obviously, this was two male loons and one was getting too close to the other loon's mate.

The loon chased him all over the lake. From one side to the other side. Just when it seemed that he would catch him, the other loon would put it into high gear and get some distance away, then just as it looked like he wouldn't be caught, he would zig instead of zag, which again would allow the other loon to almost catch him.

It was incredible just how long this went on for. This went on for what seemed like at least half an hour. I was privileged to watch the whole event. What was also amazing was that the loons seemed to be using their wings in helping themselves go back and forth on the water.

But what was even more remarkable was the fact that when they were done, all three of them came together right on the edge of the lake in front of me. I was even exhausted just watching them.

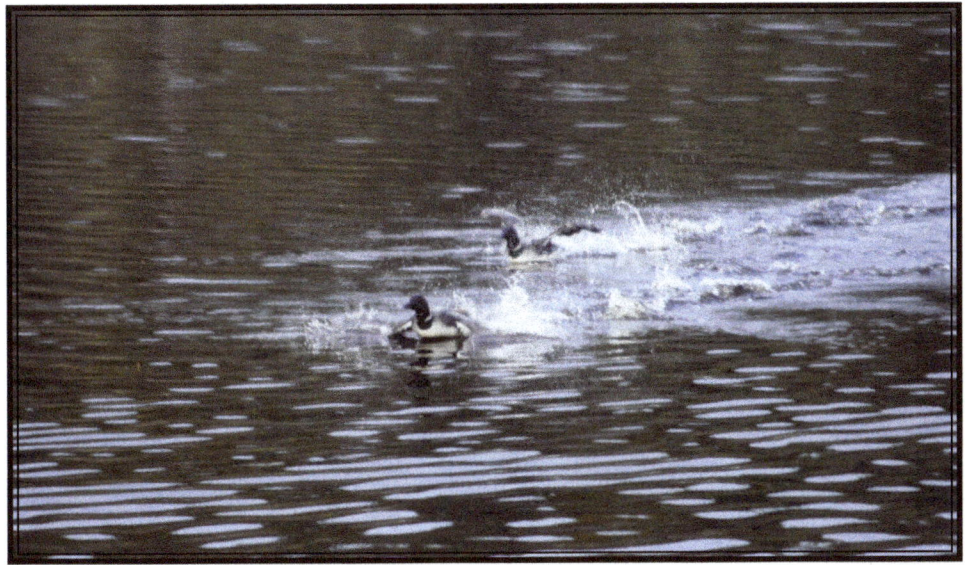

On another day as I was walking down a trail that winds along the lake, just by the Nature Center, I saw a large flock of birds swimming on the lake. They were too far away and since it was also a cloudy day, I was unable to get a very good picture of them. I still took a picture so that I could identify them. It ended up being a flock of common loons. I was able to count as many as 50 to possible as many as 60 of them in the picture.

I followed them for quite a while, I was hoping that they would swim closer to the shore so that I could get a photograph of them, but they never did get close enough.

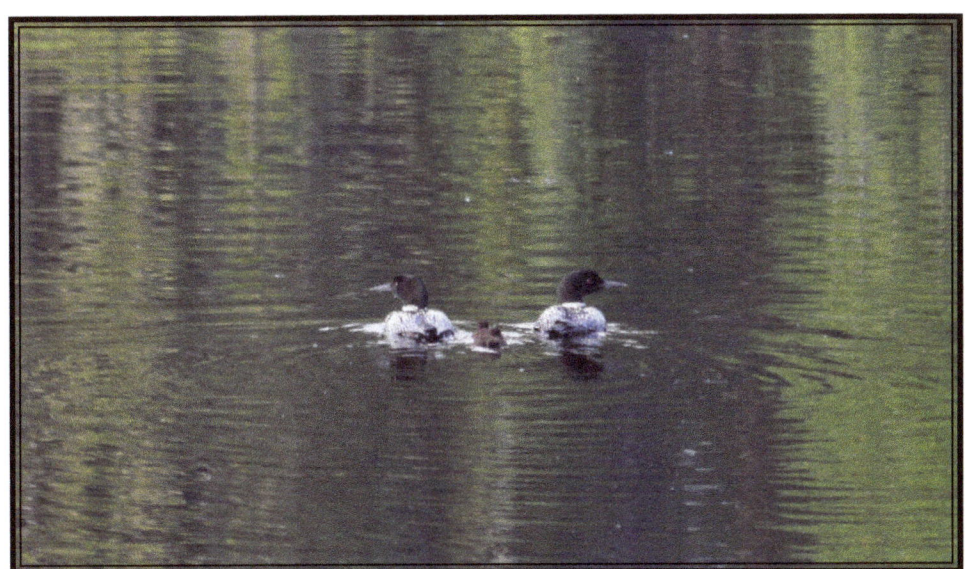

The last time that I saw a common loon was when I saw a family of loons. It was a family of four.

It was quite interesting to watch them as the days went by. To see the adults fishing for their young ones was truly amazing and to see how the young ones were progressing in their training was incredible. Even though, they were too young to dive yet, I could see how they were imitating their parents by searching for their own food, thus receiving valuable training until they were able to catch their own.

Yes, the common loon was a fascinating bird in which to watch and enjoy, besides they allowed me to get some amazing photographs of a truly amazing bird.

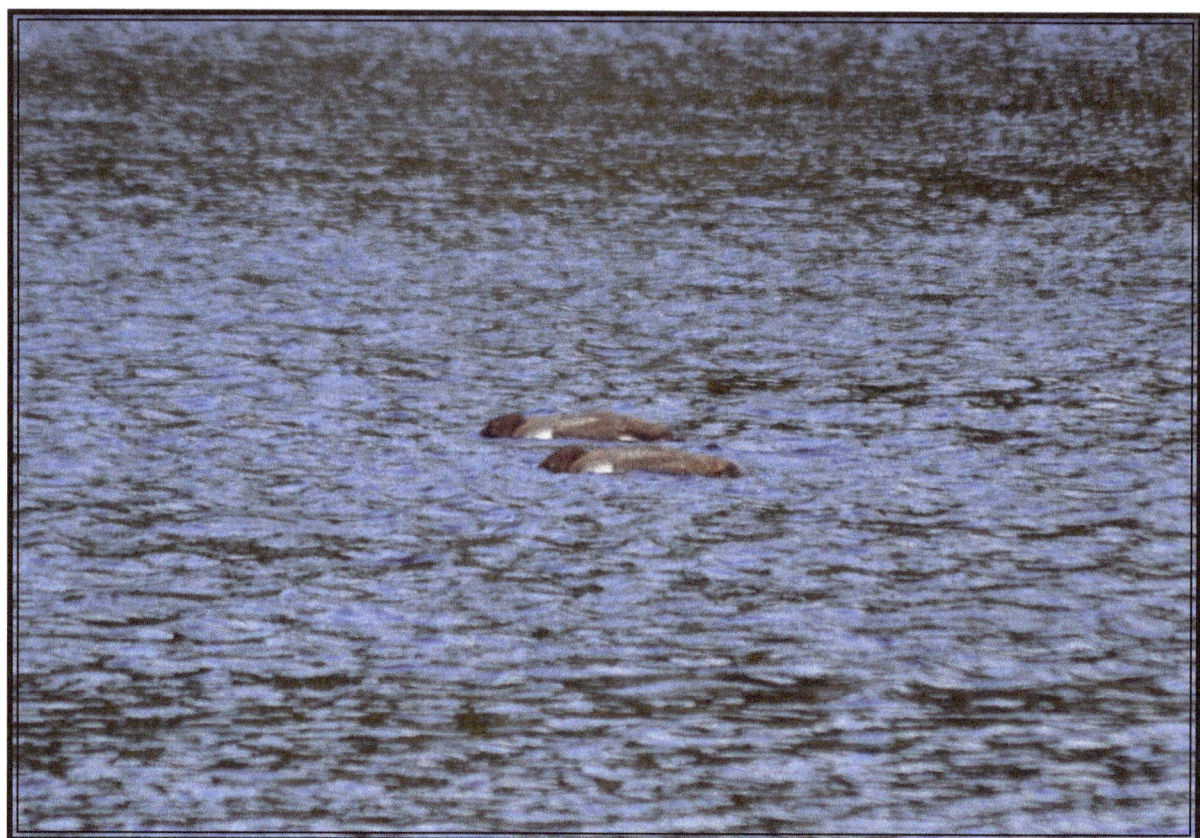

# The Gray Jay

There was another bird that I had an amazing experience with, it was the gray jay. Actually, I had a couple of memorable moments which highlight that something truly amazing can happen when one least expects it.

This happened to me one day while I was at the river. Every time that I went down to the river, I always walked the boardwalk that goes to the bridge. You never know what one can see further down the river.

On one such trip back, I noticed a gray jay that was sitting on a tree that was on the edge of the river. To enable me to get an amazing picture, I tried to get as close to the gray jay as I could. But what I didn't realize was that there were several gray jays in the area, probably, as many as five or six of them.

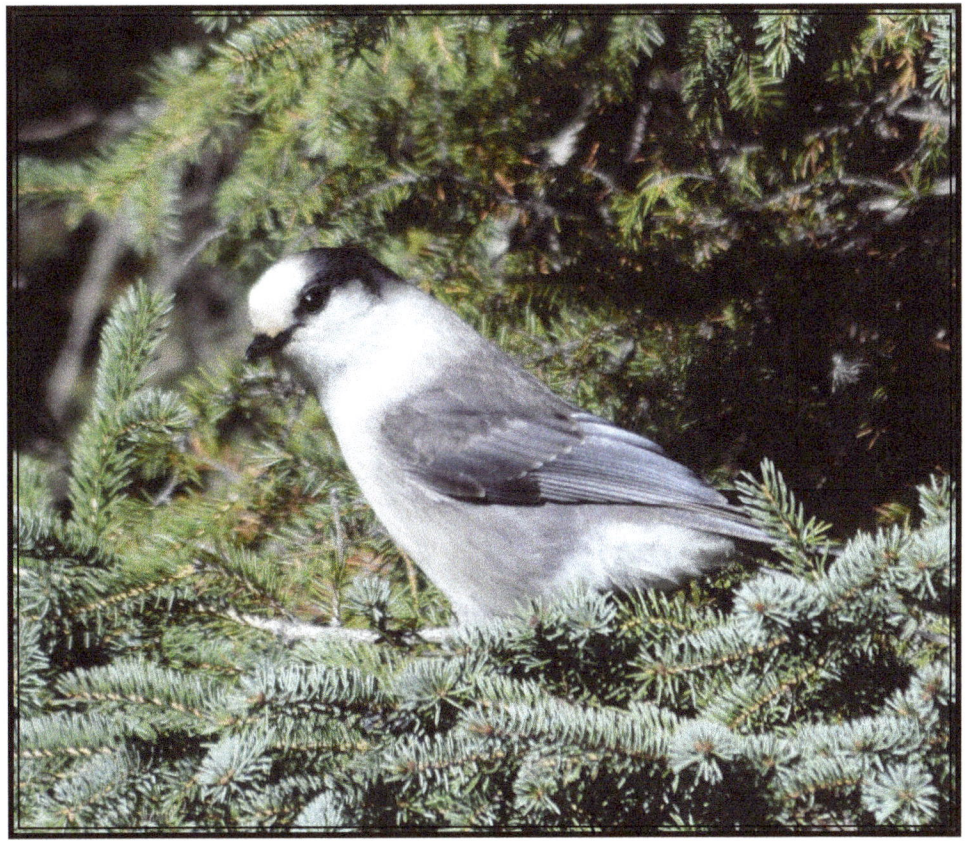

It was quite a surprise to me, because they didn't behave like I expected. I assumed that once they saw me, they would just fly away.

But they didn't. They just stayed in the vicinity that I was. They even flew right at me so that I even had to duck several times. Maybe they were upset with me and were trying to chase me away from where I was.

That was okay, as it gave me some amazing pictures of them.

The second memorable experience that I had with a gray jay was truly unique, something that was pretty special too. One day as I was walking back to my campsite, I noticed a couple of gray jays.

Needless to say, I immediately took after them to see if I could get an amazing photograph of them. When I finally caught up to them, I took a picture. As soon as I got my photograph, the gray jay flew a few steps away about 8–10 steps further down the road. I followed and when I got close enough, I again took more pictures.

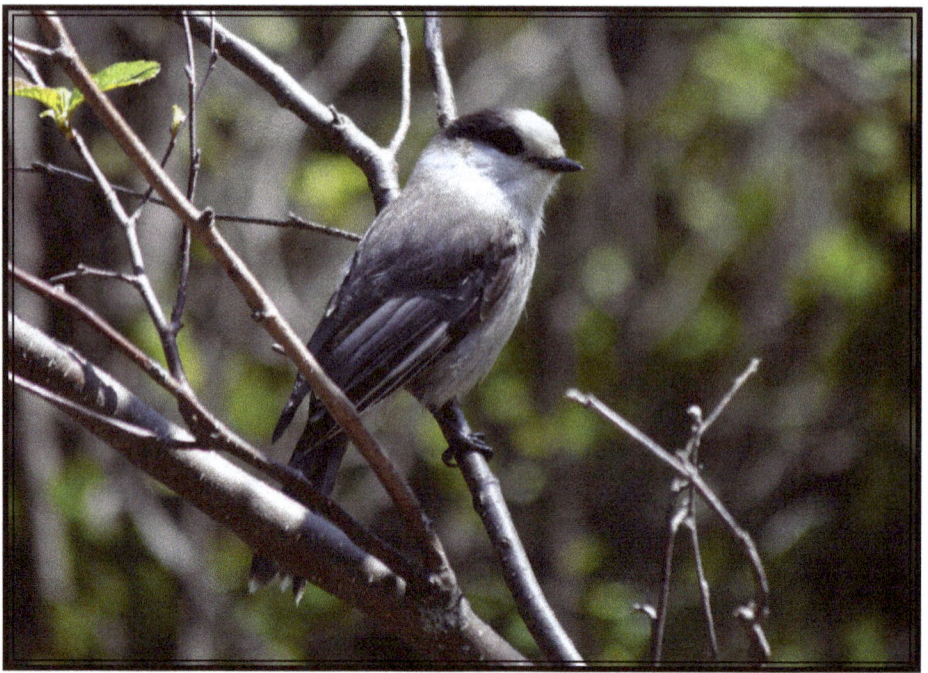

Again, the gray jay did the same thing. I again followed. For the third time, the gray jay flew just a few steps ahead of me before landing in a tree.

I began to notice a pattern. So what I did was the only thing that I could do. I decided that I would see if I walked 8–10 steps ahead of the gray jay, would he follow me? To my great amazement and surprise, this is exactly what happened. After I walked about 8–10 steps past the gray jay, he flew towards me, right across from where I was standing. I took some great pictures.

I thought to myself that since I was successful, I would naturally try it again. Guess what? It worked again. After I walked 8–10 steps ahead of him again, the gray jay again flew and landed on a tree branch straight across from me.

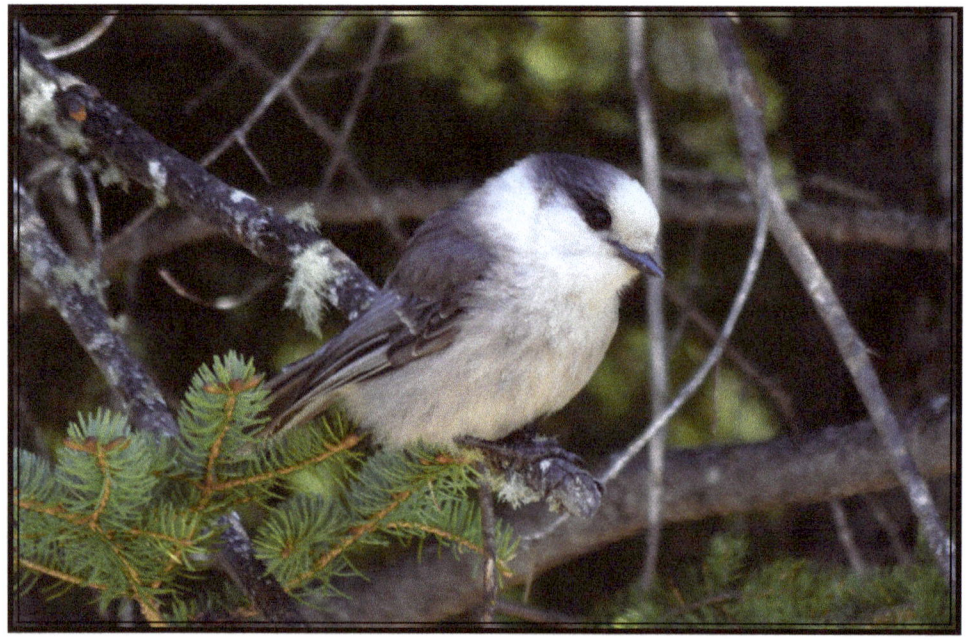

I did this for about four or five times, before finally the gray jay had enough of me and headed back further into the bush.

I had a lot of enjoyment when taking photographs of a gray jay.

I actually came back to the park in late September and I could not believe what I was seeing. It was unbelievable just how many gray jays there were, giving me many opportunities to get some amazing pictures of a very cute and amazing bird, the gray jay.

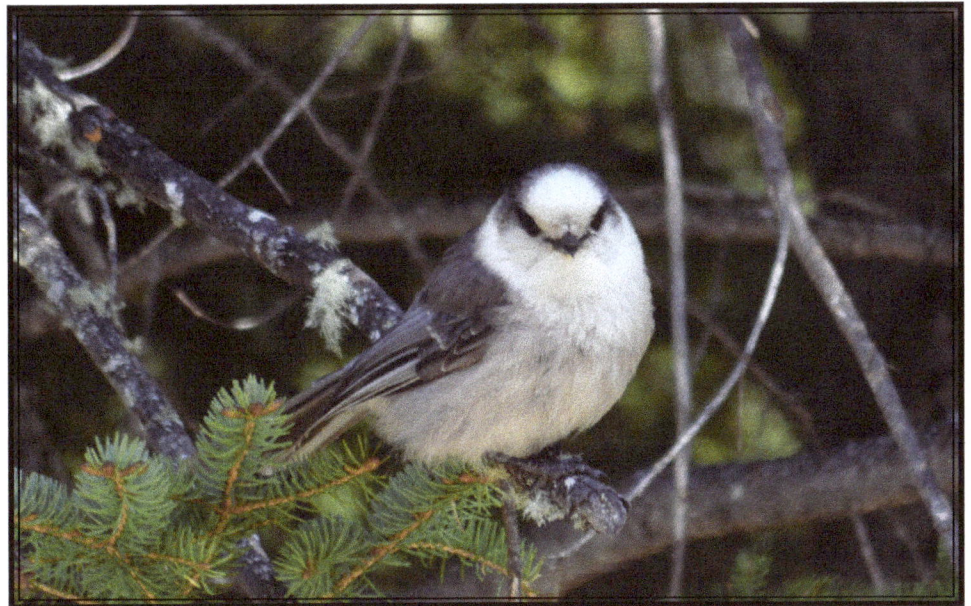

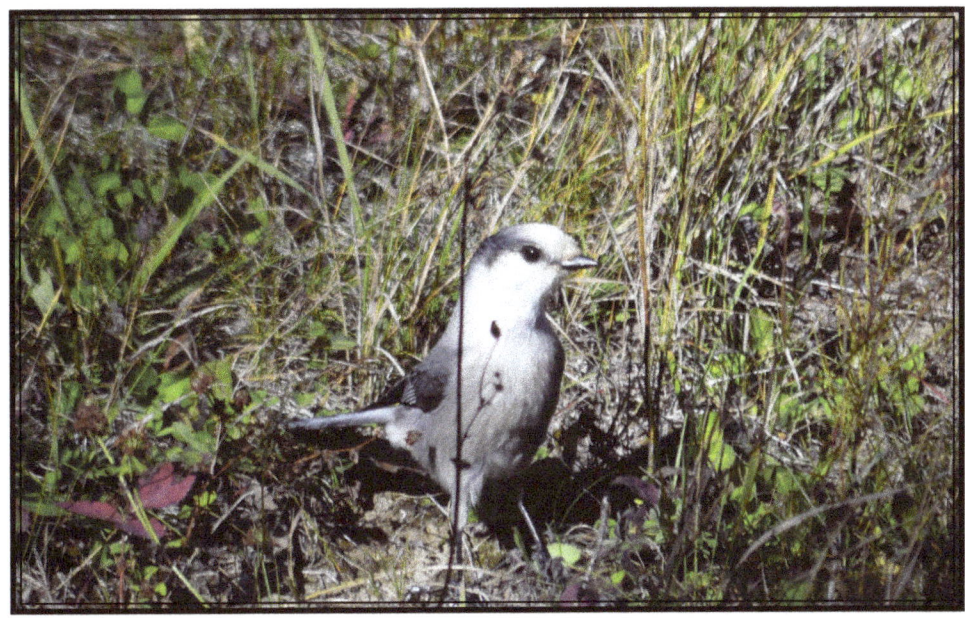

# The Great Blue Heron

The first few times that I tried to get a photograph of the great blue heron was impossible, as soon as they saw me, they flew away. I was beginning to wonder if I would ever get an amazing picture. But with time and a lot of patience, I was able to eventually get a photograph.

The first time that I was able to get a great picture of a great blue heron, it happened in a unique and amazing way. When I was down by the river, I saw a great blue heron flying and he landed just down the river from where I was. I tried to see if I could get a great picture of him, but by the time I got to where he was, the great blue heron saw me and immediately flew away.

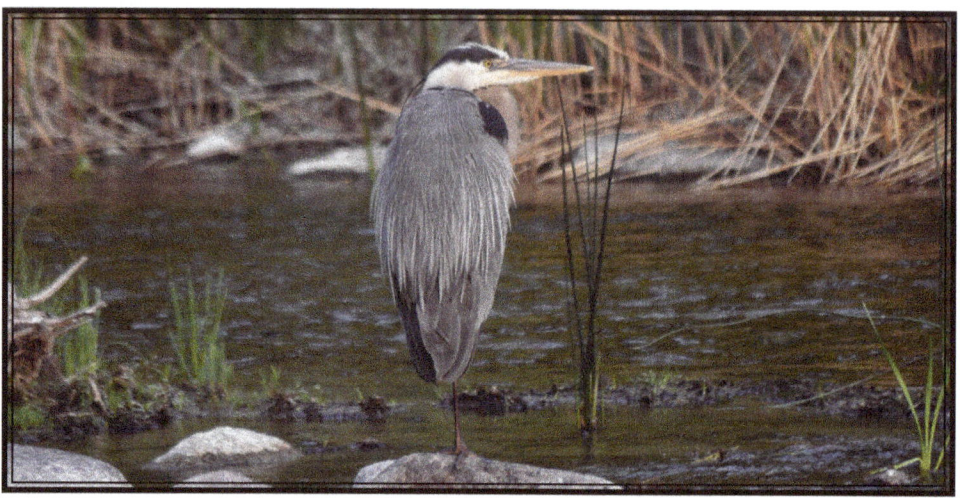

Thinking that all was lost, I walked back to the picnic area besides the river. But as I entered this area from the path, I saw that the great blue heron had not gone that far up the river.

He landed just beside this picnic area. I wondered if the heron would fly away as soon as he saw me, as that is what usually happens, so I was going to sneak up on him, so that the heron would not fly away before I got a picture. But, to my surprise the heron didn't. I was able to walk right up to the edge of the river and took a few amazing pictures and since the heron was in no rush to leave, I ended up just sitting on the edge of the river and watched the great blue heron for about a half an hour.

One time while I was watching the heron, I noticed something that proved to be quite remarkable. The heron showed me what a tremendous fisherman he was. The heron caught the fish in his beak, so it appeared, then walked to the edge of the river. He then dropped it on the ground and then proceeded to maneuver the fish around in his beak so that it could be swallowed whole, head first.

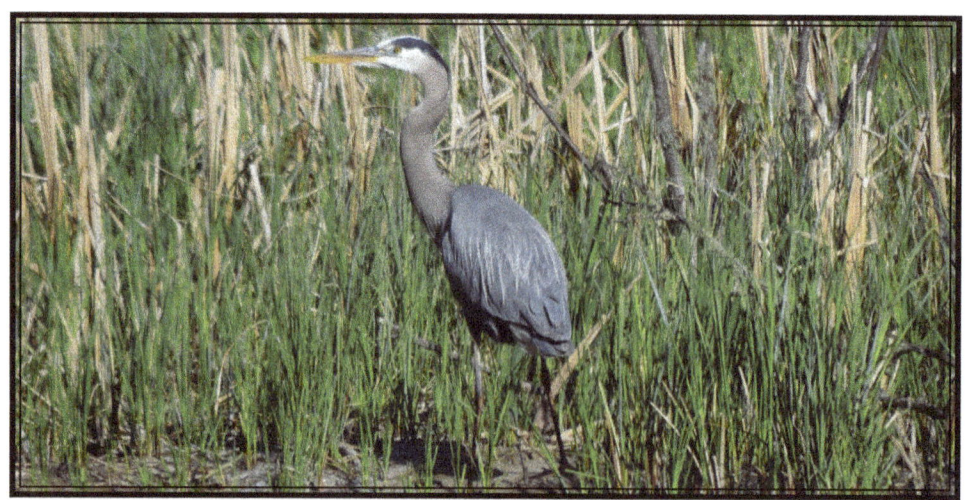

Considering how big the fish was, it took him some time to get it down and swallow it. You could definitely see by how his neck expanded. Another thing that this experience taught me, was that the heron didn't catch the fish as I had thought, he had stabbed the fish with his beak, quite a remarkable accomplishment and showed how skilled they really are.

One other time that I saw a heron, I noticed that he kept looking up into the trees. I was puzzled by this behavior, I thought that the heron was looking at something in the trees, but I couldn't see anything that he might have been looking at so I didn't give it any more thought. Just one of those things.

But when I saw two great blue herons doing the same thing, I began to think that there must be a logical explanation for what they were doing. I still couldn't see what they were looking at, they had to be looking at something, so I thought.

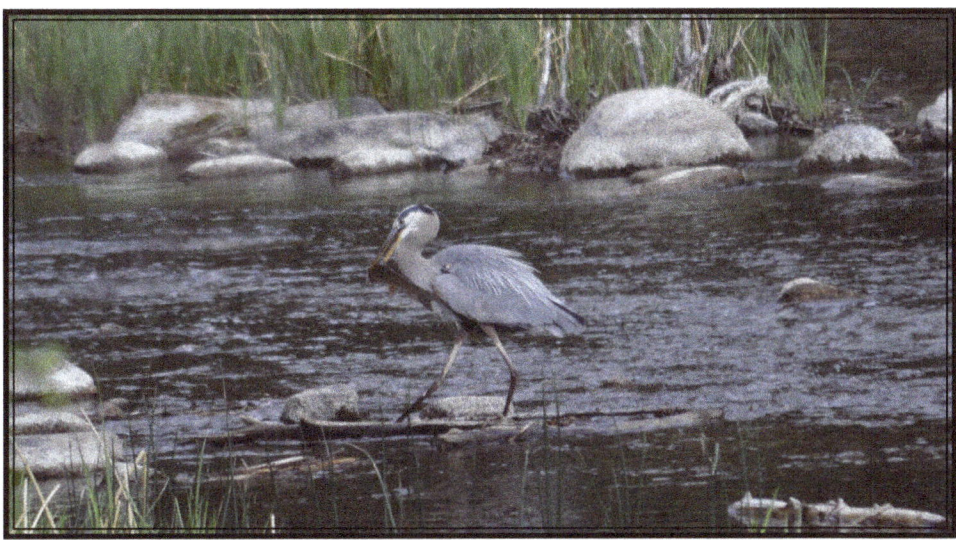

Well, one day when I was at the river, I met a lady so I told her what I had seen concerning the two great blue herons and how they were behaving. She explained to me that this was their mating dance.

Well, isn't it romantic? Yes, it proved to be another unique and special event to witness and I was certainly glad that I was able to get an amazing photograph of this romantic event. Too bad it had to be such a cloudy day.

Another amazing opportunity for a picture of a great blue heron happened again at the river. My mother and I were sitting at a picnic table and were enjoying a pleasant evening at the river while watching the heron in the river.

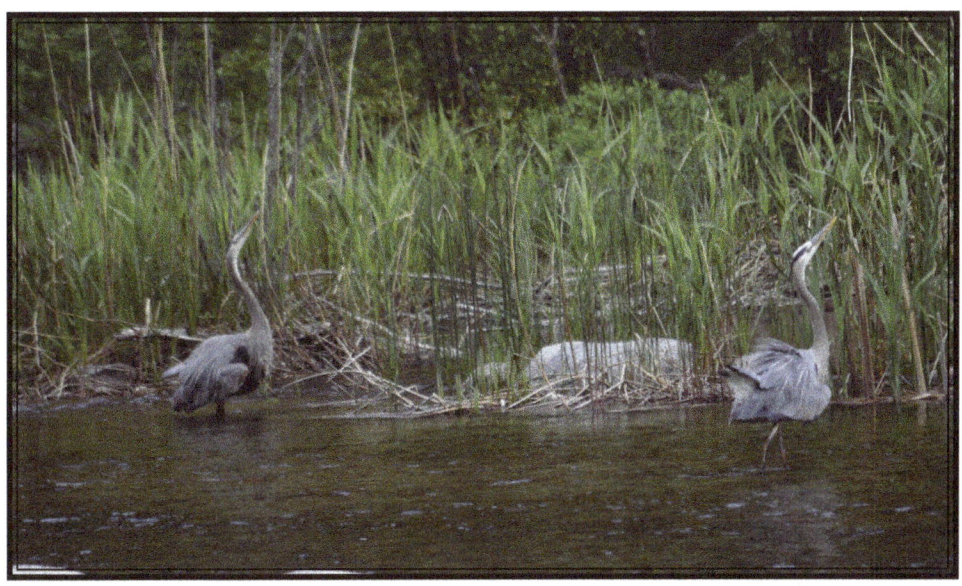

I noticed that there was quite a few fish just above the first row of rocks, whereas, the heron was standing past the third row of rocks waiting for a fish. To my amazement and surprise, I just happened to tell my mother that I bet the heron would fly closer to us because of the fish. Sure enough, this is exactly what happened. The heron had become impatient at how unsuccessful he was in getting a fish, so naturally, he flew to where the fishes were swimming.

Not only did the great blue heron fly so close to us, but we also saw the heron catch a fish as well, which sure didn't take long for him to do. I was able to get an amazing picture and I was also looking forward to being able to get a picture of the heron swallowing the fish, thinking that I had time since it would take a while to swallow it like it did the last time.

But to my surprise and disappointment, I only took my eye off of the great blue heron for only a second, but that was long enough.

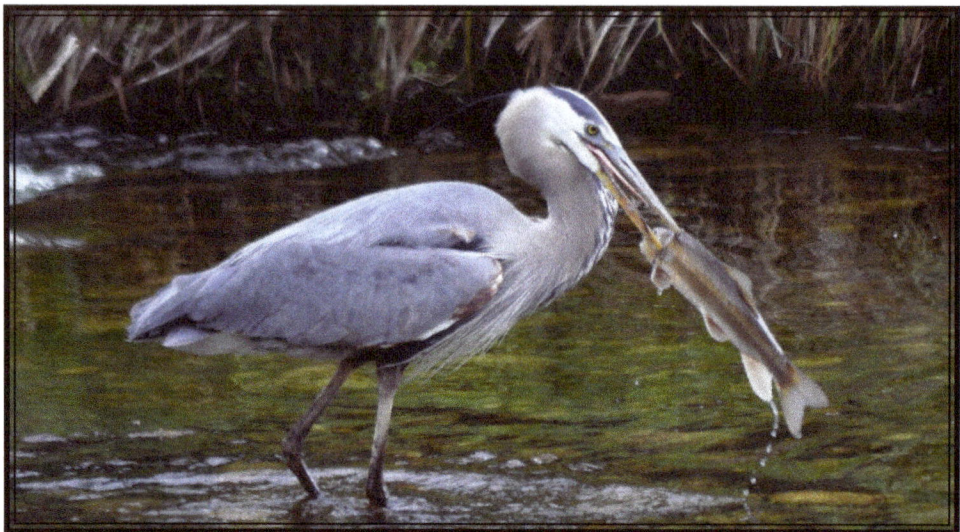

The fish was gone and I didn't even get a picture of it. I looked in disbelief as I missed an opportunity to get a picture of this amazing event.

The last time that I saw a great blue heron was at the river and I noticed that it was up in one of the pine trees that were along the river.

At first when I saw the great blue heron, it wasn't moving, then all of a sudden it moved, opened its eyes, raised its head up, obviously it must have been sleeping in the tree. Truly, a remarkable accomplishment, well maybe not, considering it is a bird, but you don't think of a heron sitting in a tree, they are usually seen on the ground. I was still able to get a picture of the great blue heron as it was perched on the branch of a pine tree.

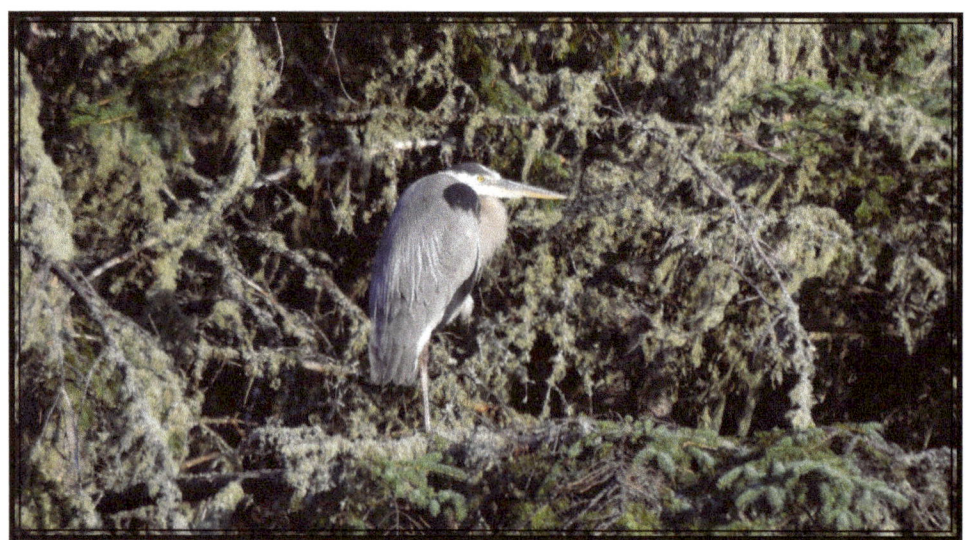

Yes, it was a very common thing to see a great blue heron on the Waskesiu River, which allowed me to see many amazing events and therefore, was privileged to photograph this amazing bird, The Great Blue Heron.

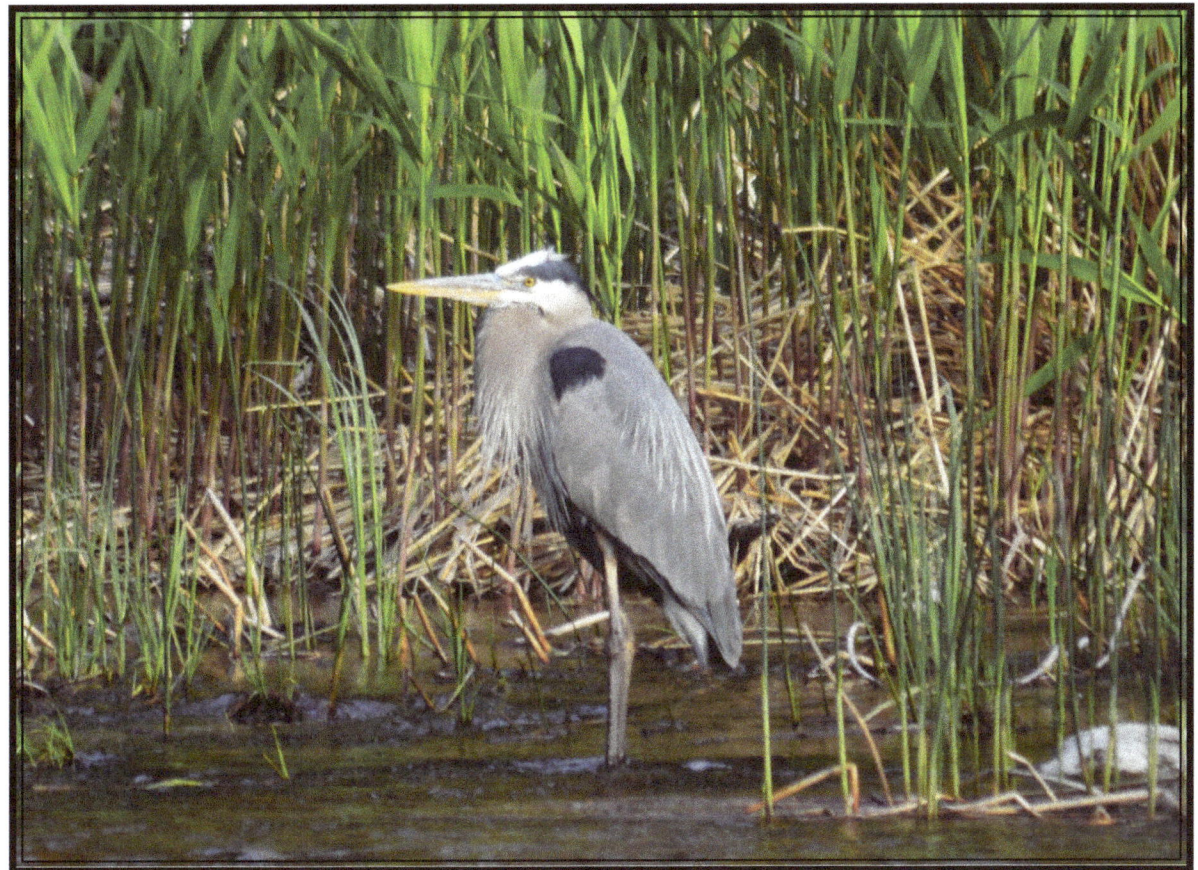

# The American White Pelican

Even though, I had seen the American white pelicans many times and thus was able to photograph them a few times, I wasn't able to get an amazing picture. But one night when I was at the river, I was truly privileged to enjoy something amazing with regards to these incredible birds.

While I was standing on the bridge, admiring the amazing view of the river, I noticed quite a few American white pelicans swimming on the river. There must have been 20 to as many as 30 pelicans. I immediately headed down the path along the river so that I can photograph what these birds were doing.

I could see that they were swimming around the first boardwalk that leads one to the river, so off I headed.

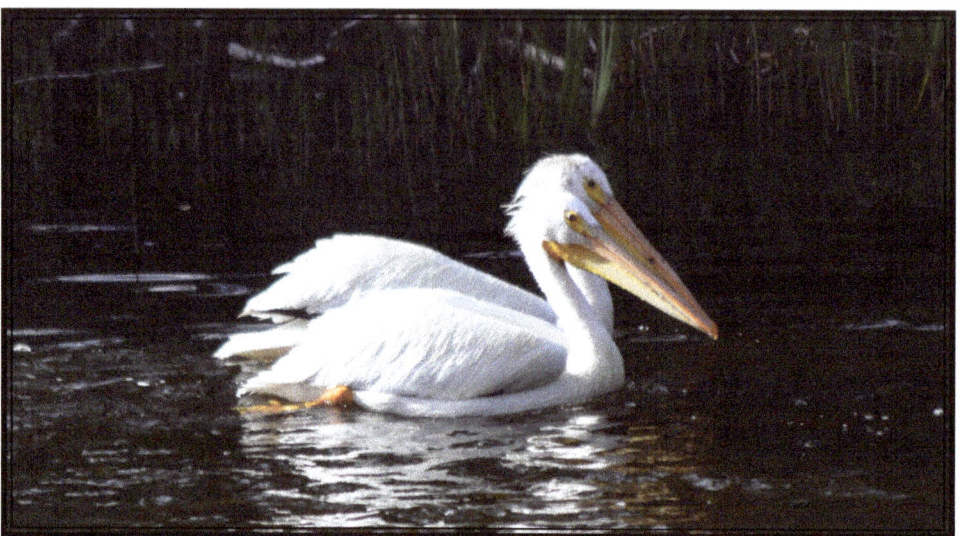

When it comes to birds, they fly away as soon as they see you, so I was going to sneak up on them so as not to scare them into flying away. As quiet as I could be, I walked down the boardwalk to the edge of the river. To my benefit, there was a tree that kept me hidden from the pelicans, although as it turned out, it didn't really matter. They were far too busy to pay any attention to me.

But, I still kept as low as I could, to keep myself out of view of the pelicans, just in case. I was able to see and take pictures of as many as nineteen American white pelicans as they were fishing for their food. I ended up watching them for thirty minutes, maybe a little longer, until my knees began to ache as I was in a crouched position. I was able to get some incredible pictures of them as they were fishing on the river, even swimming right past me.

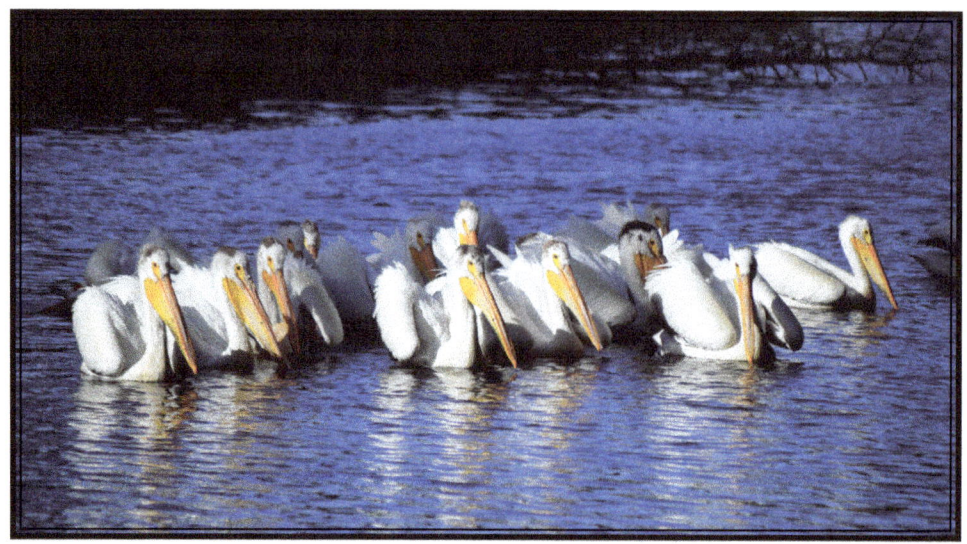

Thirty-five or so pictures later, I decided to walk back to the picnic area as I believed that I had taken enough amazing pictures of the American white pelicans. It was truly amazing to watch them as they tried to catch their dinner. To see as many as 16–19 of them work in unison, herding the fish before they tried to catch them. Although after seeing this incredible event, I still can't understand how they were able to catch anything.

You can see them work so well together as they moved the fish to an area where they could be caught, but when it came time to try and catch them, they would jump and flap their wings, diving head first into the water with their butts in the air. Ultimately making so much noise, I find it hard to believe that they could catch anything. But obviously, they are successful, unless they were just being trained on how to catch fish.

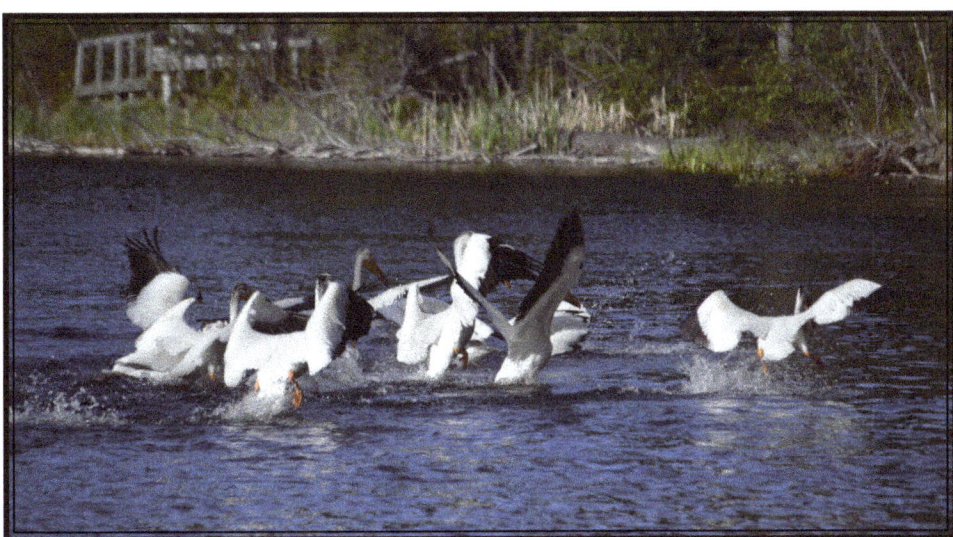

But it was still amazing to watch and enjoy these beautiful birds, the American white pelicans. But that wasn't the end of my enjoyment.

To my utter surprise or should I say shock, the pelicans came right up to where I was sitting at a picnic table. These American white pelicans began to fish in between the three rows of rocks that were right beside the picnic area. I was able to watch them for another two hours, until they finally left or I had to go home for supper. Whatever the case, it truly proved to be an enjoyable and incredible evening.

It was interesting to watch them as a great blue heron was also among the rocks, trying to catch a fish. But because the pelicans were making so much noise and because there was so many of them, the great blue heron was getting a little disturbed to say the least. Finally, he got so mad that eventually the great blue heron left. He obviously realized that supper would have to wait, because with all this noise, he was never going to be able to catch anything.

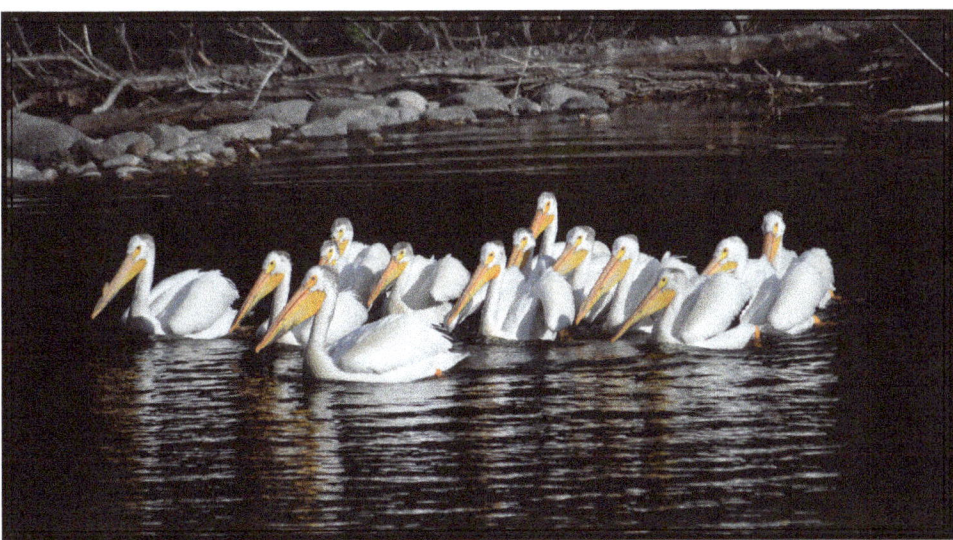

But needless to say, I was able to get a picture of the great blue heron with a whole bunch of American white pelicans in the background.

It was truly an amazing evening, to be able to experience such an amazing event brought me great enjoyment as I watched these amazing birds – the American white pelicans.

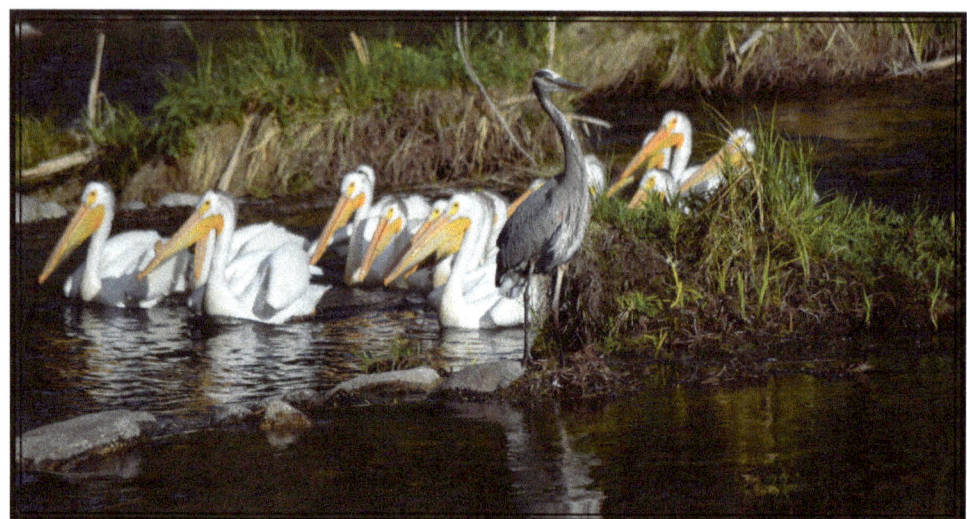

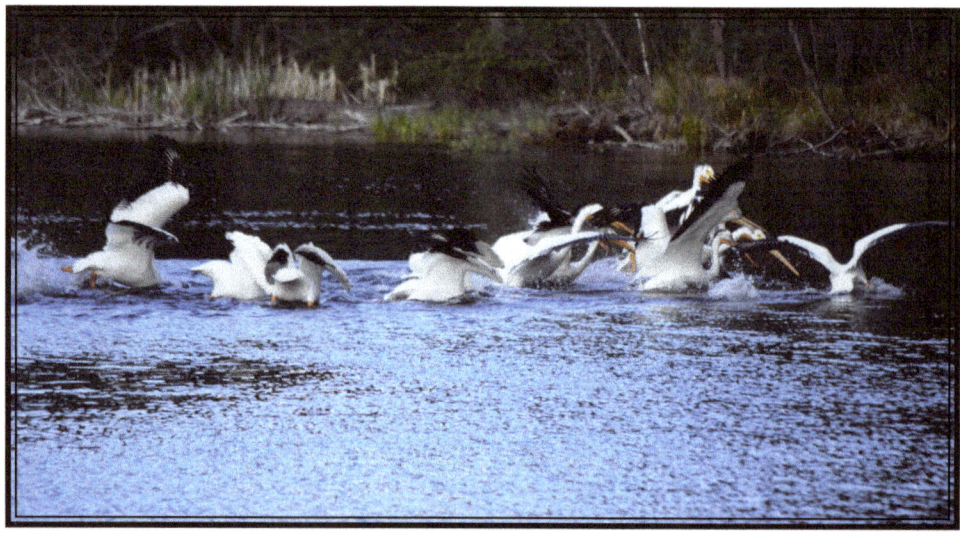

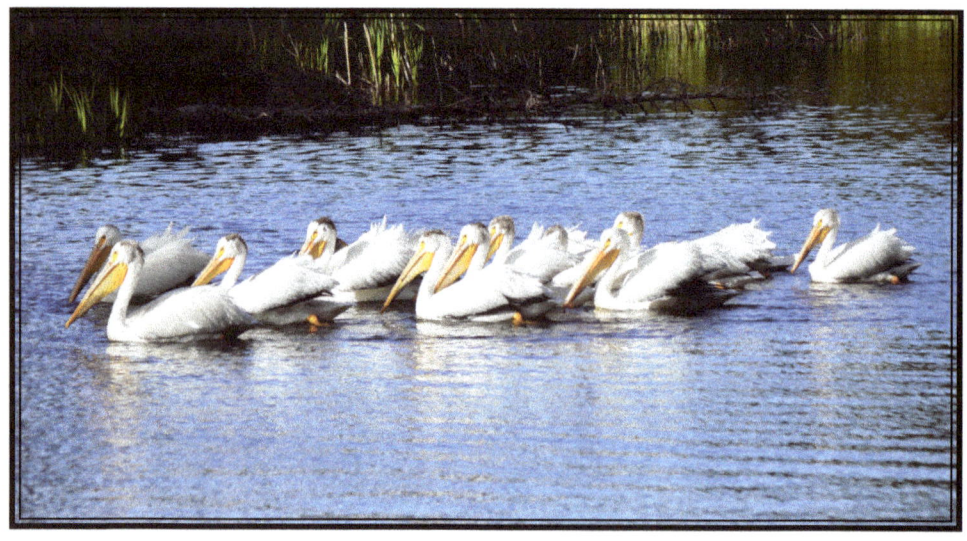

# The Belted Kingfisher

The hardest bird in which to take a picture of, in my opinion, is undoubtedly, the belted kingfisher. It is very hard to get close enough to a belted kingfisher in order to get an amazing picture. You know where they are because of the sound they make, but before you can get close enough for a picture or sometimes even to see them, off they go, gone and all the time as they are flying away, they are making a loud and far-carrying rattle noise. No doubt, laughing at me as I struggled to walk down the cliffs, over rocks and who knows what else, but all to no avail.

But even though they are very hard to see, I have found out that with a lot of patience, one can still get an amazing photograph.

Again, as I was standing on the bridge and admiring the river, I was surprised and amazed that a belted kingfisher had landed on a dead branch that was not all that far away from where I was. I immediately took a few pictures, but as always, I tried to get an even better picture by trying to get closer. But I also knew that if I moved to close, the belted kingfisher would just fly away. Naturally, I did the only thing that I could do. I got down on my hands and knees and I was going to crawl along the length of the bridge, out of his sight. It worked. I crawled along to the edge of the bridge and the belted kingfisher was still perched on the tree branch.

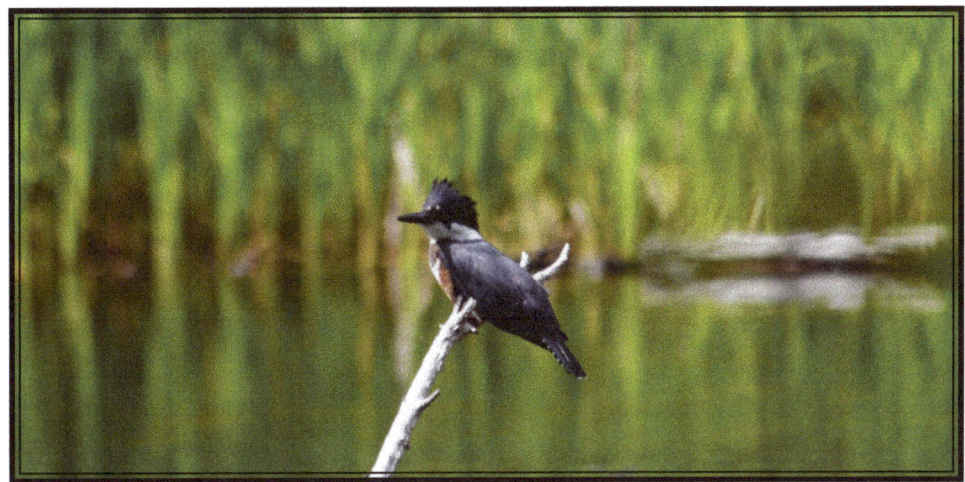

Now, what was I going to do? As soon as I popped my head up, the belted kingfisher would fly away. To make sure that this wasn't going to happen, I just stuck my camera out pass the railing of the bridge. But I no sooner did this and one rattling noise later, the bird was gone. All that sneakiness for nothing. Oh well, I still was able to get a picture and that is all that matters. Plus, I was able to get an experience of how ridiculous I was prepared to get, just to get an amazing picture of the wildlife that one can see in the park.

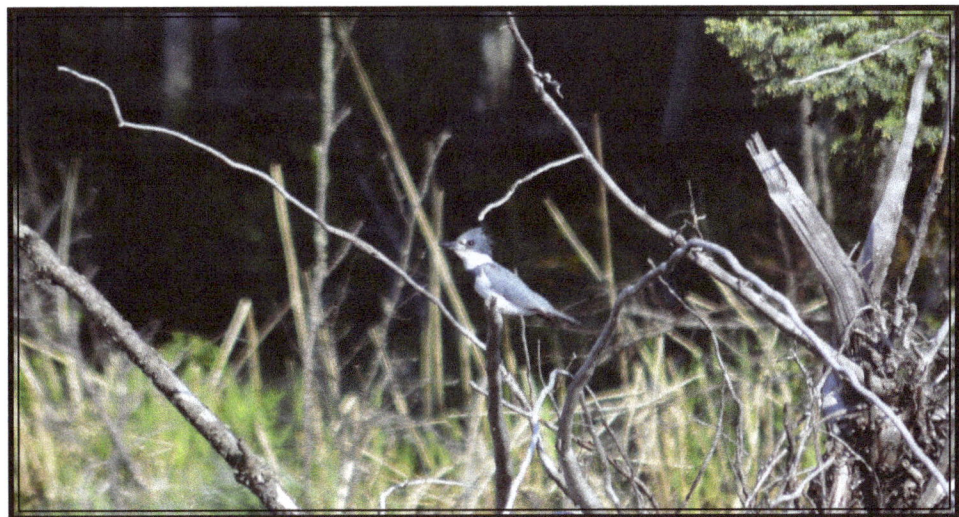

One other time that I was able to get an amazing and incredible photograph of a belted kingfisher, I was again at the river. I had just walked down the boardwalk to the bridge that went across the river.

I was just standing on the bridge looking both upstream and downstream to see if there were any animals or birds on the river.

To my surprise, I noticed something sitting on a branch overlooking the river. It was too far away for me to see what it was, so I immediately took a picture of it so that I could enlarge the image on my camera and thus be able to identify what bird it was. Here it was a belted kingfisher.

What an incredible find. Needless to say, that was not going to be much of a picture, since the belted kingfisher was too far away. Now I didn`t know how to solve my problem of how I was going to get close enough, so that I can get an amazing picture of him.

Well, I was going to definitely try, anyways. So I proceeded to walk back down the boardwalk as quietly as I could until I was straight across from the belted kingfisher, all the time hoping that he would not fly away.

The first part of my plan worked out great. I was able to get right across from him and he didn`t fly away. But the only problem was that there were too many trees in the way, I could not get a clear picture of the belted kingfisher. So, naturally the only thing I could do was try to get closer.

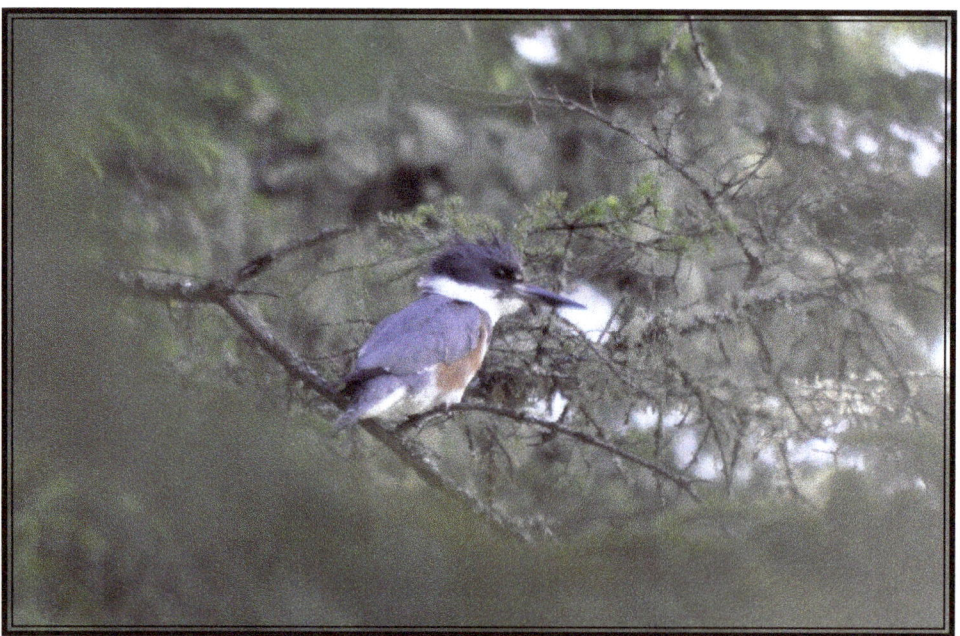

This meant that I would have to get off the boardwalk and walk towards were the belted kingfisher was perched on the branch. A very fortunate outcome for me as well was the fact that the ground was covered in moss, therefore, I was going to make no noise at all. What was also going to be helpful was the fact that he was also looking away from me, towards the river. Because of how everything worked out in my favor, I was allowed to get incredibly close to the belted kingfisher and take some amazing photographs.

Yes, as hard as it was, I was extremely privileged and excited to get some amazing pictures of an amazing bird – the belted kingfisher.

# The Ruffed Grouse

To say that the ruffed grouse is protective of her chicks is stating the obvious. I had a unique experience when I was in the park that highlighted this very fact. But before I get to this, I had another enjoyable experience one day after golfing. I went to retake some pictures of a flower that I had taken the previous day. It was a cloudy day when I took these pictures so now that the sun was out, I went back because the pictures always turn out better when the sun is shining.

When I returned to where the flower was, I got out of my truck and walked across the highway to the edge of the ditch. As I was about to take my picture of the flower, when all of a sudden, a whole bunch of small birds flew out of the tall grass. I began to wonder what was going on. I was a little taken back by what was going on. Maybe dumbfounded would be a more accurate word for it.

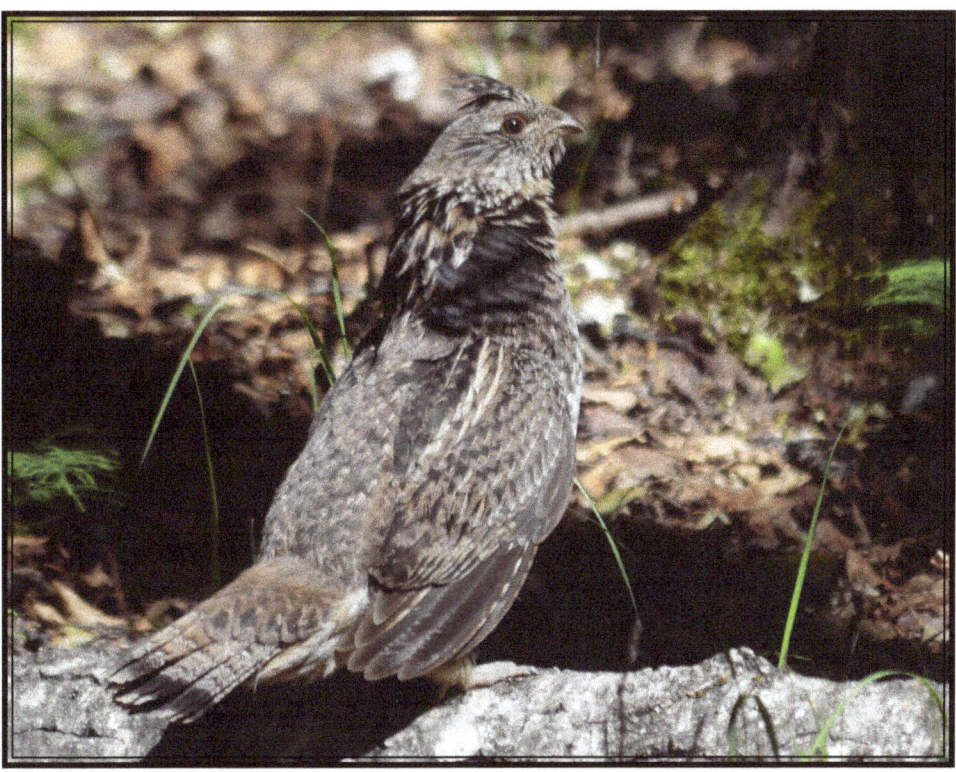

There had to be as many as twelve, probably even more. As they landed in the bush, I began to wonder how I would be able to take a picture of all these tiny chicks, but they were way too quick and disappeared into the bush. Sadly, I was unable to get a picture of these chicks.

At this time, I saw the hen, a ruffed grouse, who came sauntering out from the tall grass and just walked into the bush. But, I was thrilled and truly amazed that the mother hen just happened to come across a tree trunk and therefore, she decided to pose for me on top of this trunk. This naturally gave me an amazing opportunity to get some incredible photographs of a ruffed grouse.

One thing that I didn`t get from this experience was a picture of a ruffed grouse with her tail feathers fanned out, but as always I was going to have to be just a little patient as I waited for the opportune moment.

Incidentally, this is exactly what happened the next time that I saw a ruffed grouse. I was coming home from a trip that I had made to the Kingsmere River Trail. As I was driving, I came across a tree that had fallen down, but was not laying on the ground as the branches were still up off the ground. Because I was driving pretty slowly, I was able to see a ruffed grouse with her chicks that just happened to be underneath the tree. Well, needless to say, I immediately stopped my truck to see if I could get a picture of them.

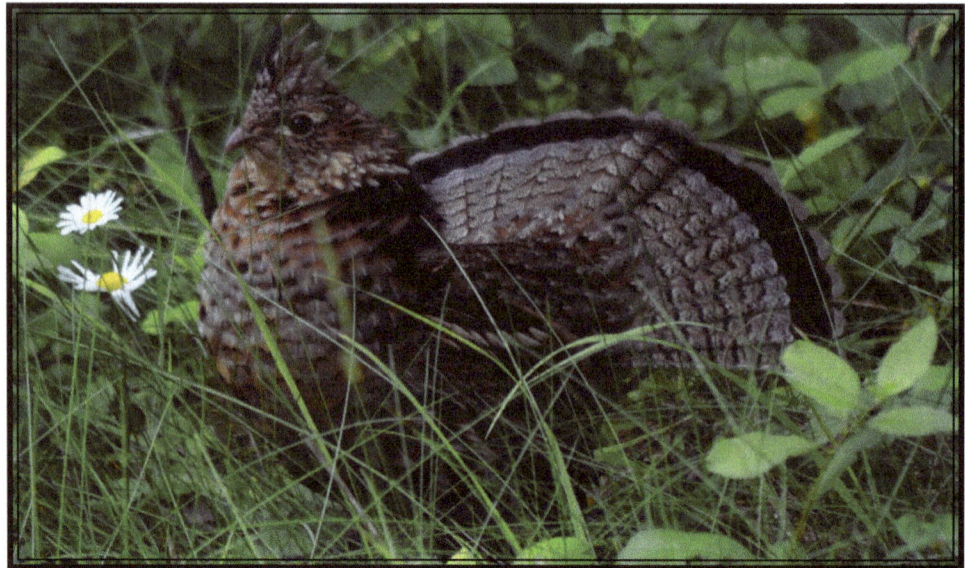

Again, I was too slow and thus unable to get a photograph of the chicks, but because I quickly headed to where they were and making sure that I got close enough because I wanted to make sure that the mother would also fan out her tail feathers. This is exactly what happened.

Probably not as fully as I had wanted, but it was still good enough to get a picture of her tail feathers fanned out.

Even though, I was able to get the picture that I wanted, I still hung around just so that I could watch them for a moment or two or until they couldn`t be seen by me any longer. I was sure glad that I did because I was able to see something truly amazing and unique from my perspective.

As I watched them, I noticed the mother was trying to lead me away from her chicks. She would get as close to the ground as she could.

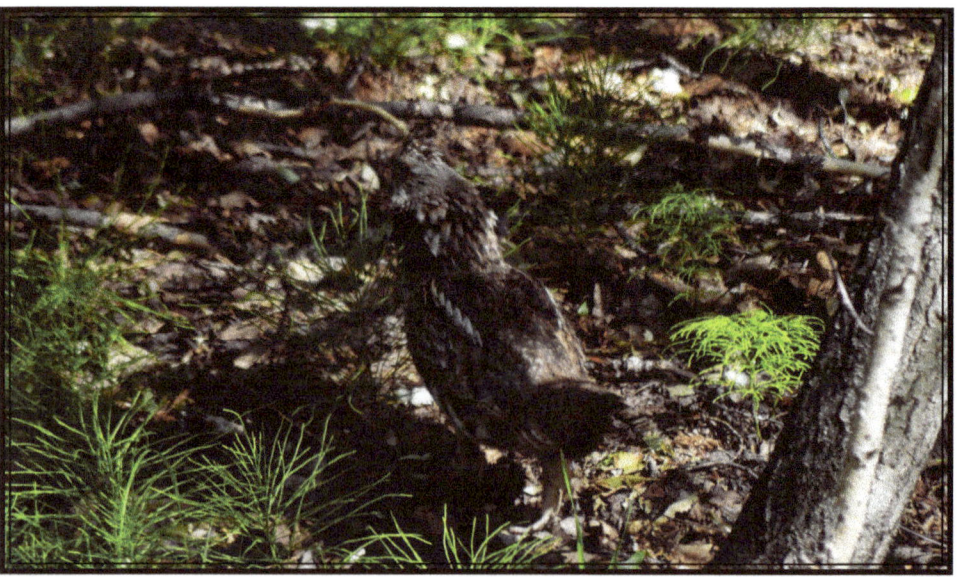

Right from her head to her tail feathers were right on the ground as she walked away from where the chicks were going. Of course, as she went in the opposite direction, I naturally followed. Curiosity had indeed got the best of me. I tried to get a picture of how she was acting, but she was too quick and I never did get a very good opportunity during all of this to get an amazing photograph.

Once she had seen that I had followed her for some distance and that her chicks were now safe, she just popped back up and walked further into the bush, no doubt to where the chicks had gone. Well, what can be said, except to say just how amazing and cunning a mother can act when protecting her young. Truly, an amazing bird – the ruffed grouse.

# The Birds of Prey

While I was in the park, I had many opportunities to see many Birds of Prey. I was able to see merlins, bald eagles, an osprey and I also saw a golden eagle.

With all these sightings, I was only able to get a picture of an osprey and a merlin. The picture of the osprey was quite unique and exciting to see. While I was at the river, I saw a bird flying along the river, so I immediately took a few pictures because the bird had a fish in its talons. I never had seen this kind of a bird before, so I was quite excited to learn from my book of birds that this was an osprey.

Naturally, since this was a bird that I had never seen before, I kept my eyes open for another opportunity for an amazing picture of an osprey. But even though I saw ospreys many times after this, I never was able to get a photograph of them again.

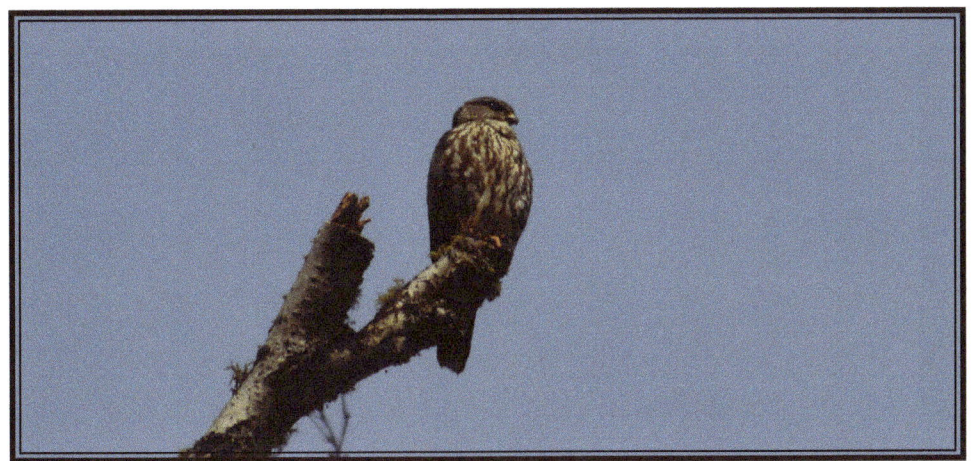

I was also able to see bald eagles many times. I even saw two bald eagles flying together along the river, but I noticed the two of them too late and thus was unable to get a picture of them. I sure wish that I had, since it would have been an amazing opportunity for a unique photograph. But I did have one interesting experience with regards to a bald eagle. One day when I was at the river, I saw two black birds sitting way up in a tree or so I thought. Therefore, I foolishly didn`t pay much attention to what was going on, I just thought that it was just two crows or maybe even ravens. That is until another black bird took after them and chased one of the birds away. As soon as it started to fly away, I immediately noticed that by its coloration that it was a bald eagle and of course, because it was a juvenile, as it had not yet developed its most distinguishing mark, its white head, therefore, I didn`t realize what the bird was until it was too late.

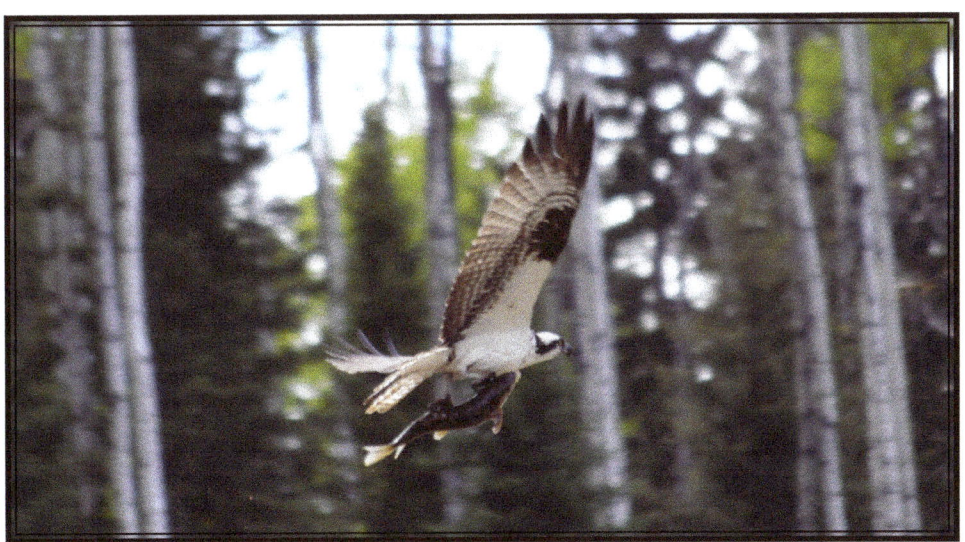

The other amazing experience that I had was when I was sitting by the lake on the last stairway on the old Kingfisher Trail. I actually was waiting to see if the common loons would appear so that I could take a picture of them. Even though they did not show up, I was still able to enjoy a mother common goldeneye with her ducklings.

As I was watching them, I heard a chirp by the mother and all of a sudden, the mother and then the ducklings immediately went under the water. It didn`t take me long before I realized why the mother let out a chirp. Out of nowhere, a big black bird came swooping in, but to no avail, a swing and a miss all because of the attentive mother and a loud warning call. The family was safe for a while longer.

I believe that this had to be a golden eagle for a couple of reasons. Since it was black and took after these ducks it had to be an eagle, it certainly was big enough, HUGE! And because it didn`t have the light coloration of the underwings of a juvenile bald eagle, it could not have been him, leaving him out. So the logical conclusion to come up with, at least from my standpoint, is that it must have been a golden eagle.

One other thing that was unique from my standpoint was the opportunity that I had in being able to see birds that I had never seen before. Even though I did not have any incredible experiences with certain birds, I was still able to get some amazing photographs of these birds.

# The Evening Grosbeak

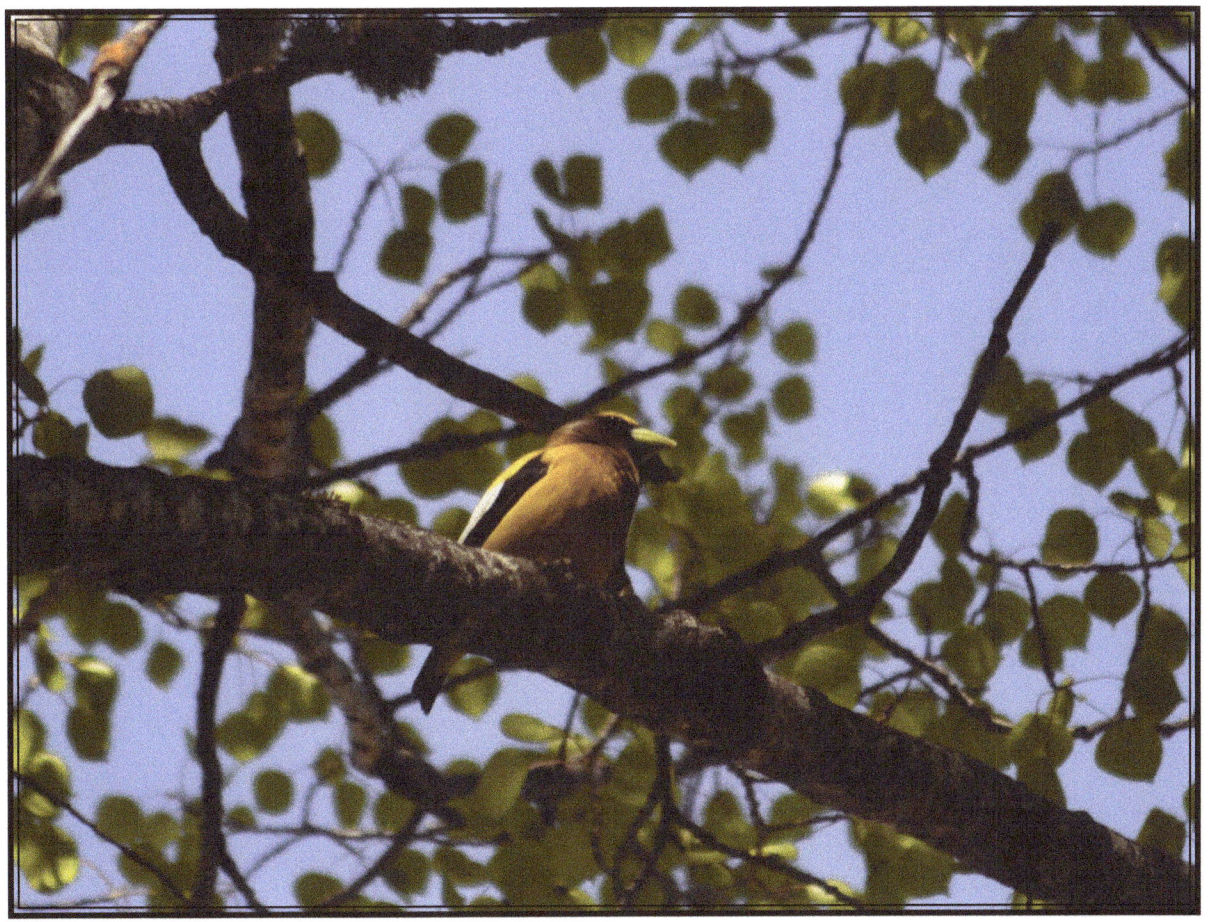

# The Common Goldeneye

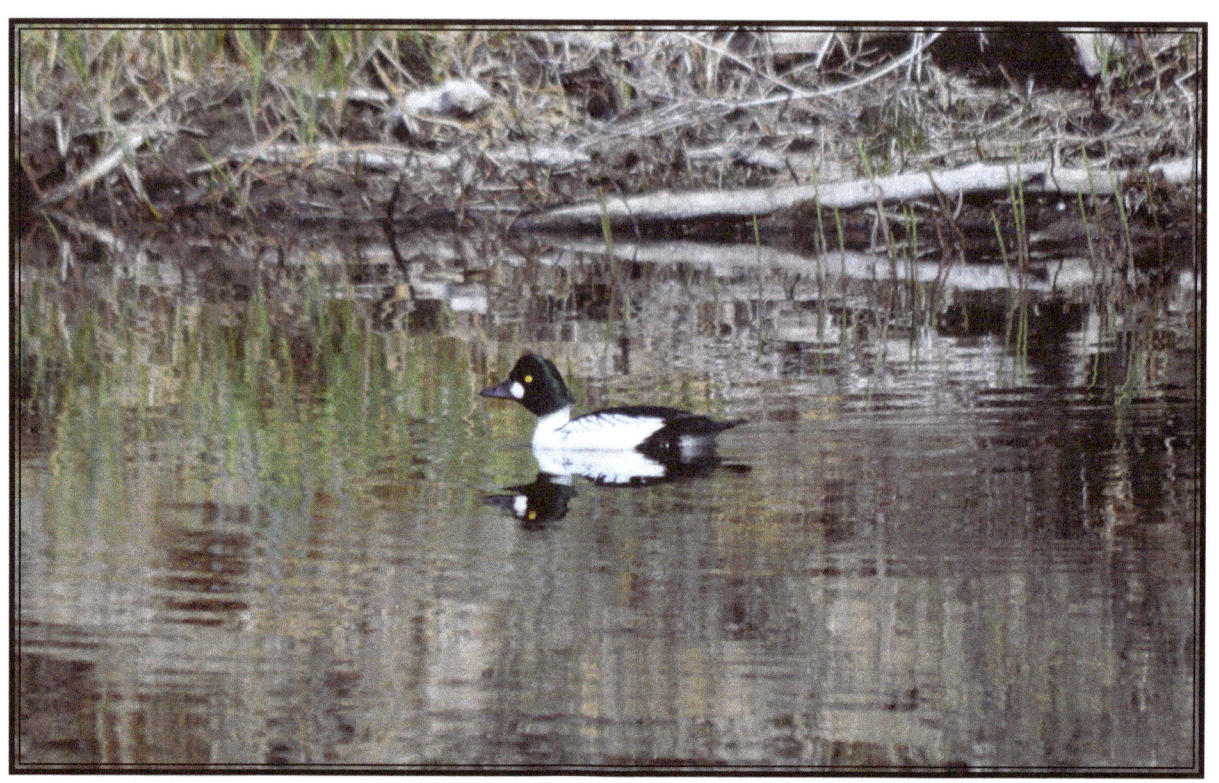

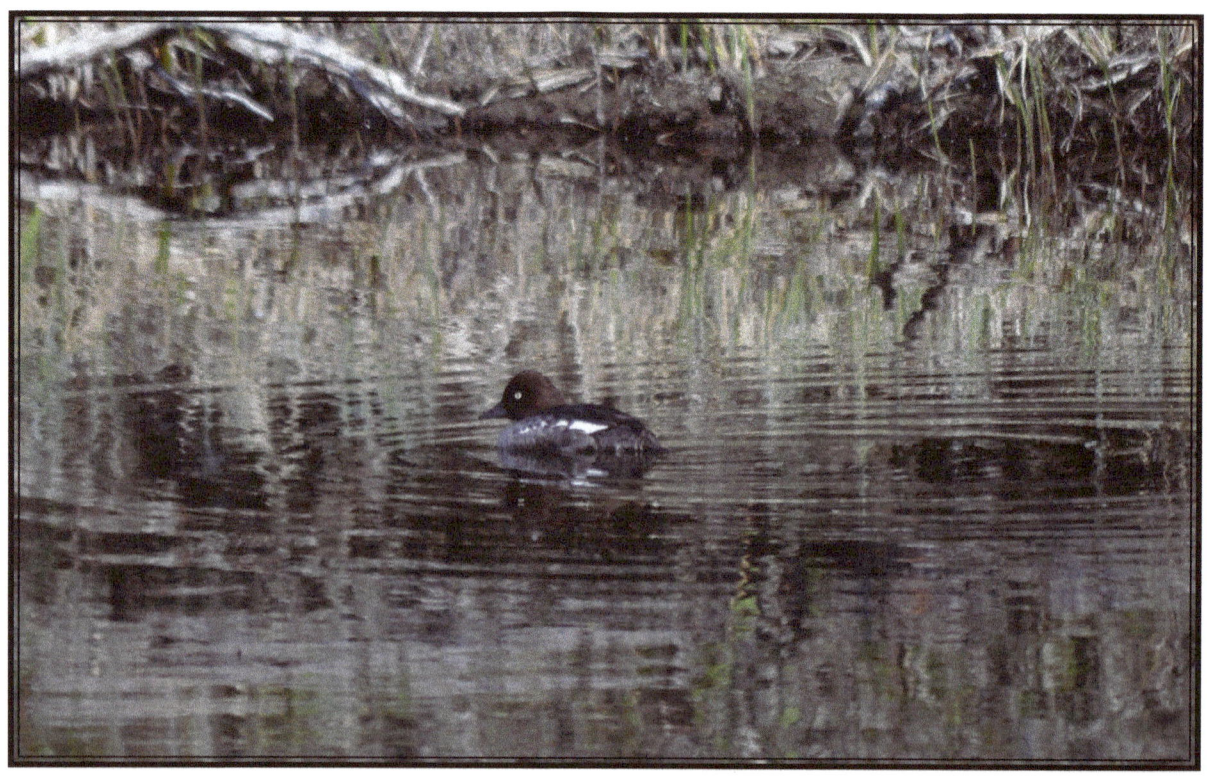

# The American Wigeon

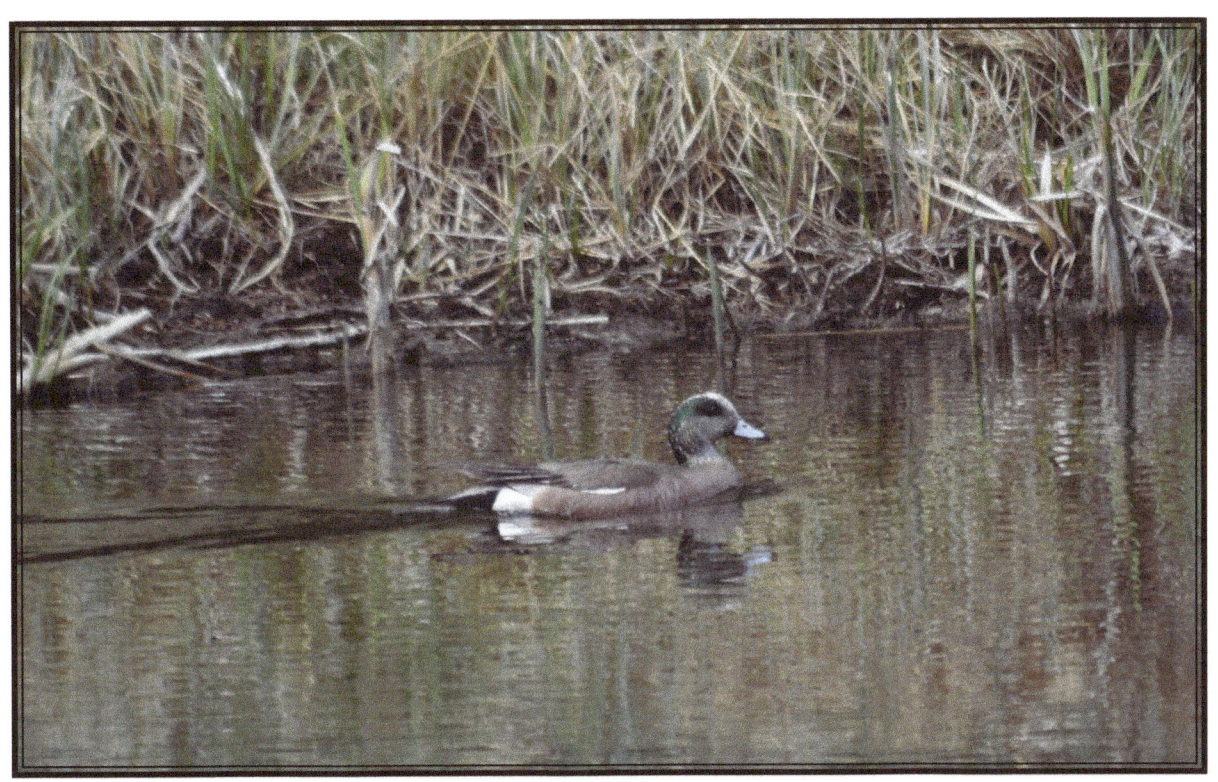

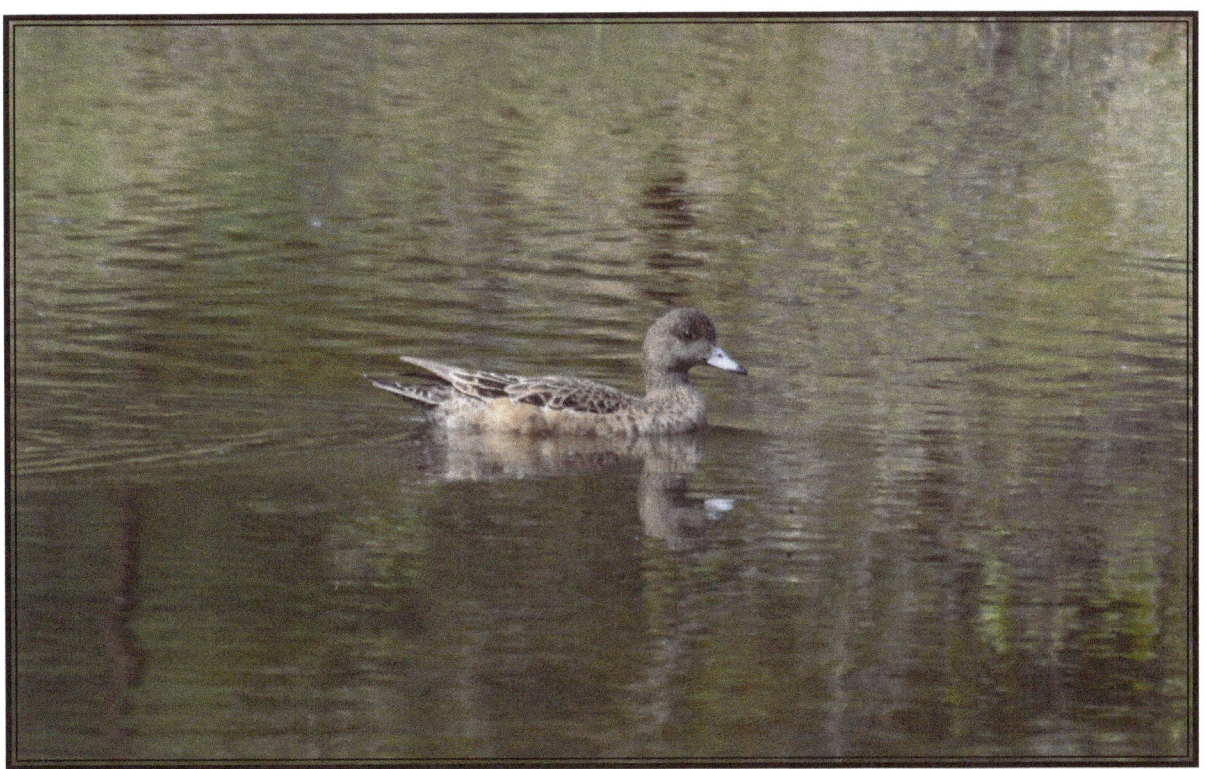

# The Common Merganser

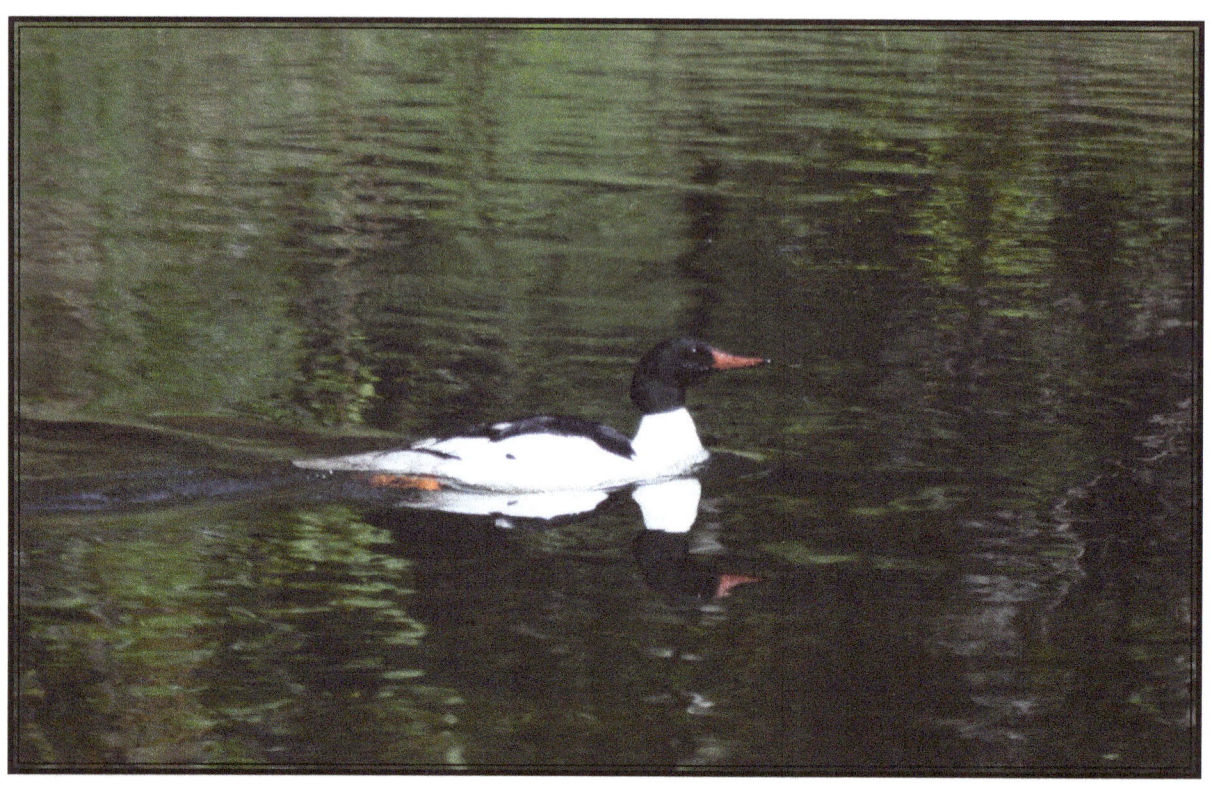

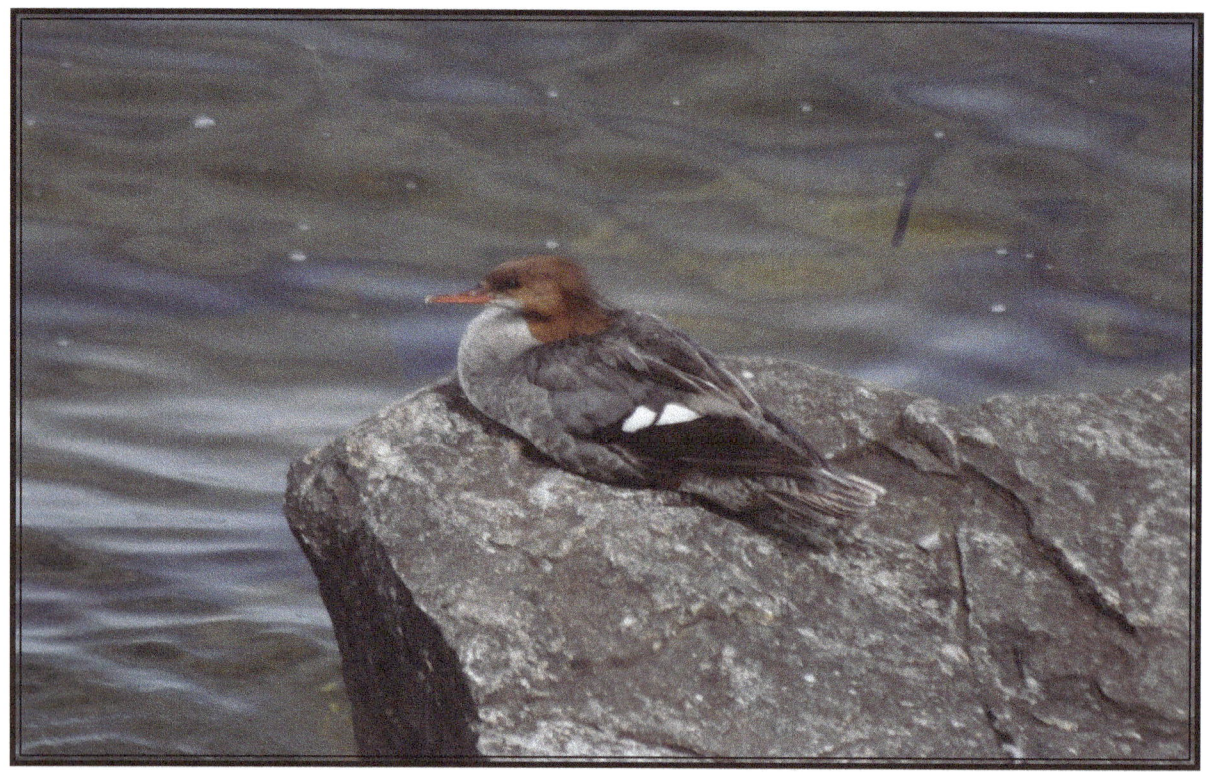

# The Red-Breasted Merganser

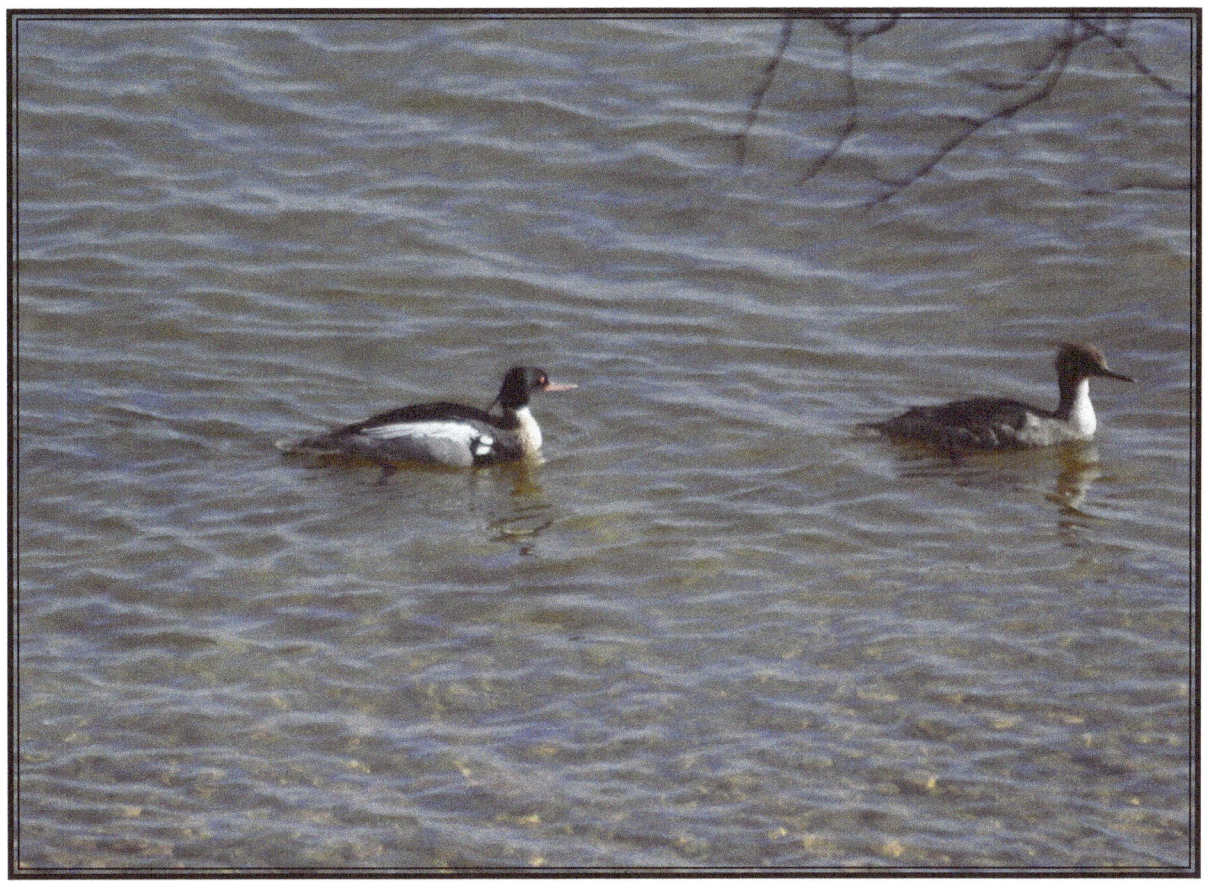

# The Spotted Sandpiper

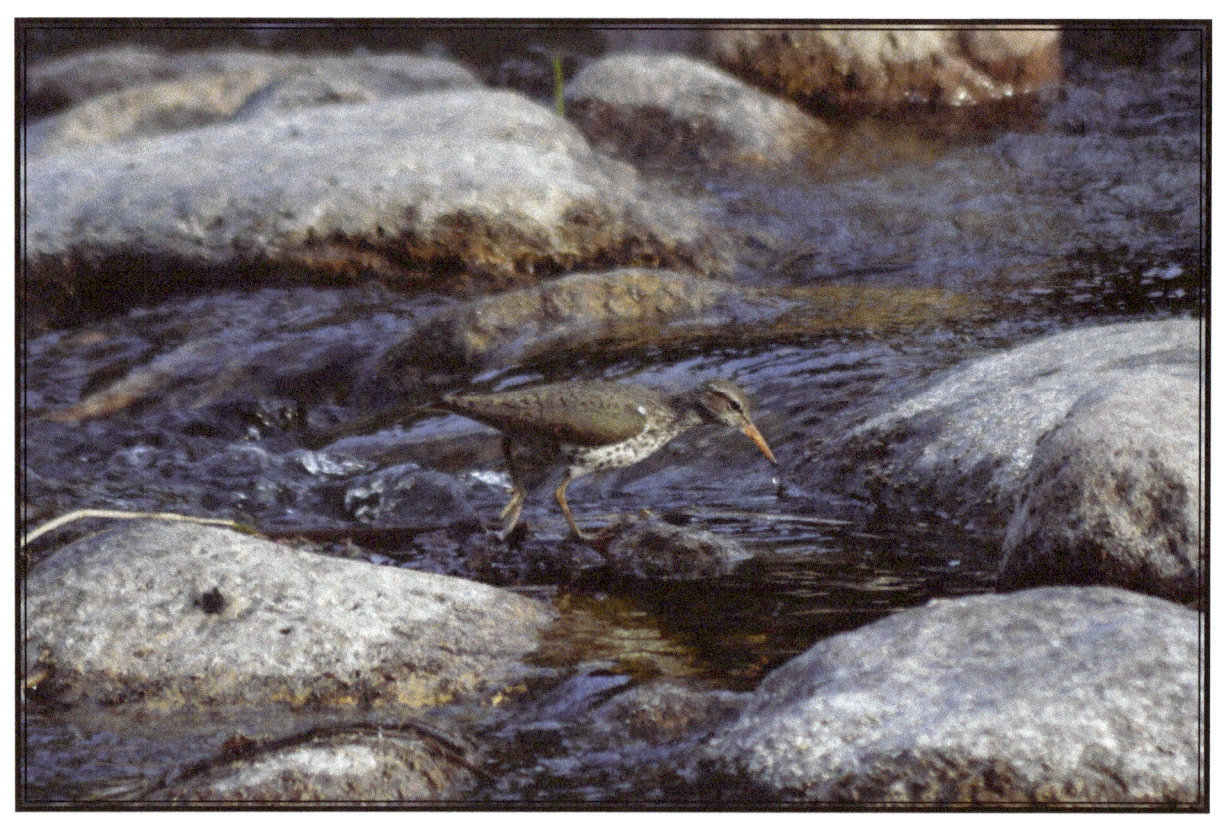

# The Stilt Sandpiper

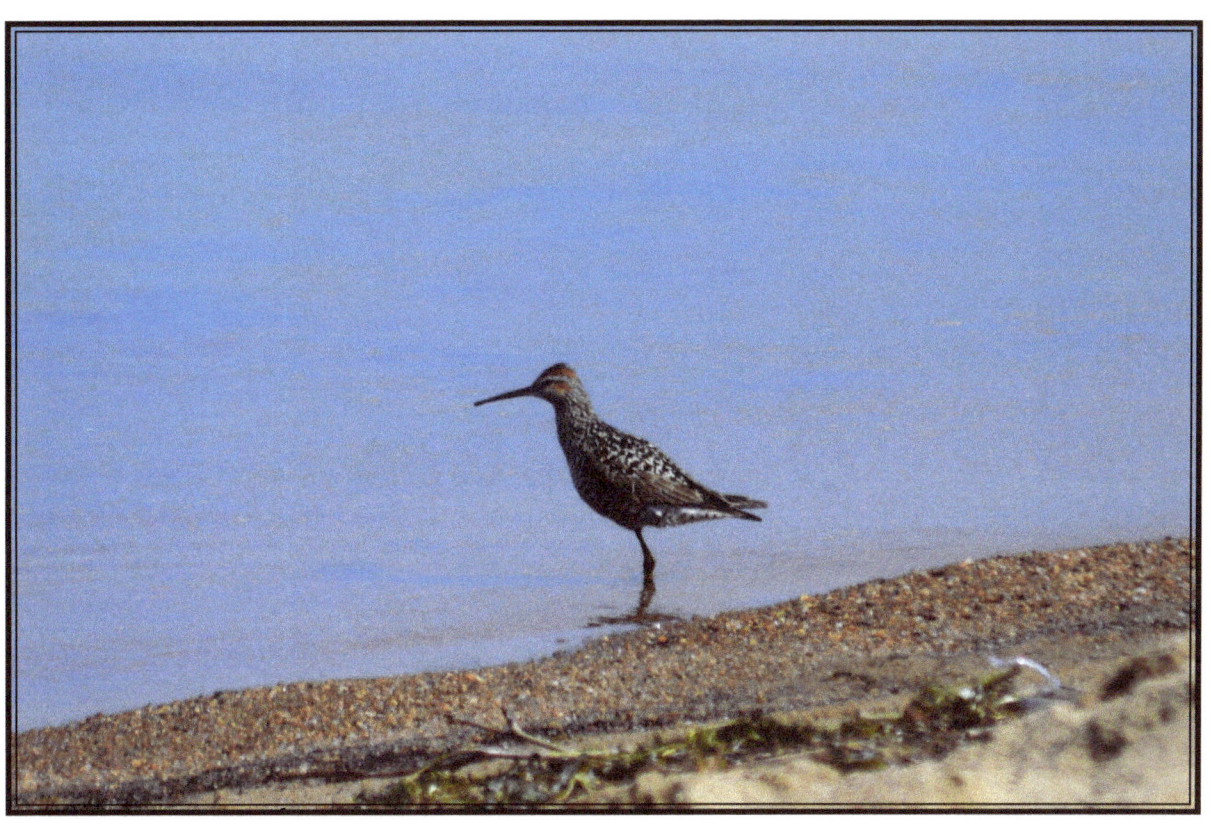

*Butterflies*

# The Common or Violet Meadow Blue

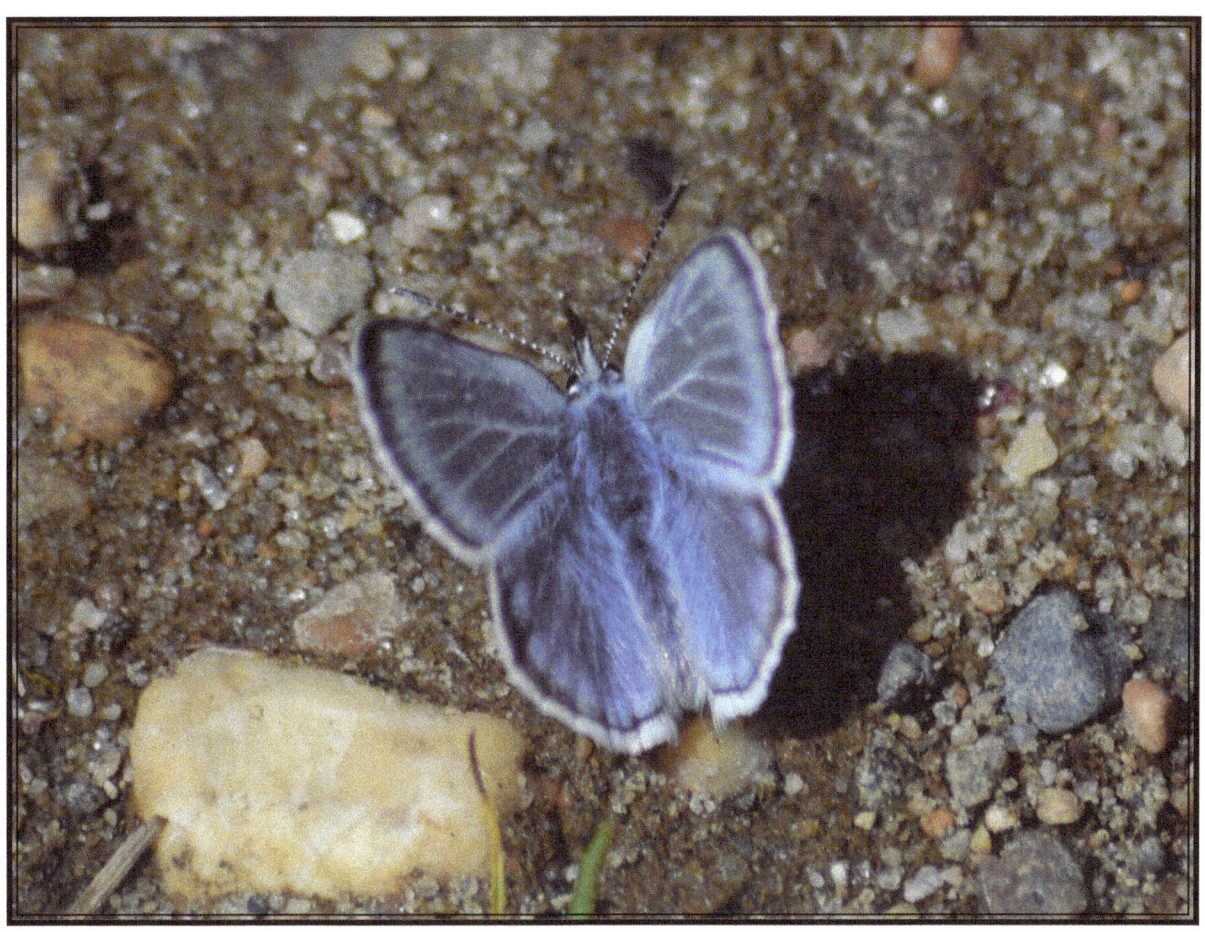

# The Common Swallowtail

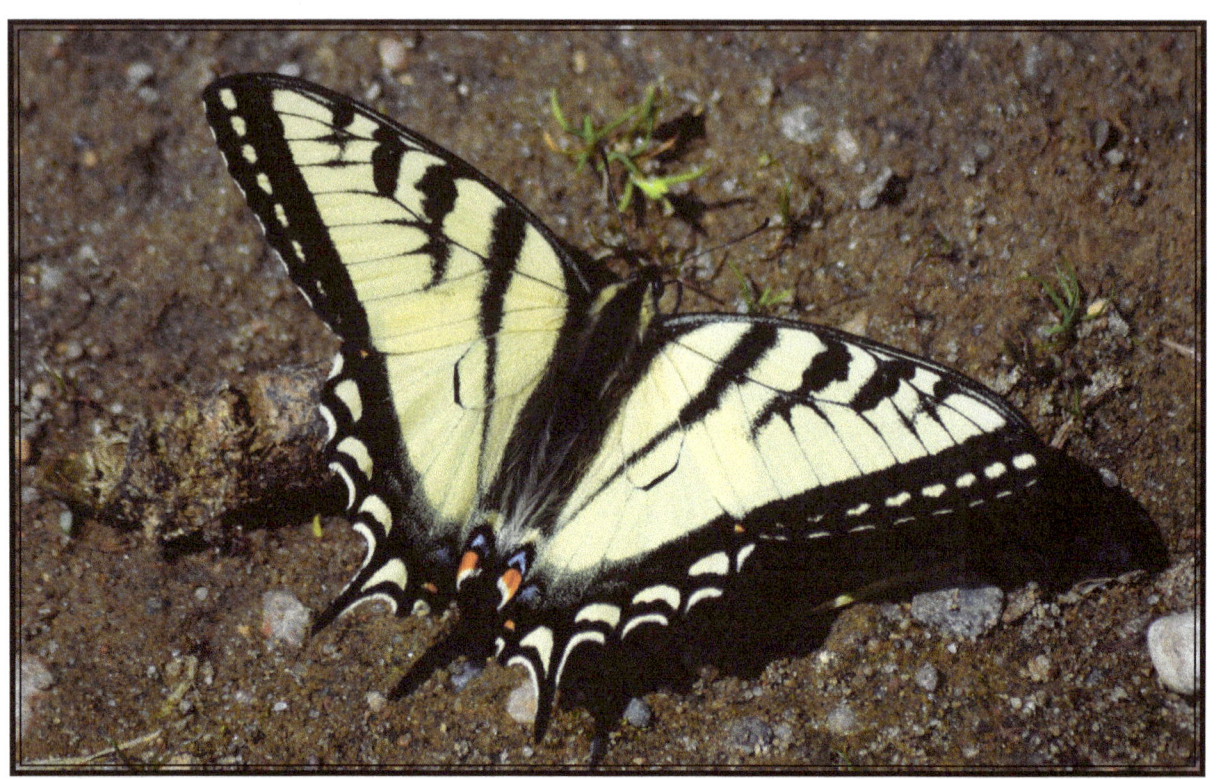

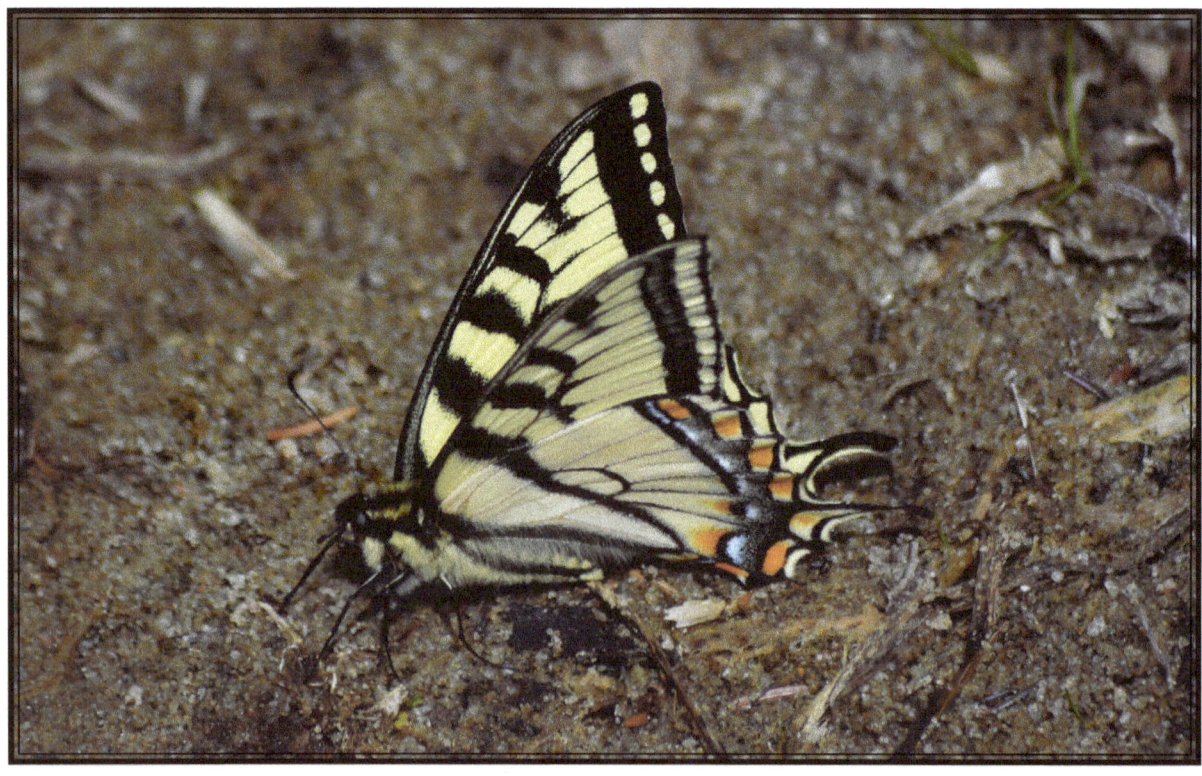

# The White Admiral

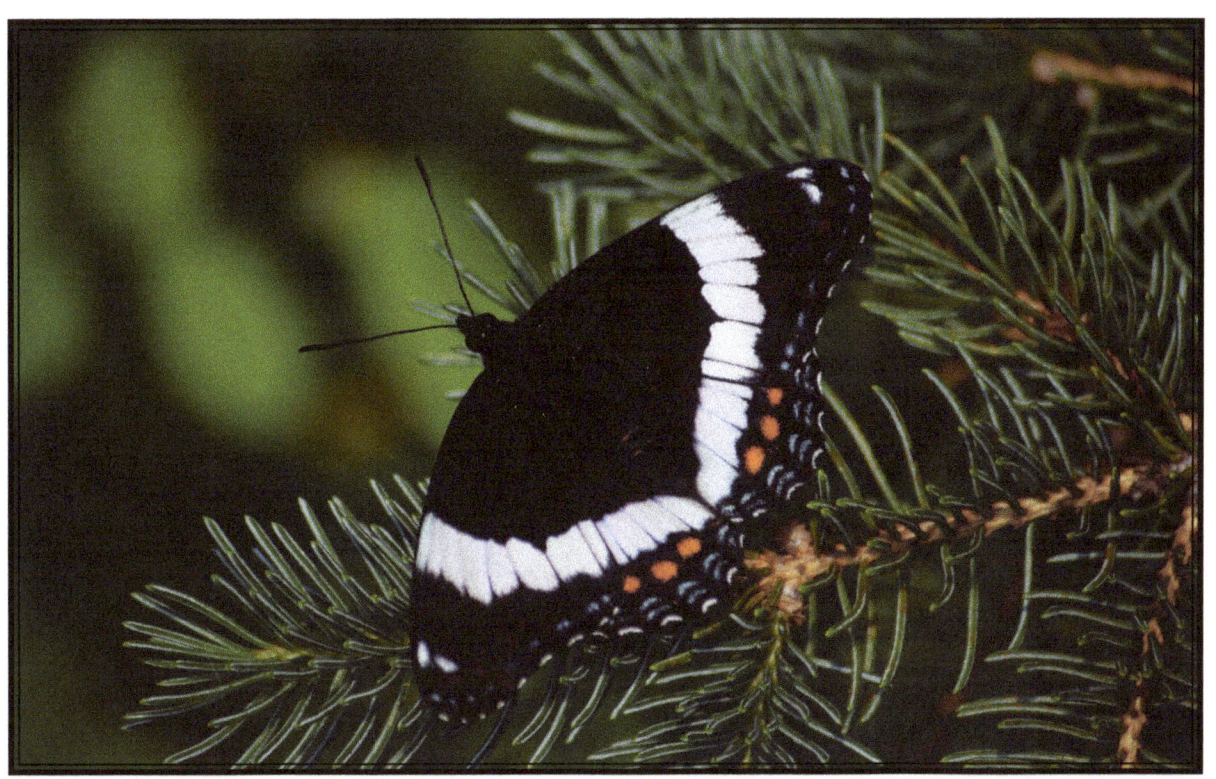

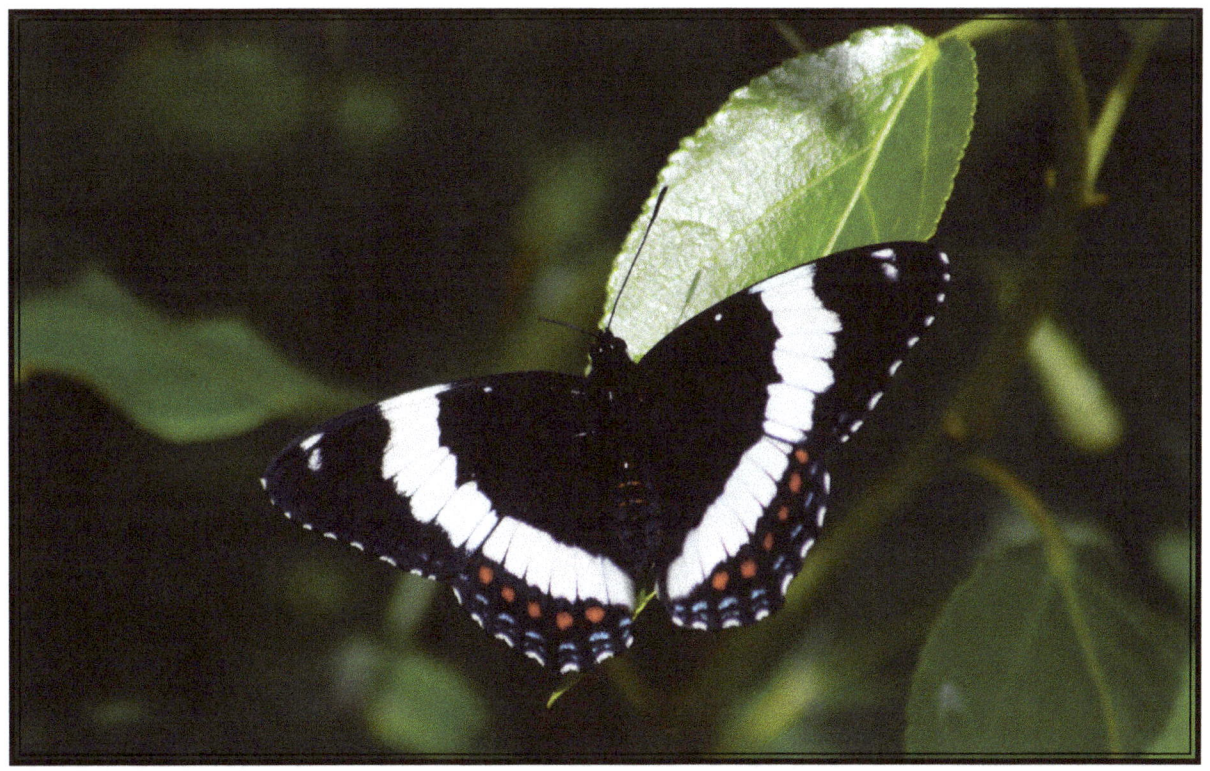

# The Tortoiseshell Butterfly

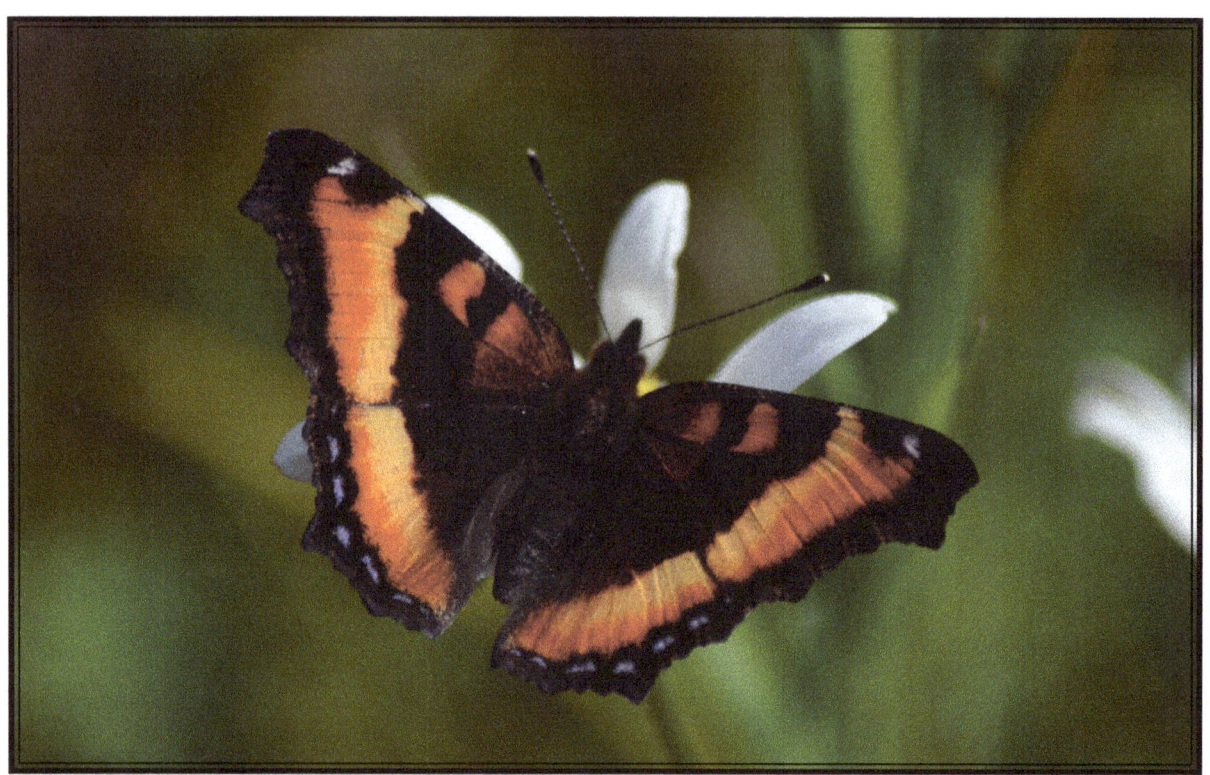

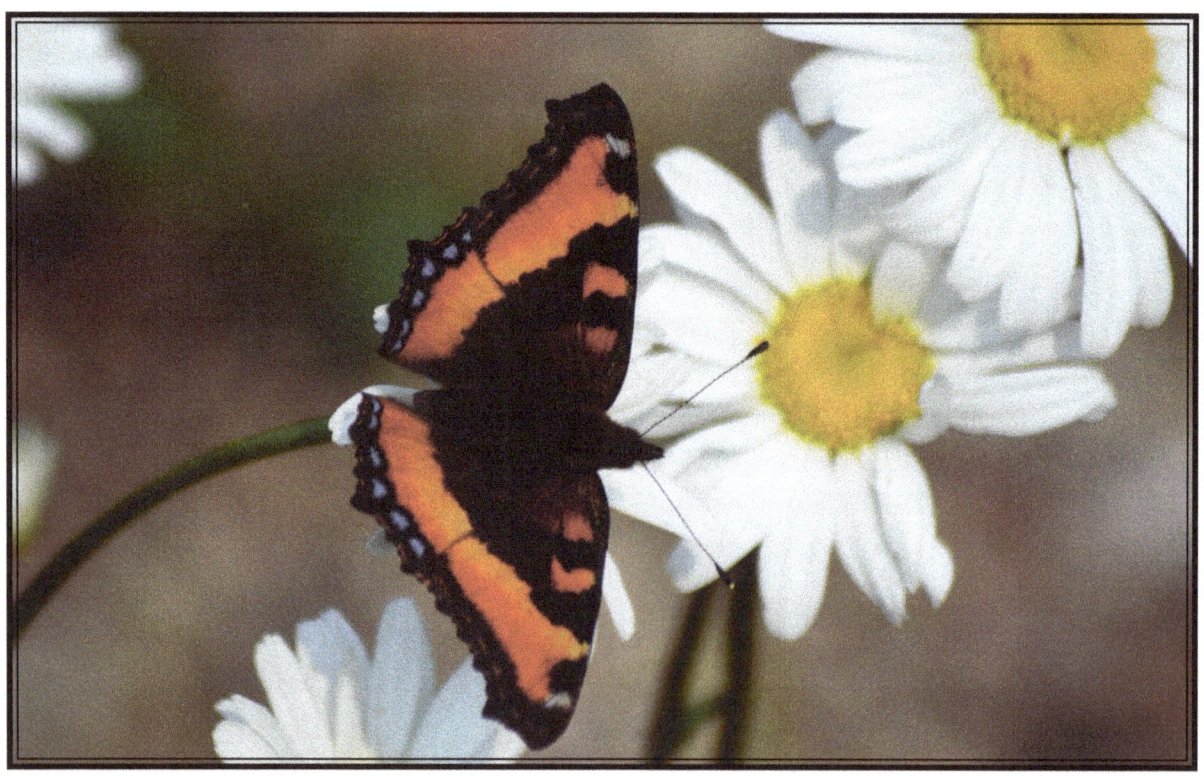

# The Comma Butterfly

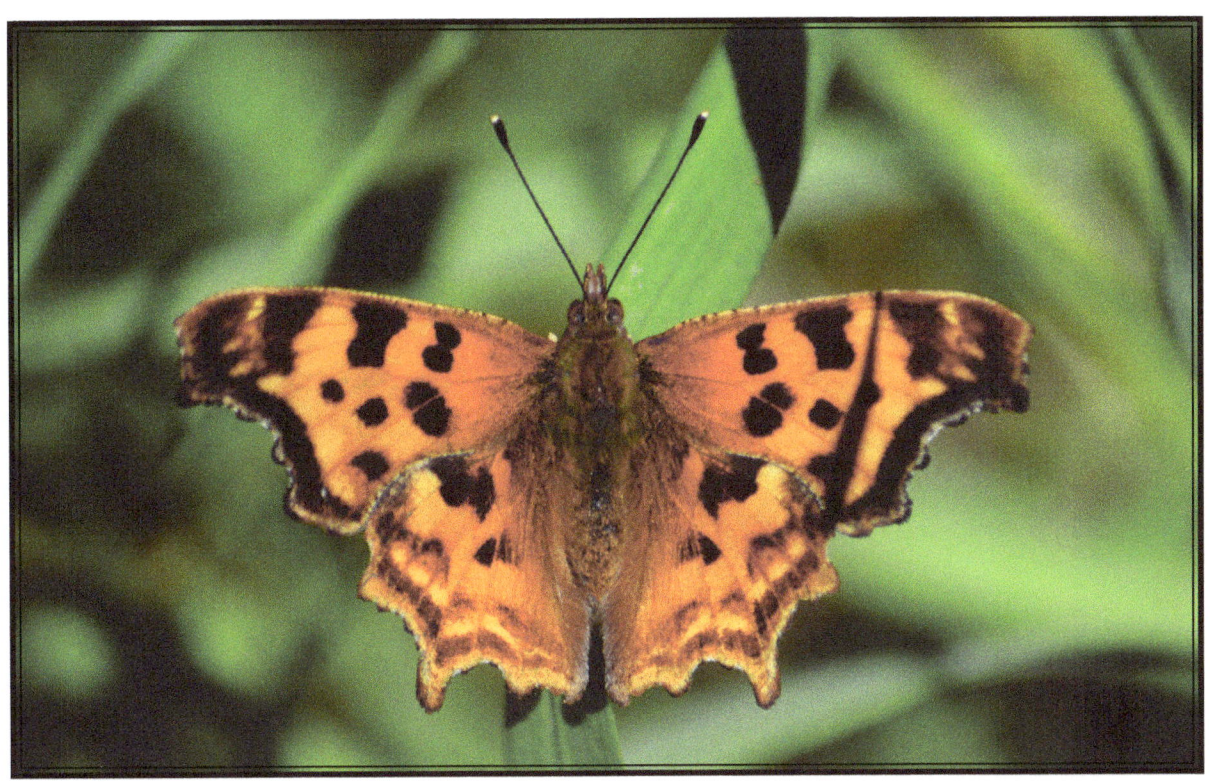

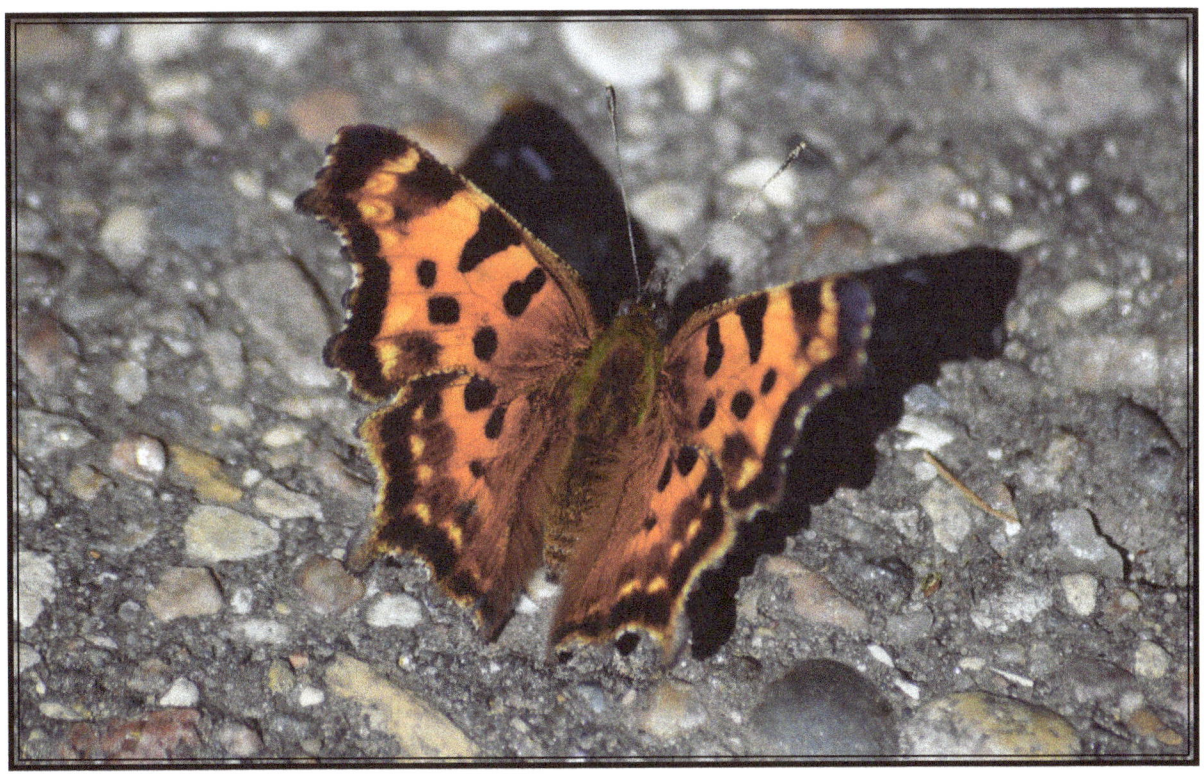

# The Dark Green Fritillary

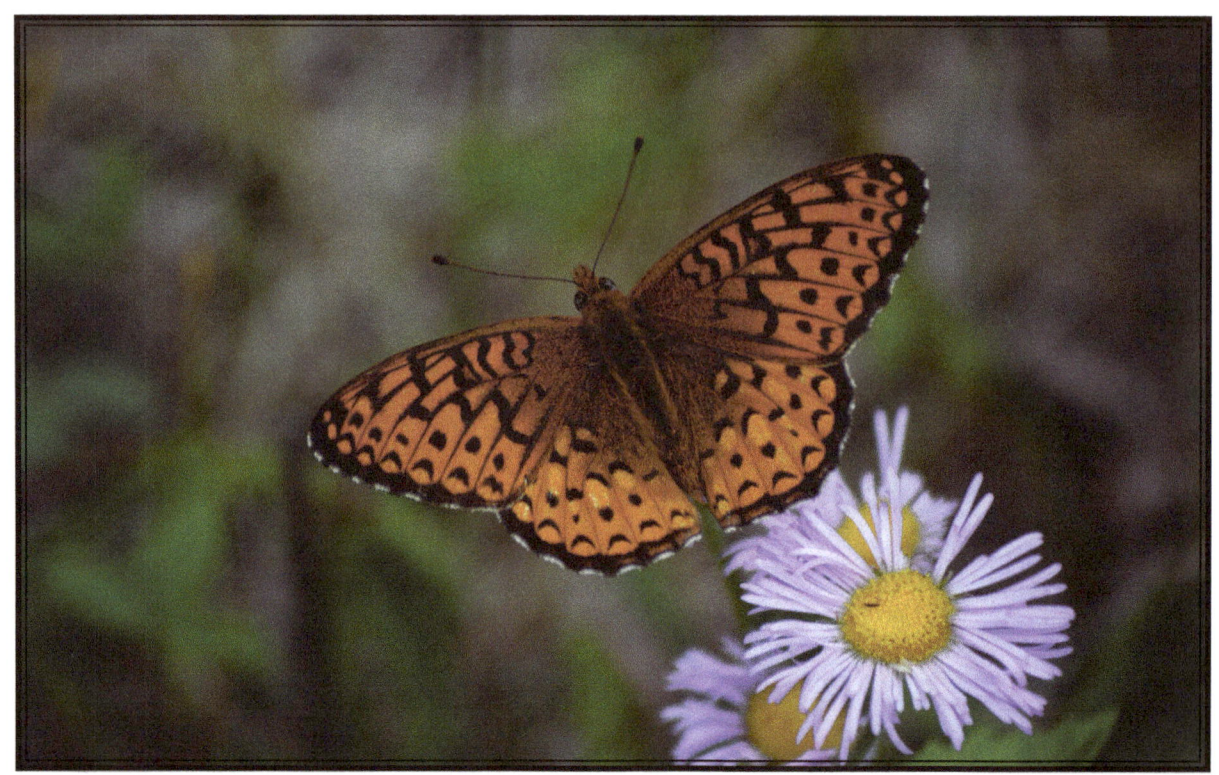

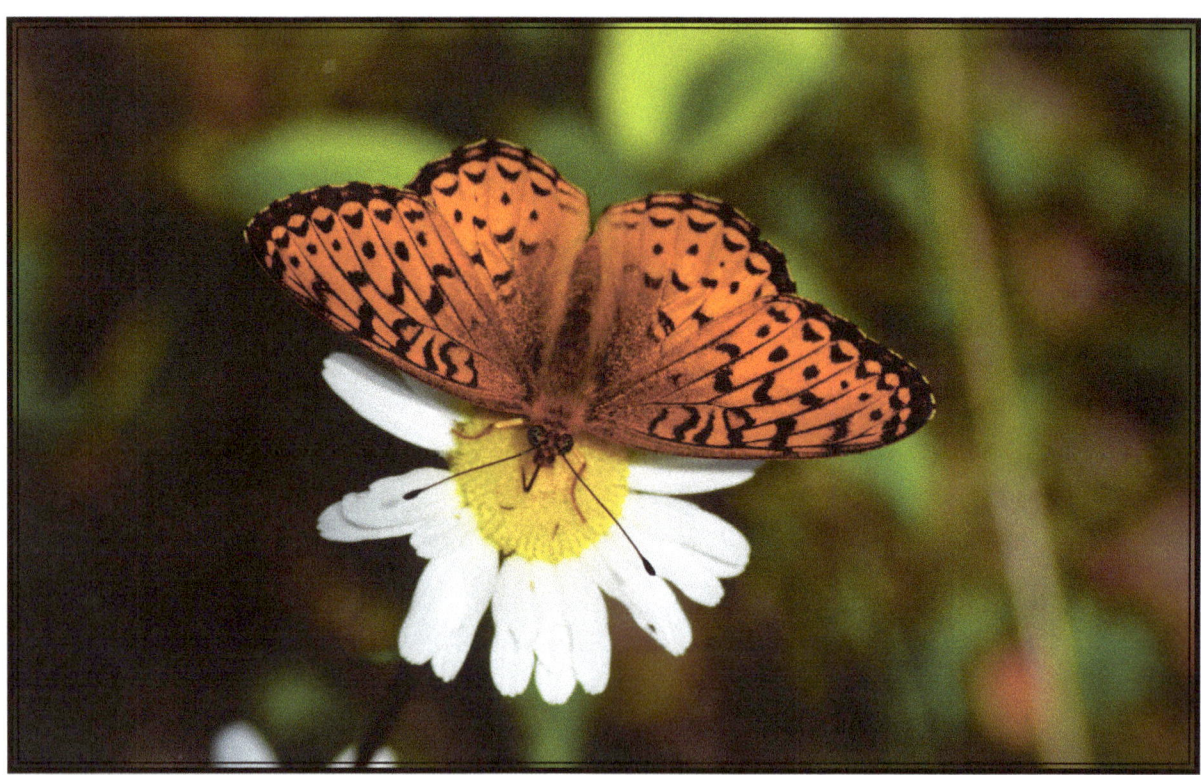

# The Silver-Bordered Fritillary

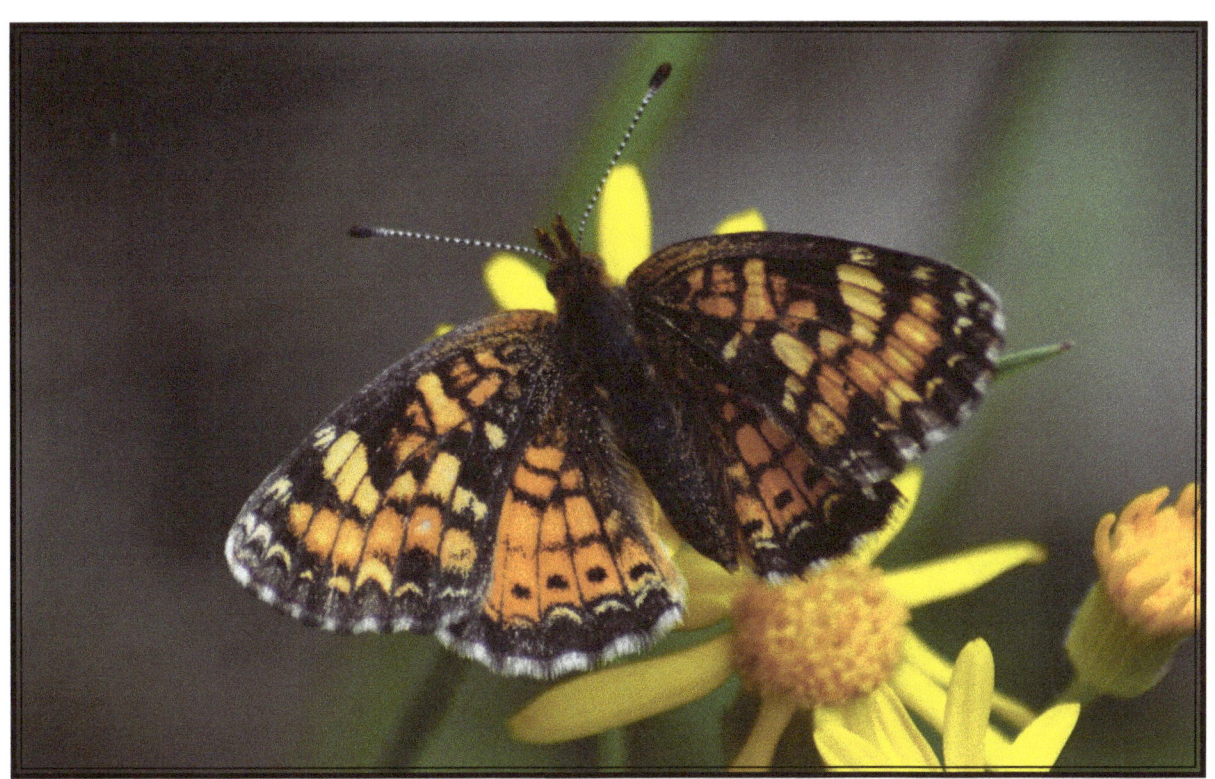

# The Clouded-Yellow Butterfly

# The Small Skipper

# The Scotch Argus

# The Ringlet Butterfly

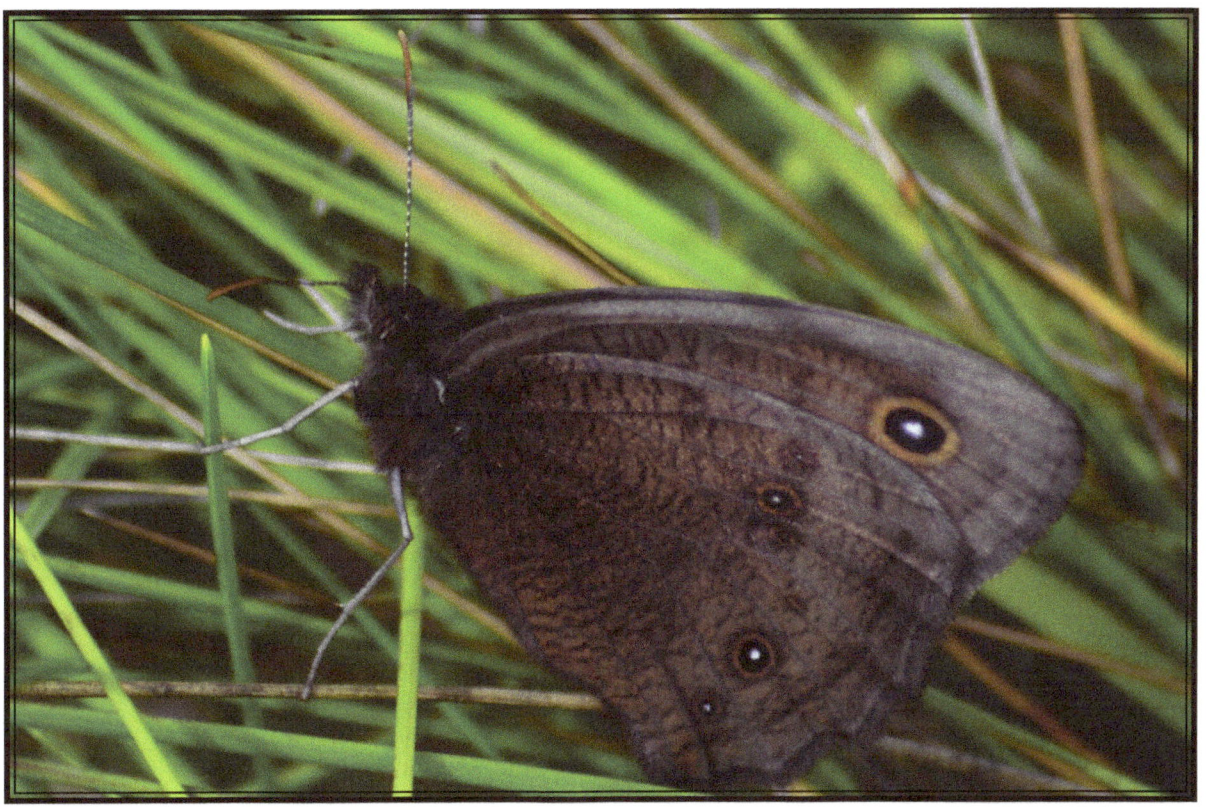

# The Silver-Bordered Fritillary

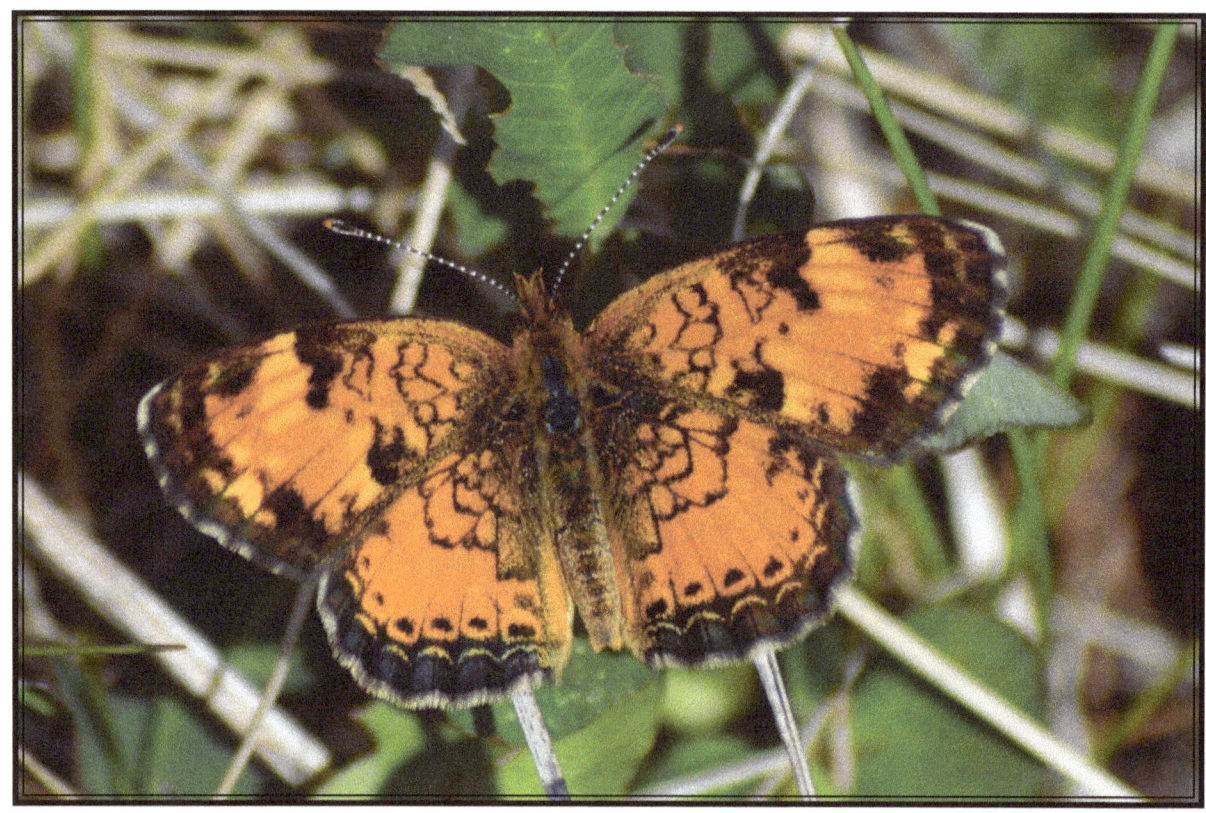

# Dragonflies

# The Blue Dragonfly

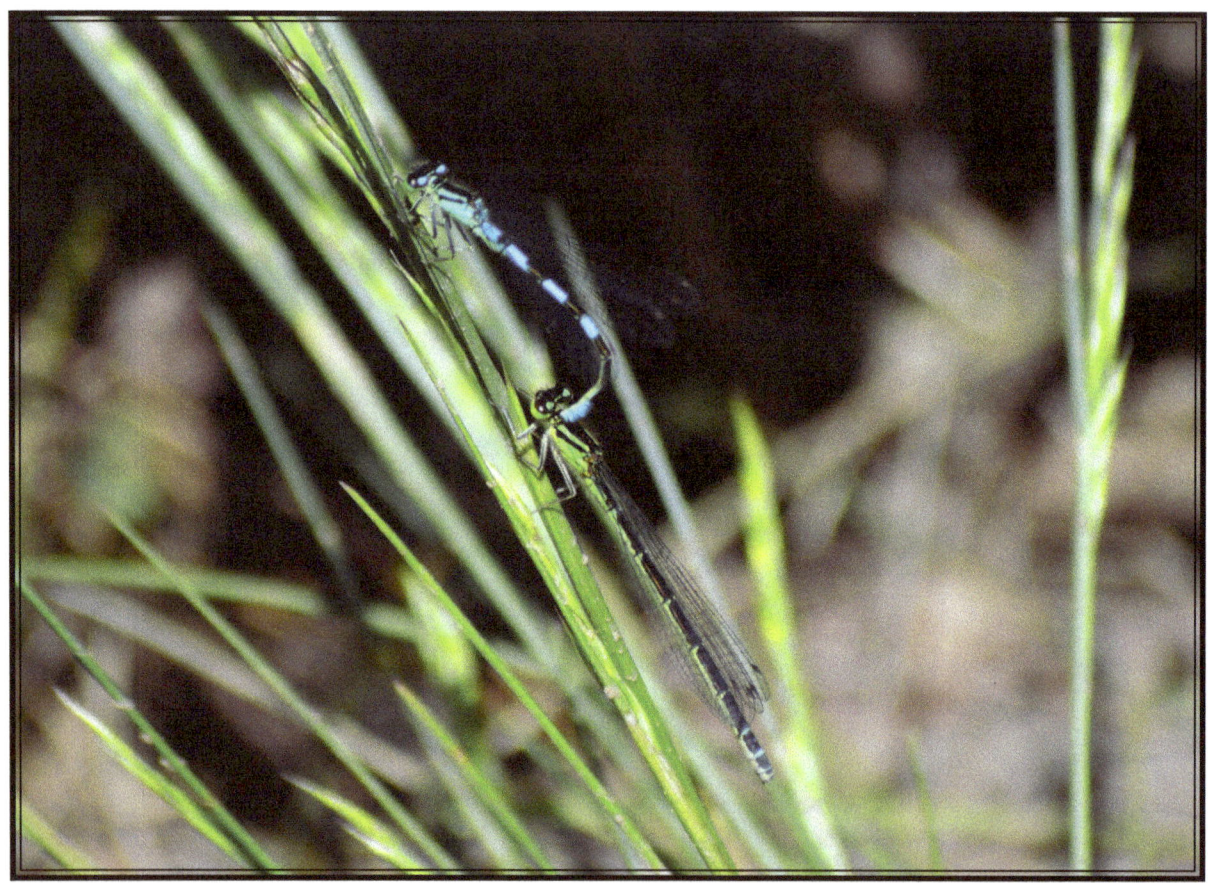

# The Sparkling Jewelwing

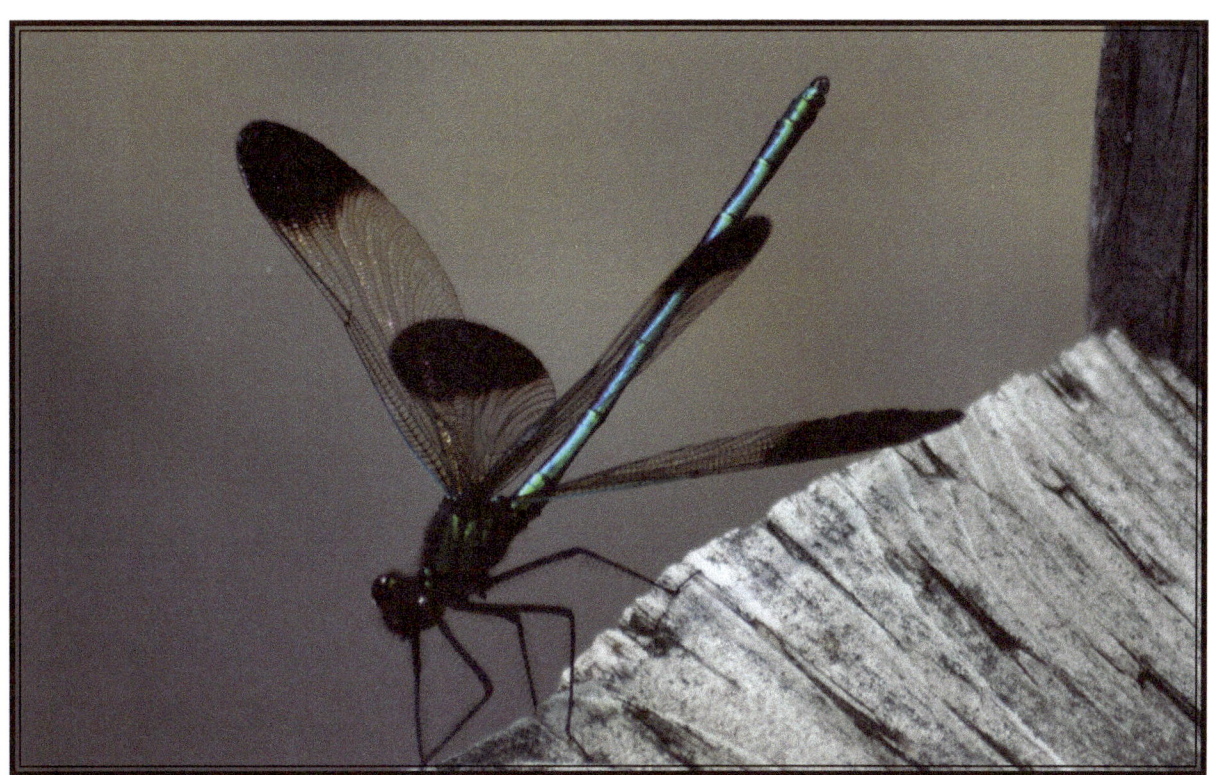

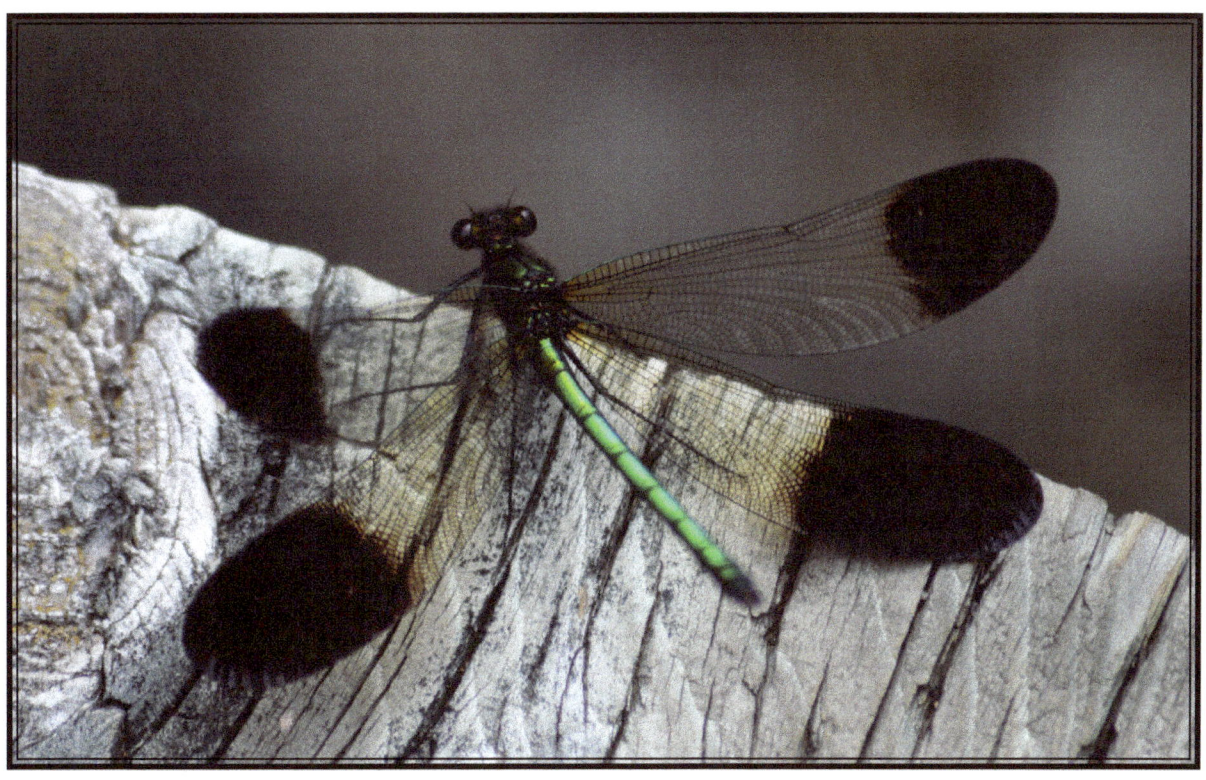

*Wildflowers*

# The Blue-Eyed Grass

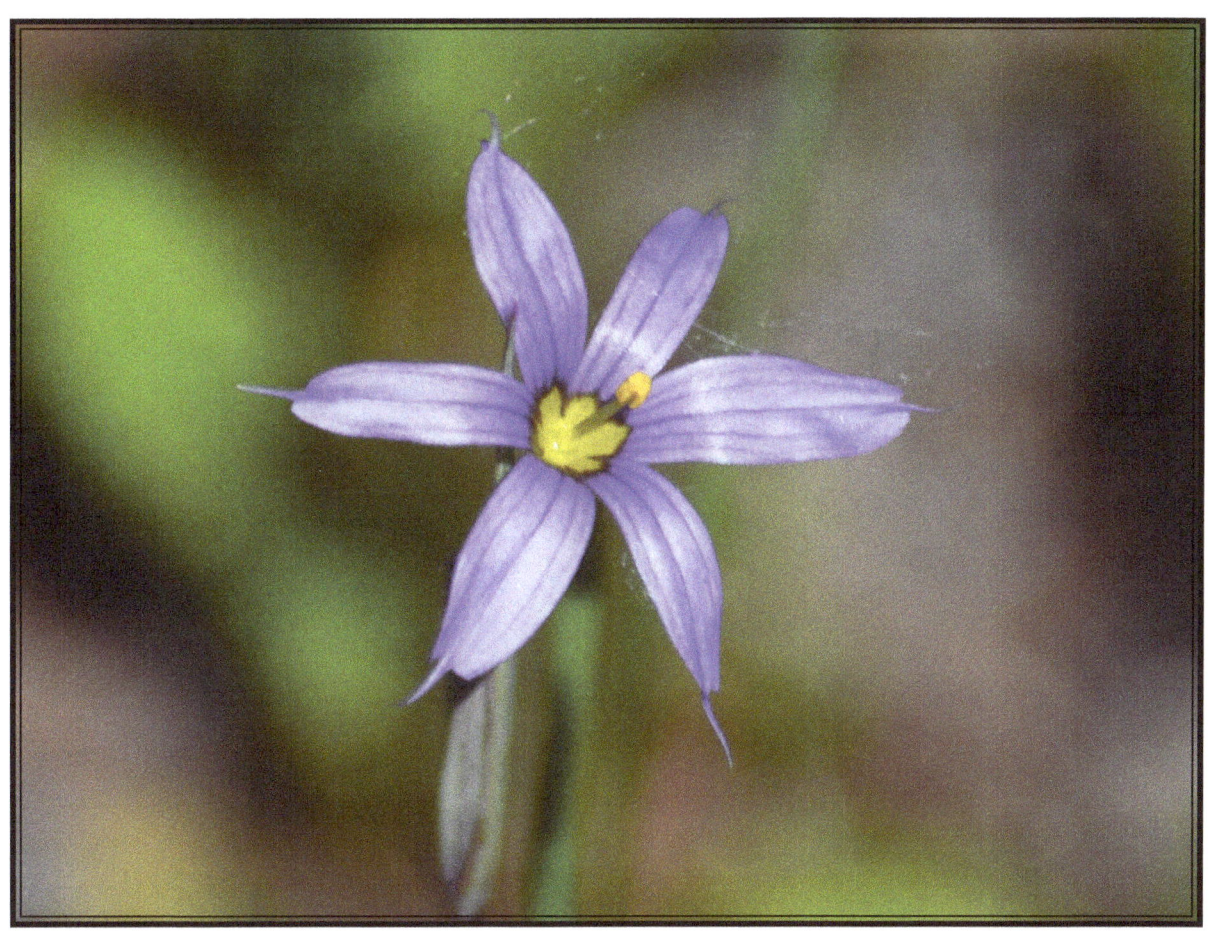

# The Prairie Lily or Red Lily

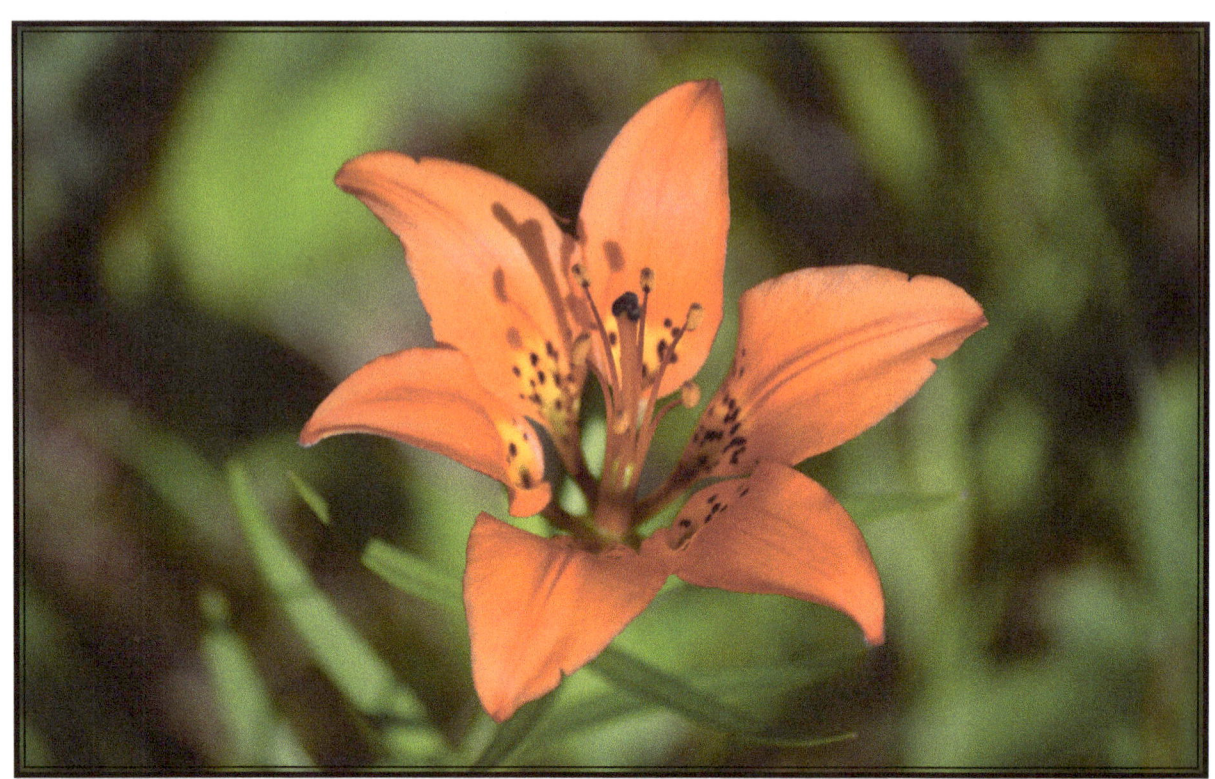

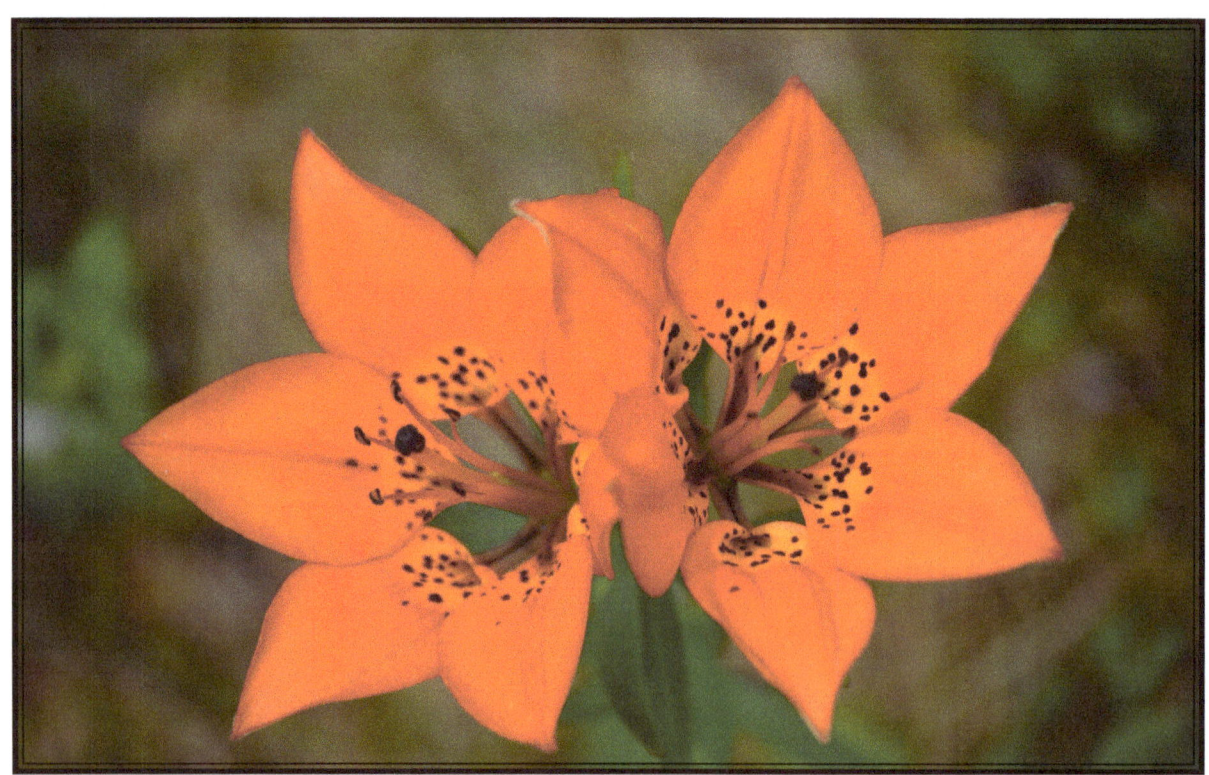

# The Yellow Lady's-Slipper

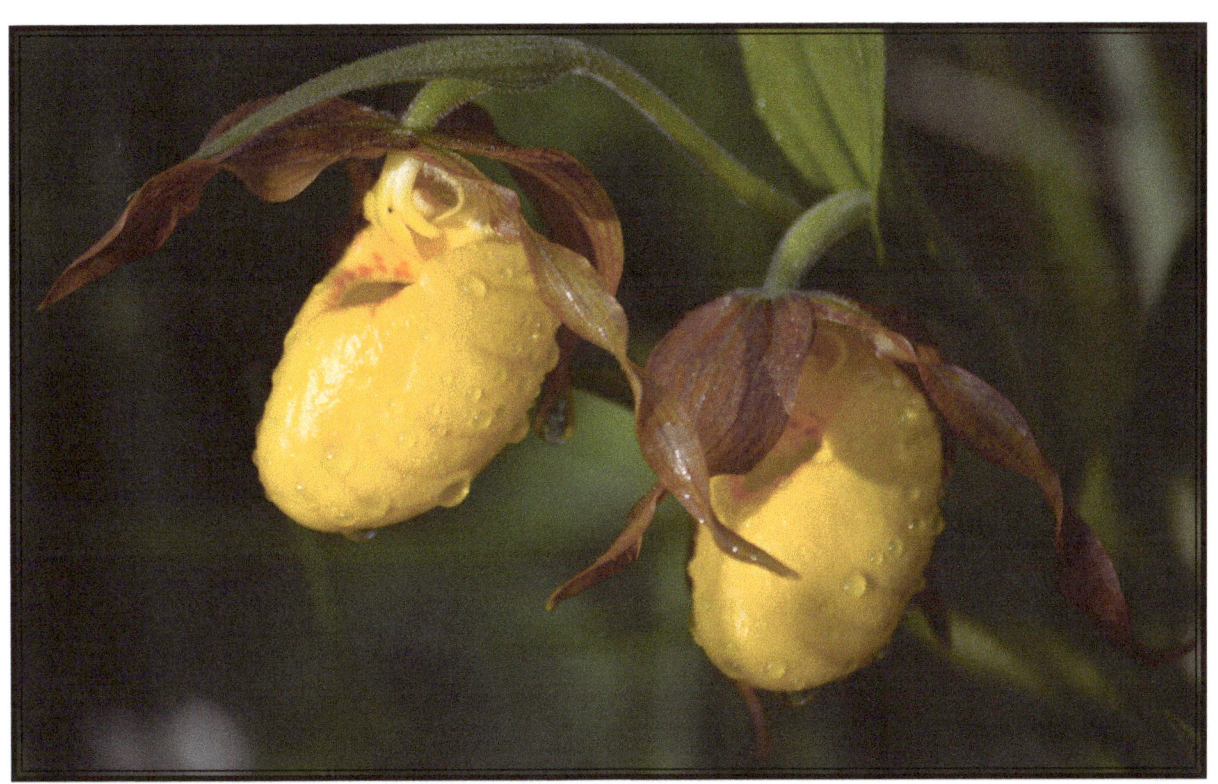

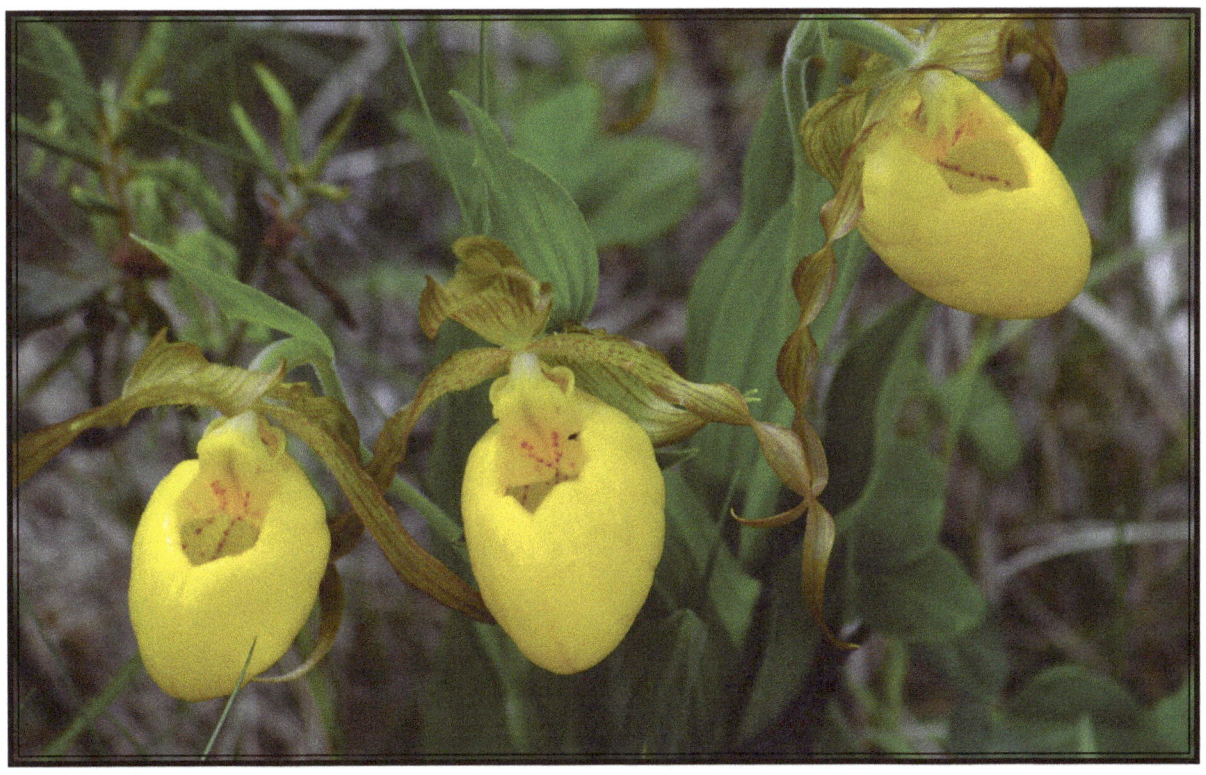

# The Hemlock Waterparsnip

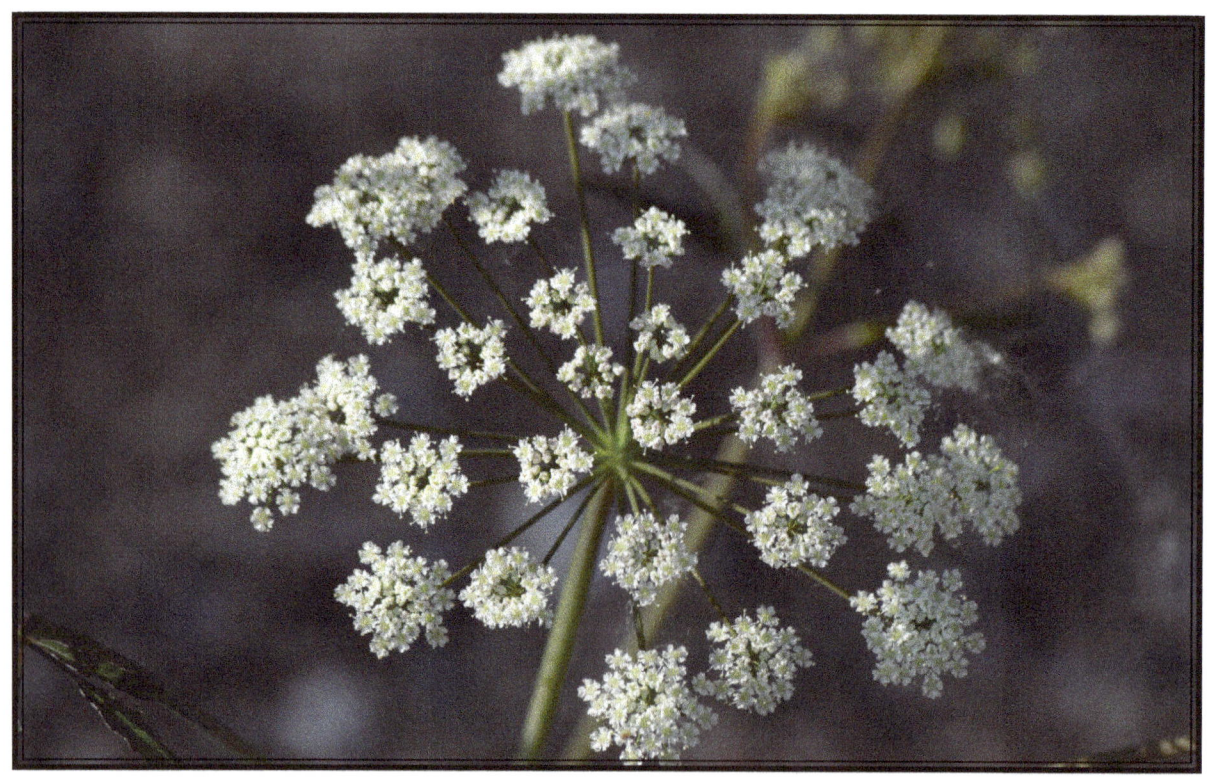

# The Pitcher Plant and Flower

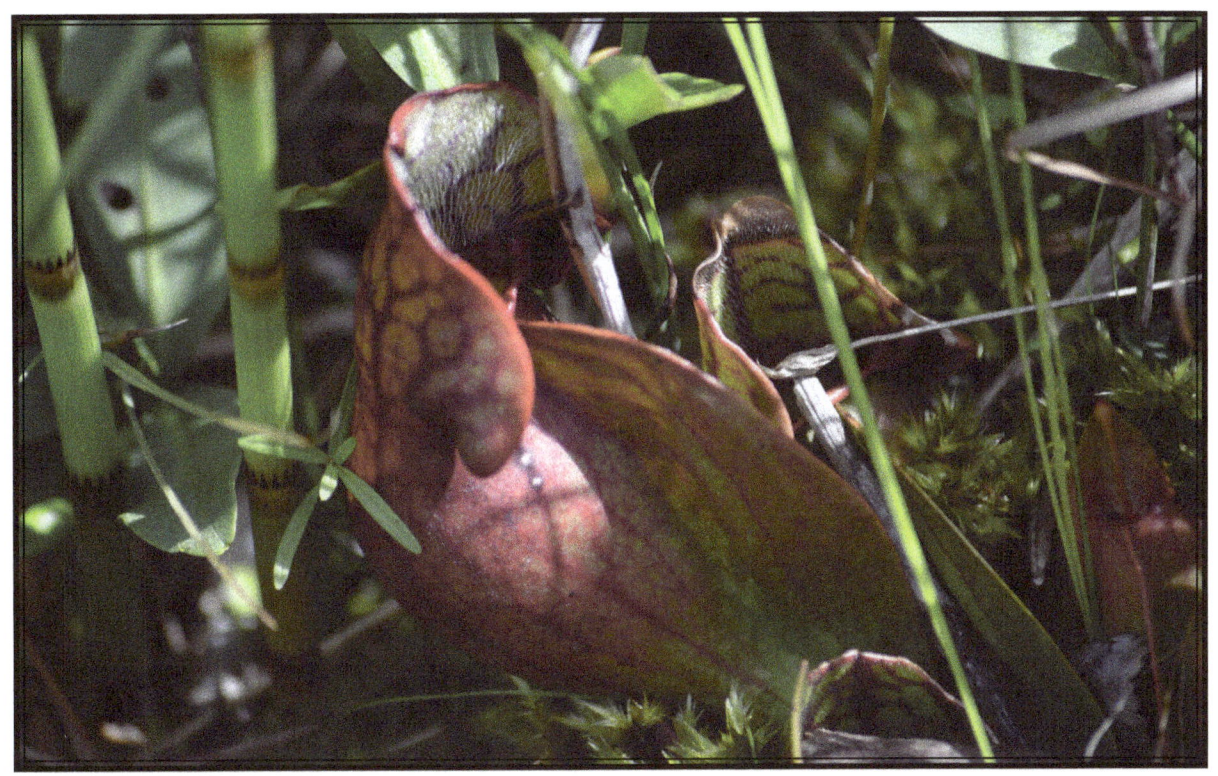

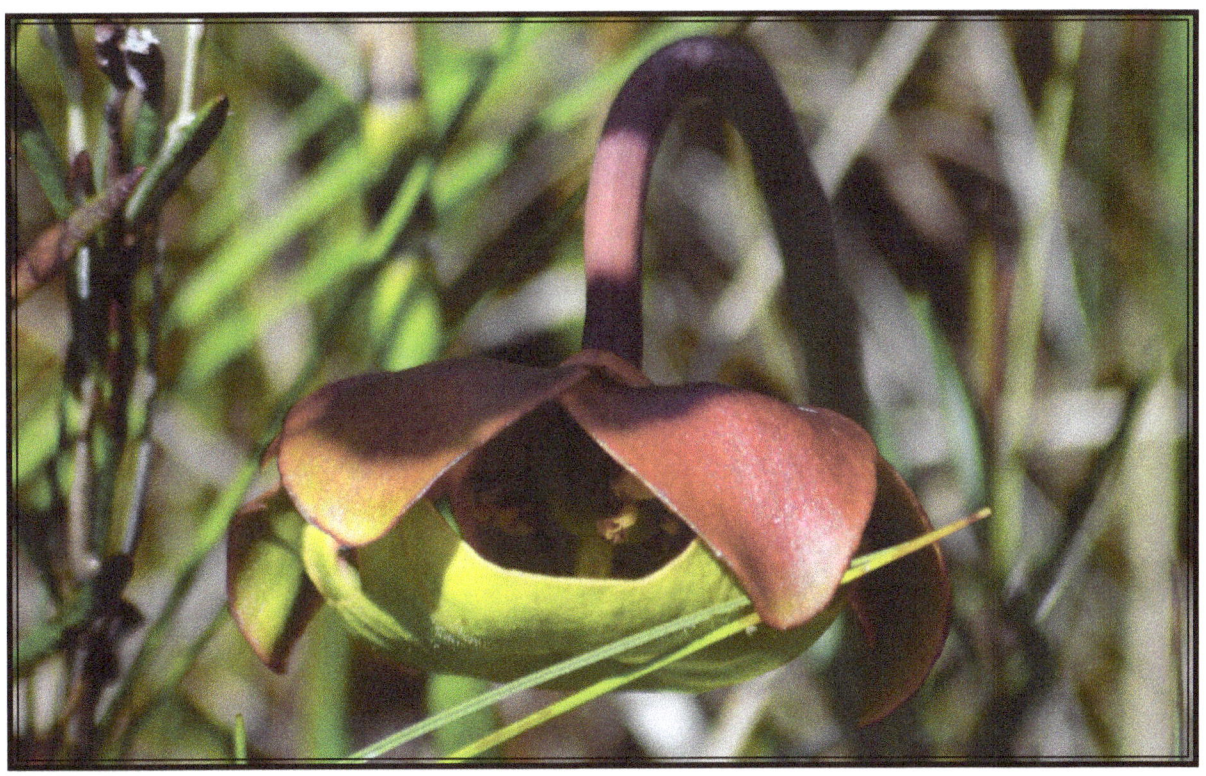

# The Bunchberry

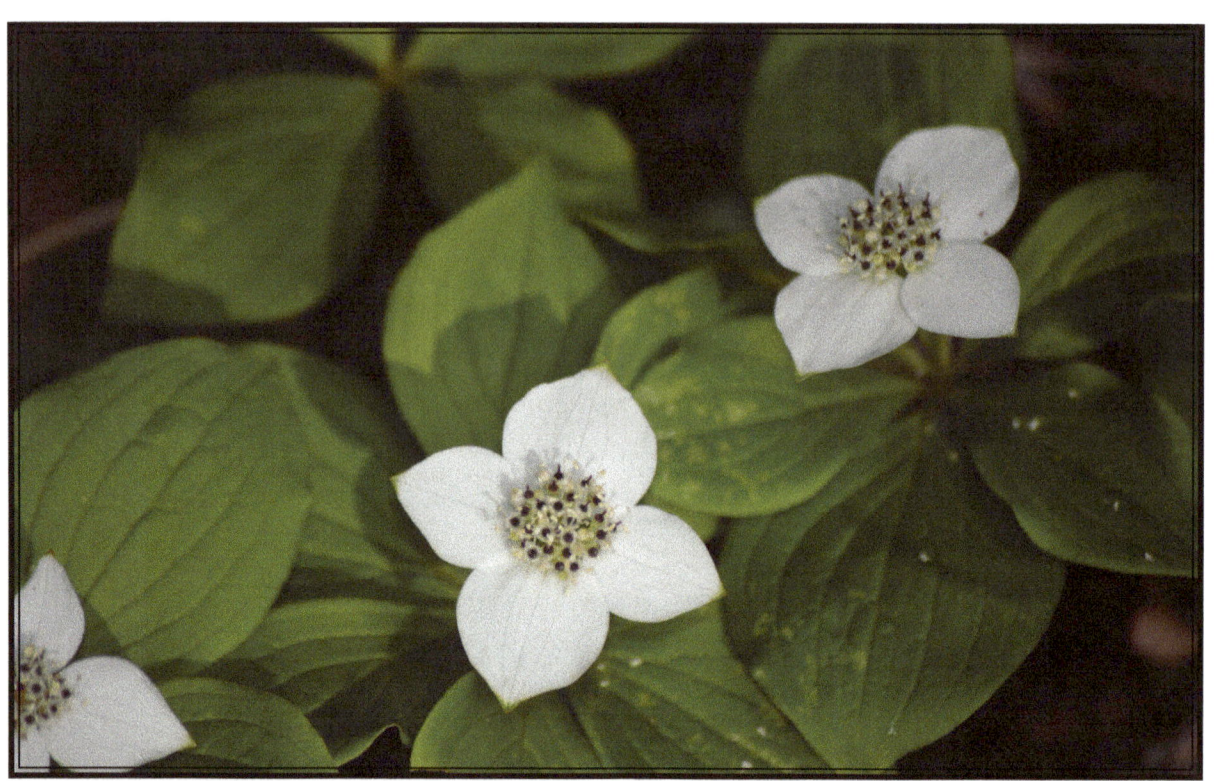

# The Western Jewelweed

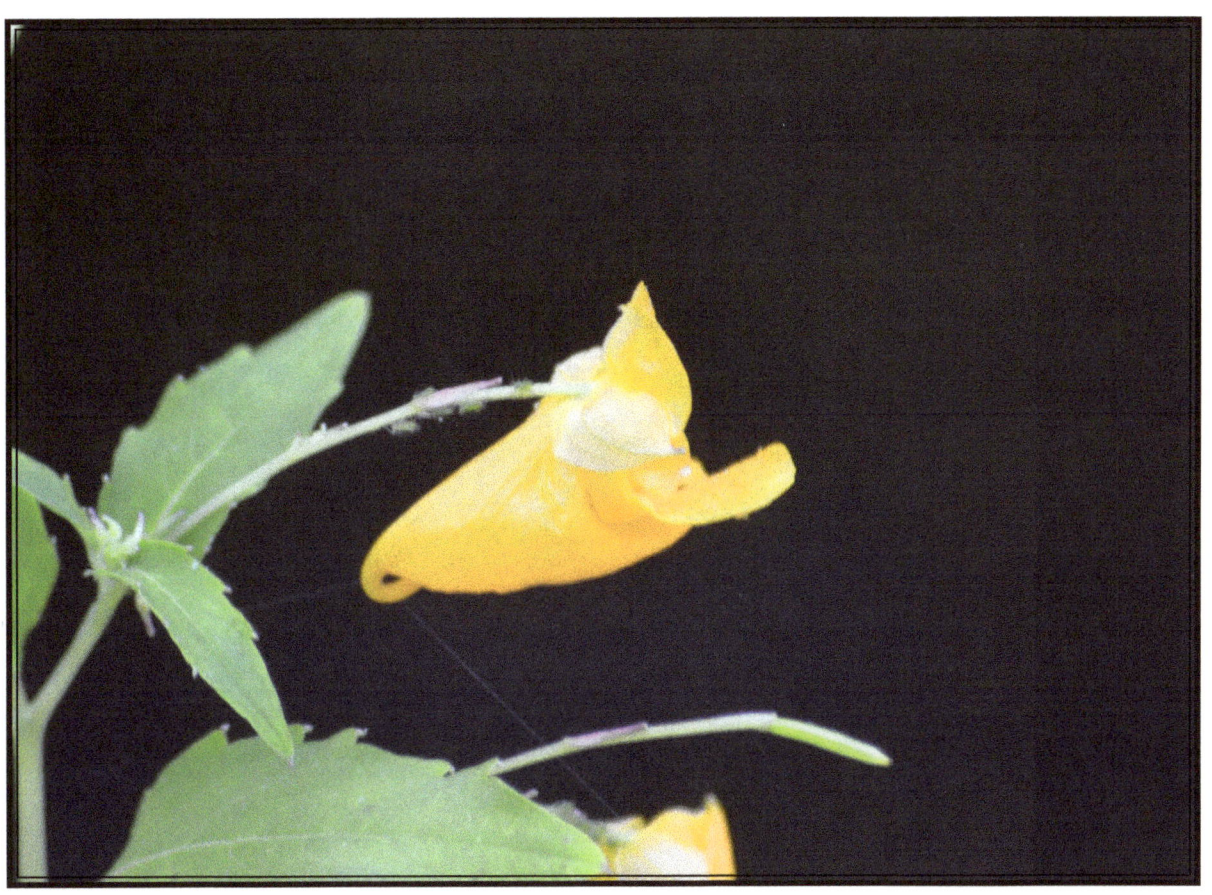

# The Wild Parsnip

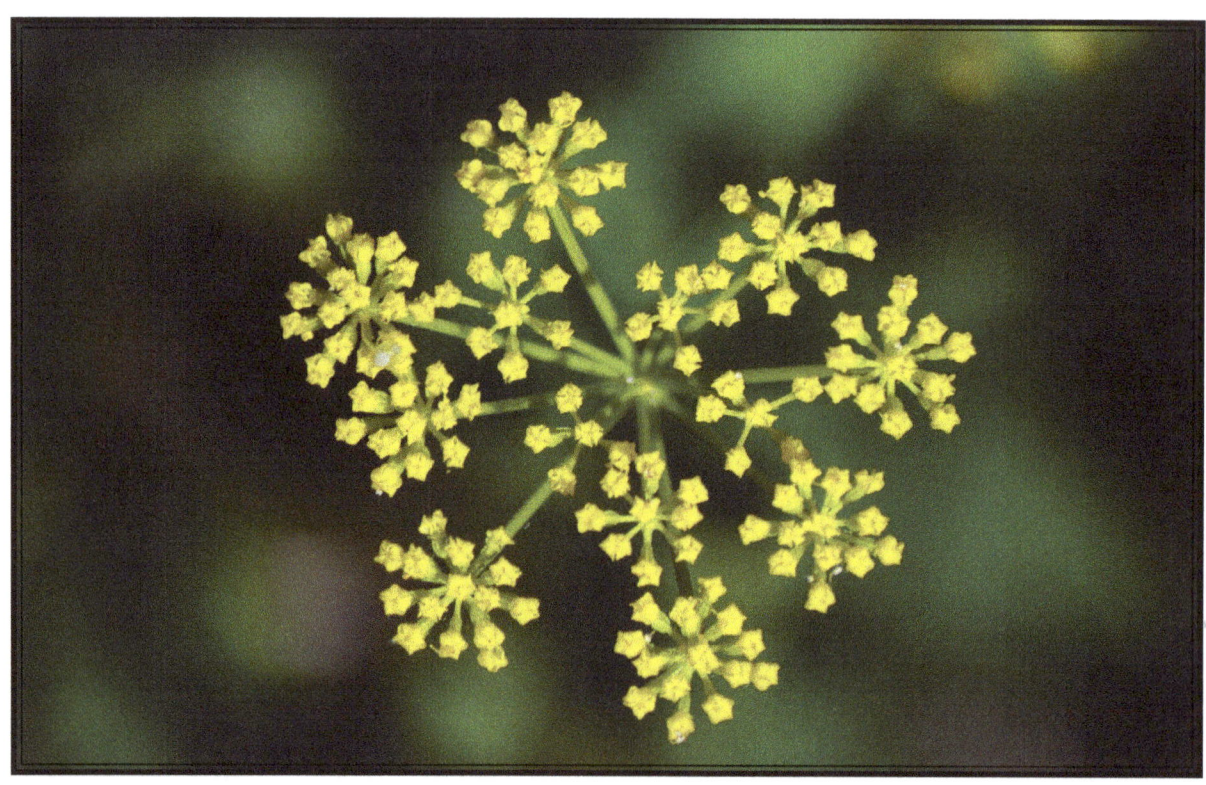

# The Small-Flowered Columbine

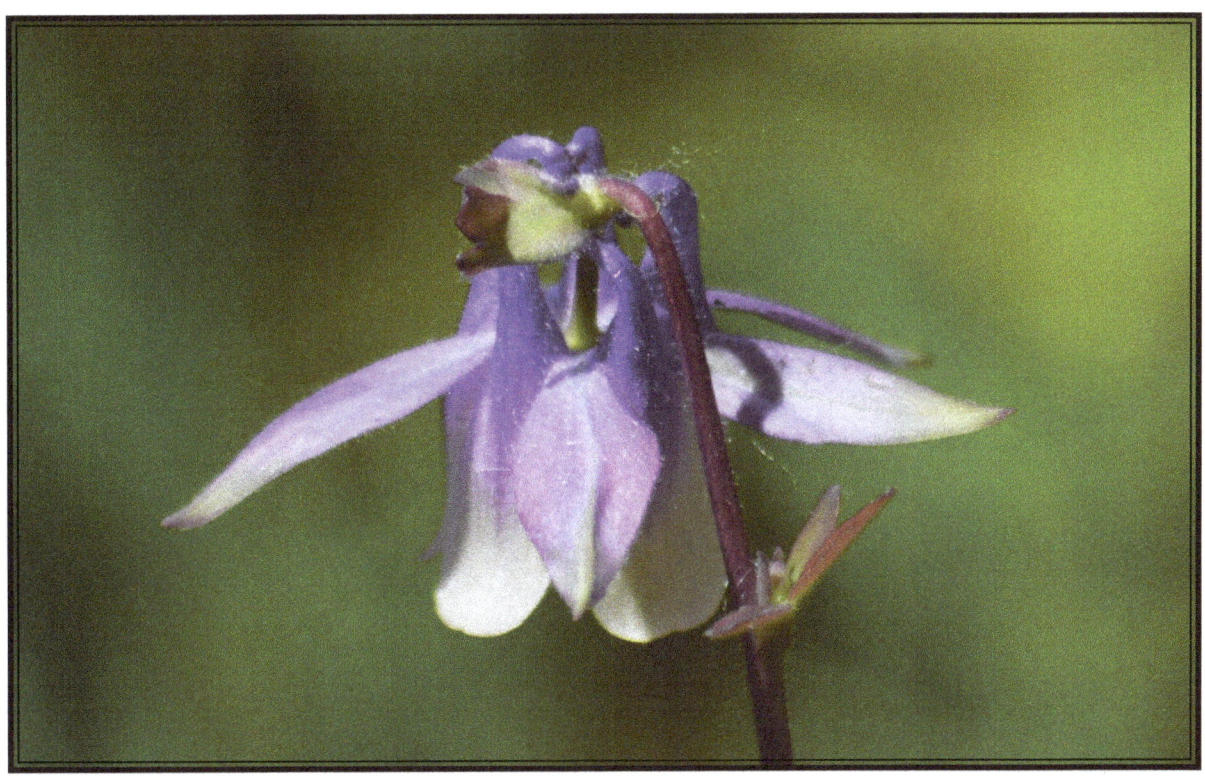

# The Hairy Vetch

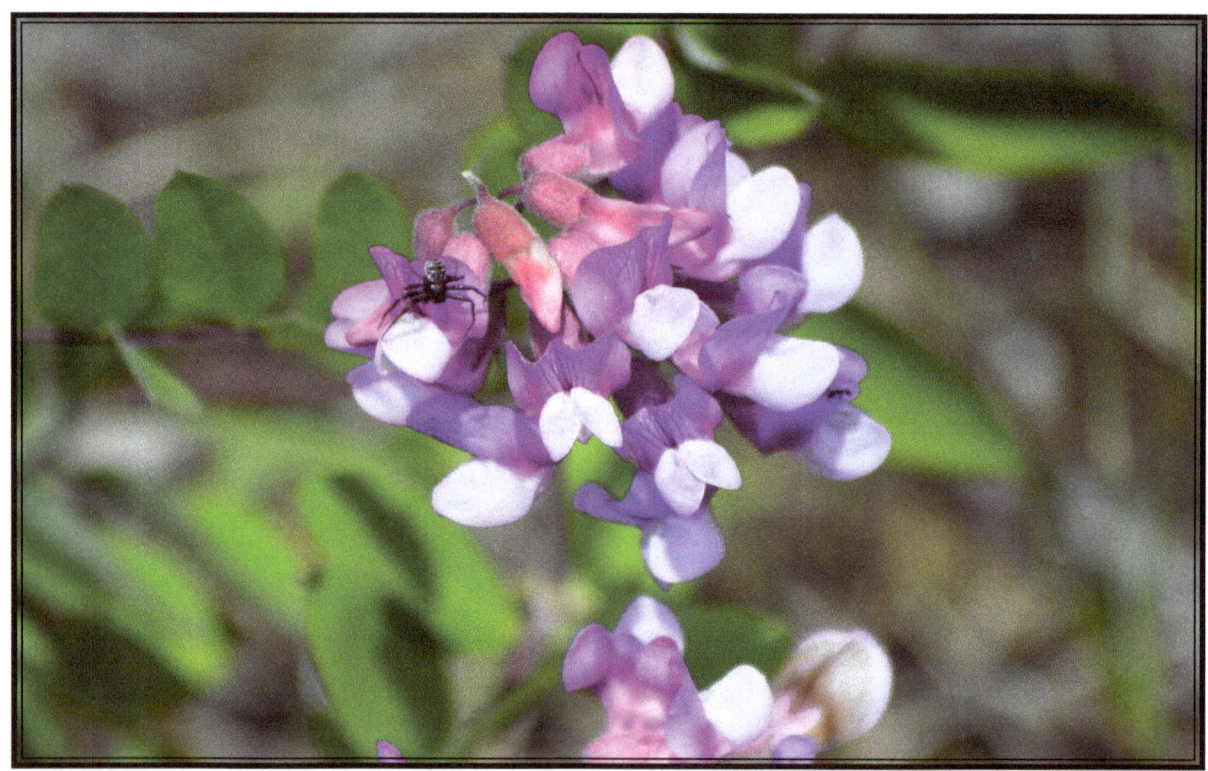

# The Two-Leaved Solomon's-Seal
# Wild Lily-of-the-Valley

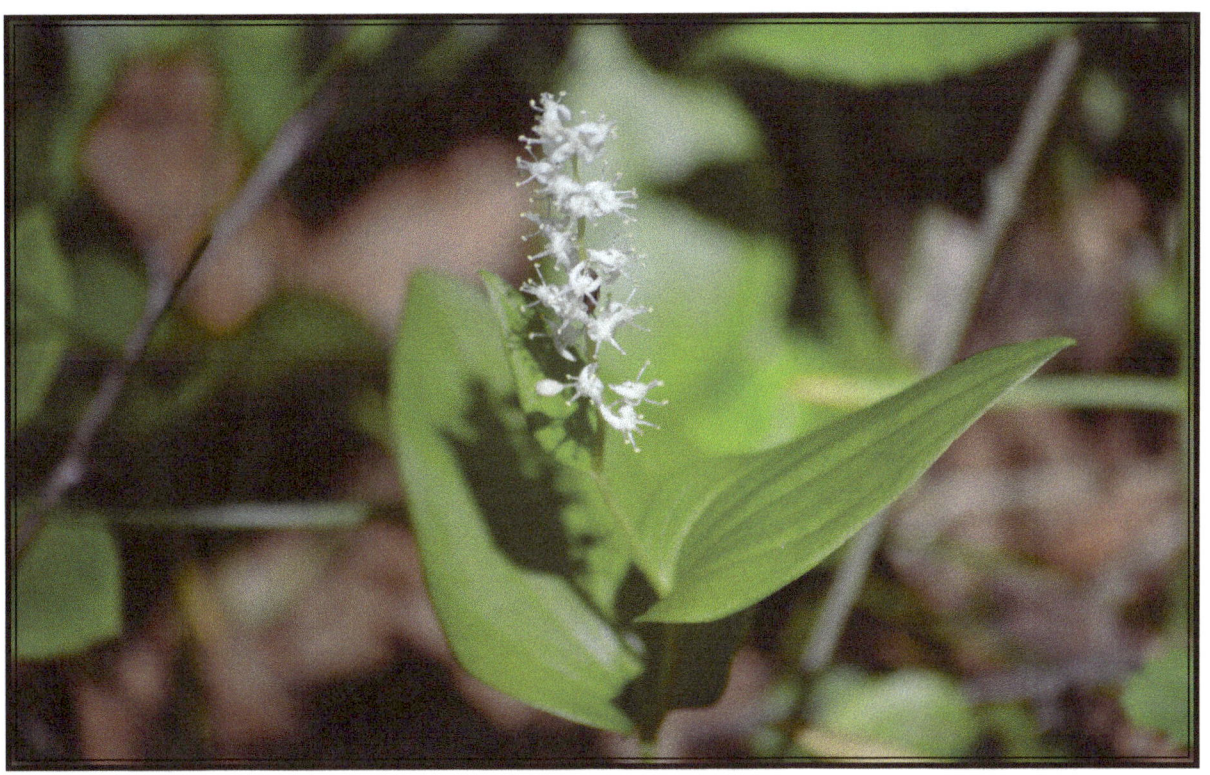

# The Starflower

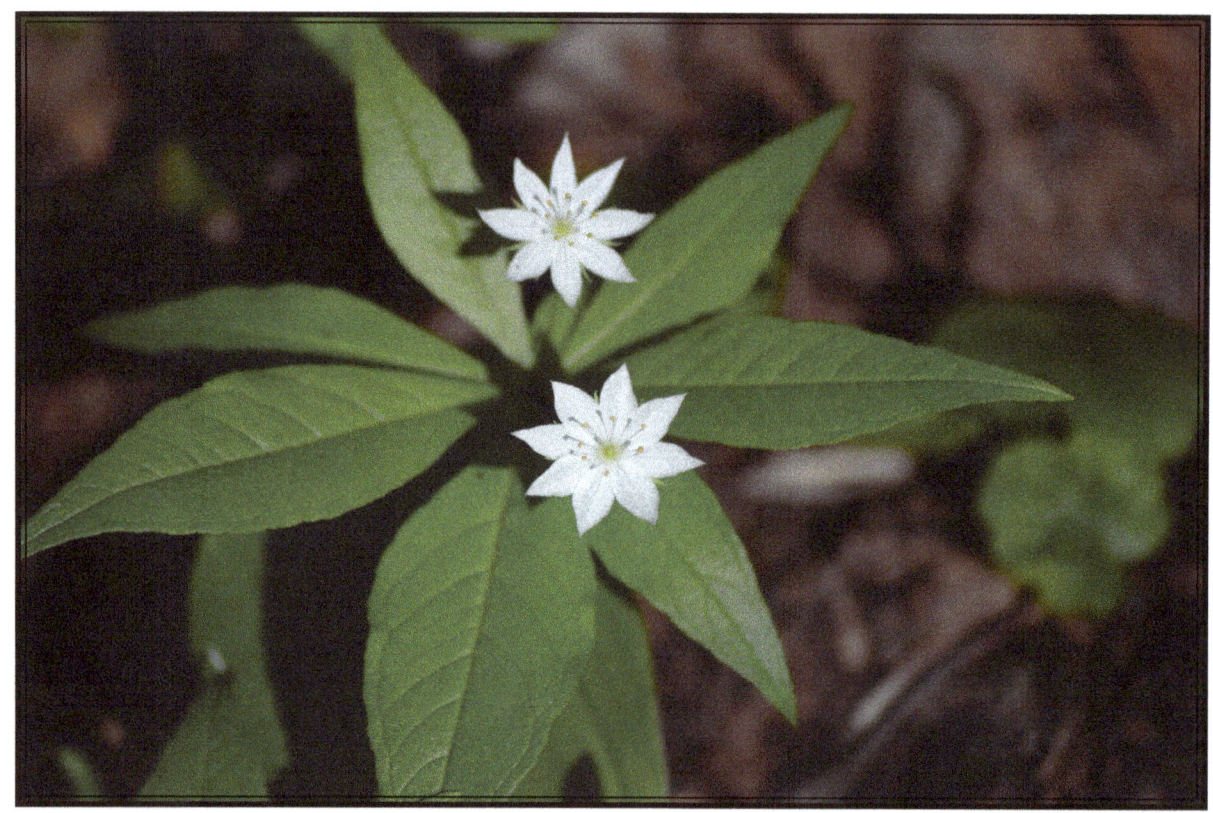

# The Butter and Eggs, Toadflax

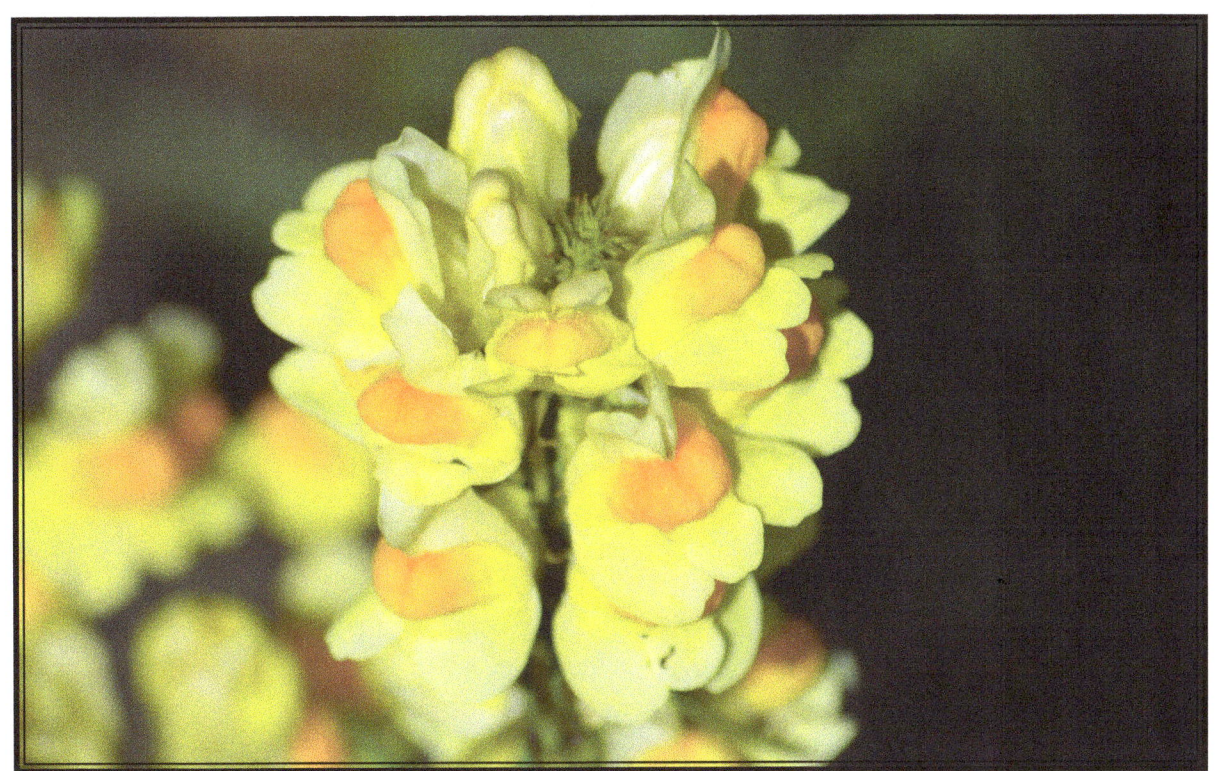

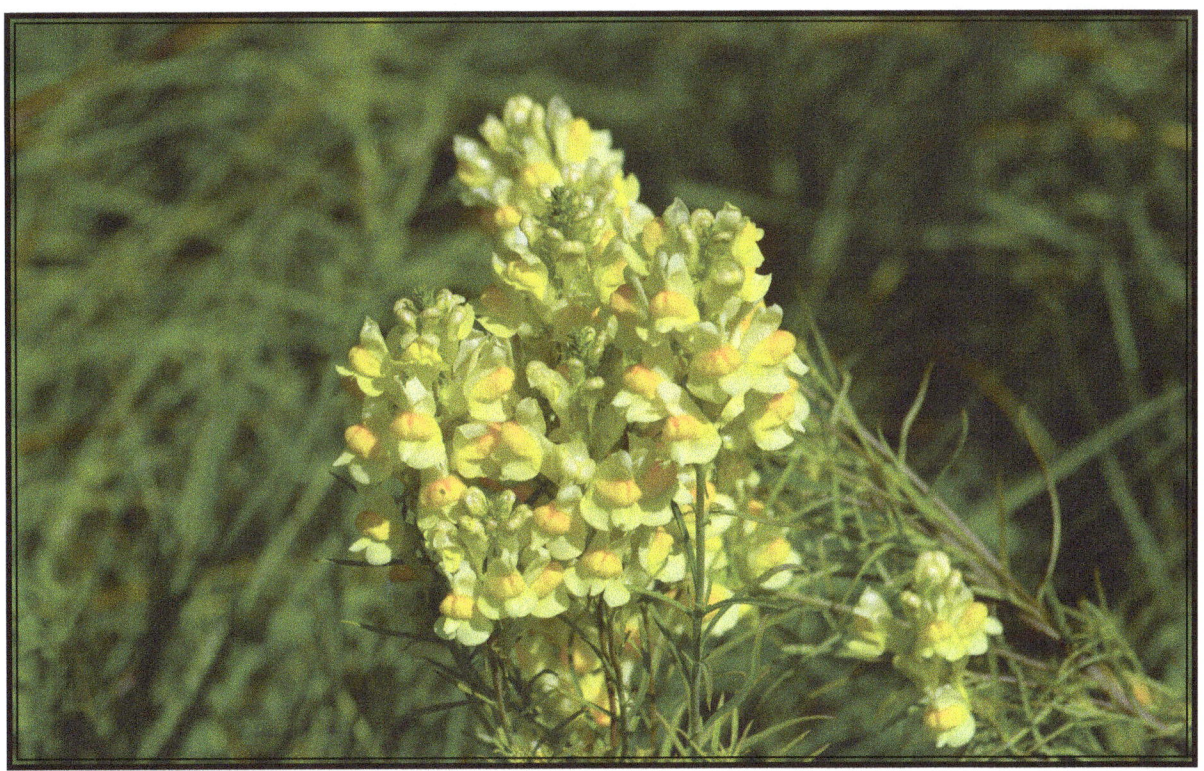

# The Marsh Marigold

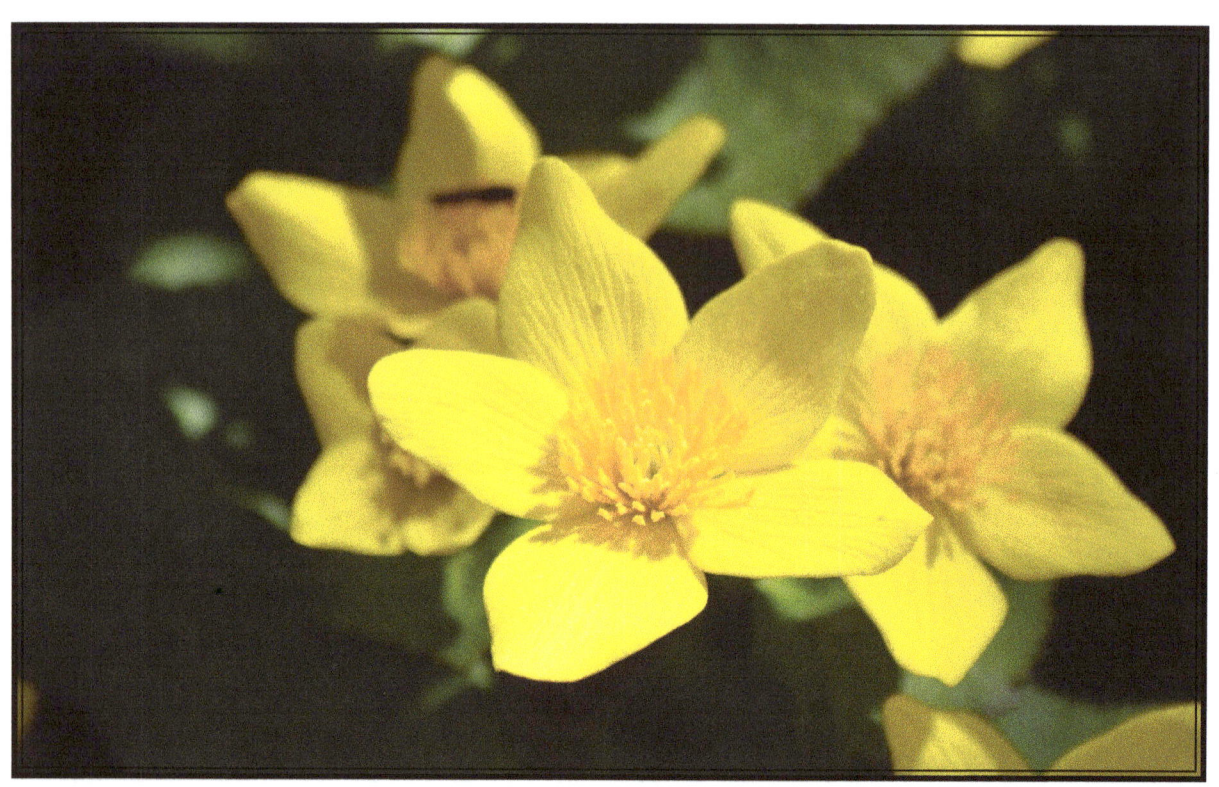

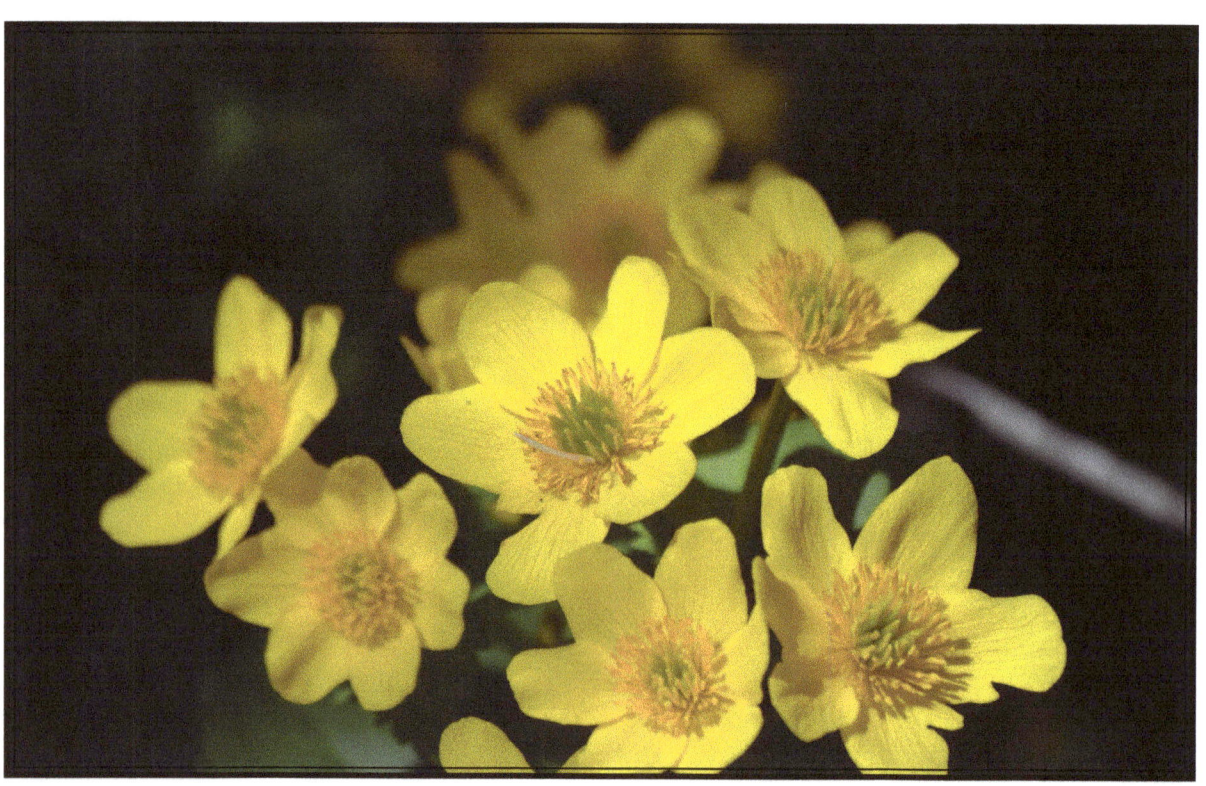

# The Yarrow

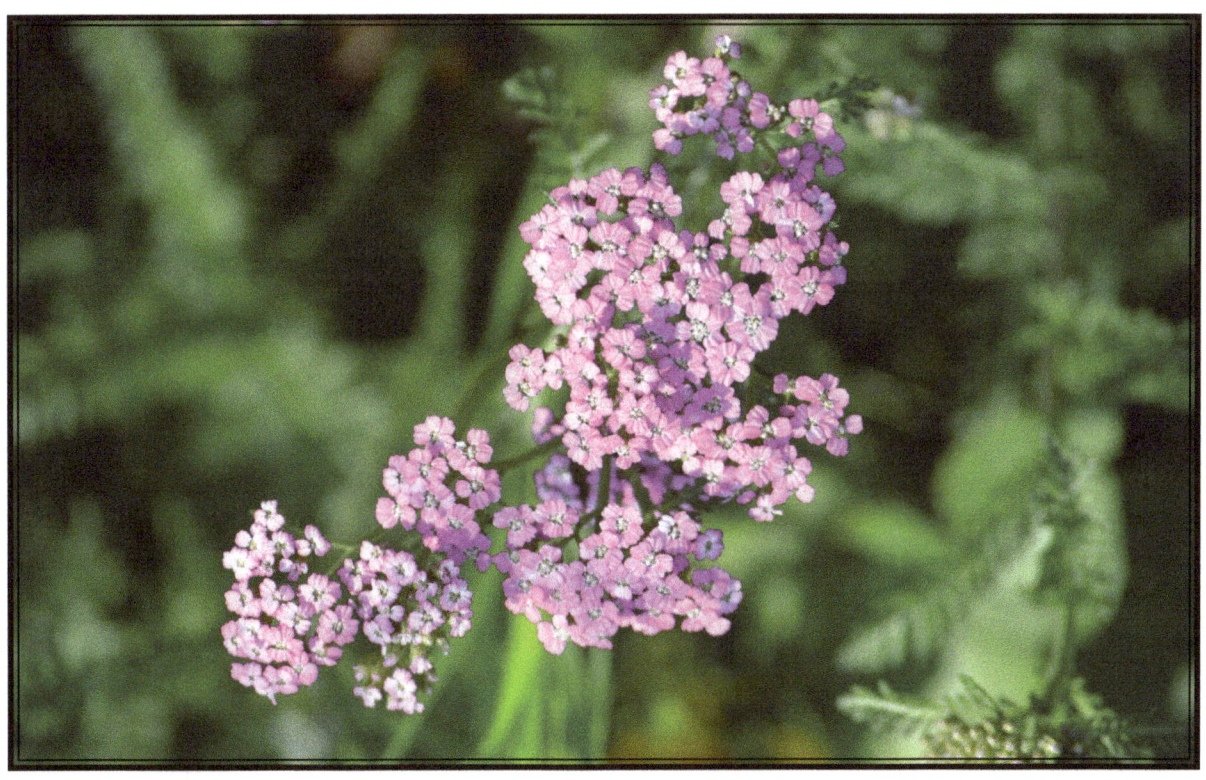

# The Common Red Paintbrush

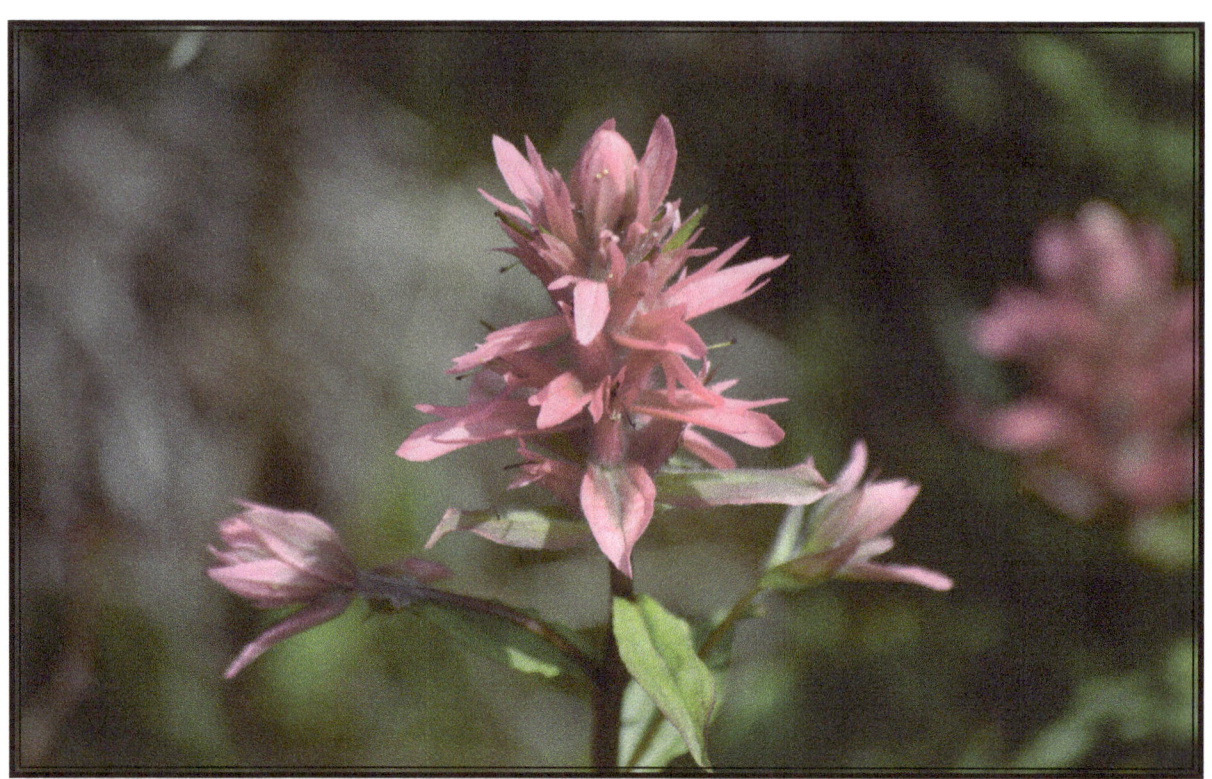

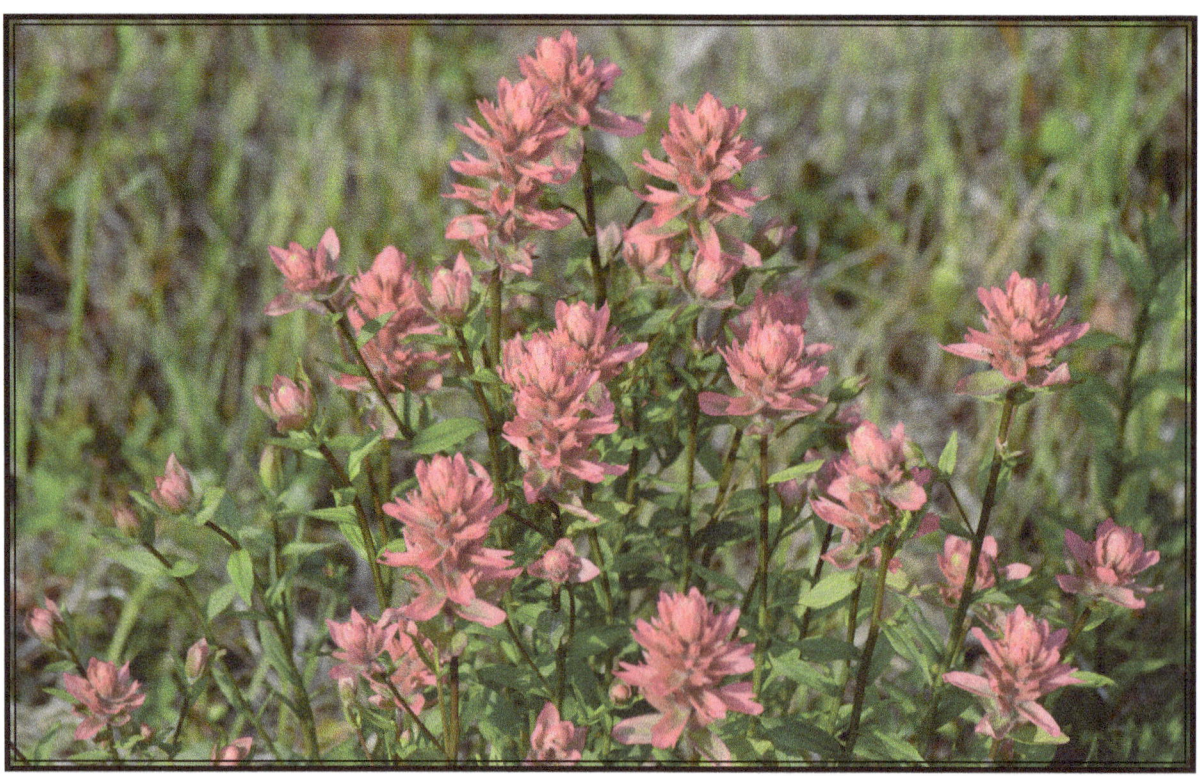

# The Yellow Pond Lily

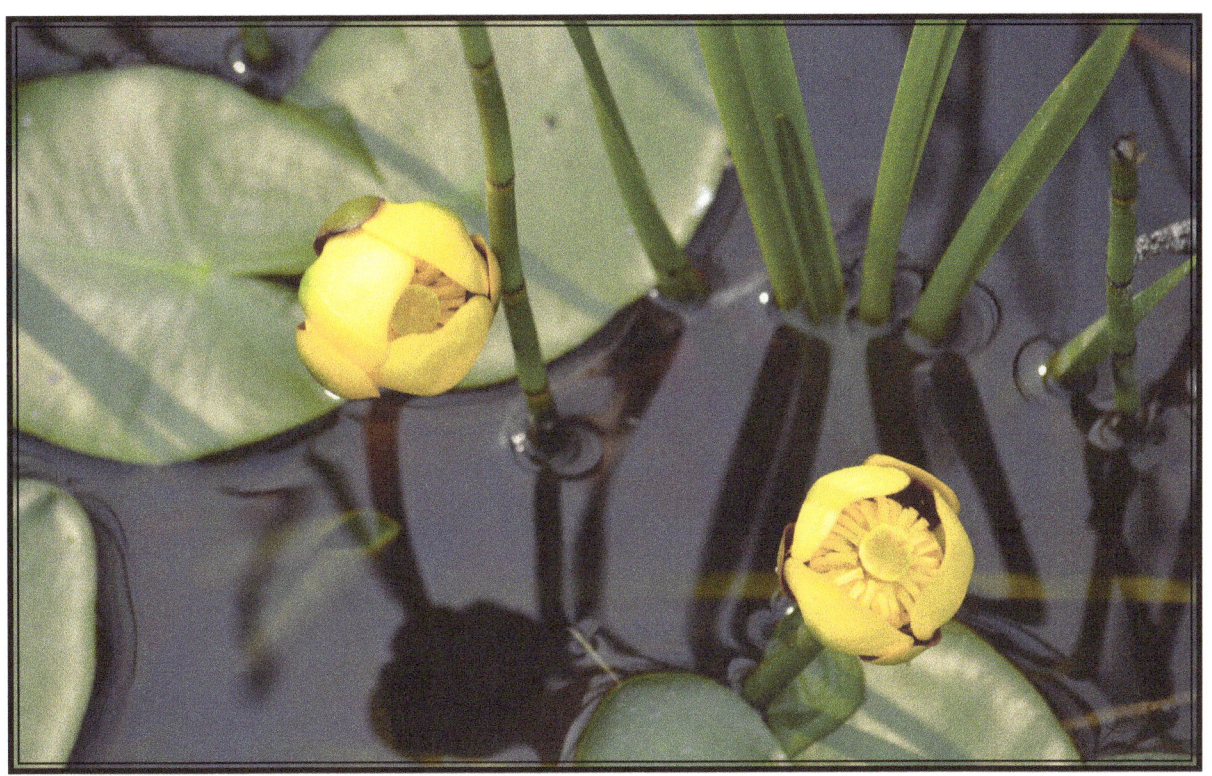

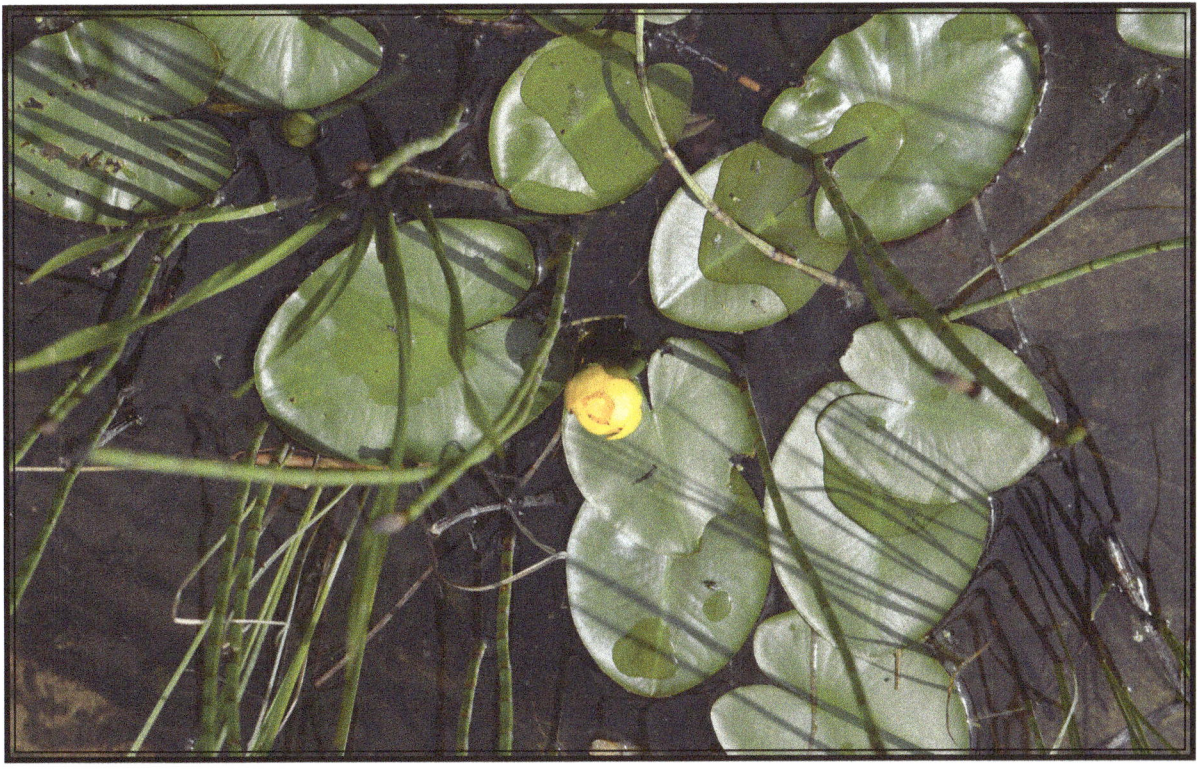

# The Canada Anemone

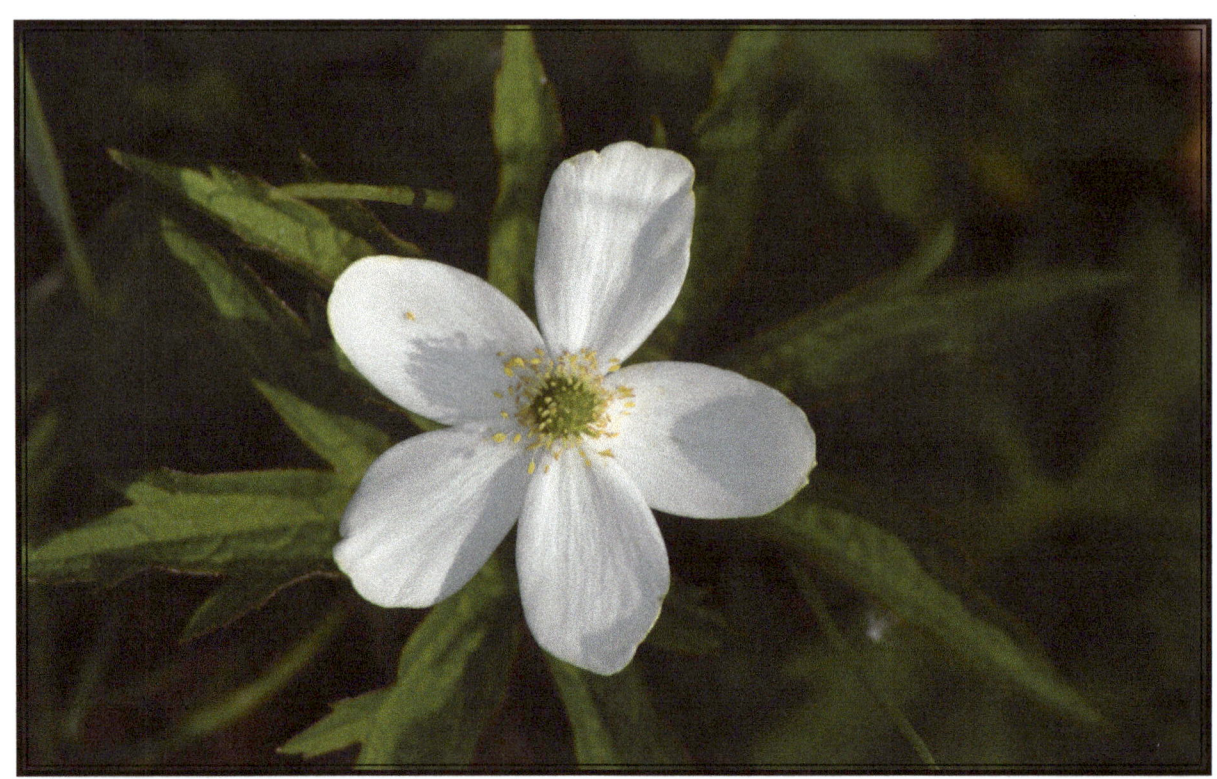

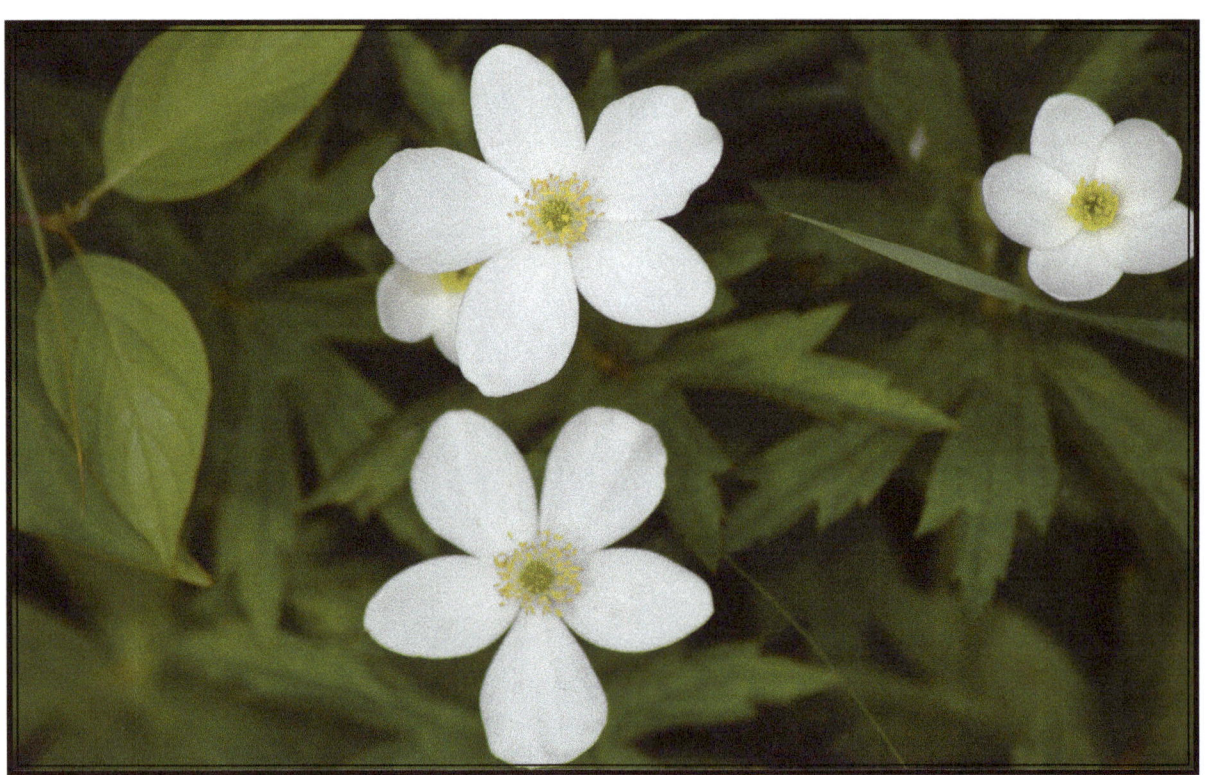

# The Western Polemonium

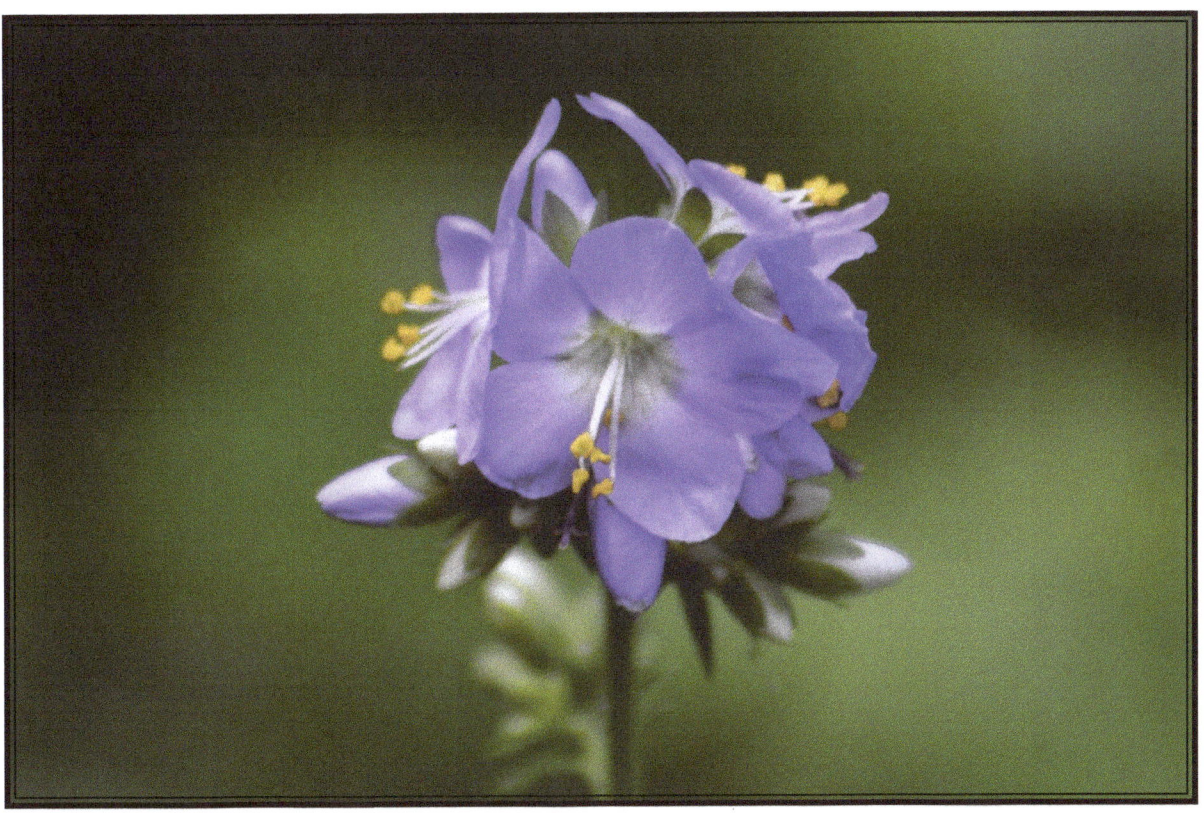

# The Northern Bedstraw

# The Fireweed

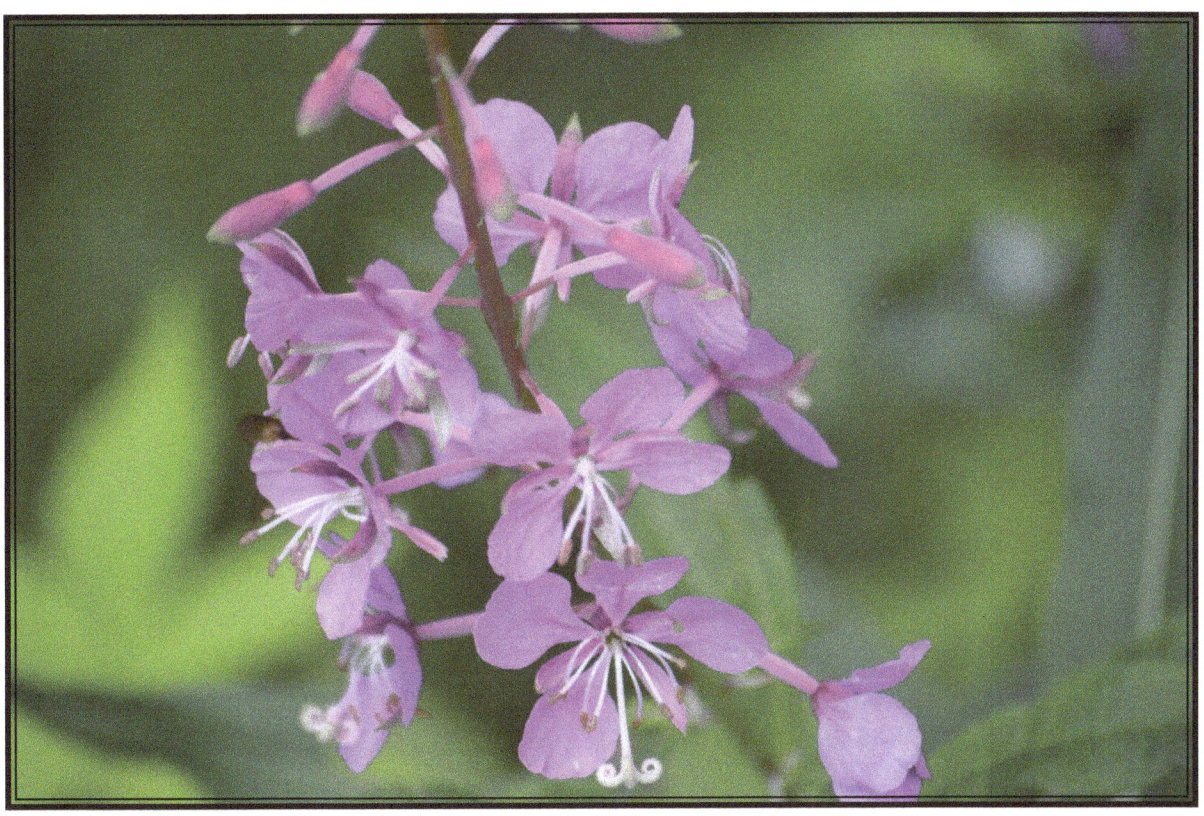

# The Philadelphia Fleabane

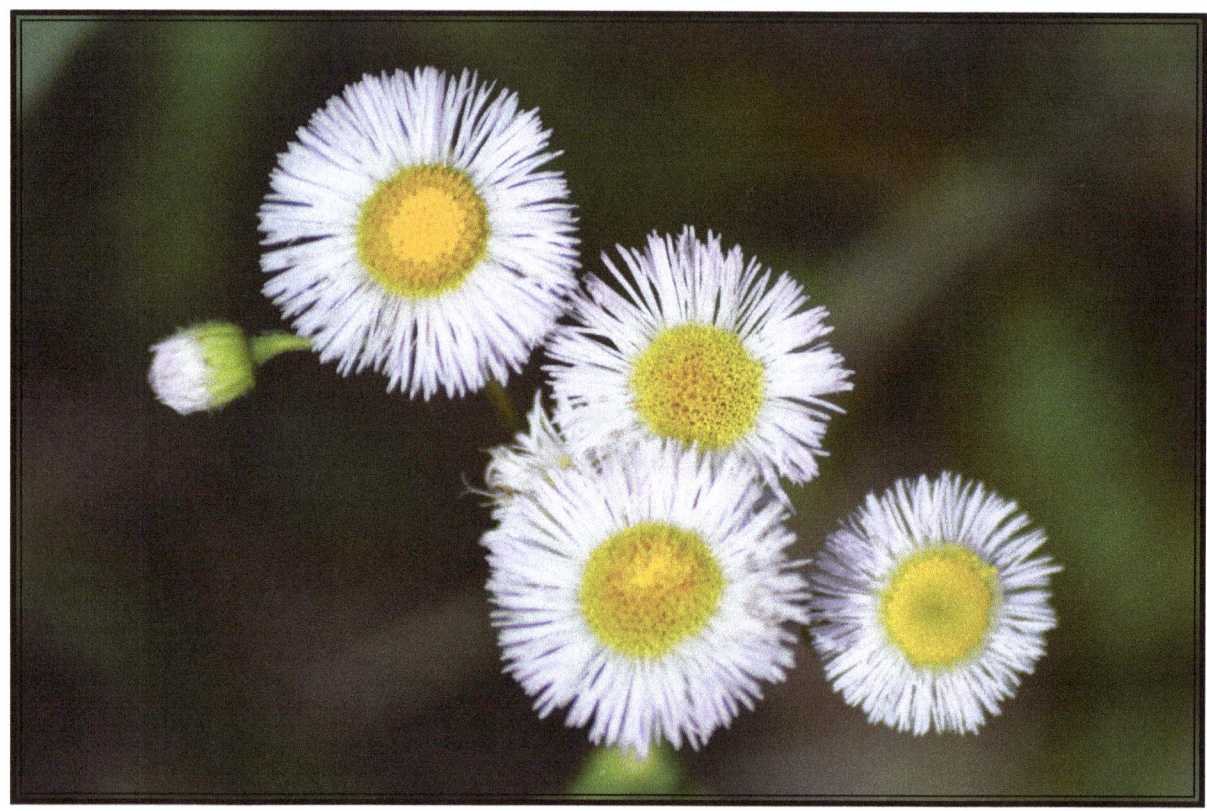

# The Wild Sarsaparilla

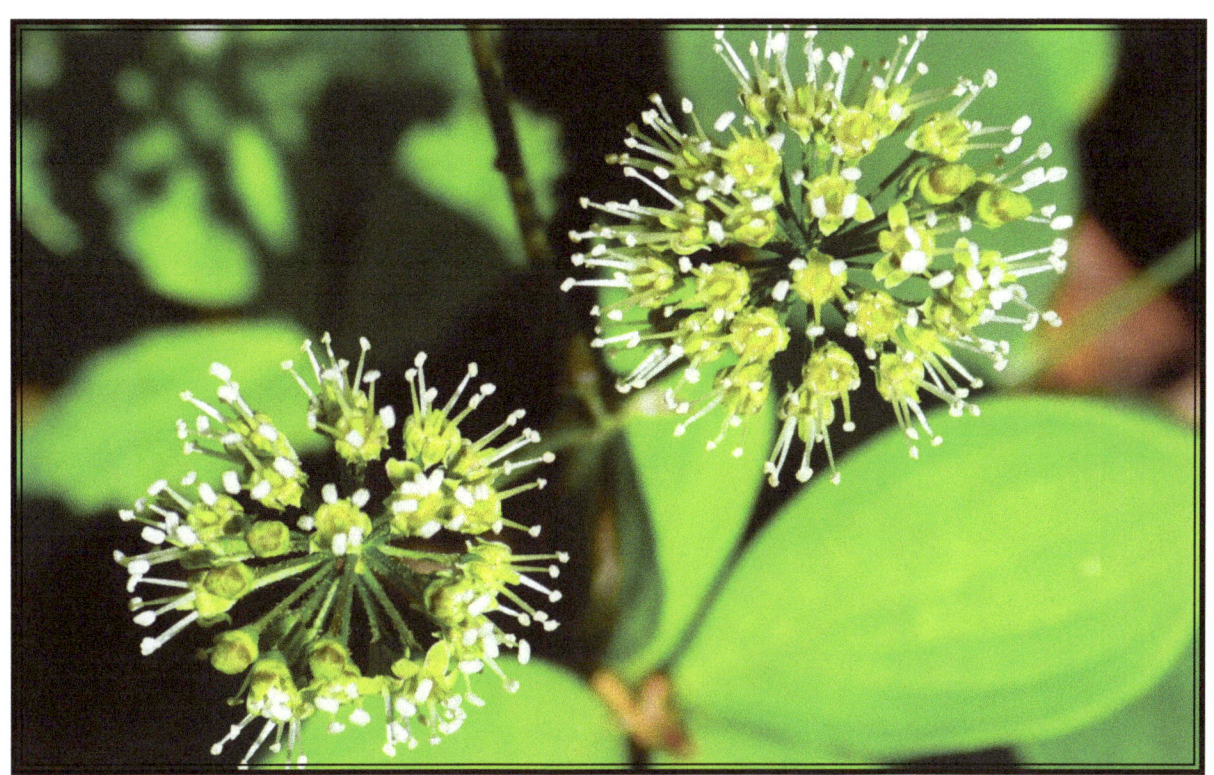

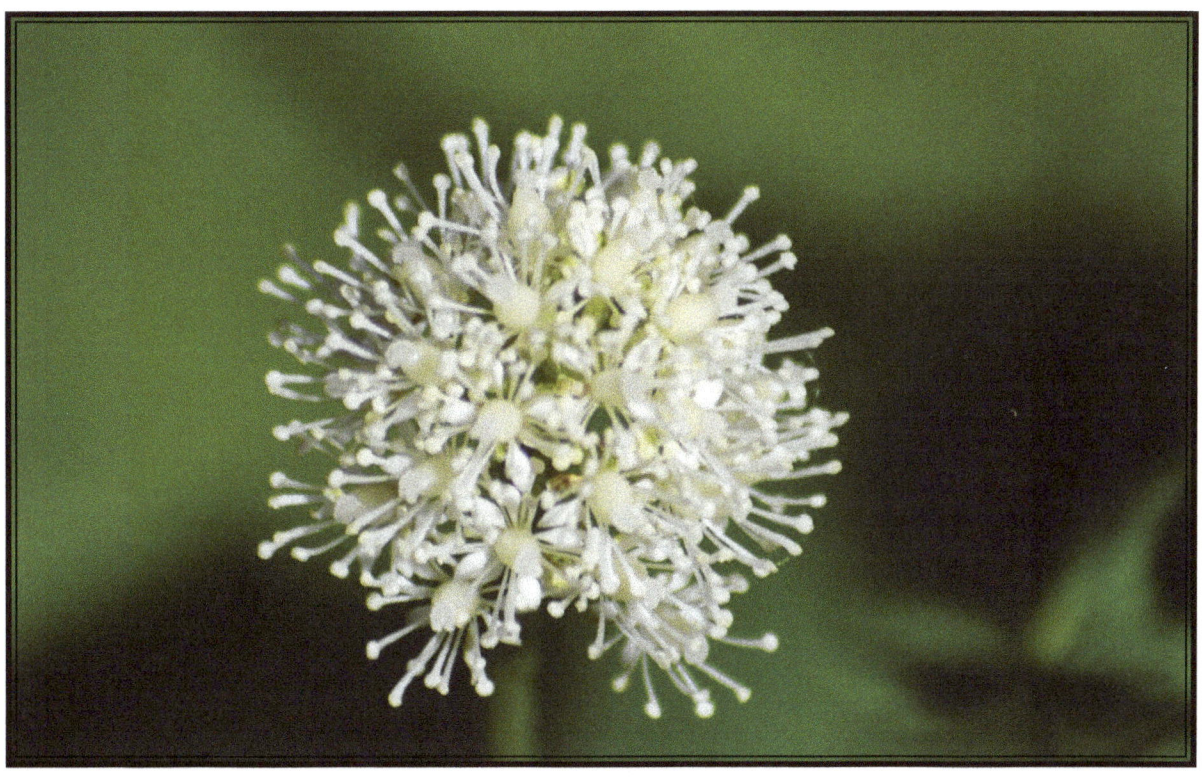

# The Bog Wintergreen

# The Bogbean or Buckbean

# The Harebell

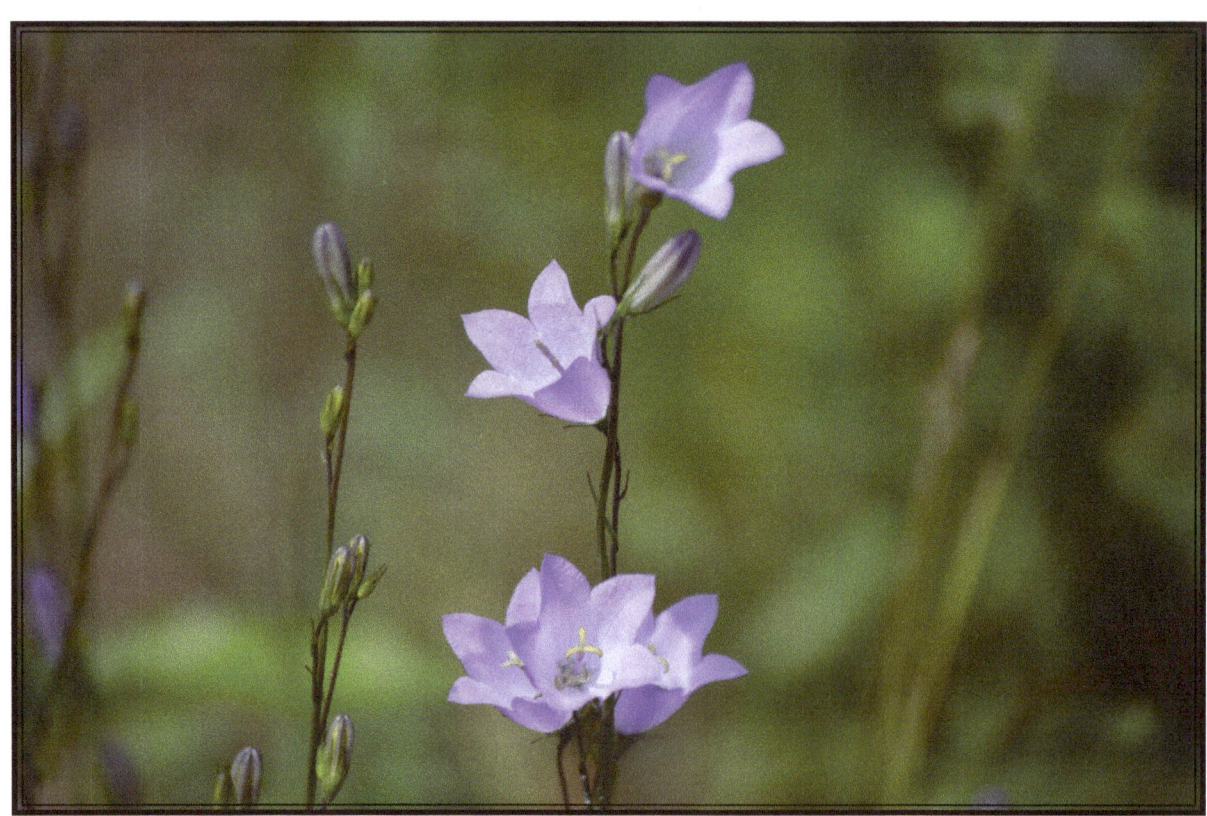

# The Canada Golden Rod

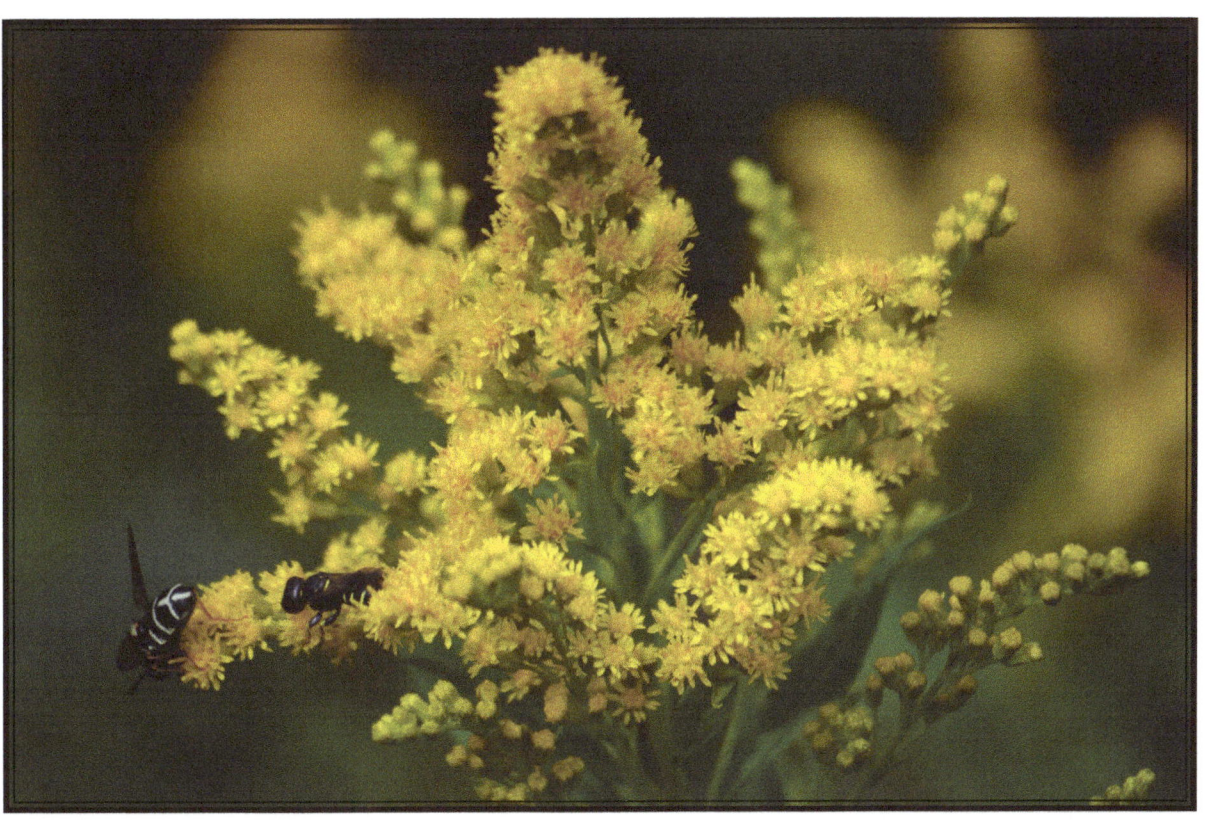

# The Oxeye Daisy

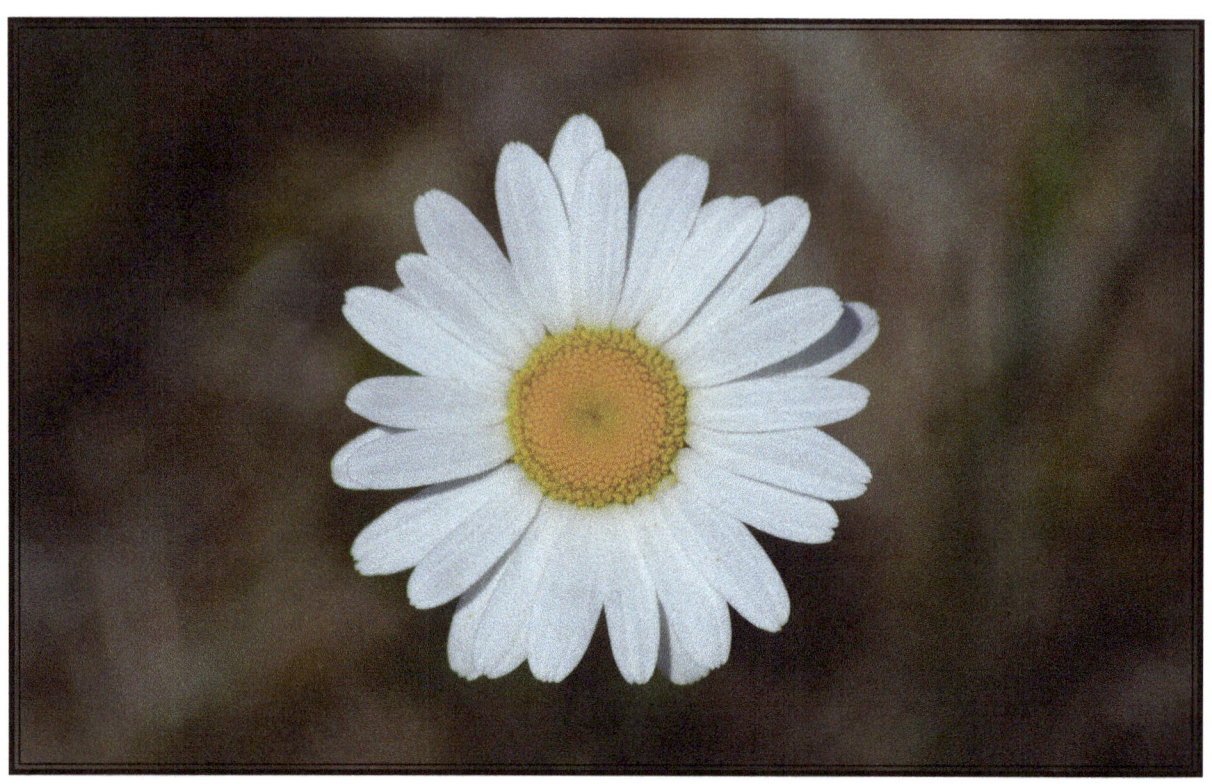

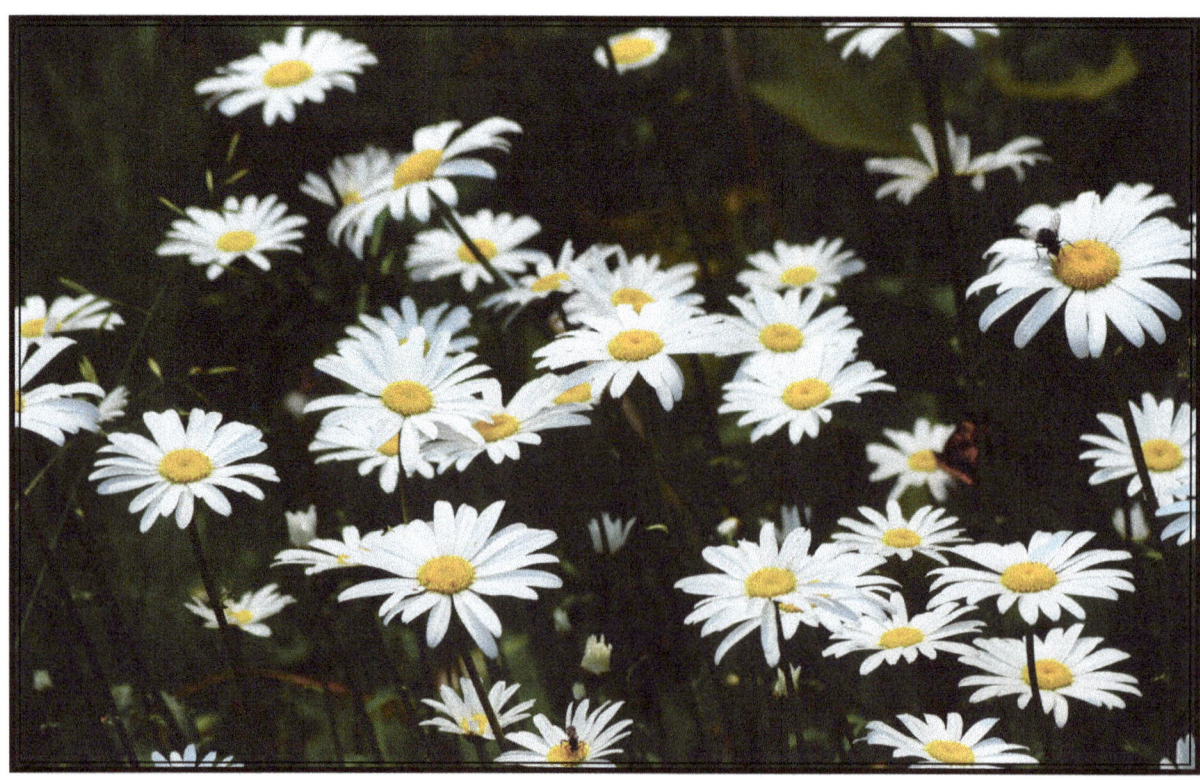

# The Golden Groundsel

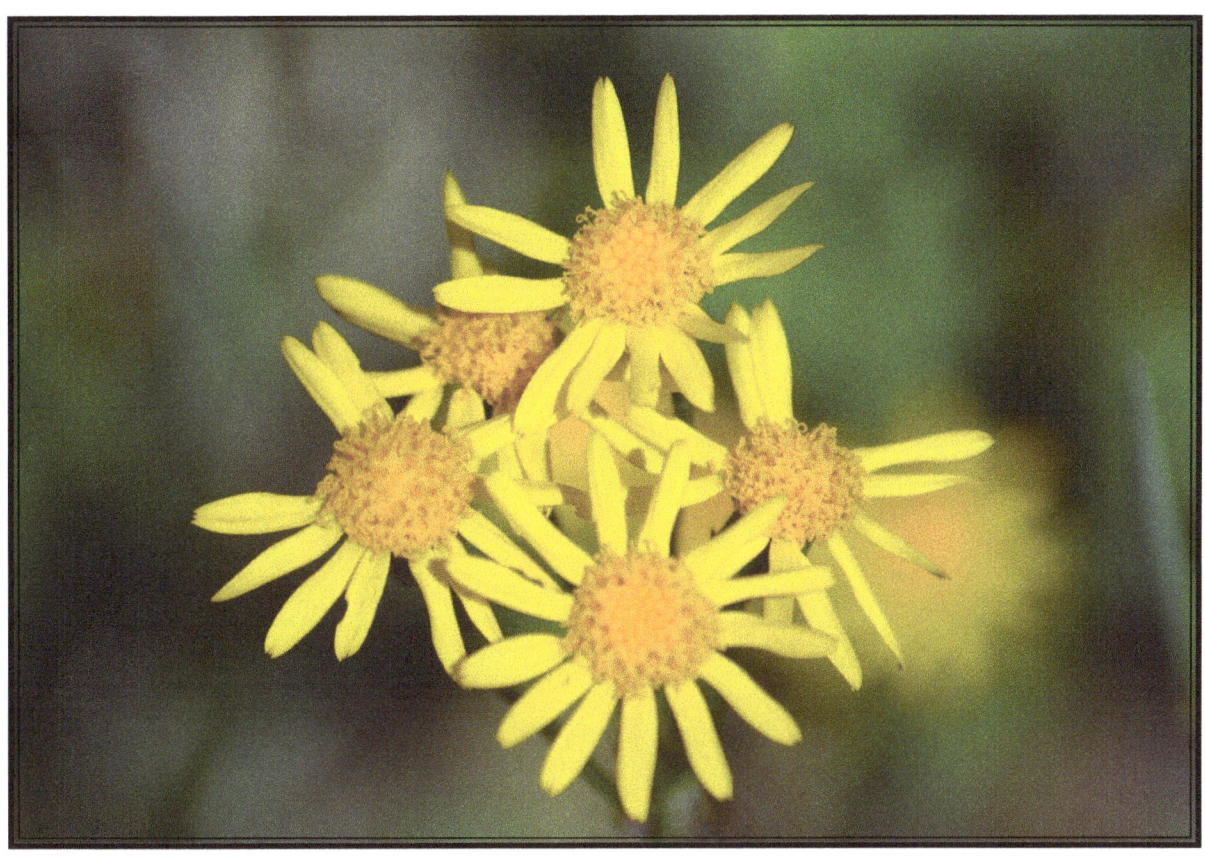

# The Yellow Avens

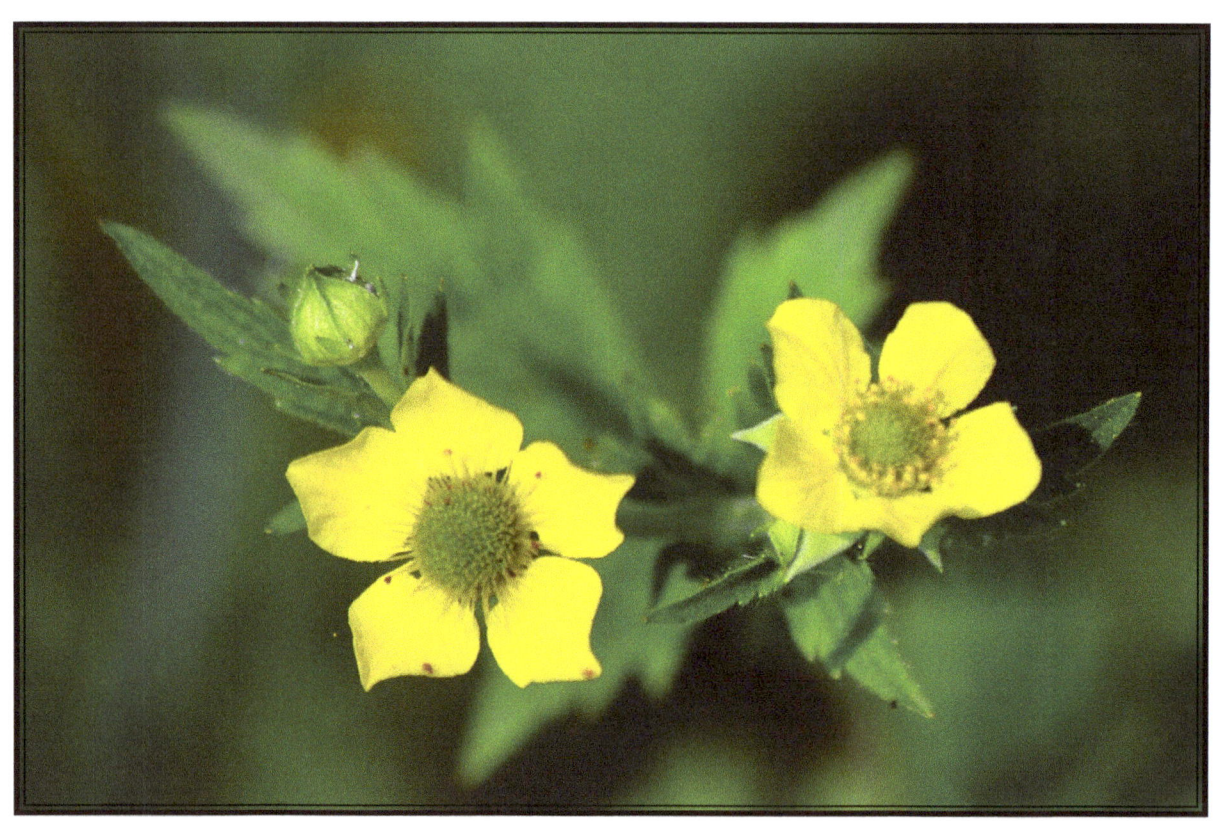

# The Horsetails

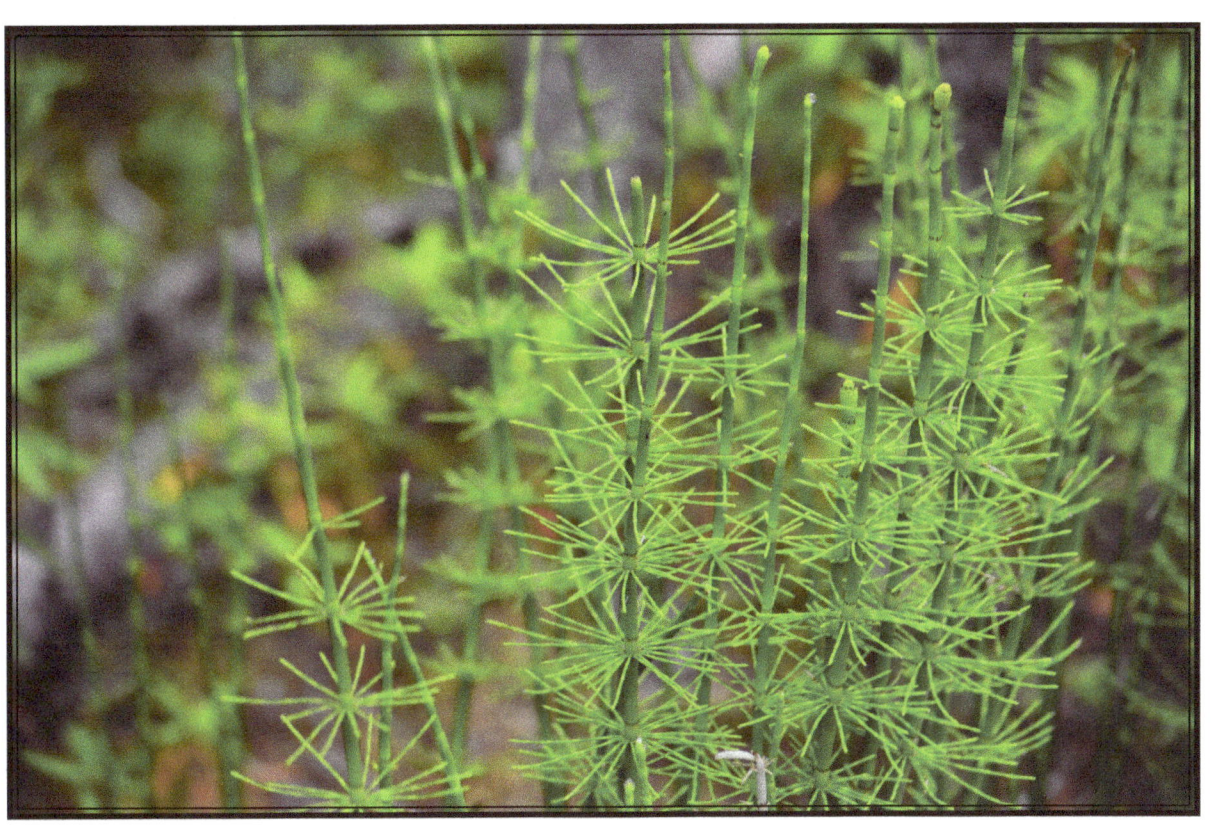

# Unknown

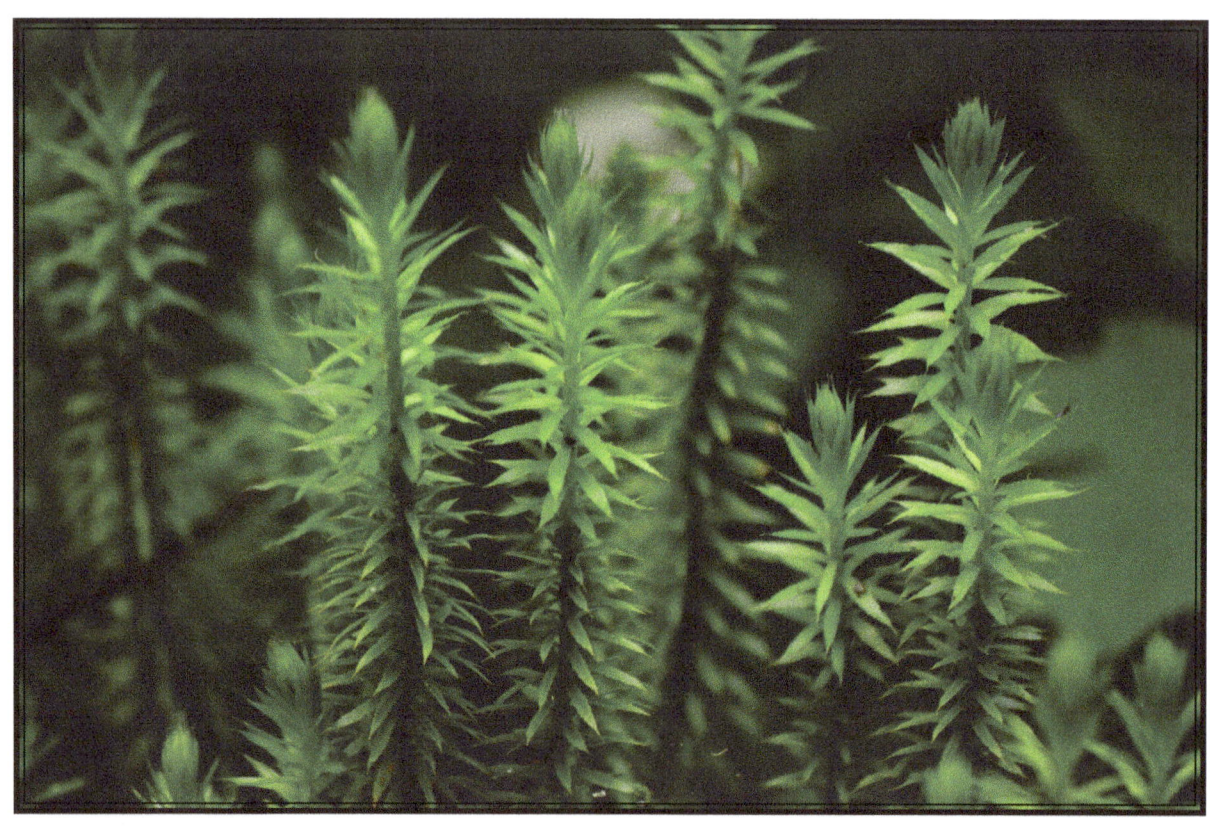

# The Saskatoon

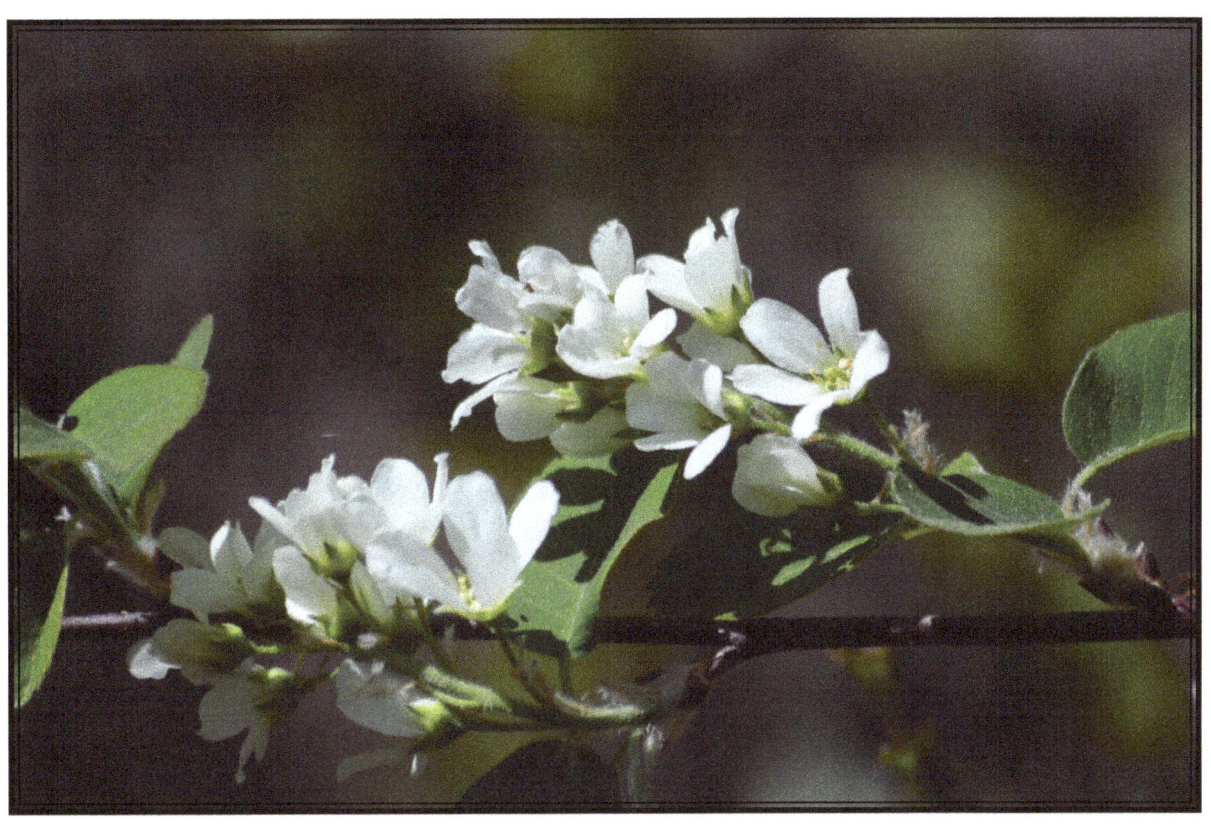

# Unknown

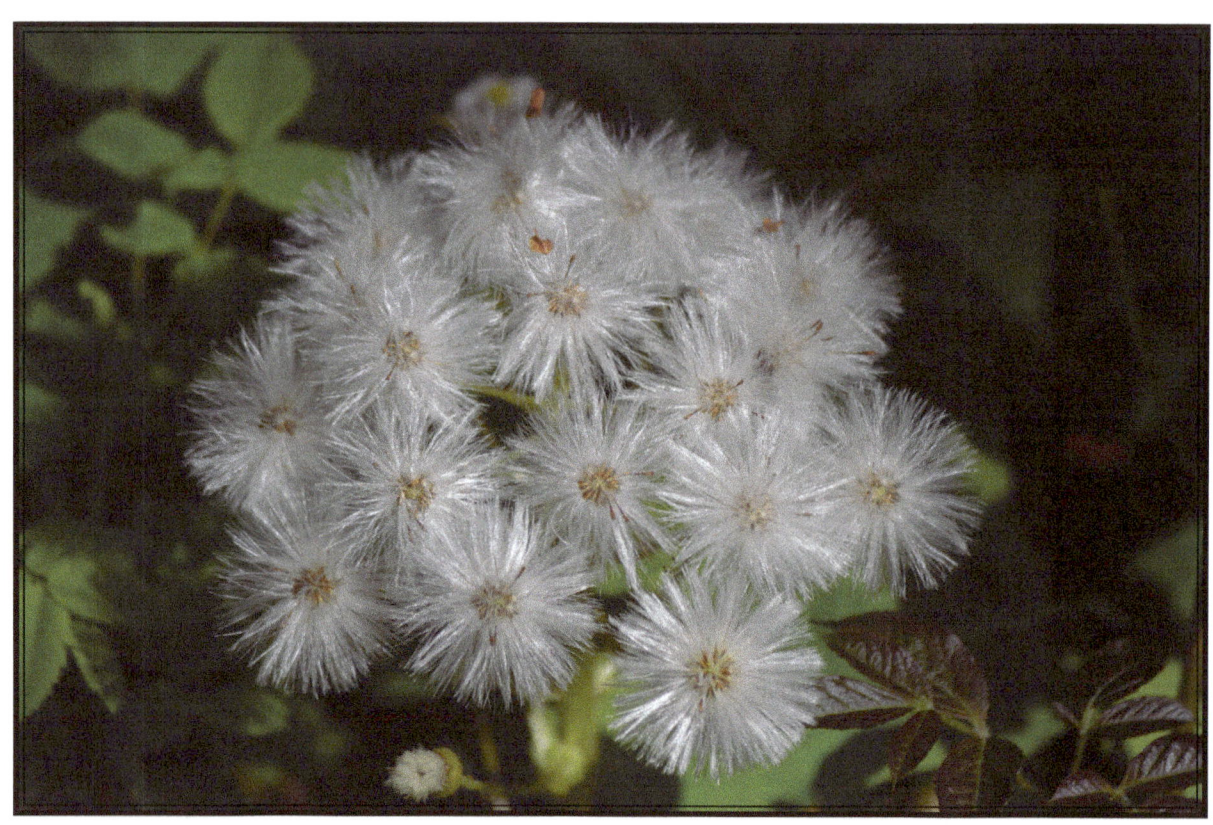

# The Hairy Hedge-Nettle

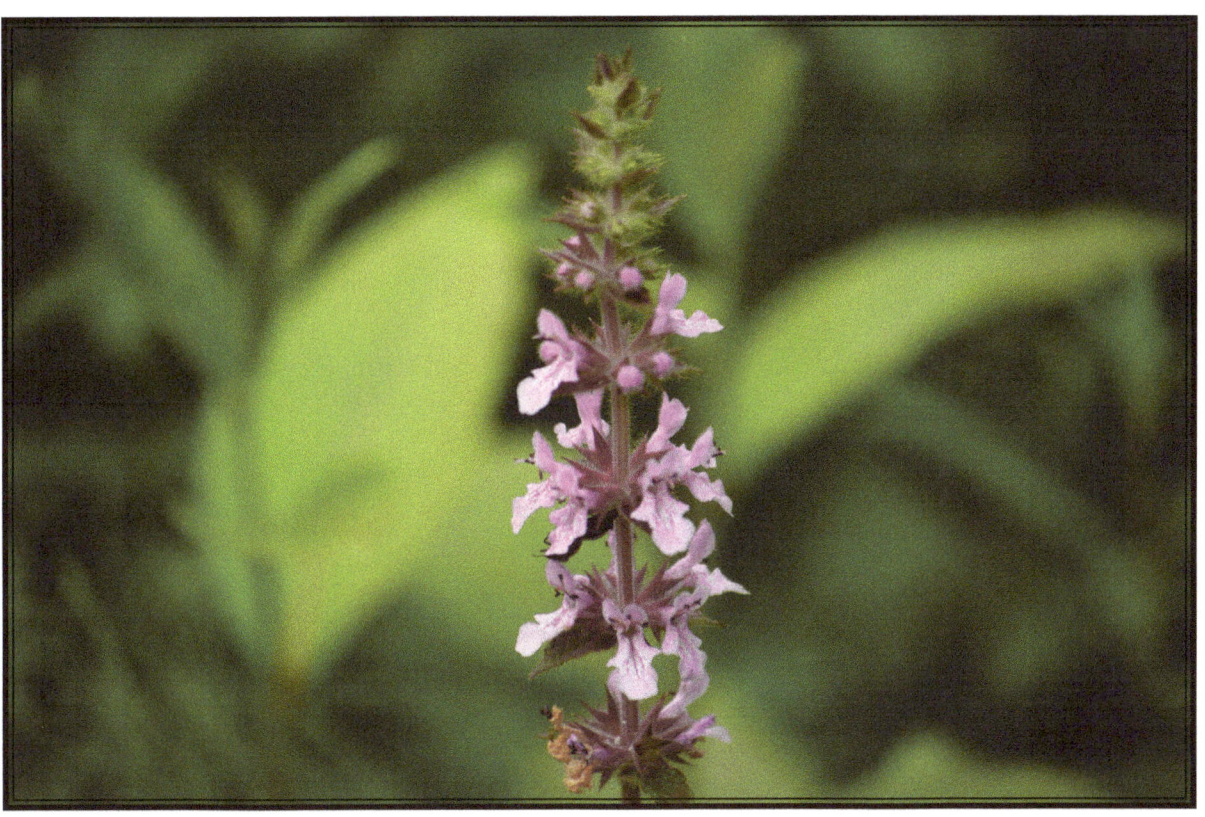

# The Rhombic-Leaved Sunflower

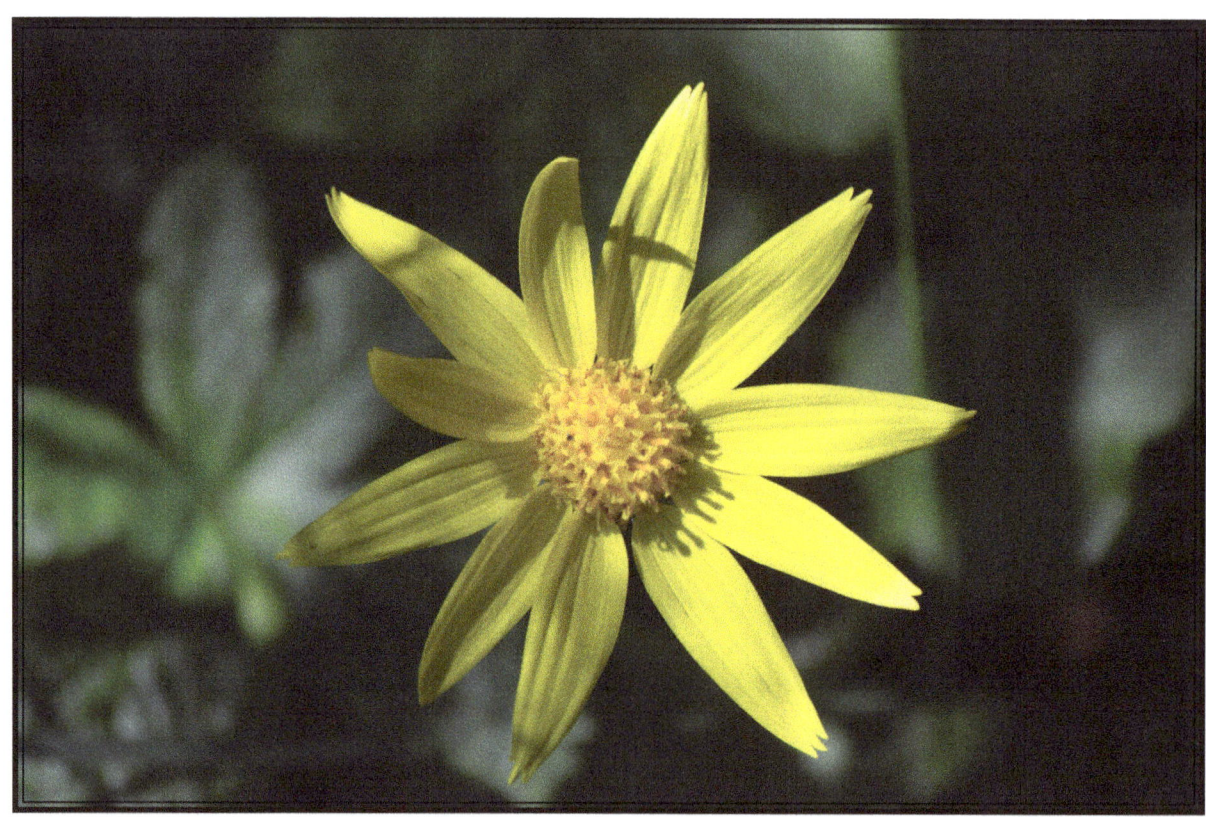

# The Wild Chives

# The Forgotten Animals

# The American Red Squirrel

Even though, in my opinion, my book about the amazing wildlife found in the park is done, my mother reminded me about another animal that I had left out, that I had forgotten to mention and that I should have put in it.

I guess when you speak about the park, it is only natural that the American red squirrel should also be mentioned, after all there are so many of them and I was able to get some amazing pictures of them as well.

Since my mother was the one that actually got me interested in taking pictures, it is only appropriate that I include the American red squirrel in my book.

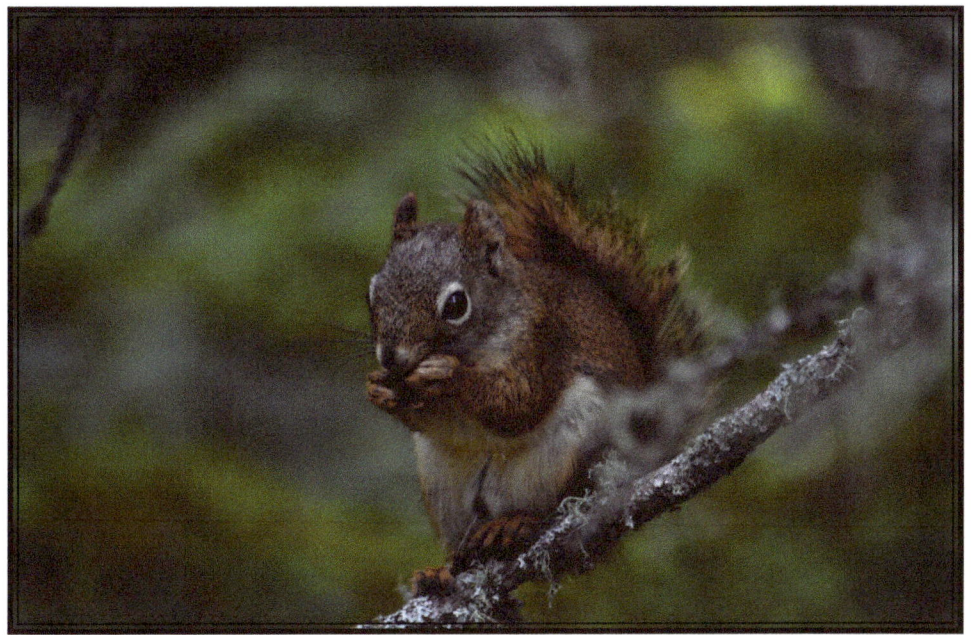

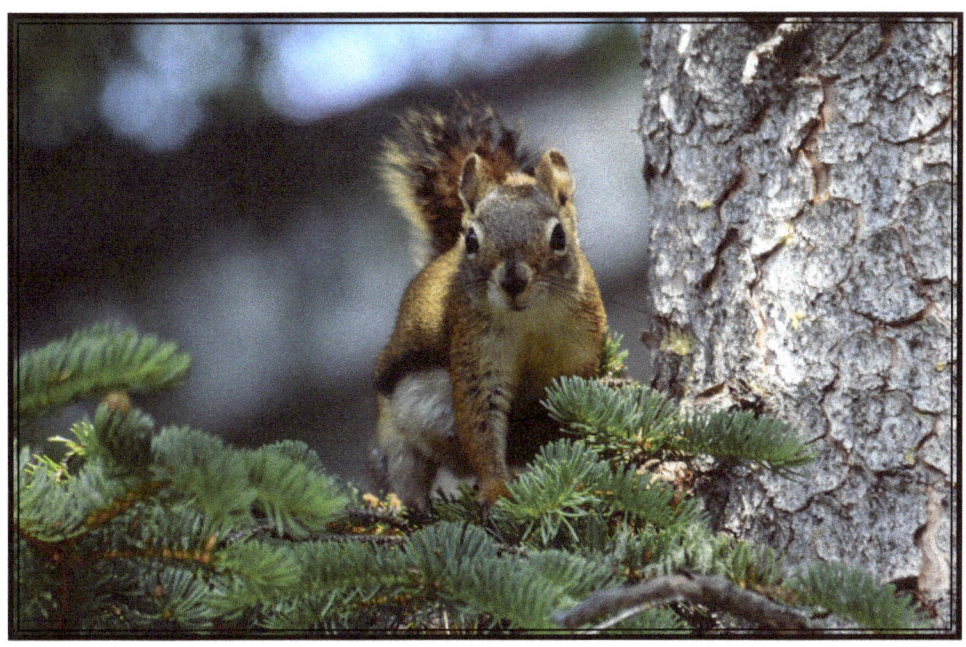

THE CONCLUSION OF THE MATTER

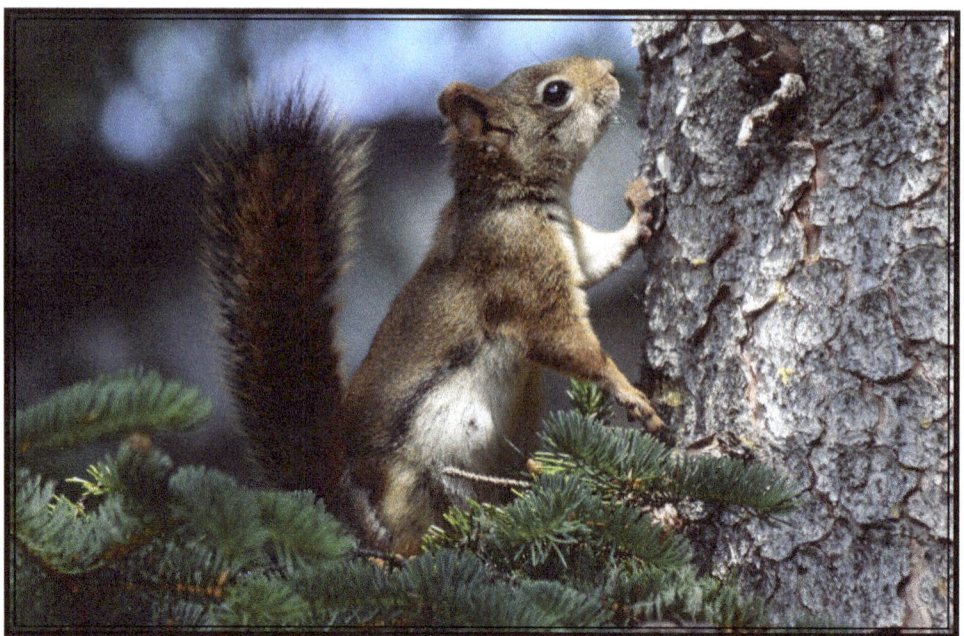

Who would have thought that in just a little more than a year ago, when I offered to take pictures for my mother because I was fortunate enough to see many unique animals and birds in the park that I would end up enjoying and taking up the amazing hobby of photography. But it has become much more than a hobby, it certainly has become a passion.

Yes, in my desire to help my mother get some unique photographs, photography quickly became something I wanted to do. I soon realized how fulfilling photography really was, especially when it comes to taking pictures of amazing wildlife.

The whole time that I spent in the park was for me an amazing experience as I watched them in their natural habitat and is something that I will never forget and I was truly privileged to experience this first hand. I just wished that I was smart enough to take up this exciting and thrilling hobby years ago, but as the saying goes, better late than never.

As it turned out, this was the most enjoyable and exciting vacation that I have ever had. It is kind of funny that after experiencing how much fun I had in taking pictures, I decided to take up this hobby because I figured that it would be cheaper for me than my other passion, which was golf. It didn't turn out to be exactly so, but gladly, it was a decision that I will never regret.

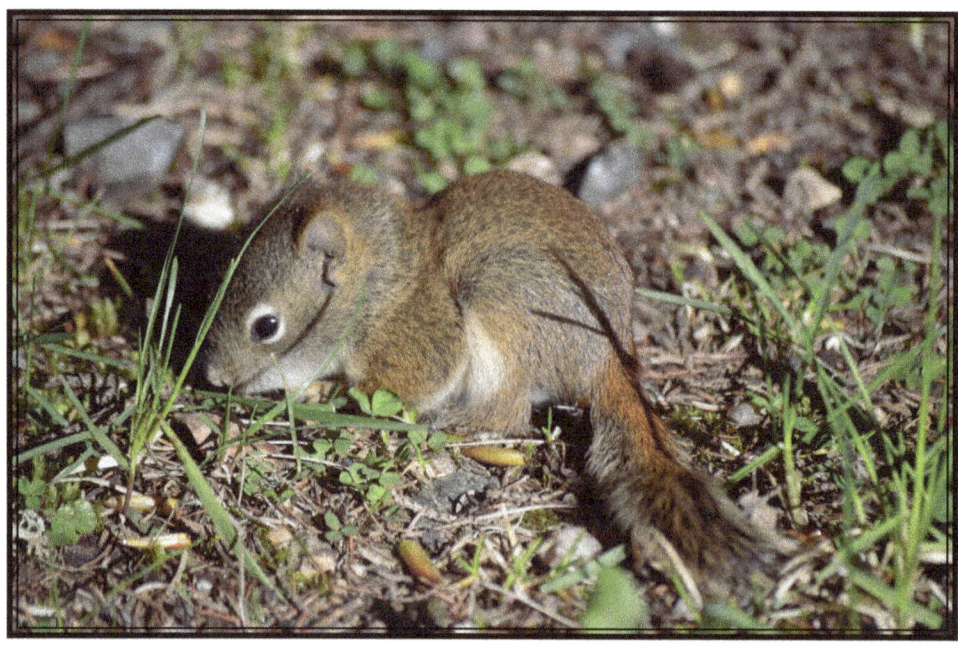

One thing that I was happy to see is the passion that others have seen in me, especially when I was given the opportunity to not only show my pictures, but to also tell my amazing experiences that I was so privileged to enjoy. I was truly honored when a few of the ladies who worked at the park mentioned to me how they could see my passion.

I certainly have a few people who I was privileged and grateful to come to know at the park and who even encouraged me to write down my experiences on paper. As it turned out for me, I am truly glad that I did because as it turned out, I was able to experience some truly amazing events as I watched so many amazing creatures and now I will have a permanent copy of these amazing and unique experiences.

# The Fall at Waskesiu

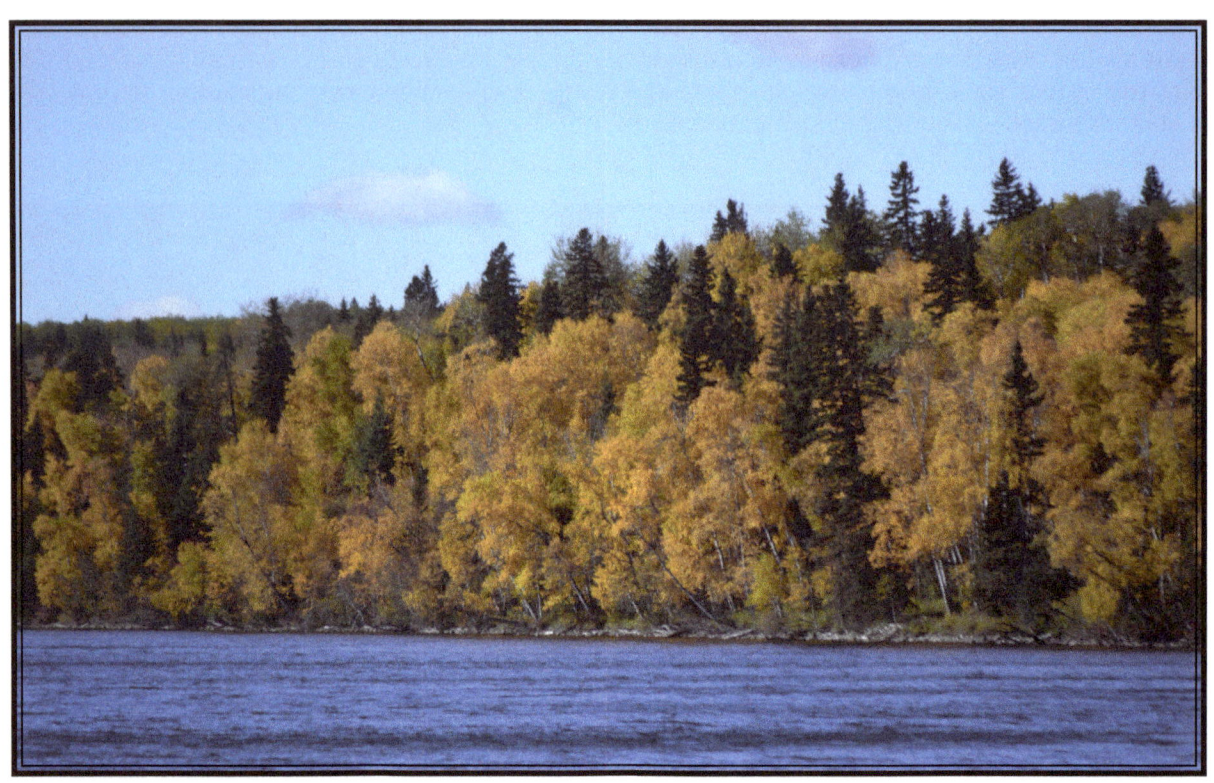

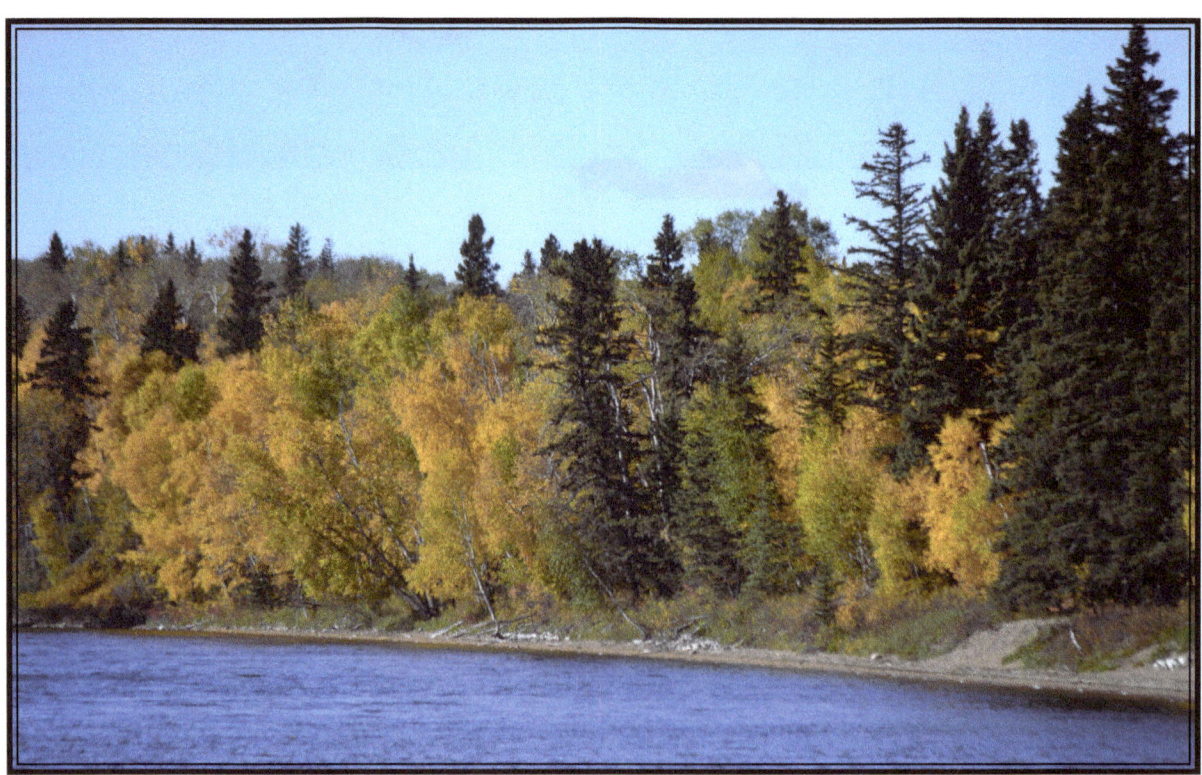

Here I thought my book had ended, but to my surprise, I soon realized that the story never really ends, the adventure always continues year after year. I found out how true this was when I went back to Waskesiu the following year.

One of the Parks personnel even asked me if I had experienced any magical moments this time and I had to admit that I had. Even though this summer was not as spectacular as the previous year, but I was still able to experience a few magical moments and also get some pictures of things that I had missed getting the previous year as well. I was also able to see some new and exciting things that I had never seen before.

Yes, last year was indeed a summer that will perhaps never be repeated again. Imagine getting pictures of wolf pups as they were playing just outside their den, as well as otters playing just right in front of me as I was standing on the bridge and the best of the best, to see a mother bear with not just one cub, but two, one was cinnamon in color, yes, it was a summer to remember. But the following year was still amazing, just the same. I still was able to see something new, which I will talk about at a later time, but I was also able to see and get some amazing pictures of the same wildlife, but in a unique setting, which also made the adventure still worthwhile.

Let me start with a very familiar bird to the park, the great blue heron and the pictures that I missed getting last year.

Last year, when I saw a great blue heron catch a fish, I tried to get a picture of him swallowing it, but the heron swallowed the fish so fast that I missed out on the opportunity. Well, this year I was able to get a picture of this event. I even have a picture of just the tail left as it is being swallowed. It is unbelievable that they can swallow a fish that big, just amazing.

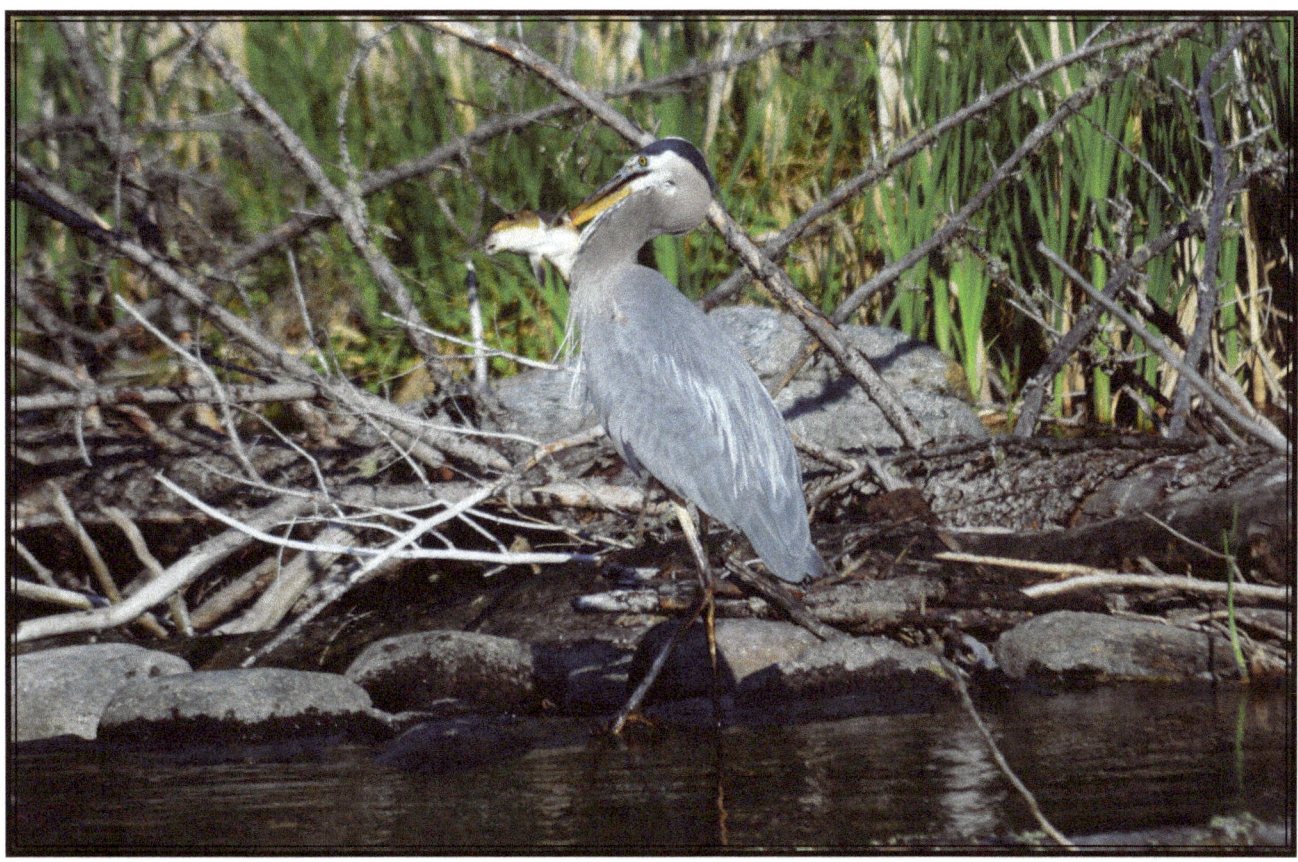

I also will sheepishly have to admit that I also cost a great blue heron his lunch as well. In my zeal to get an amazing picture of him catching a fish, I got too close. As I was walking down the rocks on the side of the bank, all of a sudden I heard a splash and when I looked up, the great blue heron was flying away, obviously, as he flew away, he had dropped the fish into the river.

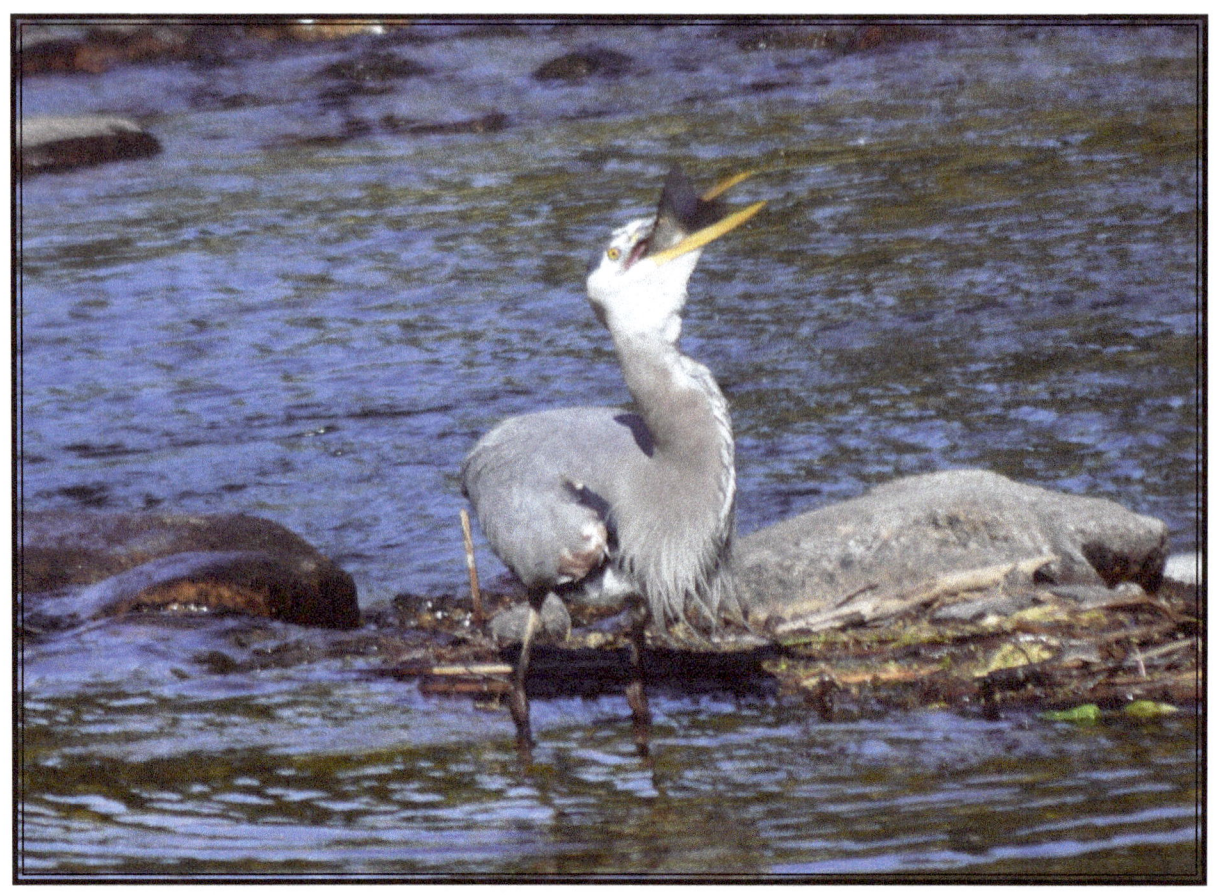

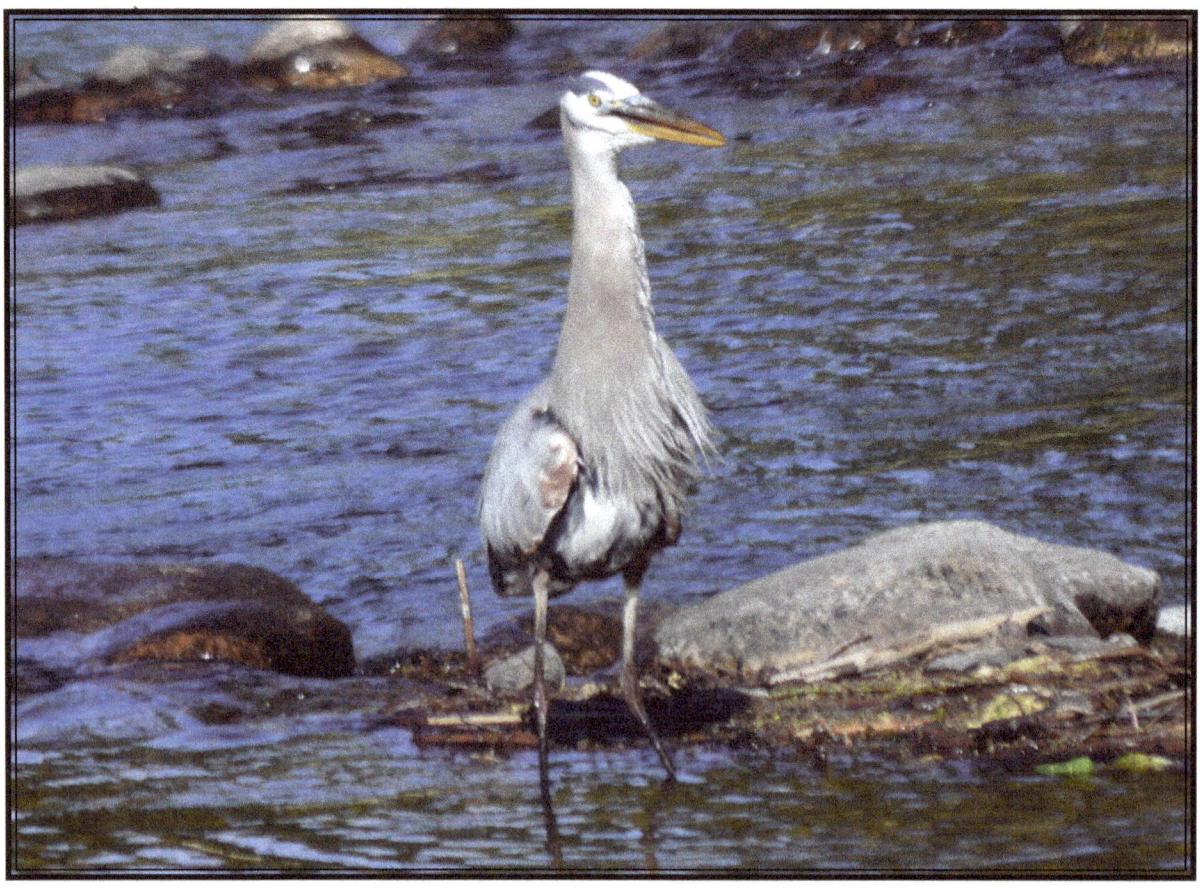

138 | *The Forgotten Animals*

# The Pileated Woodpecker

When I think of all the time and all the miles that I walked in my effort to get a picture of a pileated woodpecker, I was quite disappointed that I was not able to get an amazing picture. But, this year, I personally saw that the adventure never ends as the unique experience with the pileated woodpecker proved. It also proves that one can experience something new each year.

This year when I went to the Prince Albert National Park, the very first day that I arrived in the park, actually not that far from where I parked my trailer, I was able to get some amazing photographs of this elusive bird, the pileated woodpecker.

I was actually very excited to be able to see the pileated woodpecker not just once, but three times. The first time I was able to get a picture of a female and the last two times I was able to get a photograph of the male.

The second time that I saw the pileated woodpecker, I was coming back from the narrows. As I was driving back to the campsite, I saw a pileated woodpecker fly along the ground and then it flew up into a tree.

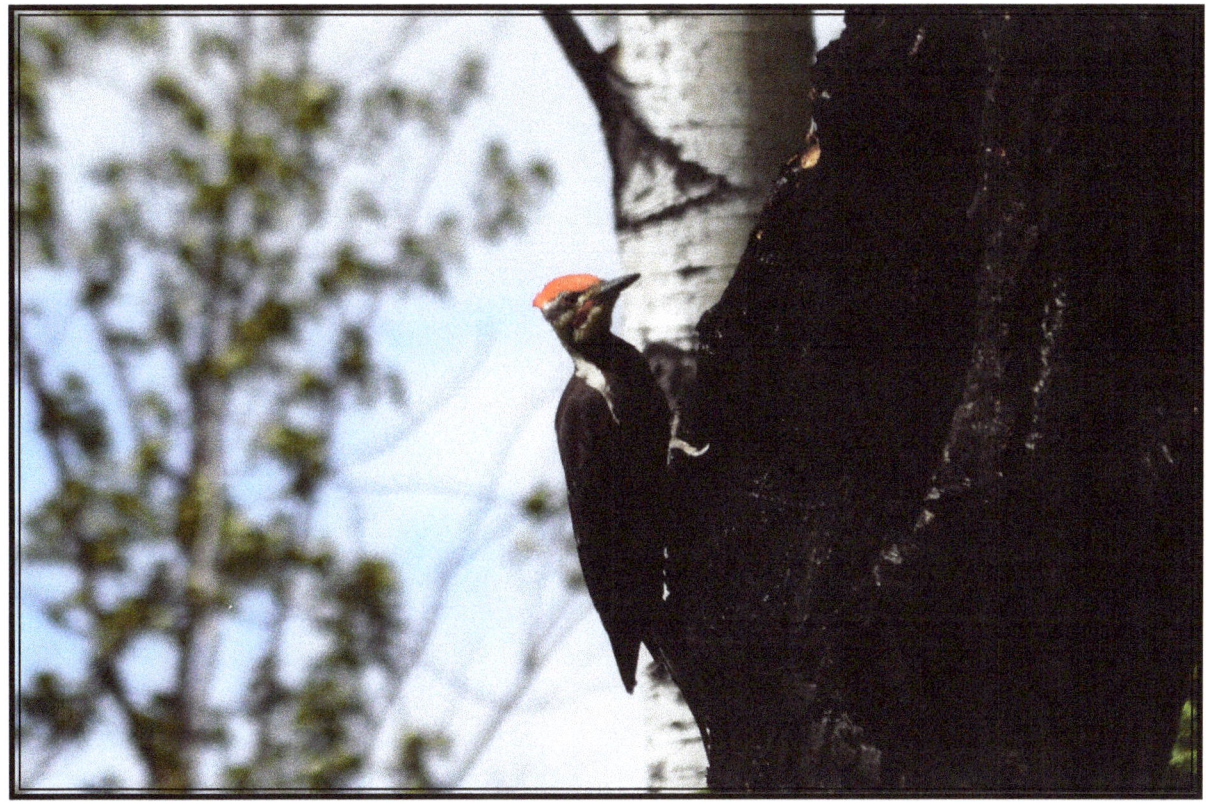

I immediately stopped my truck and jumped out. Off to the races again.

I walked a fair distance into the bush in order to get a picture of this huge woodpecker and as you can see, it is quite a large bird for a woodpecker, to my surprise, especially, when you compare it to the woodpeckers we see at home.

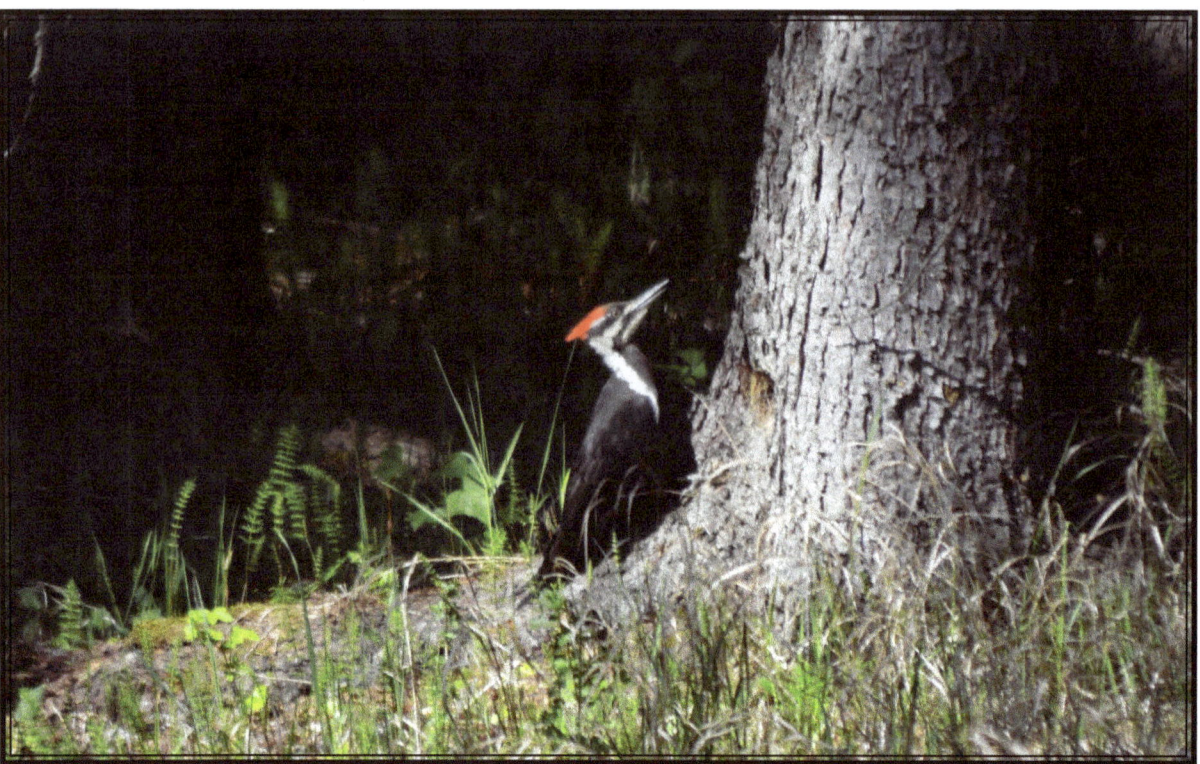

    I was able to get quite close and was able to get some amazing photographs before it went to the other side of the tree, then it eventually flew away. Yes, another example that one can see something new every year, yes, the adventure never ends.

    The last time I saw a pileated woodpecker, it landed on a tree right next to my campsite, but sadly it was too late in the evening to get an amazing photograph.

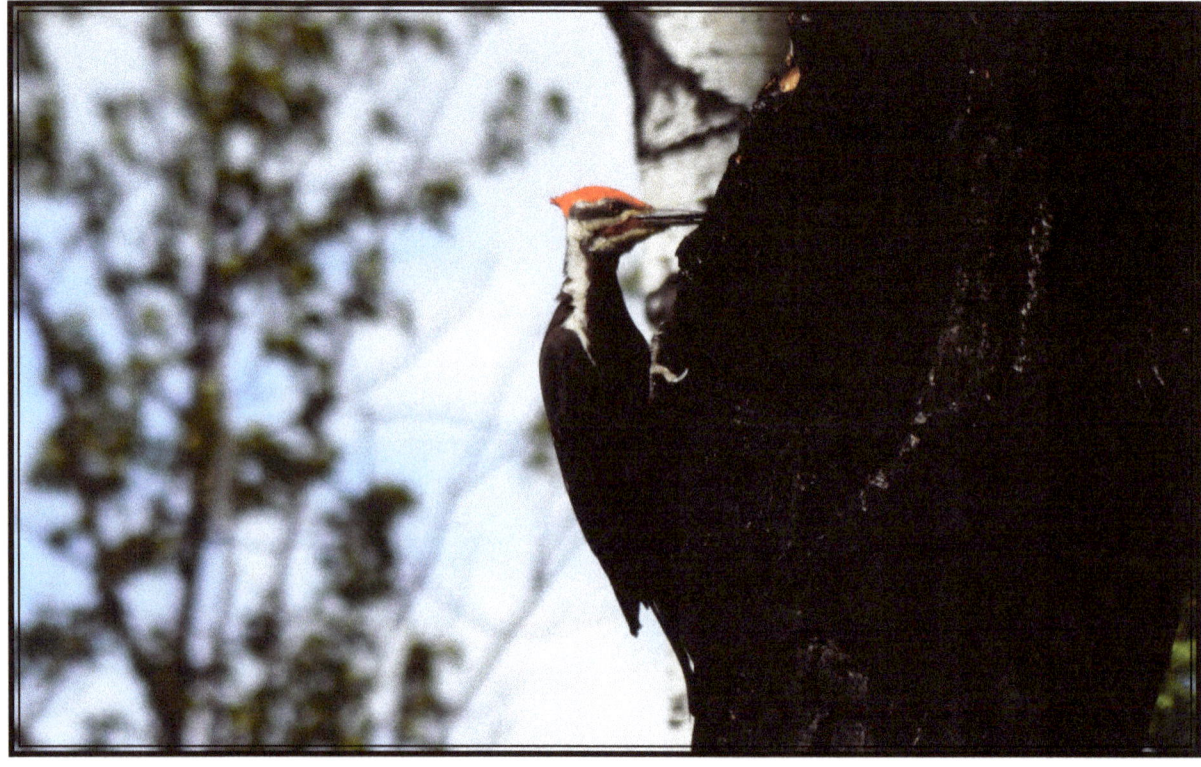

# The Pine Martin

When I first saw the pine martin, I had no idea what it was. At first I thought it was my friend, the mink, but as soon as I zoomed my picture, I realized that it wasn't. Maybe, the claws gave it away.

Well, anyways it was certainly a surprise to be standing on the bridge and to look up and see this animal coming right at me. But, always being ready to take a photograph of something unique, I was able to get some amazing photographs of a pine martin.

All I had to do was jump in front of him so that he would stop in front of me, thus I would be able to get a picture that was amazing.

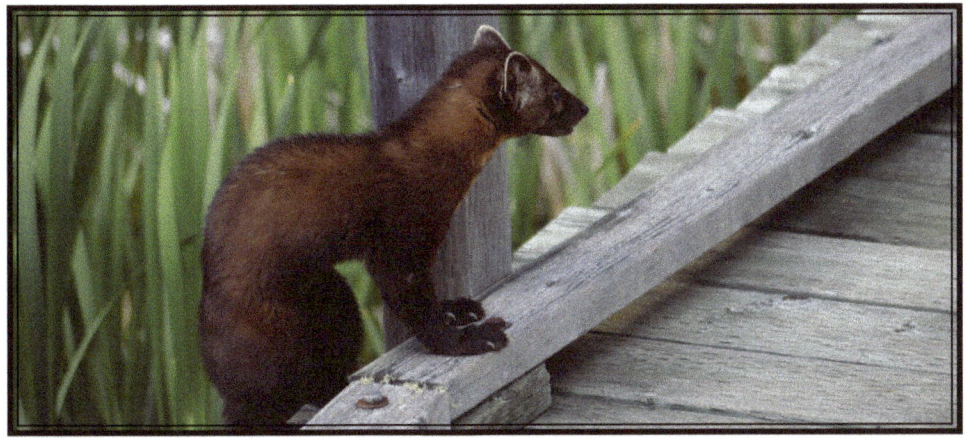

Of course, it helped when the pine martin wasn't sure what to do, it looked like it wasn't really interested in jumping into the river and since it already passed a lady on the bridge, going back was also not an option. But this indecision worked for my benefit.

As always, once I took five to six pictures and after he snarled at me I thought it was in my best interest to step aside and let him pass me on the bridge. Once he saw that I stepped aside, off he went past me and down the bridge.

After I realized it wasn't a mink, I knew that I had seen something new and I was sure hoping that my photographs had turned out. This is because how often would I be able to see a pine martin, let alone get such an opportunity as this to get an amazing photograph.

Yes, I have seen and have taken amazing photographs of a pileated woodpecker and a pine martin, but that was not all. I also had another magical moment with another animal that I really enjoyed watching a lot, it was probably the animal I watched the most – BEAVERS.

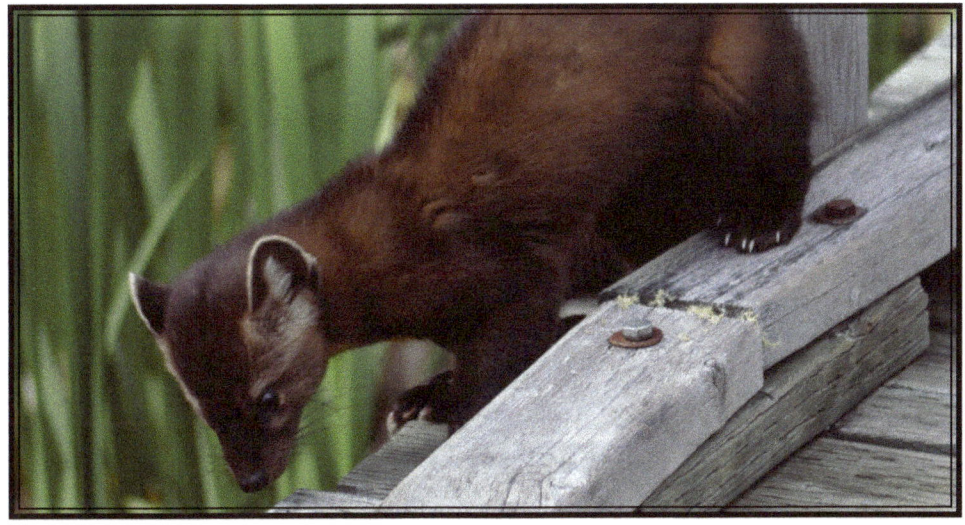

I had a lot of amazing pictures of beavers last year, but this year I wanted to take a picture of a beaver cutting down a tree. I thought this would be a fantastic opportunity to get an amazing photograph. Well, to say that I was disappointed when I did not get this opportunity, I still was able to get some incredible pictures of beavers doing something else that they are noted for. Rebuilding a dam.

I noticed that the beaver's dam was dismantled quite a few times, but as I was driving by one day, I saw a beaver swimming around where the dam was. Obviously, it was assessing the damage to their dam.

I took a few pictures of this, but because the beaver swam away and didn't seem to be coming back, I therefore, decided to leave.

When I came back a few hours later, I watched closely to see if the beavers were back, they certainly were back.

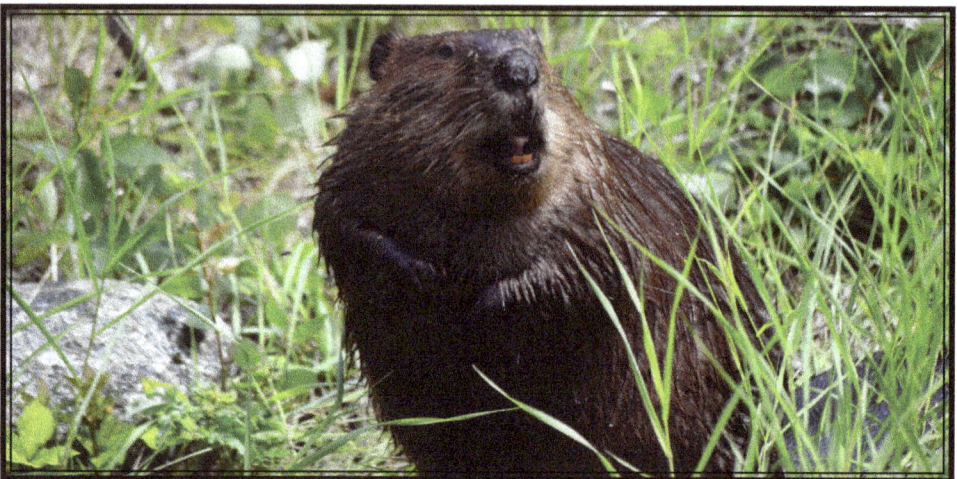

I immediately got out of my truck so that I could watch and photograph these amazing animals as they repaired their dam.

I was able to get about eight or so feet away from where they were and thus able to get some amazing photographs.

I was a little anxious, when it looked like the beaver looked towards where I was standing, I thought that maybe the beaver heard me taking pictures. He took quite a good look, but happily the noise of the shutter, didn't chase him away. He kept busy, very busy repairing his dam.

I just stood there and watched him and photographed him for over an hour. I took over 200 pictures of the beavers rebuilding their dam, of which I kept 180. I ended up making a book of beavers' photo album. Chronicling the time and the way a beaver builds his dam.

Of course when my mother looked at my pictures, she made the comment that she would not be able to decide which photographs to delete. I agreed and therefore, I kept most of them too.

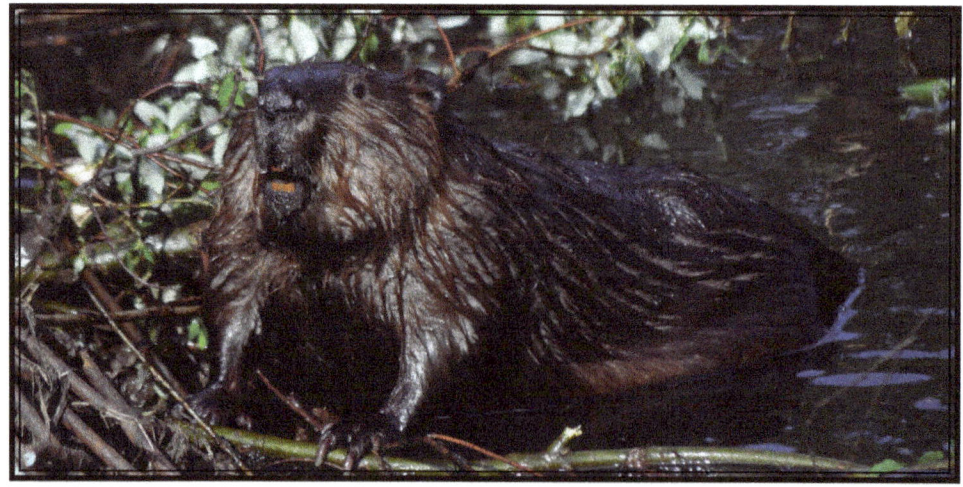

It is interesting that when I was telling someone about my experience with the beavers, the comment was made that they didn't realize that they had a beaver problem in that part of the park. Maybe the beavers thought that they had a human problem because of how many times that they had to repair their dam. HA! HA! HA!

As I was watching them rebuild the dam, I soon realized that they sure didn't waste anything. When they used a branch to plug up the dam, the beaver would eat the leaves on the branch so that nothing was not used. I also noticed that they even used the materials that made up the old dam. Pulling branches from the old dam to be used for the new dam.

It was just amazing watching how hard working and industrious they are.

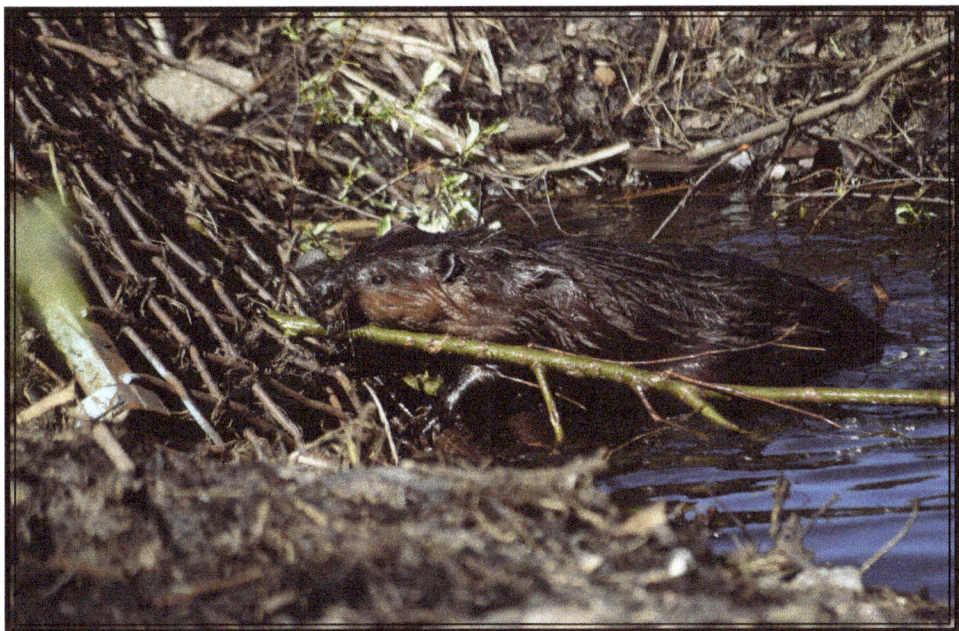

It was also surprising how strong they were as they pushed the branches into the dam, using their whole body. Happily, I was able to get some amazing pictures of the beaver doing this very thing.

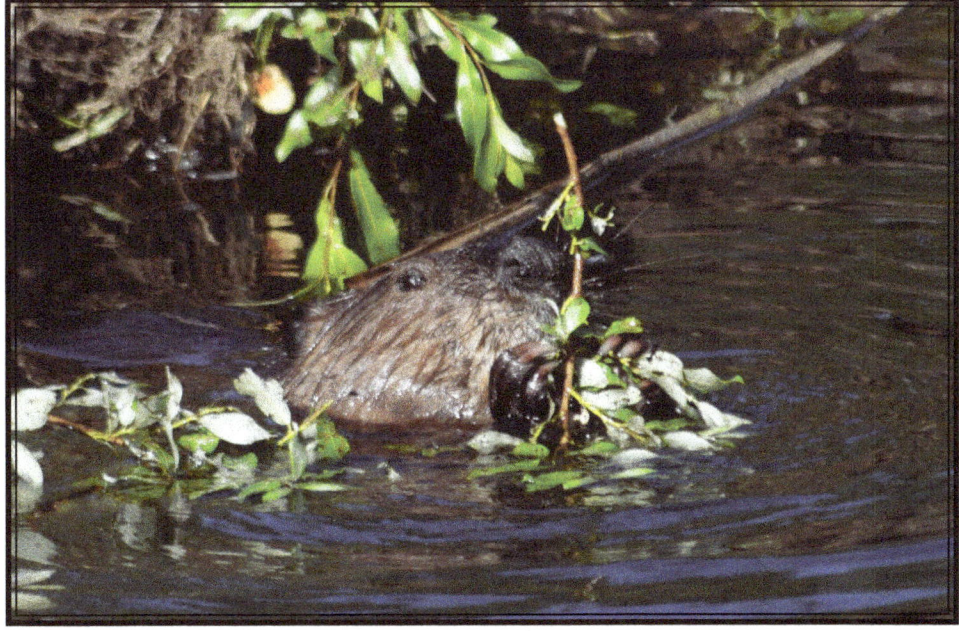

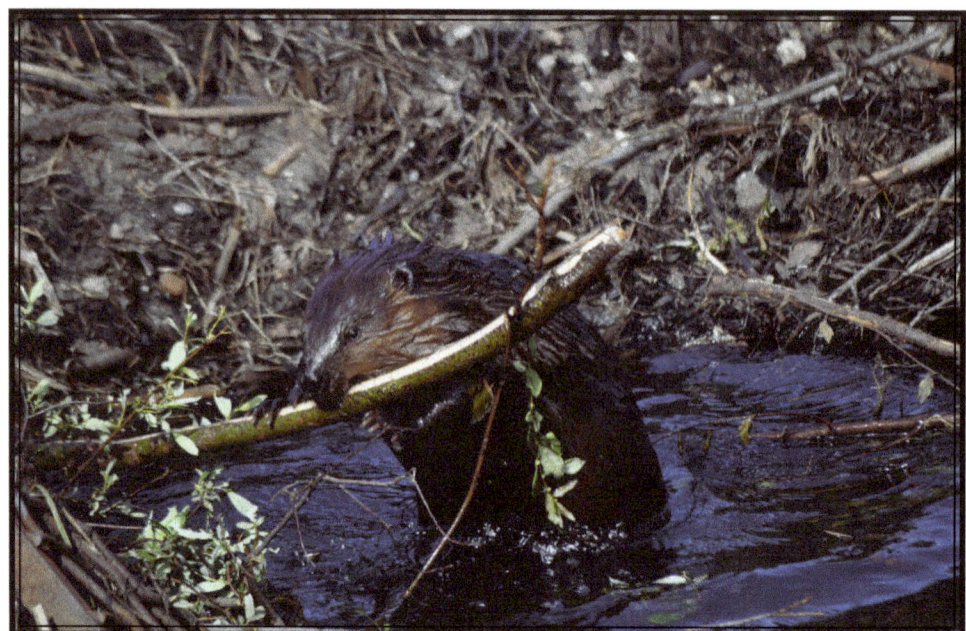

It was amazing to watch how the beavers worked at rebuilding their dam. After watching them for about an hour or so and taking so many pictures, I left to go and see what was going on at the river. To my surprise, that by the time I returned to the beaver dam about two hours later, they almost had their dam completed.

Not only are they good at what they do, experts in my opinion, but they are fast. But I will have to admit that by having a grate in front of the culvert certainly helped the beavers complete their task that much faster. Yes, you can see why I enjoyed watching and photographing the beavers so much. I was even thrilled to have a beaver walk up to where I was standing on a fallen tree, just two feet away, as it came to get some young trees for food. Simply AMAZING.

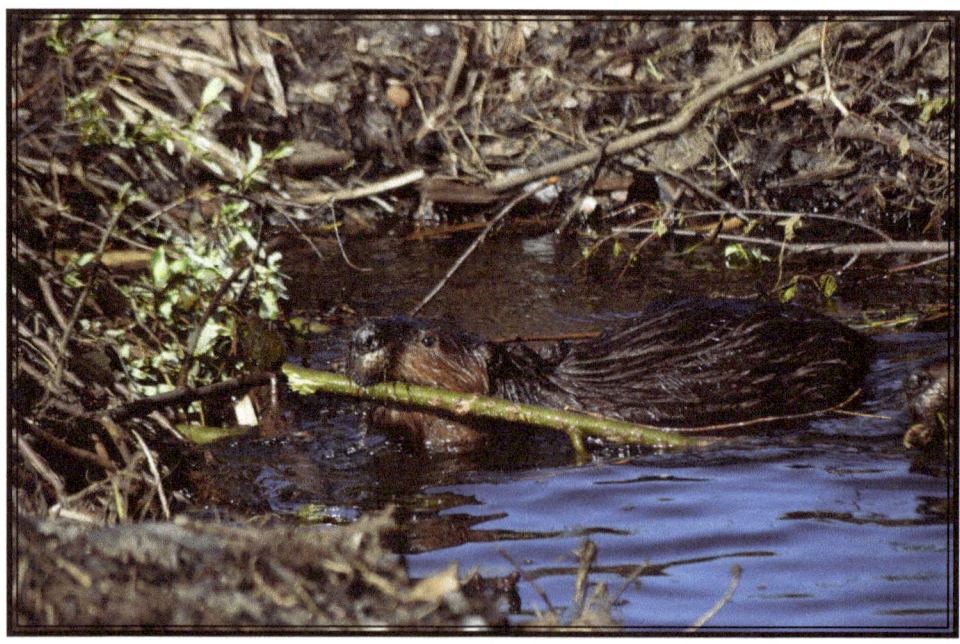

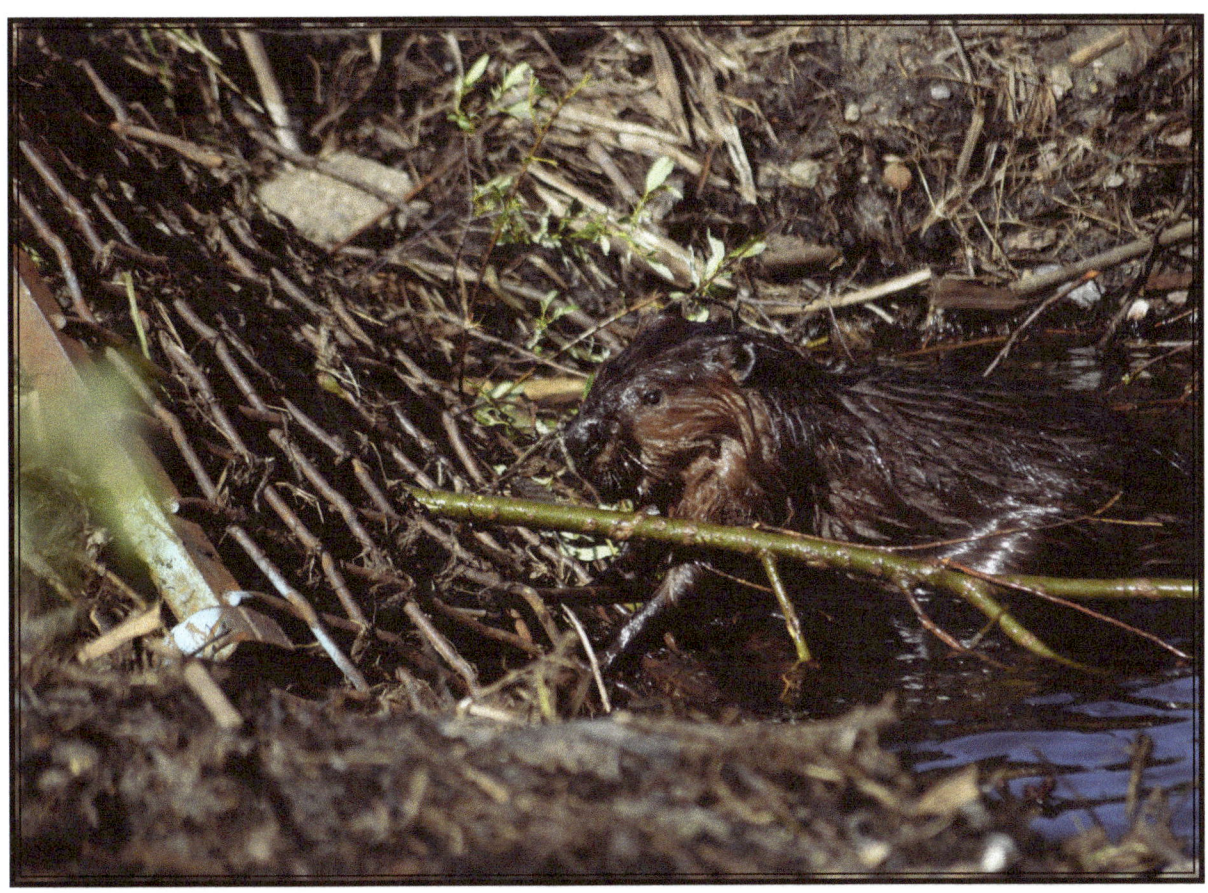

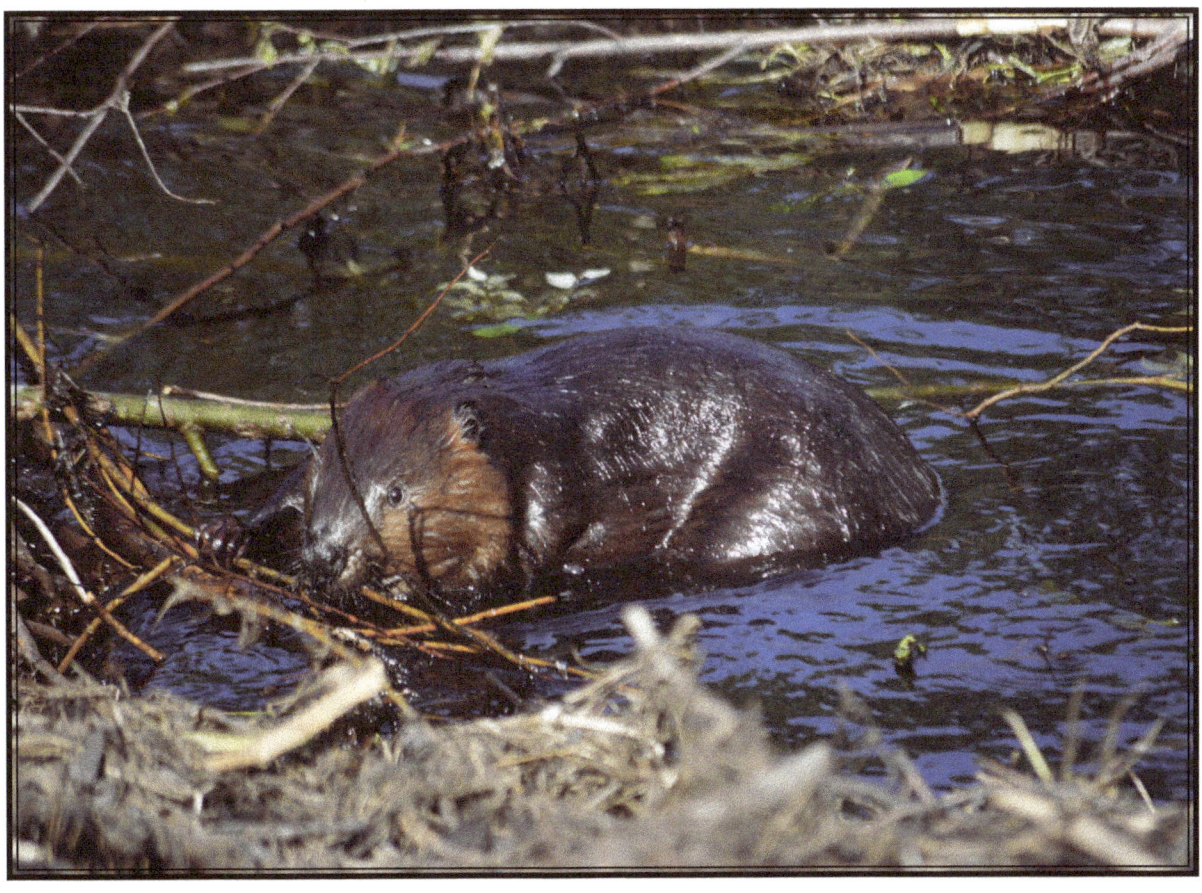

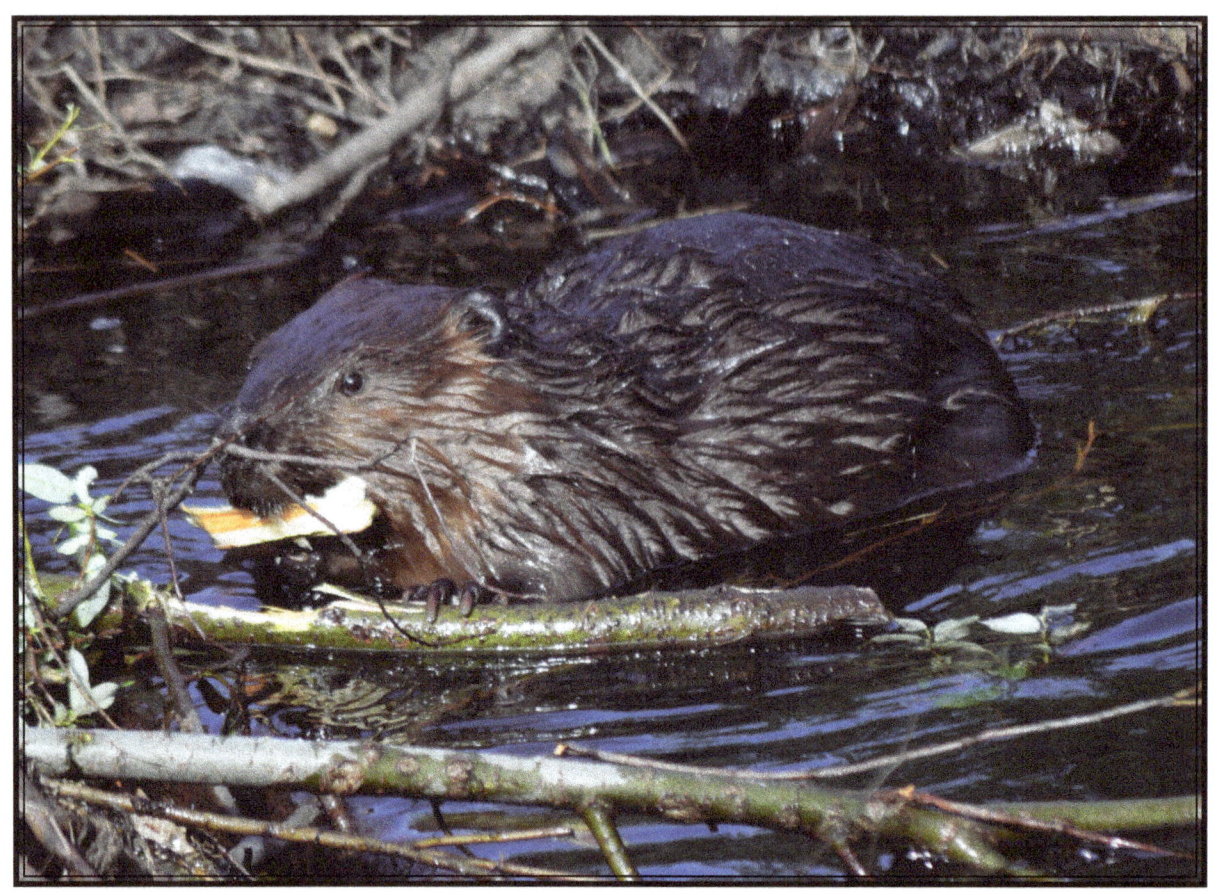
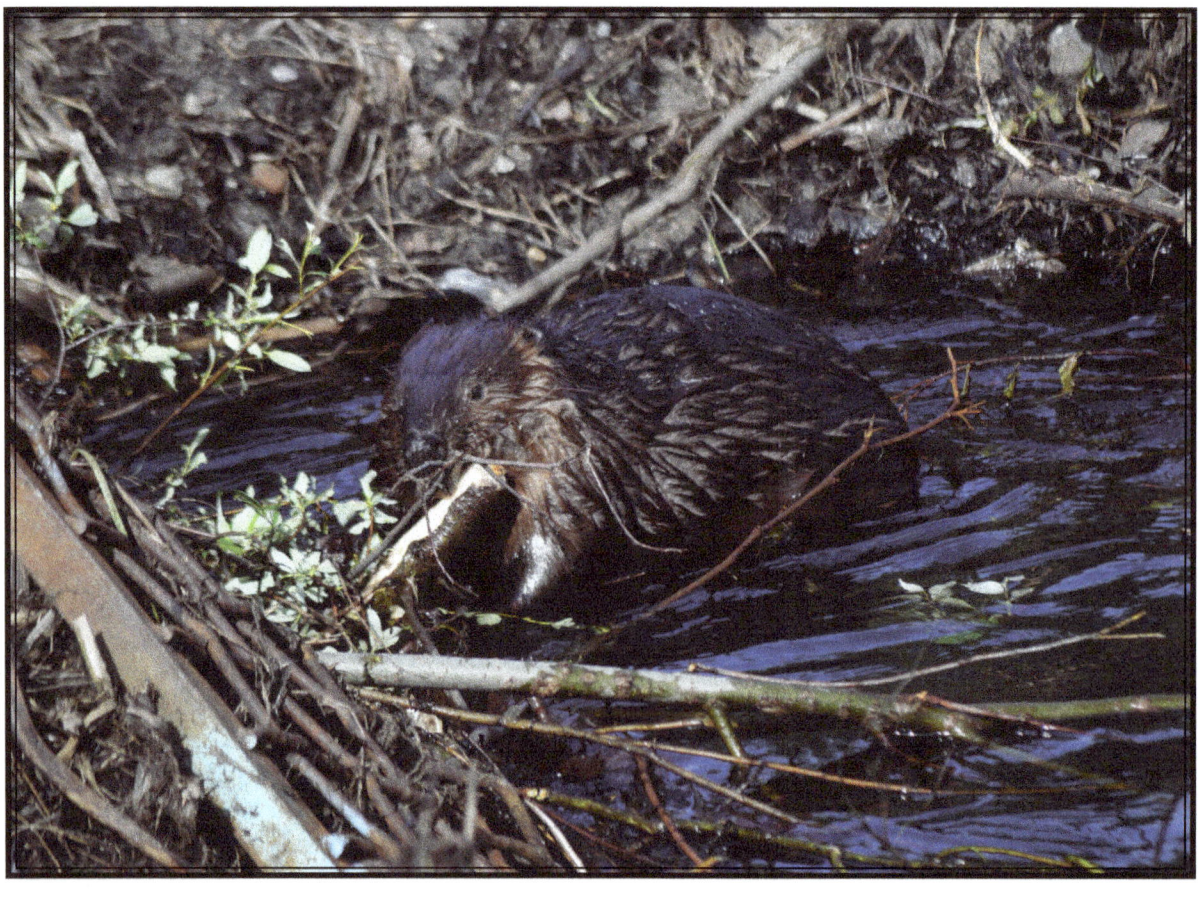

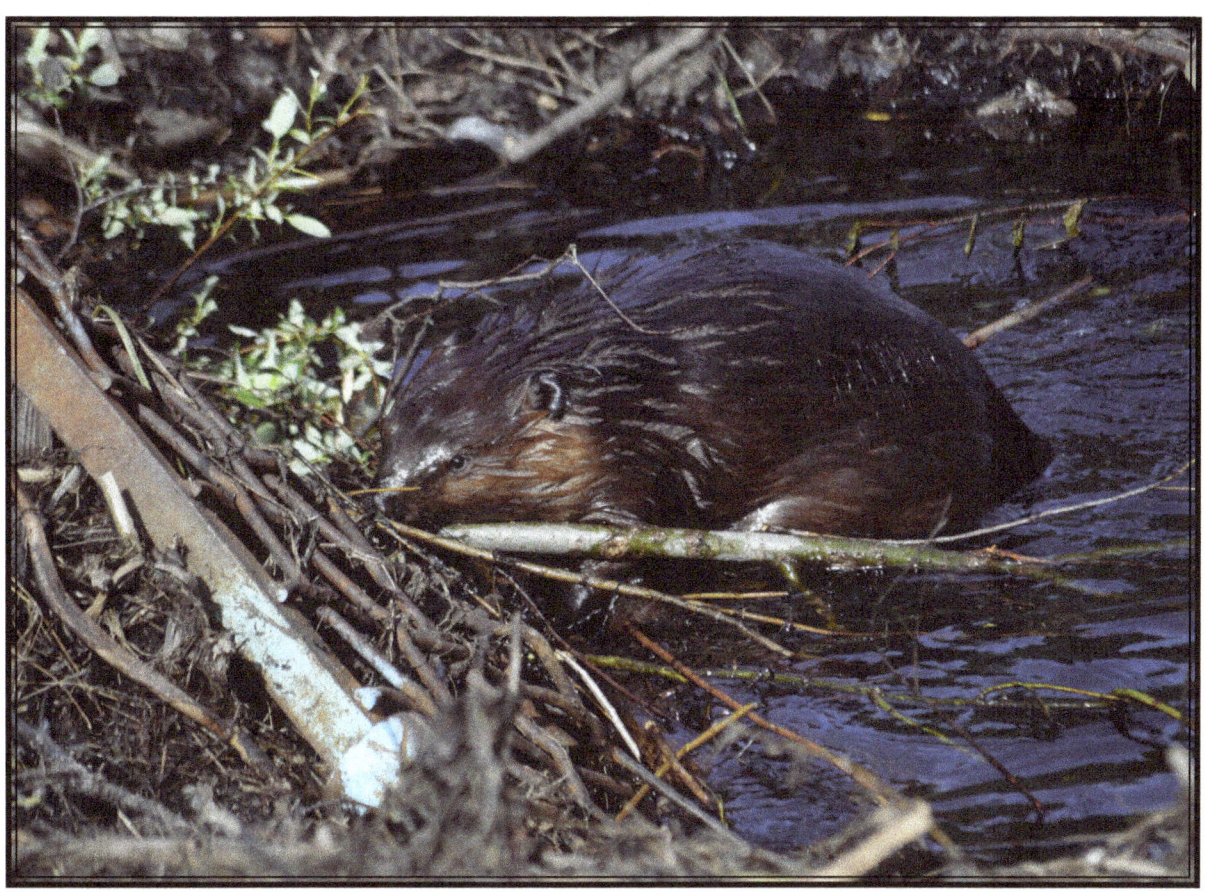
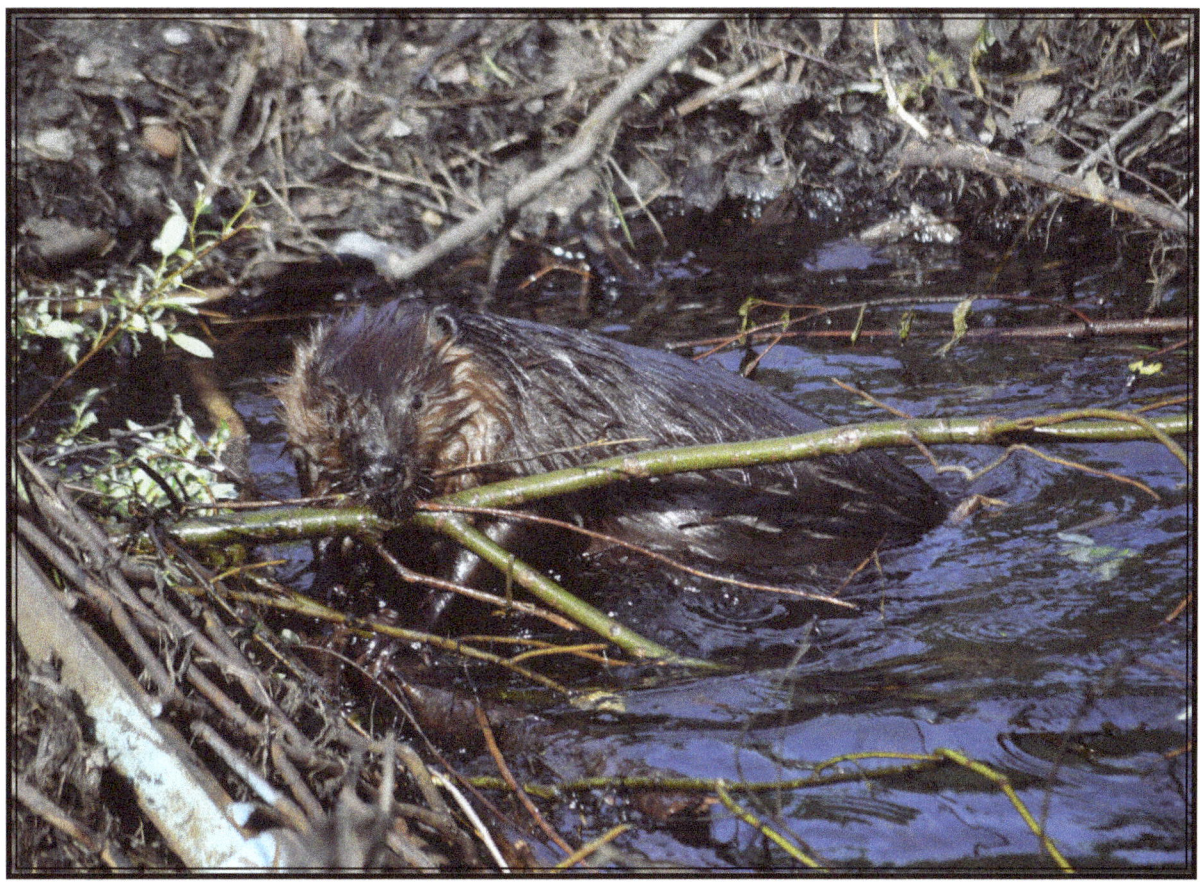

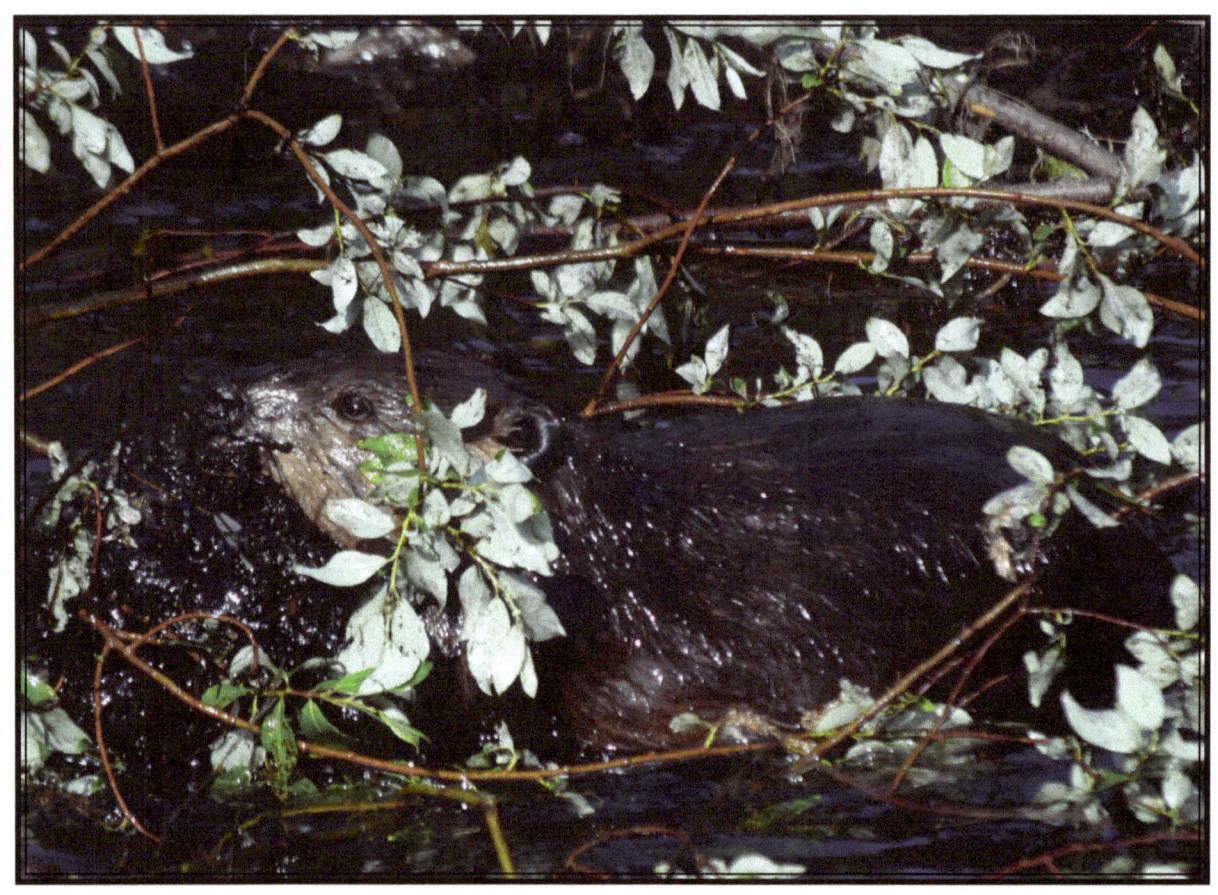

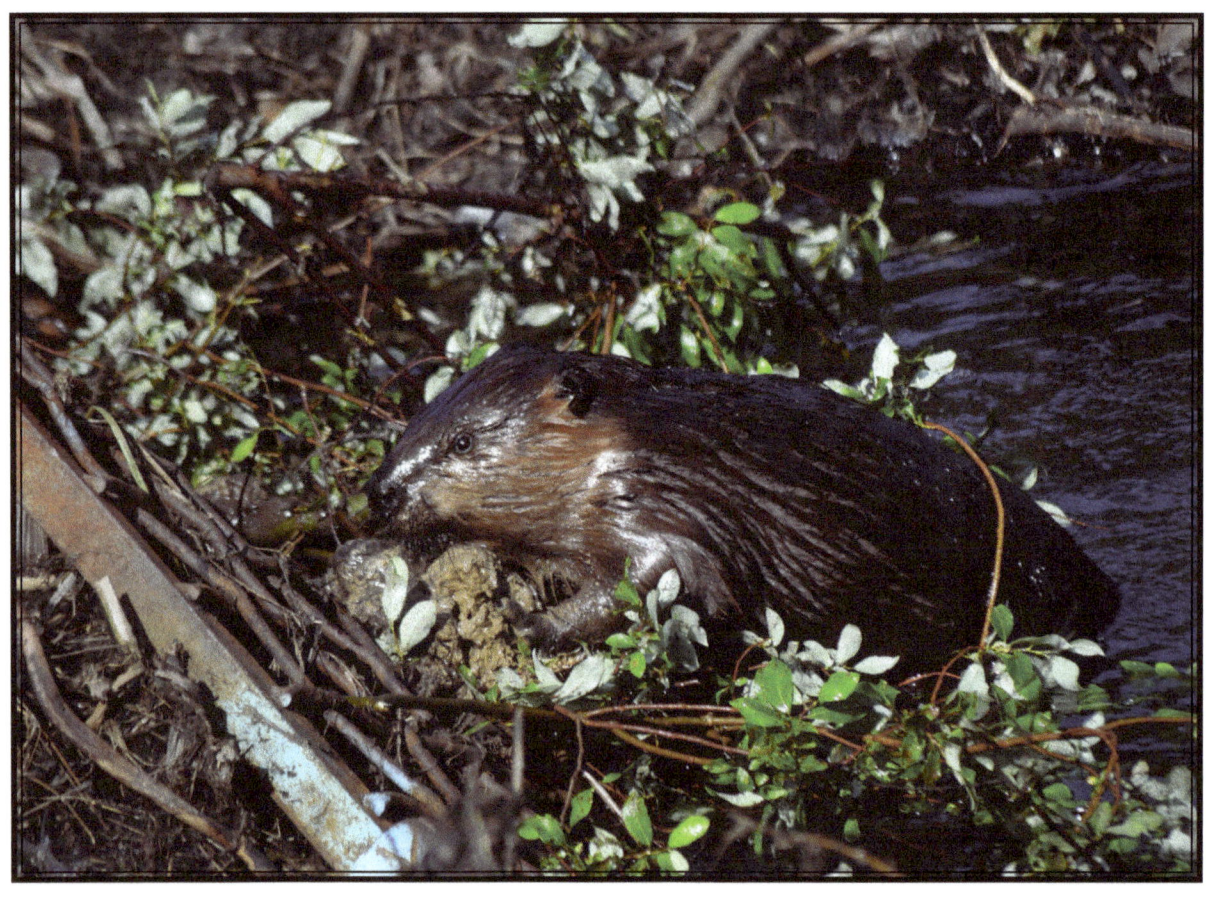

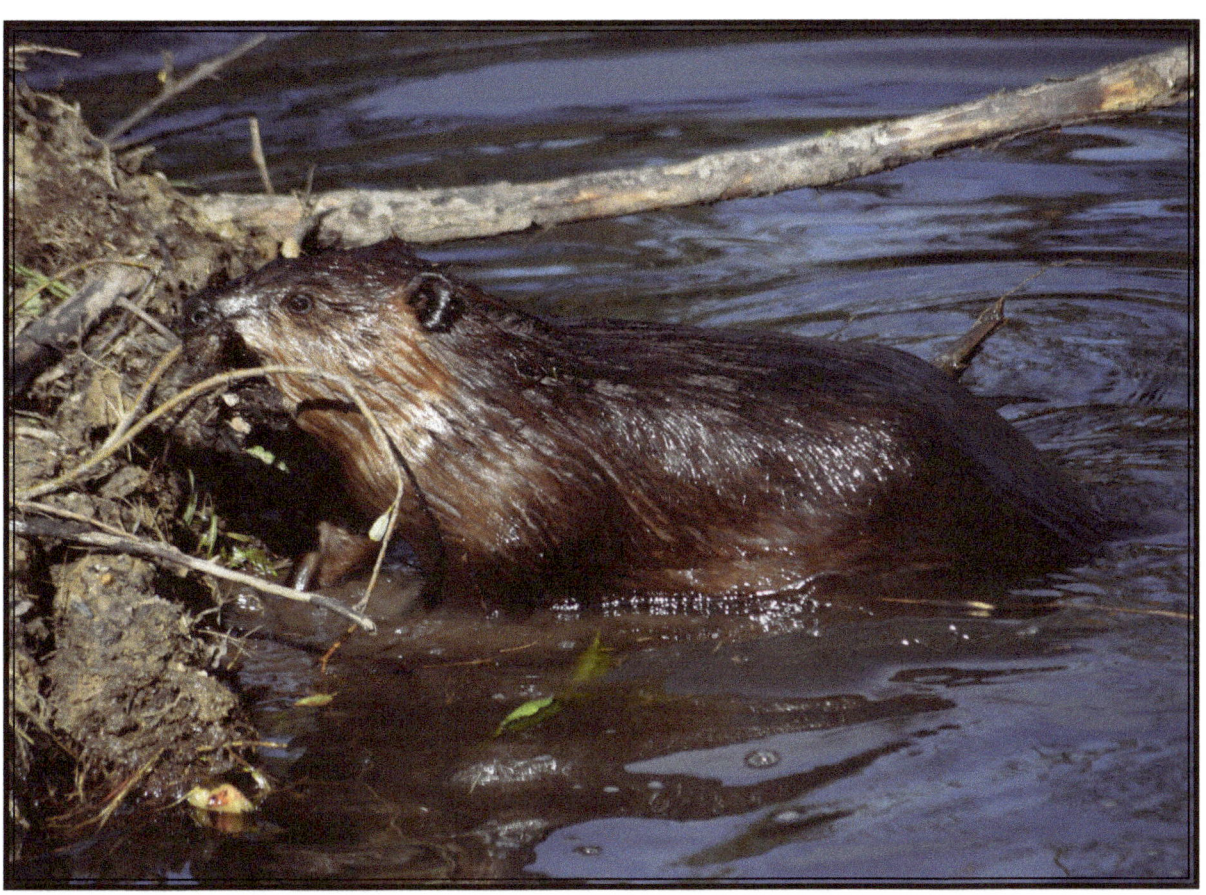

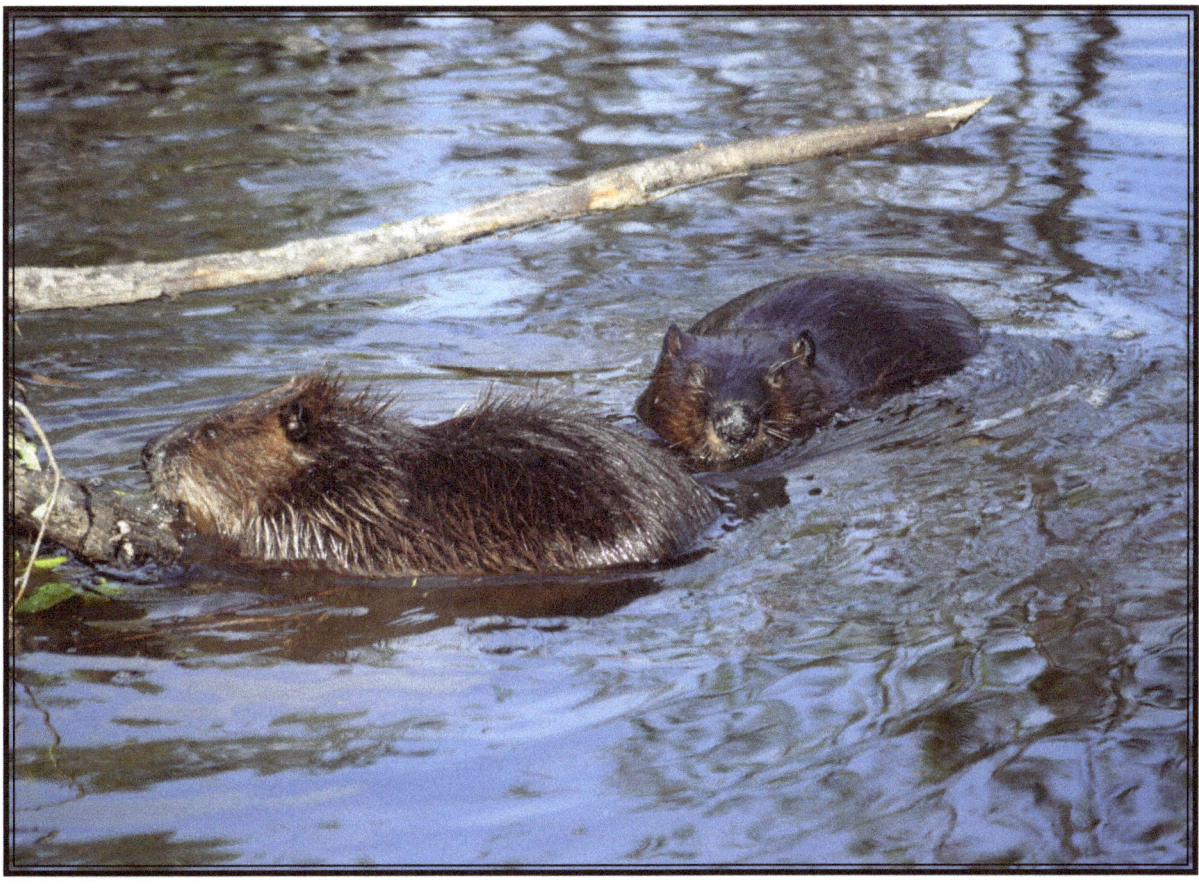

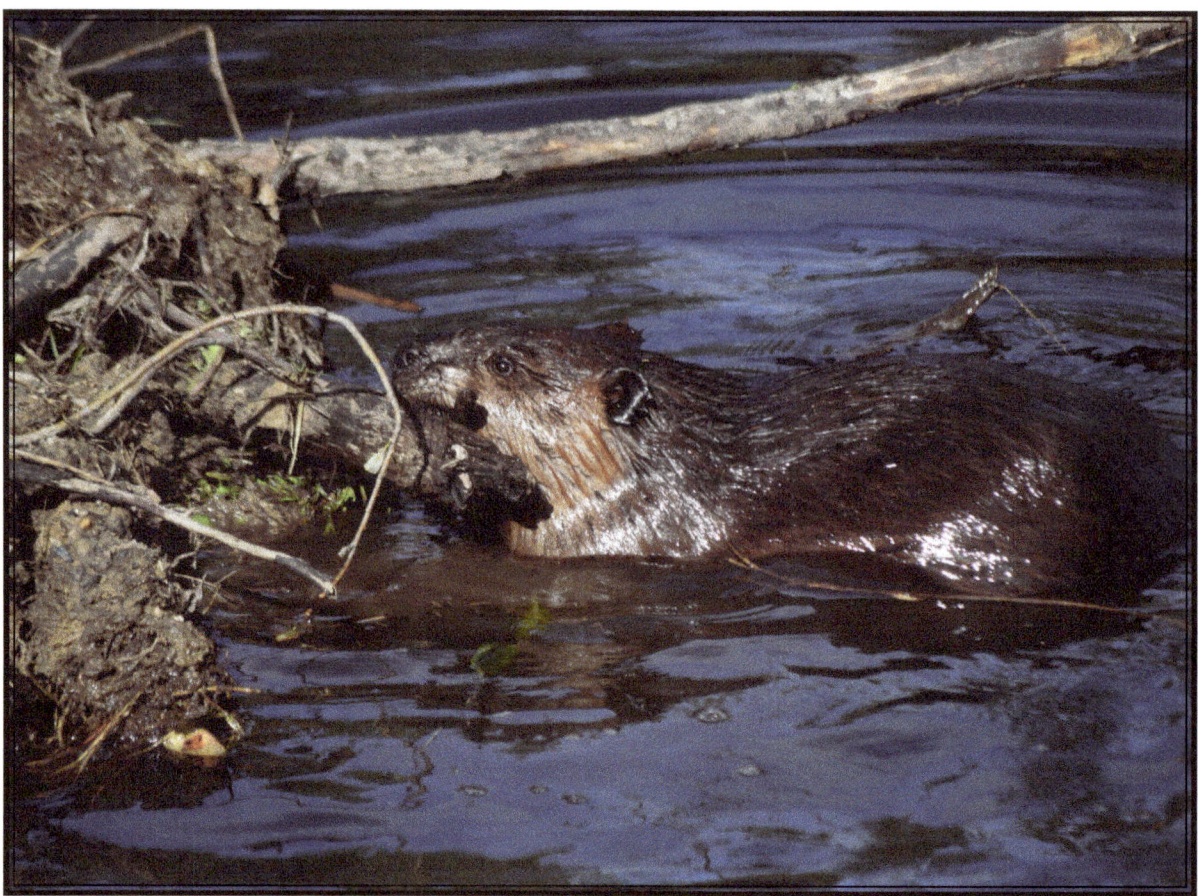

    Yes, when it comes to experiencing new and exciting adventures each year, it is also nice to be able to see a variety of different birds that can be seen and unique, just as the pileated woodpecker was.

    The following year I was also able to see and photograph a few birds that I had never seen before. From a cute little chestnut-sided warbler to a spruce grouse. From a boreal chickadee to a Bonaparte's gull to name a few. Yes, it was certainly amazing to see and to be able to photograph such a variety of birds.

    I was even able to take pictures of birds that I thought I knew what they were but was mistaken, such as the time I thought I was taking a photograph of three ring-necked ducks and to my surprise and amazement, one of the ducks was a greater scaup.

# The Chestnut-Sided Warbler

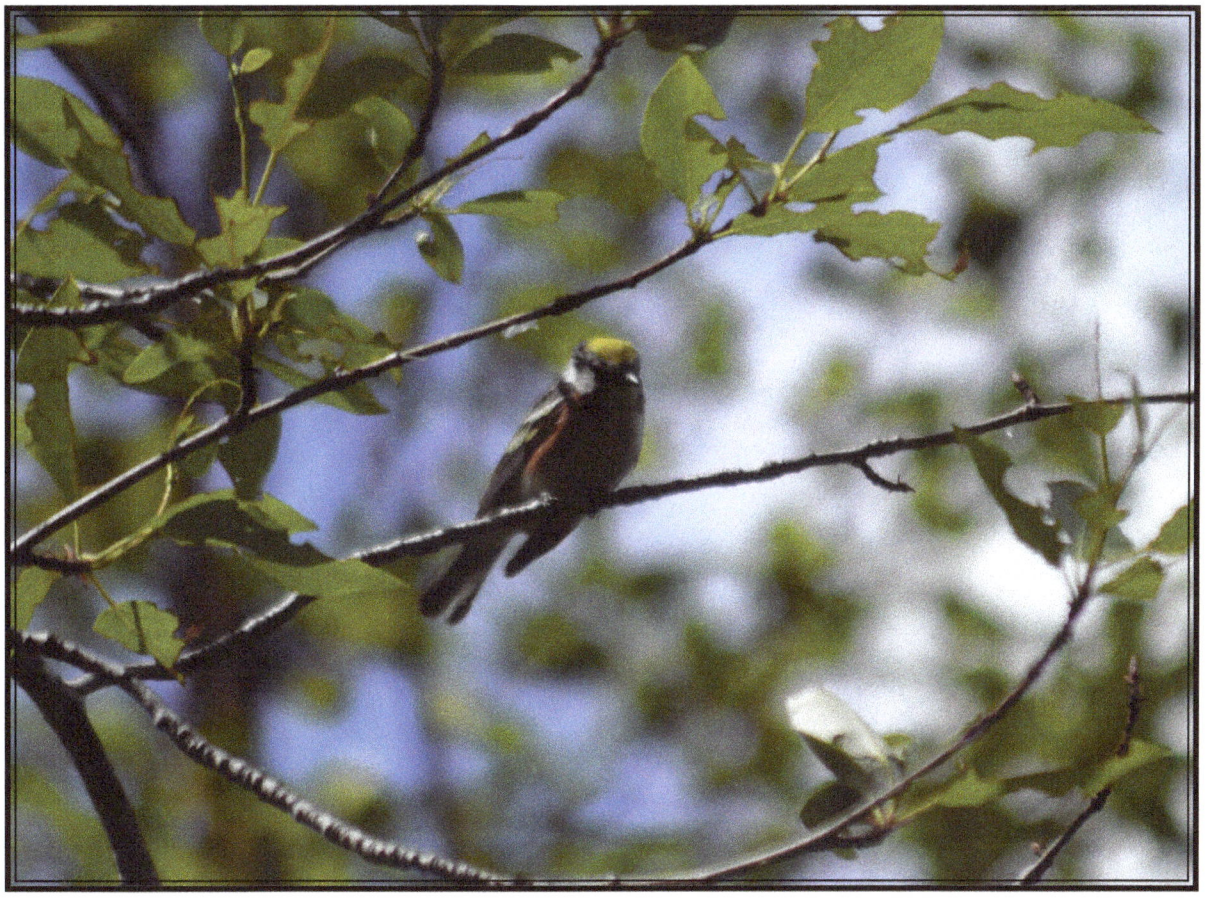

# The Spruce Grouse

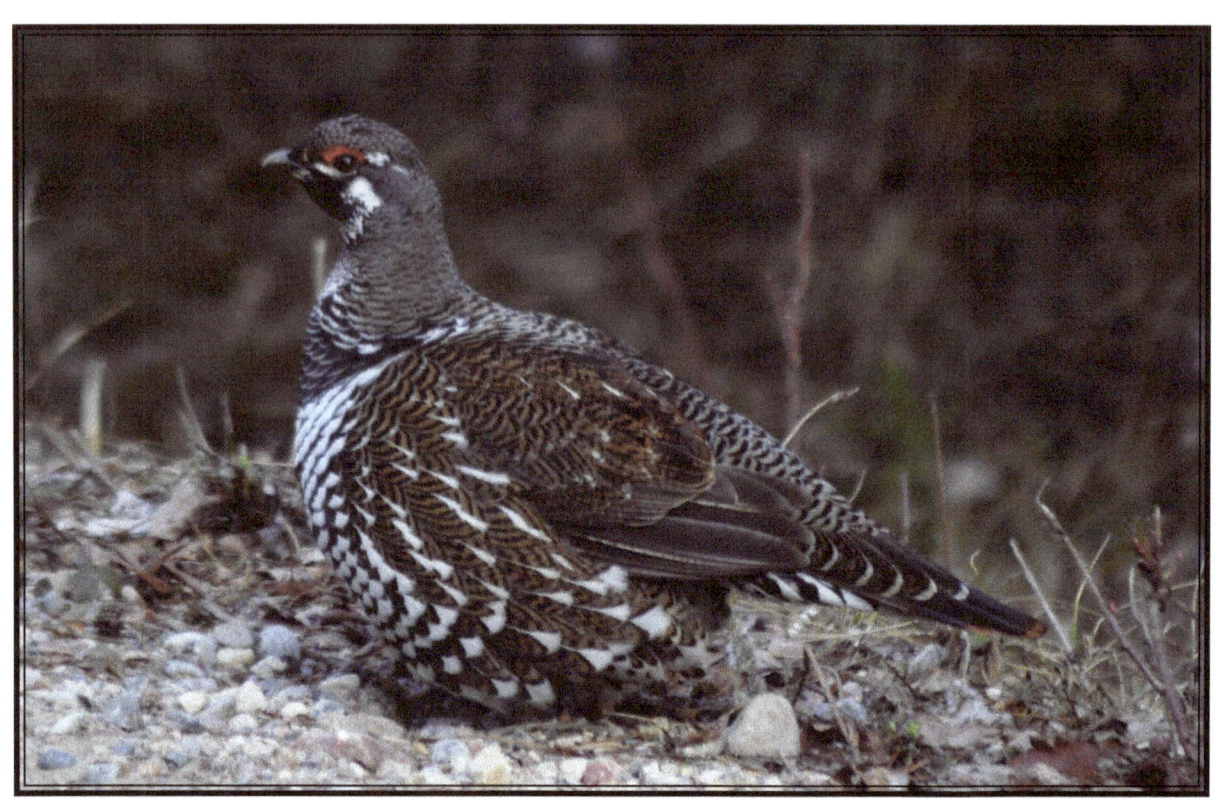

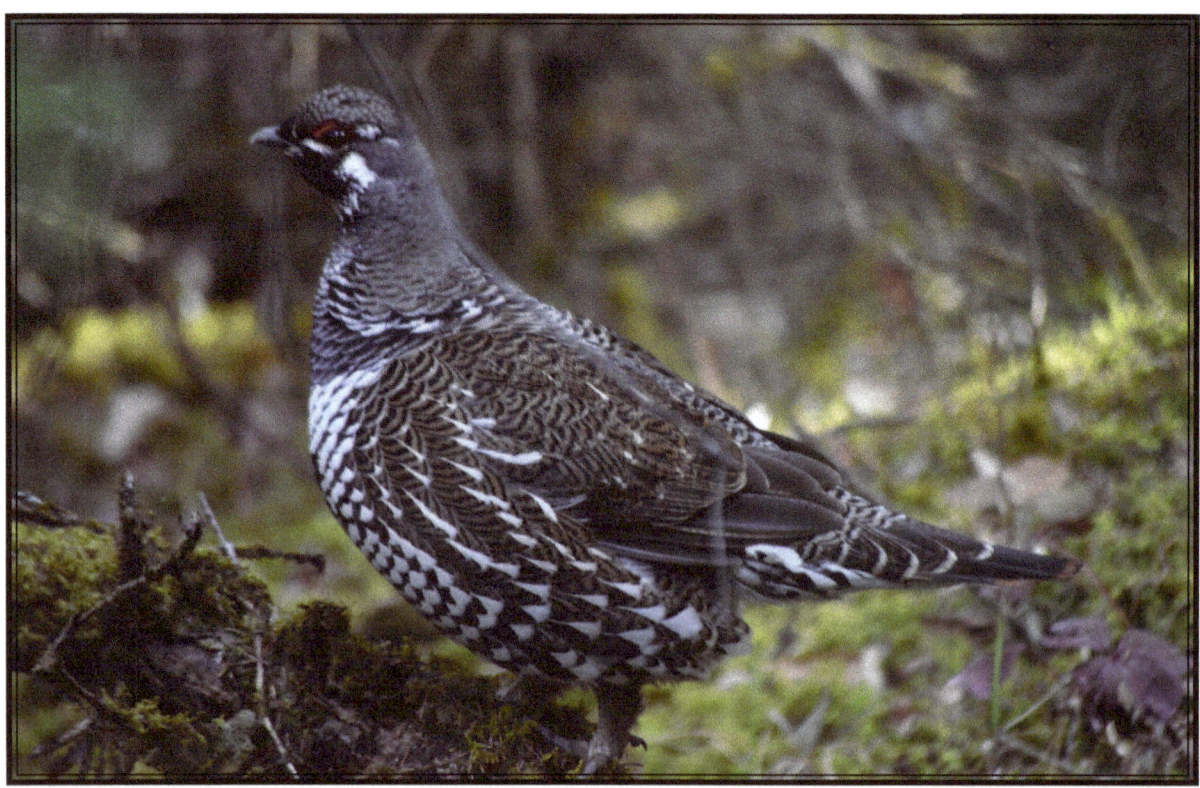

# The Song Sparrow

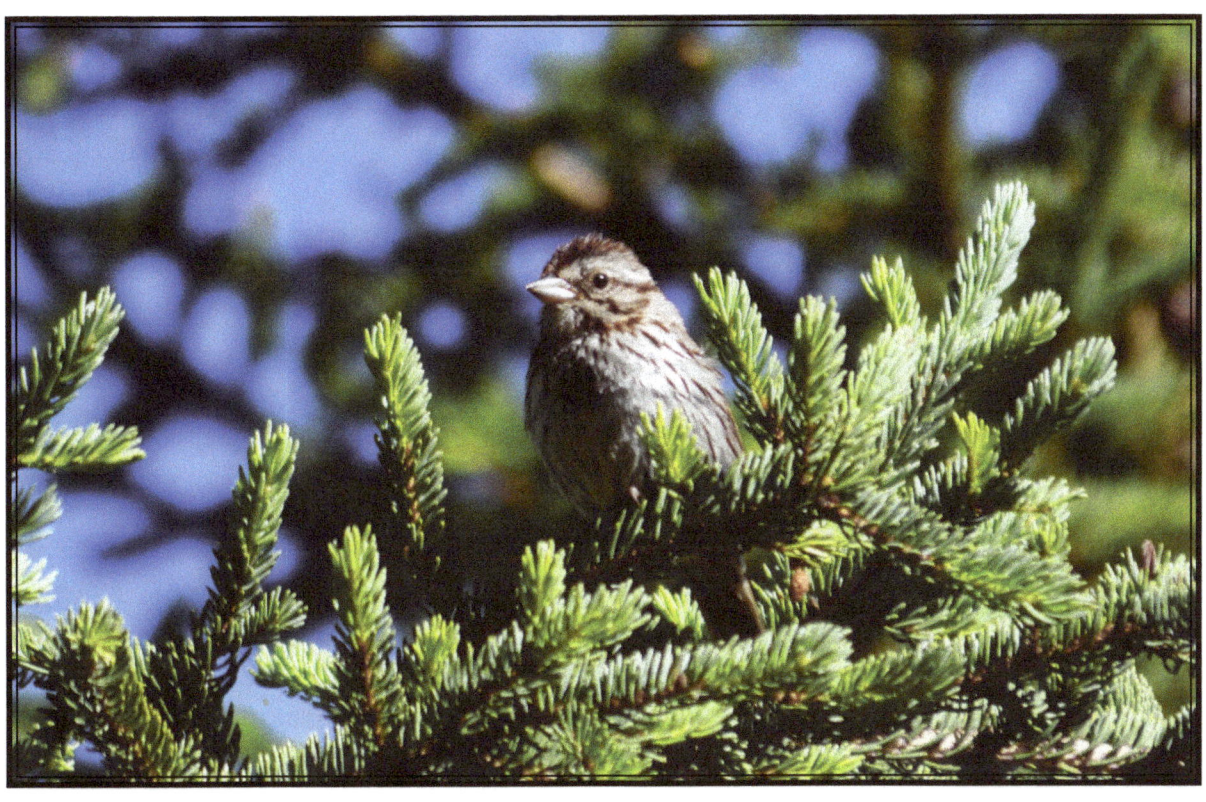

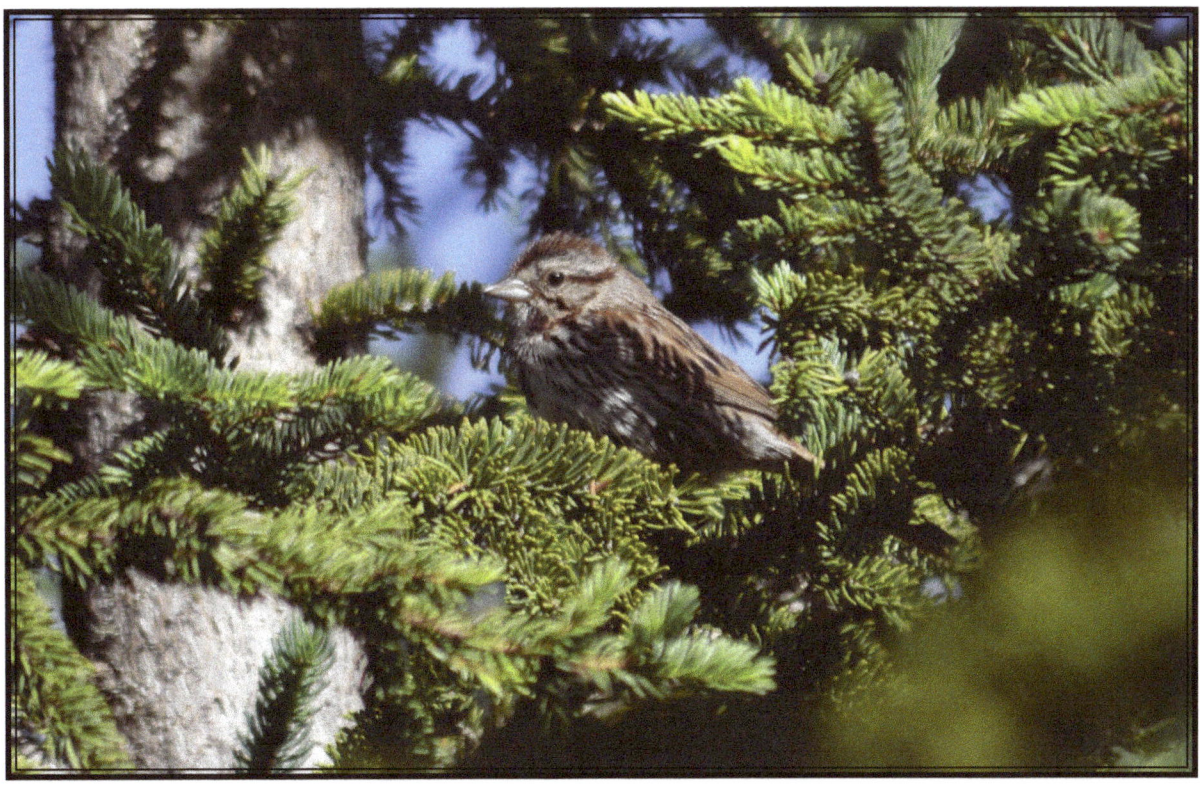

# The Boreal Chickadee

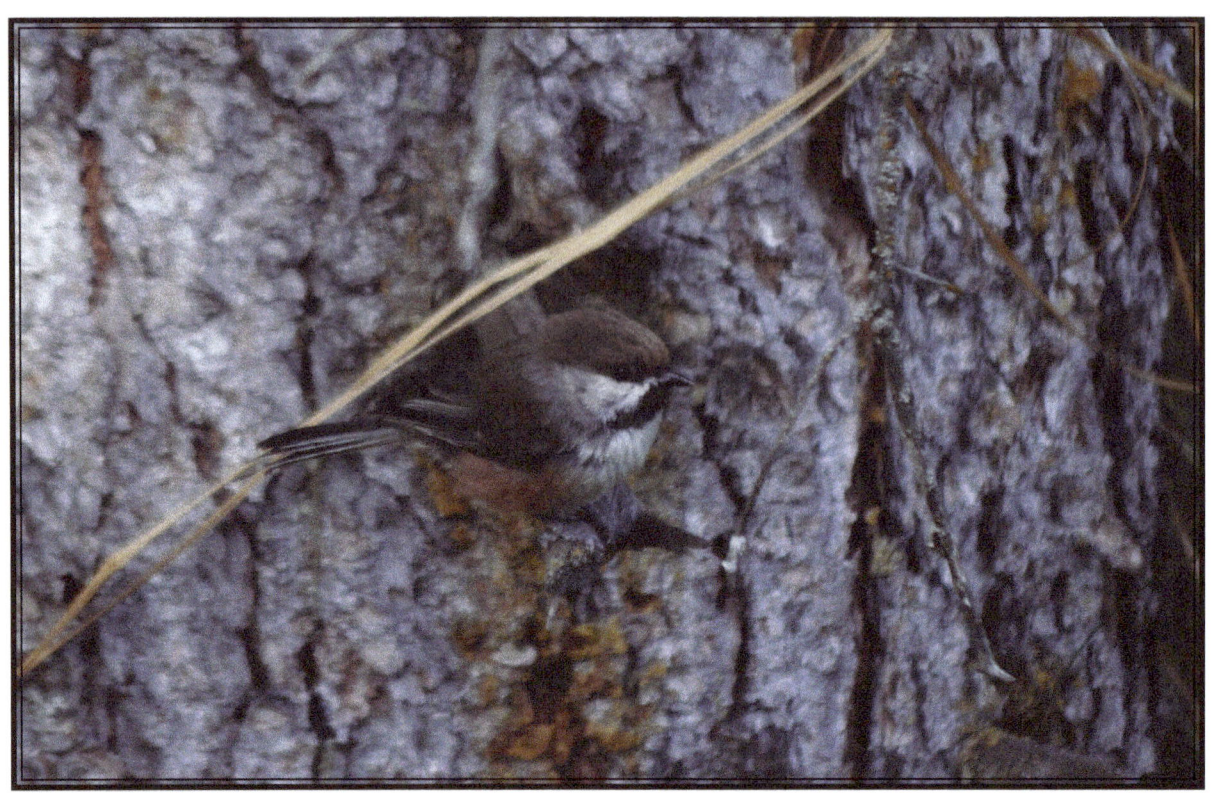

# The Greater Scaup

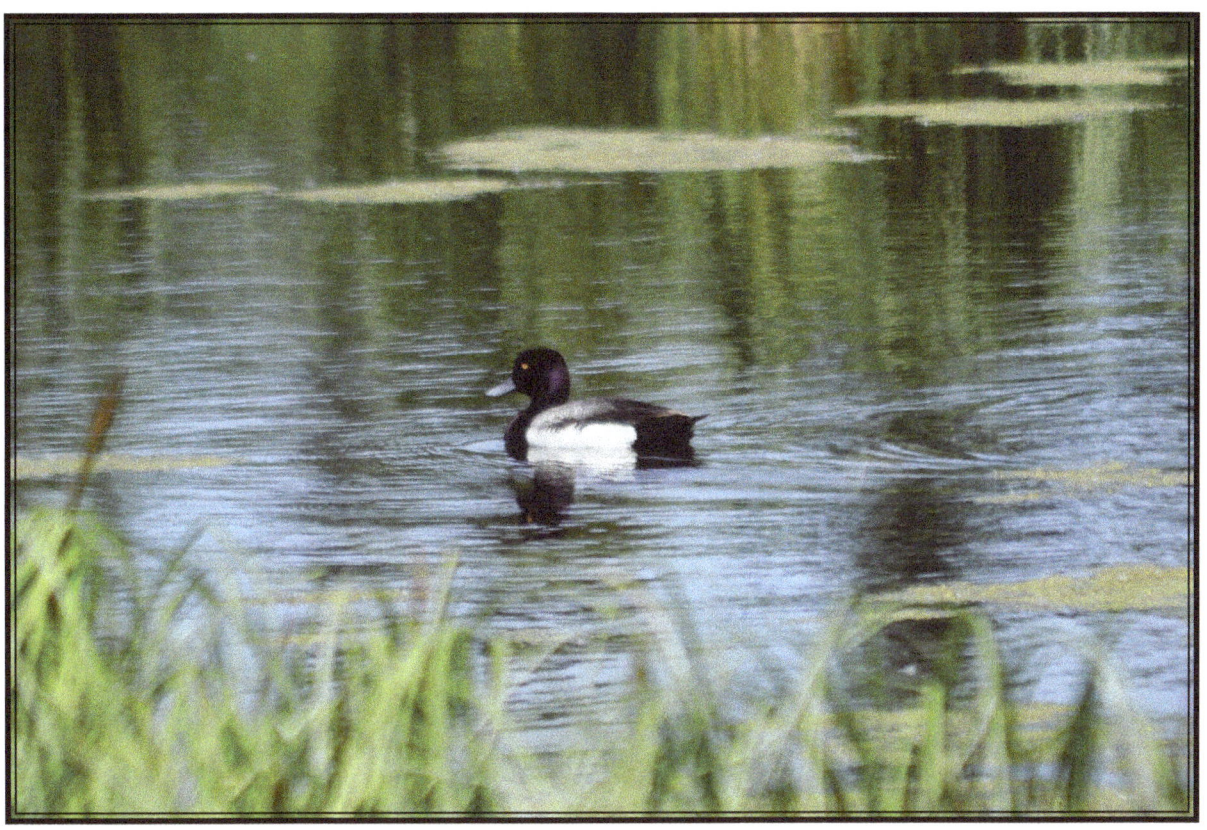

# The Ring-Necked Duck

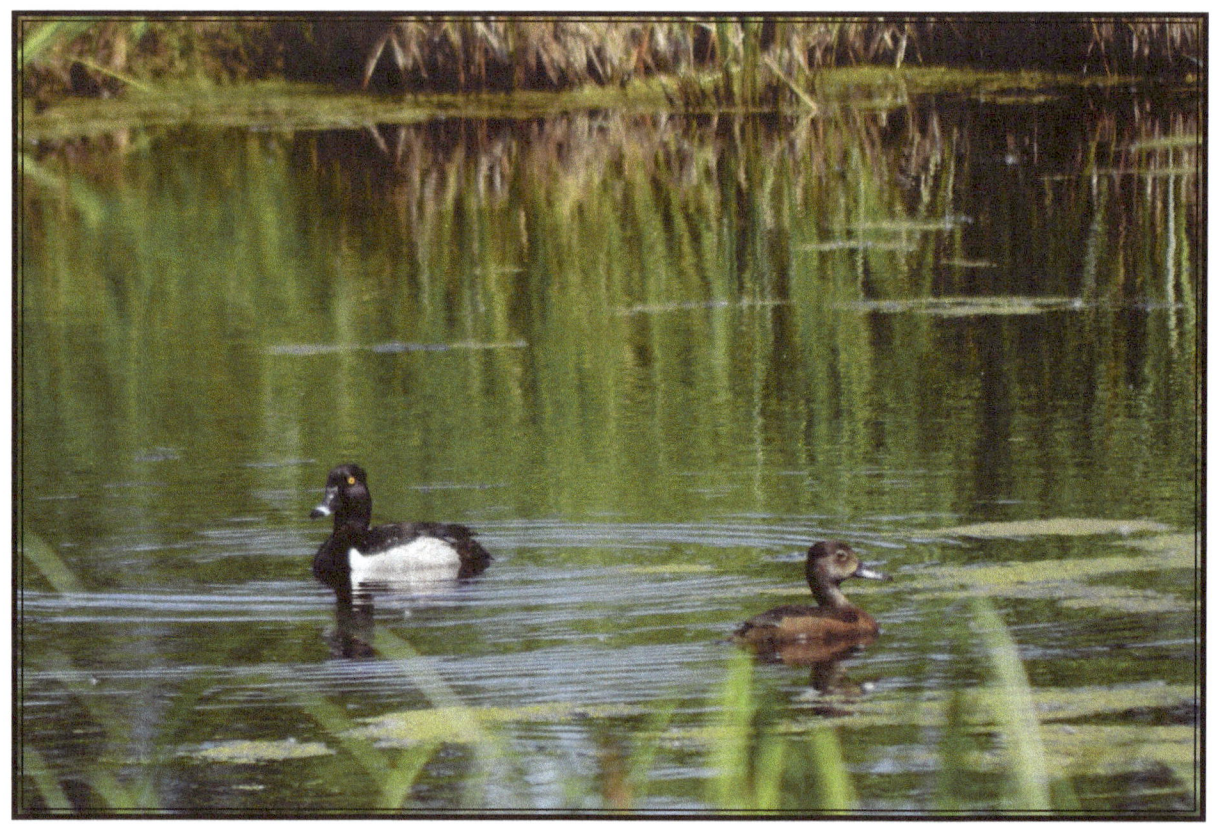

# The Bonaparte's Gull

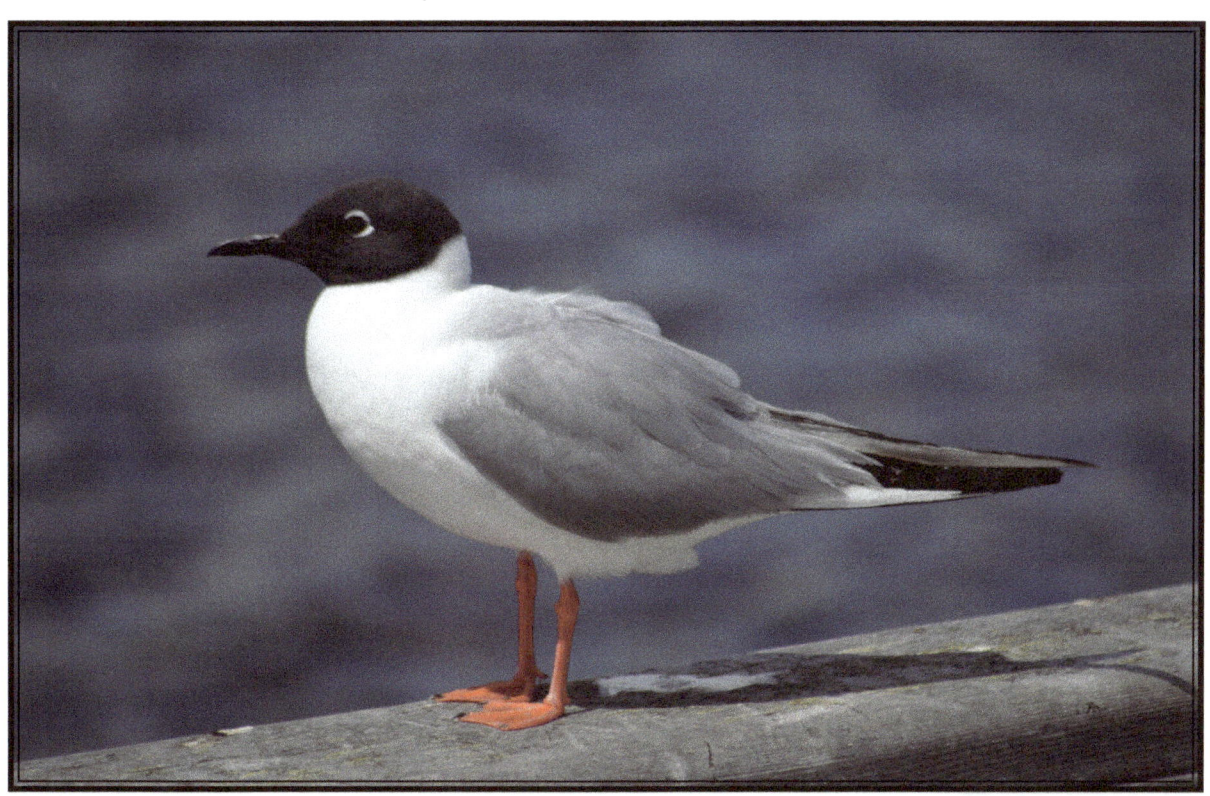

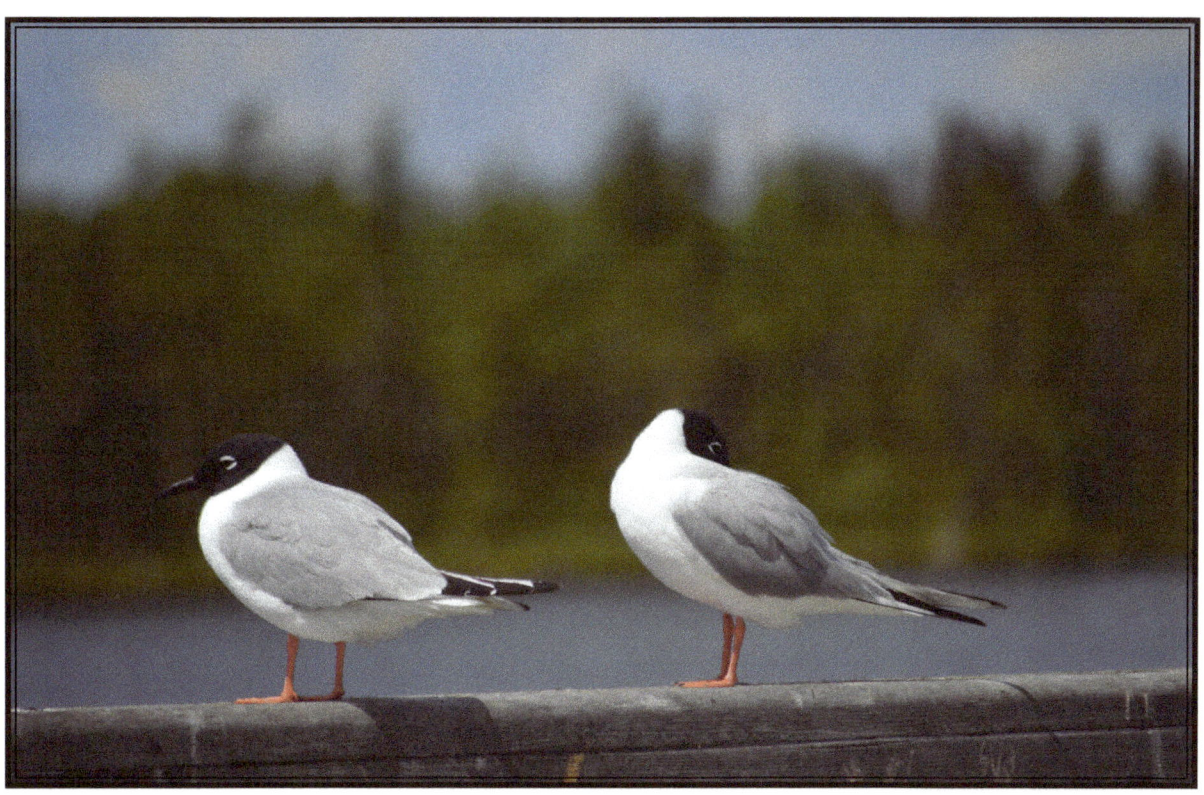

# The Bonaparte's Gull

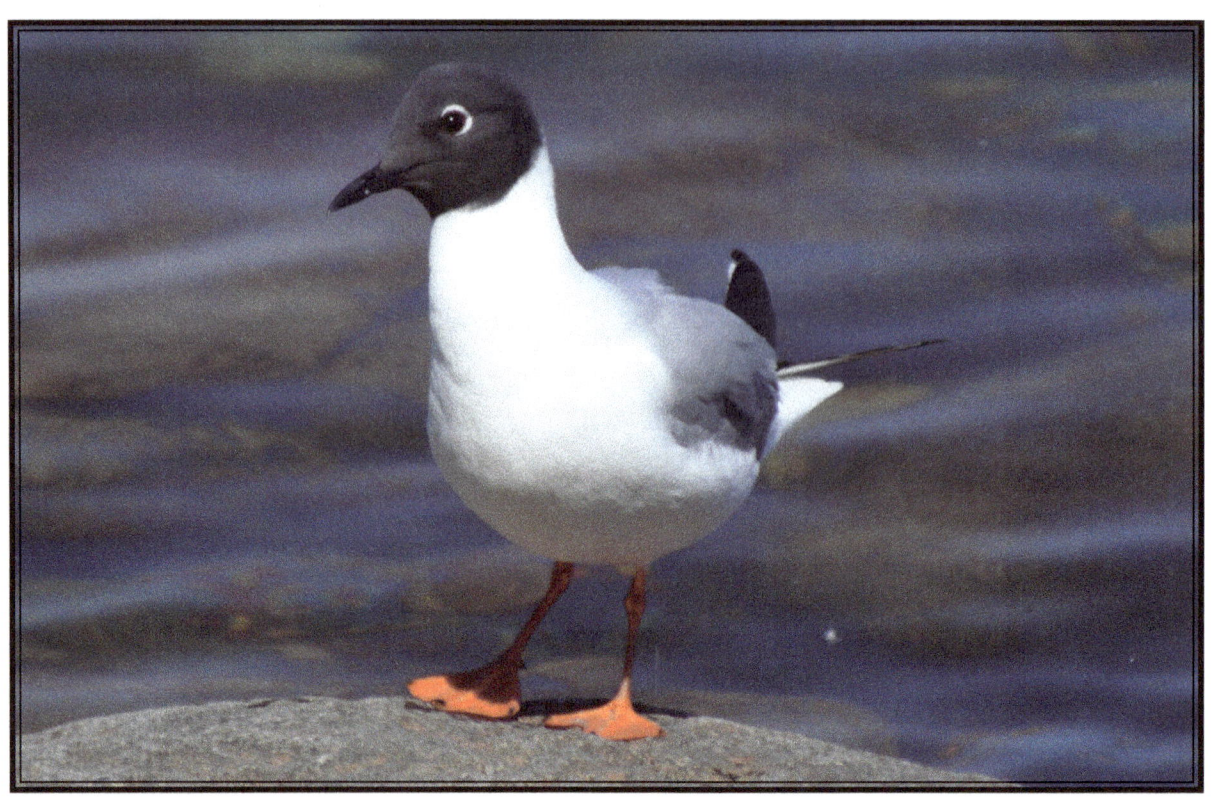

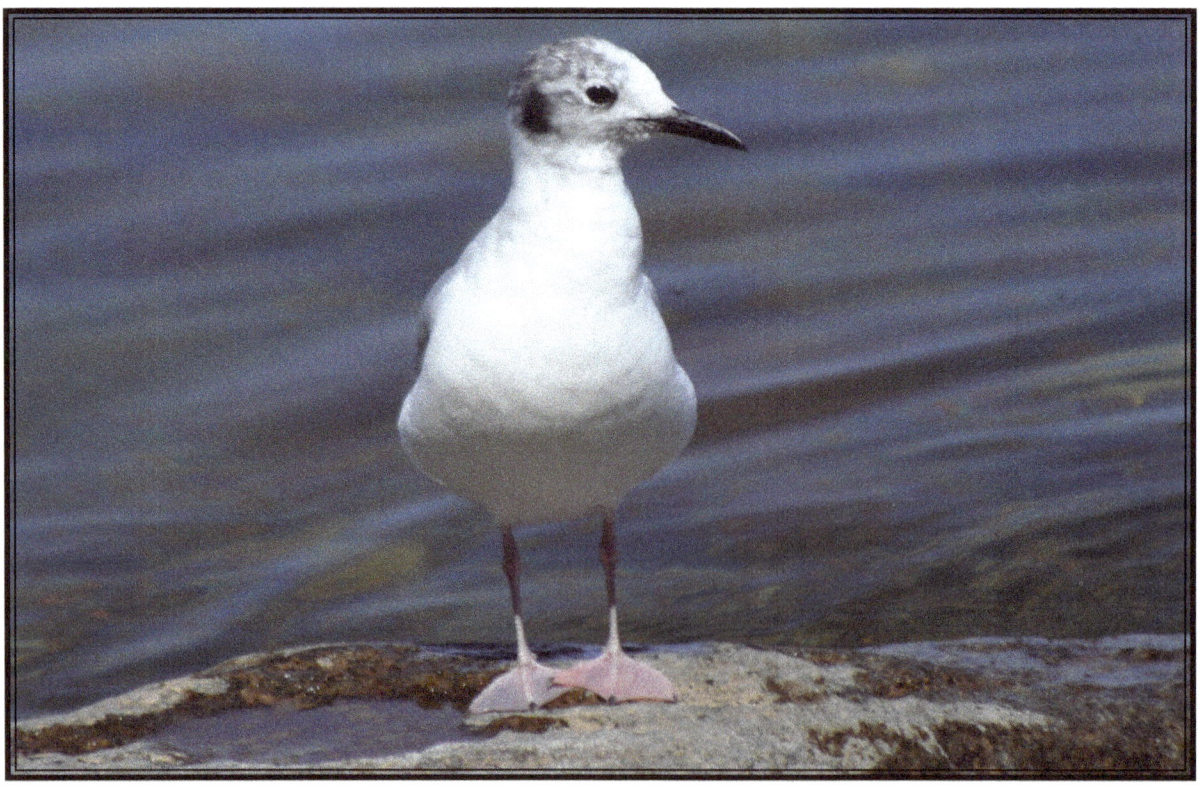

# The Eastern Phoebe

It is too bad that with so many different birds that can be found in the park, I was able to photograph so few of them. Well, as the saying goes, maybe next year, yes, the adventure always will continue.

Even though I was unable to see only a few new variety of birds, I was still able to see and photograph the same birds that I had seen the previous year, but in totally new and amazing new settings. Such as being able to photograph common mergansers. A male and a female sitting on an island in the middle of the river or a couple of young ones riding on the back of their mother. Even being able to watch a female fishing in among the rows of rocks that are on the Waskesiu River.

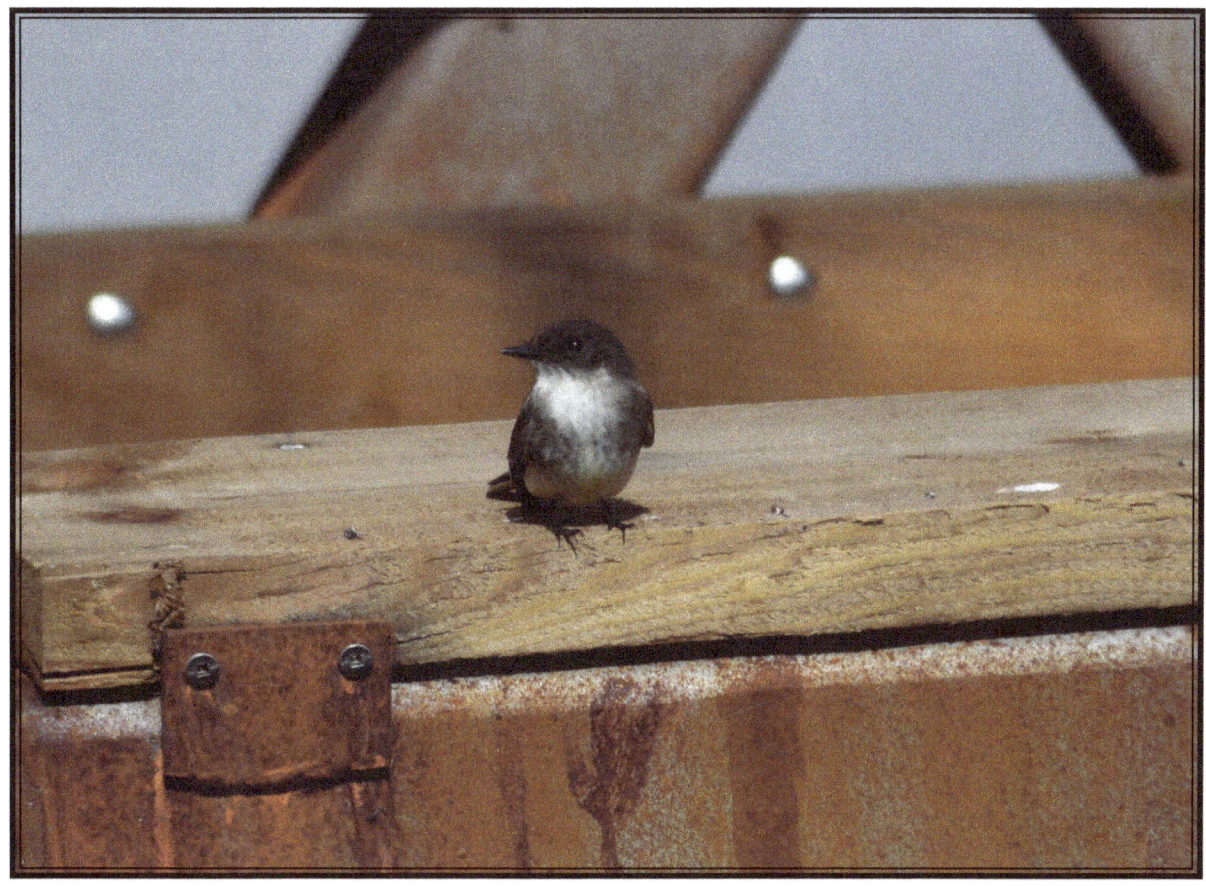

Not to mention a wide variety of birds, yes quite common to see, but still amazing to photograph. It was amazing how close I was able to get to a number of waterfowl. Whether it was a mallard duck or a ring-billed gull. Even a black-billed magpie or an American crow sitting on a rock, made for amazing photographs, that is in my humble opinion.

Even though these and other animals are easily seen in the park, I just had to put them in my book. They made the photograph just too beautiful to leave them out. Simply, AMAZING.

# The Common Merganser

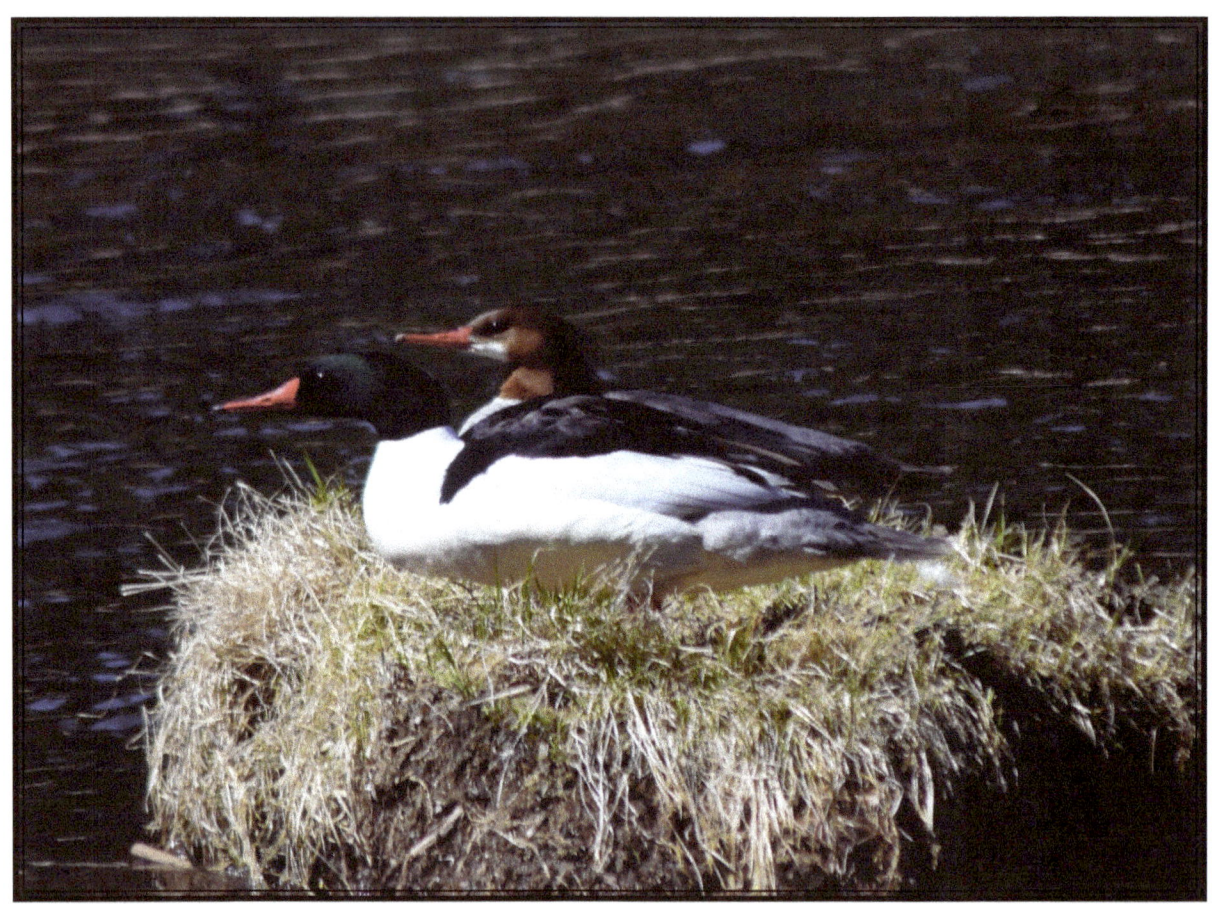

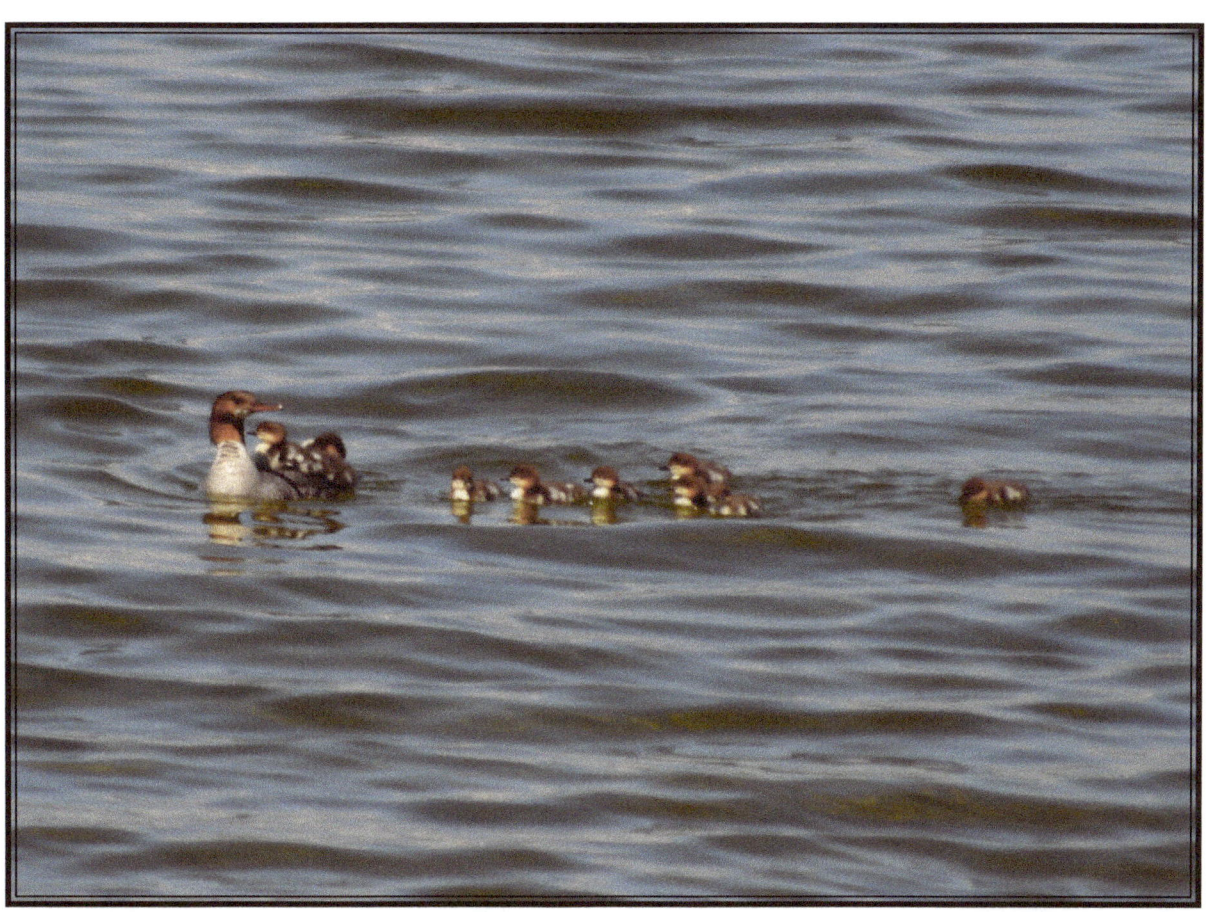

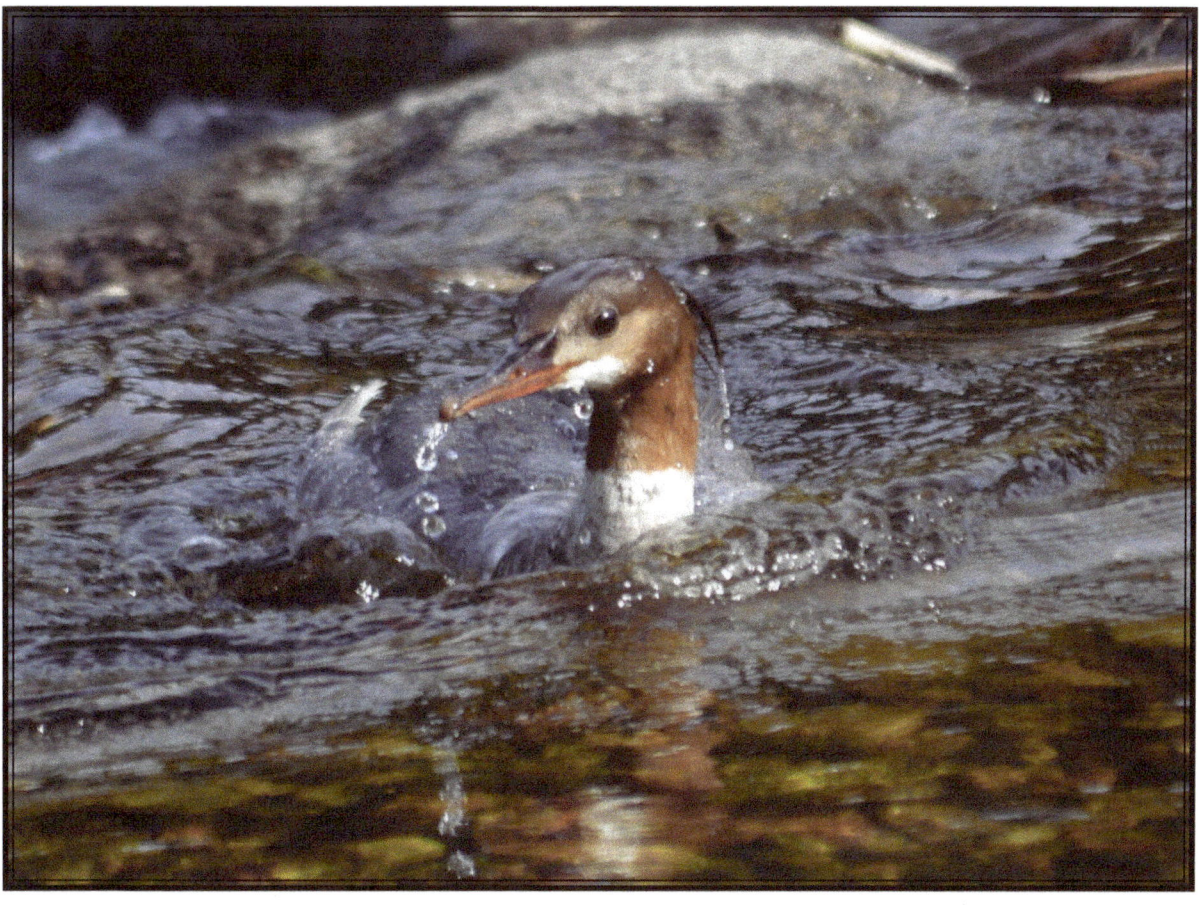

# The Mallard

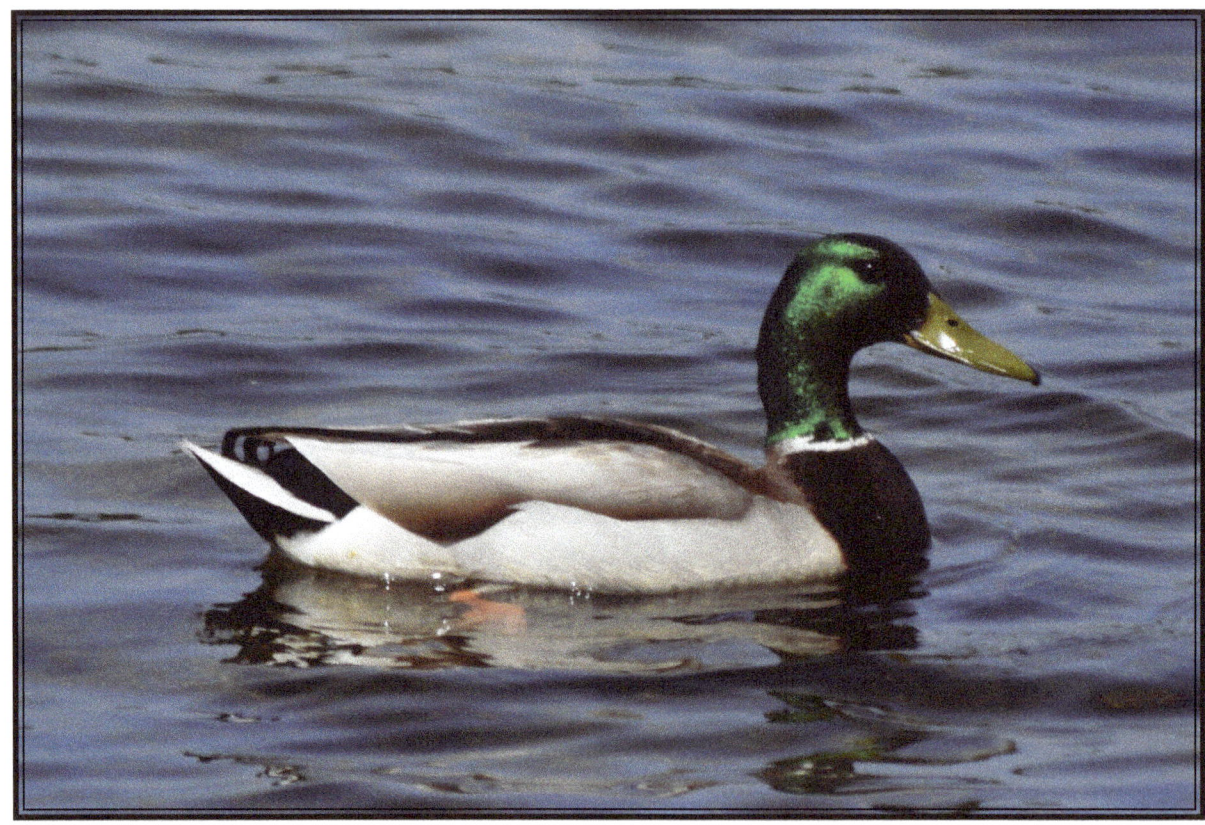

# The Bufflehead

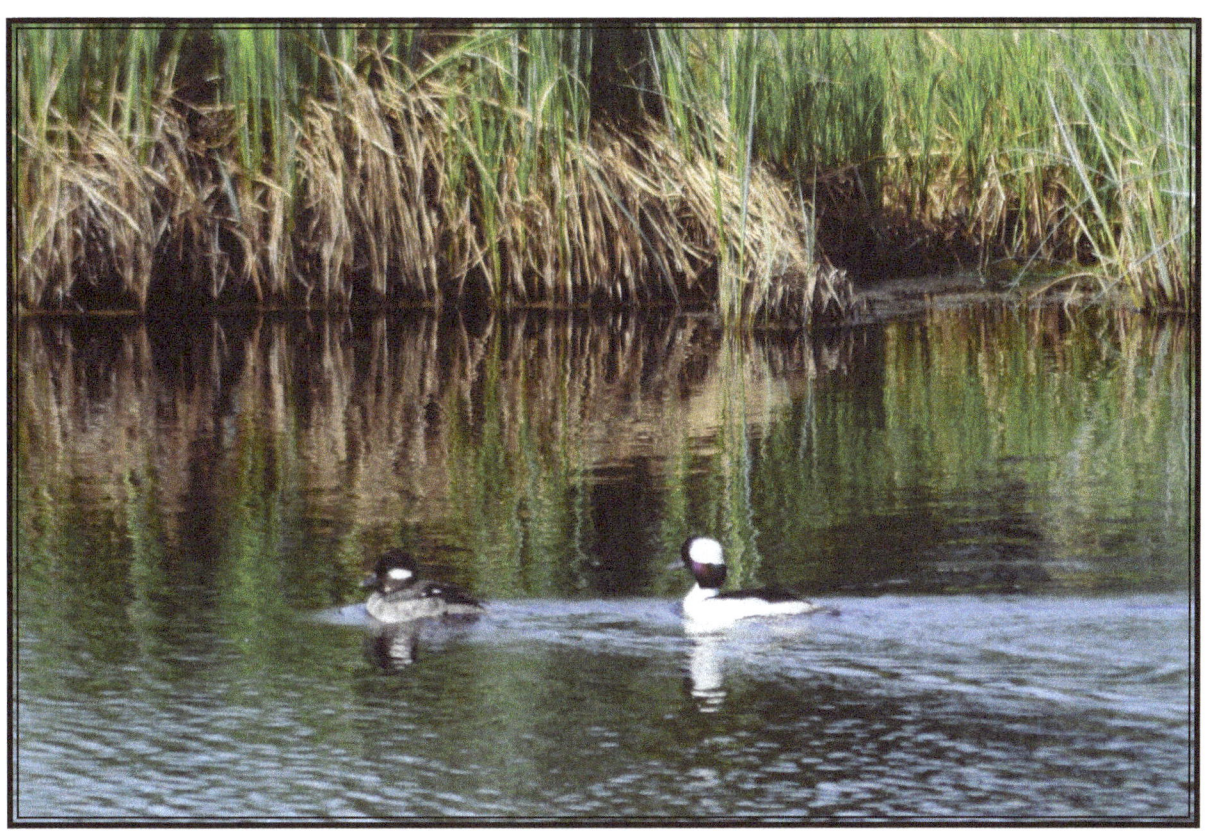

# The Ring-Billed Gull

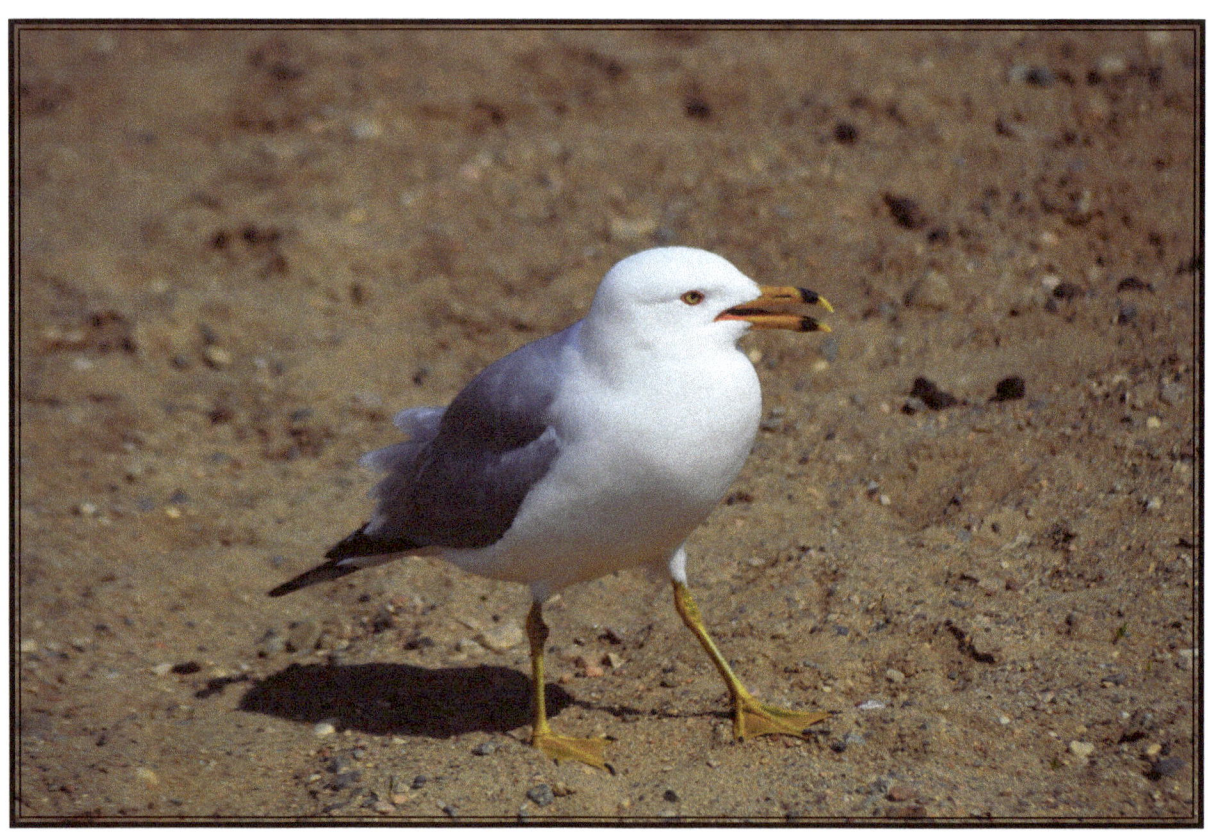

# The Lesser Yellowlegs

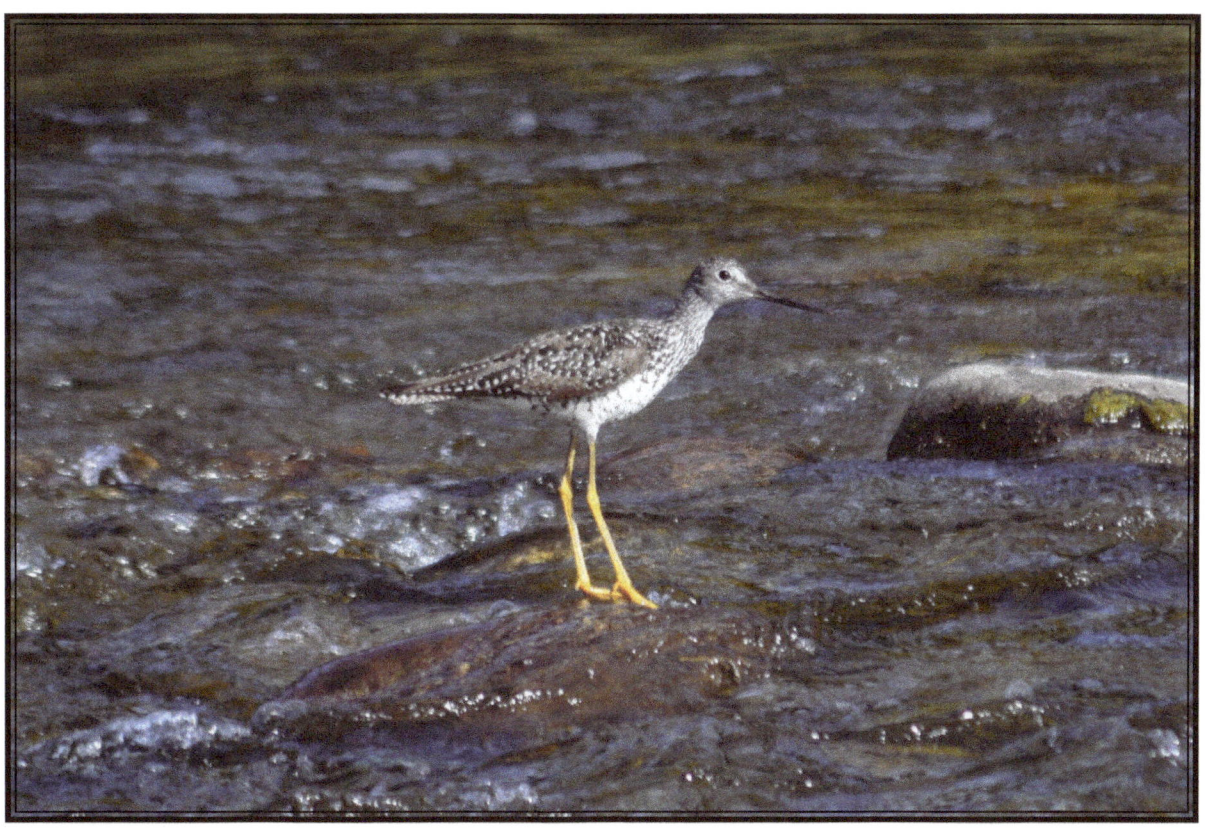

# The Chipping Sparrow

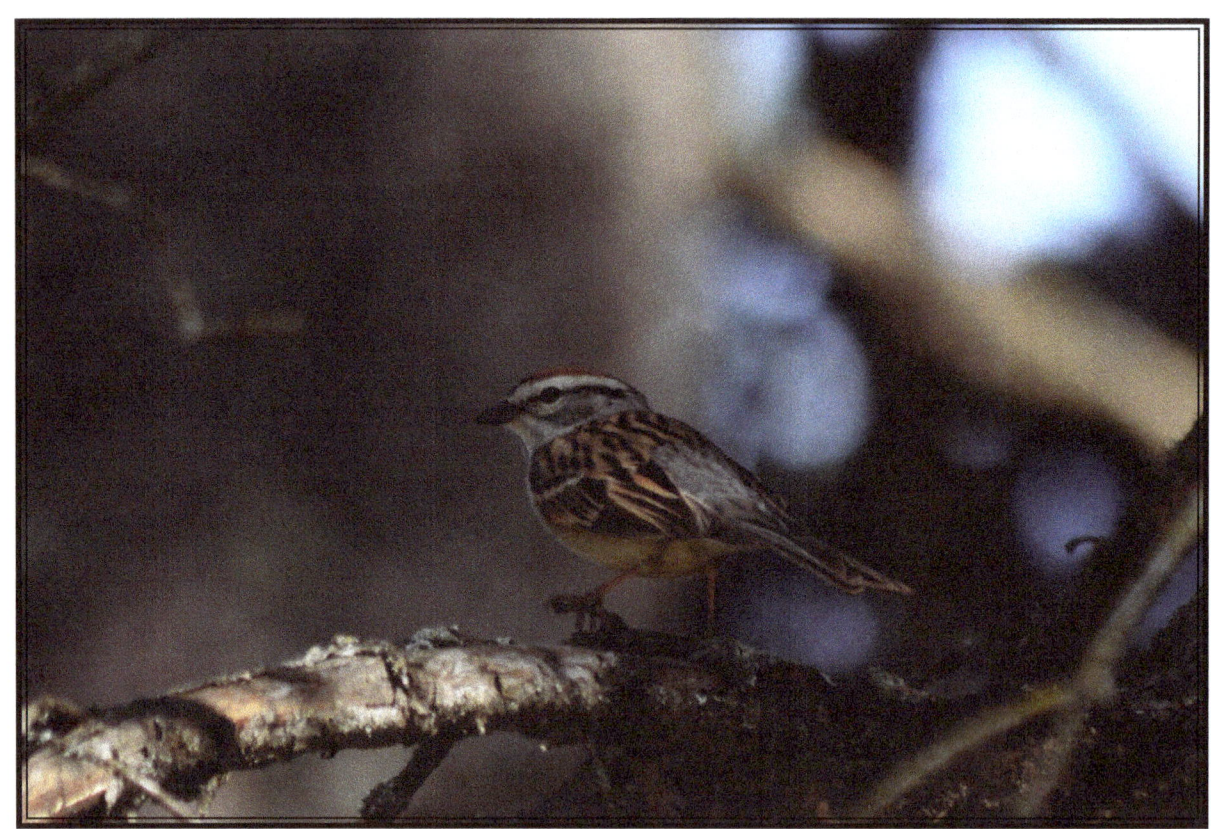

# The Red-Winged Blackbird

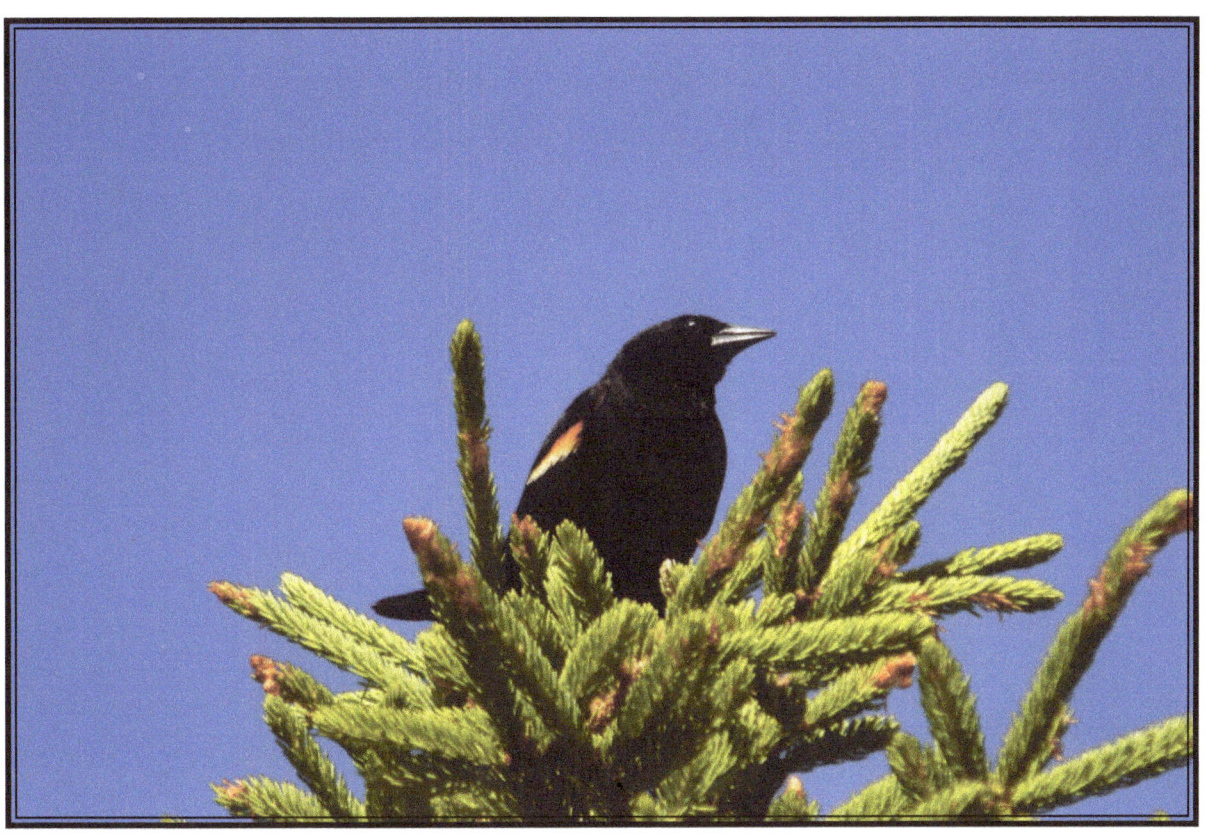

# The Black-Billed Magpie

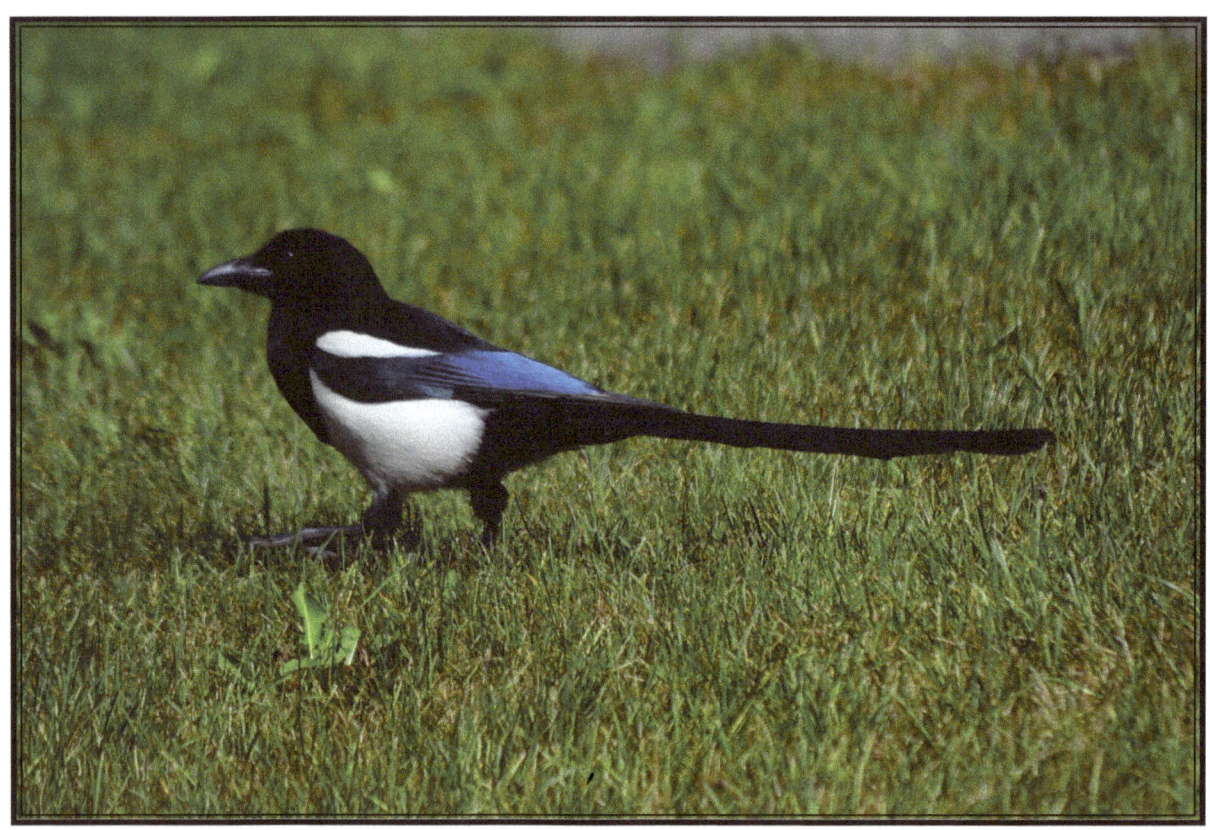

# The American Crow

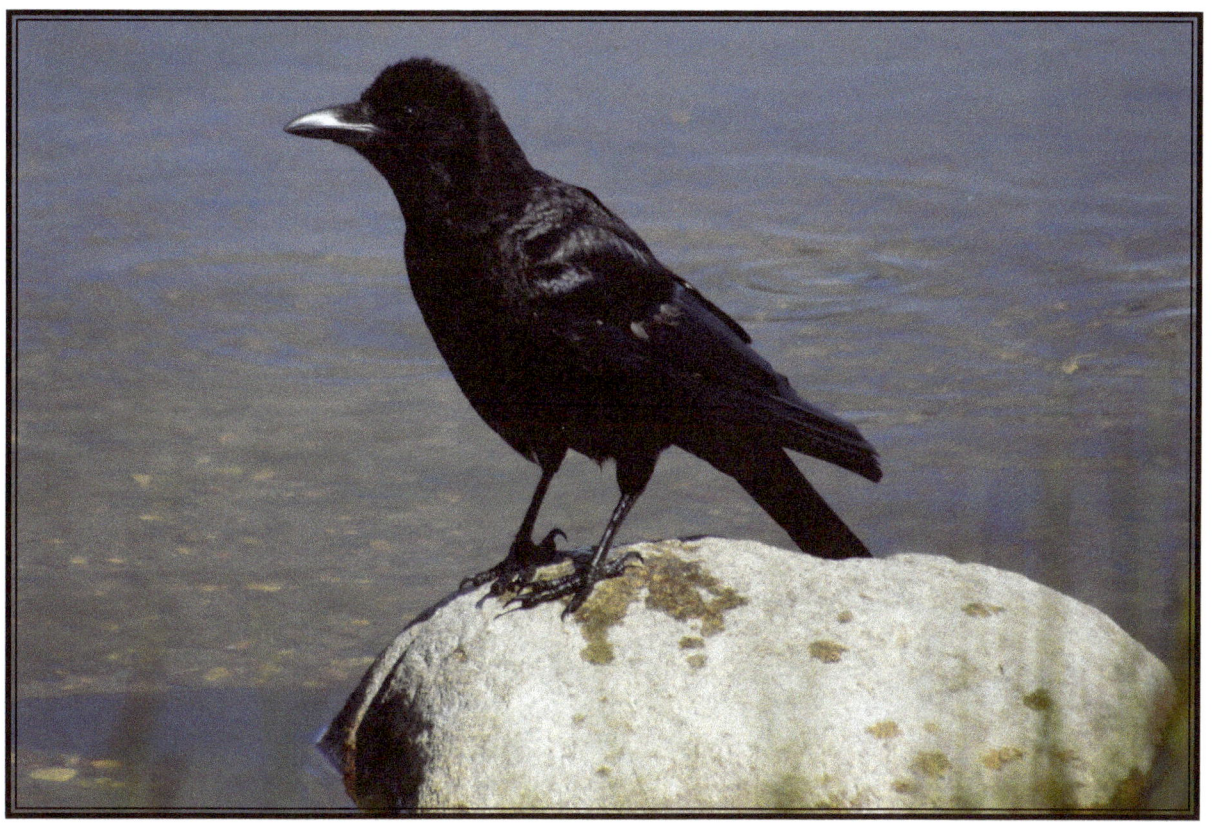

# The Common Merganser

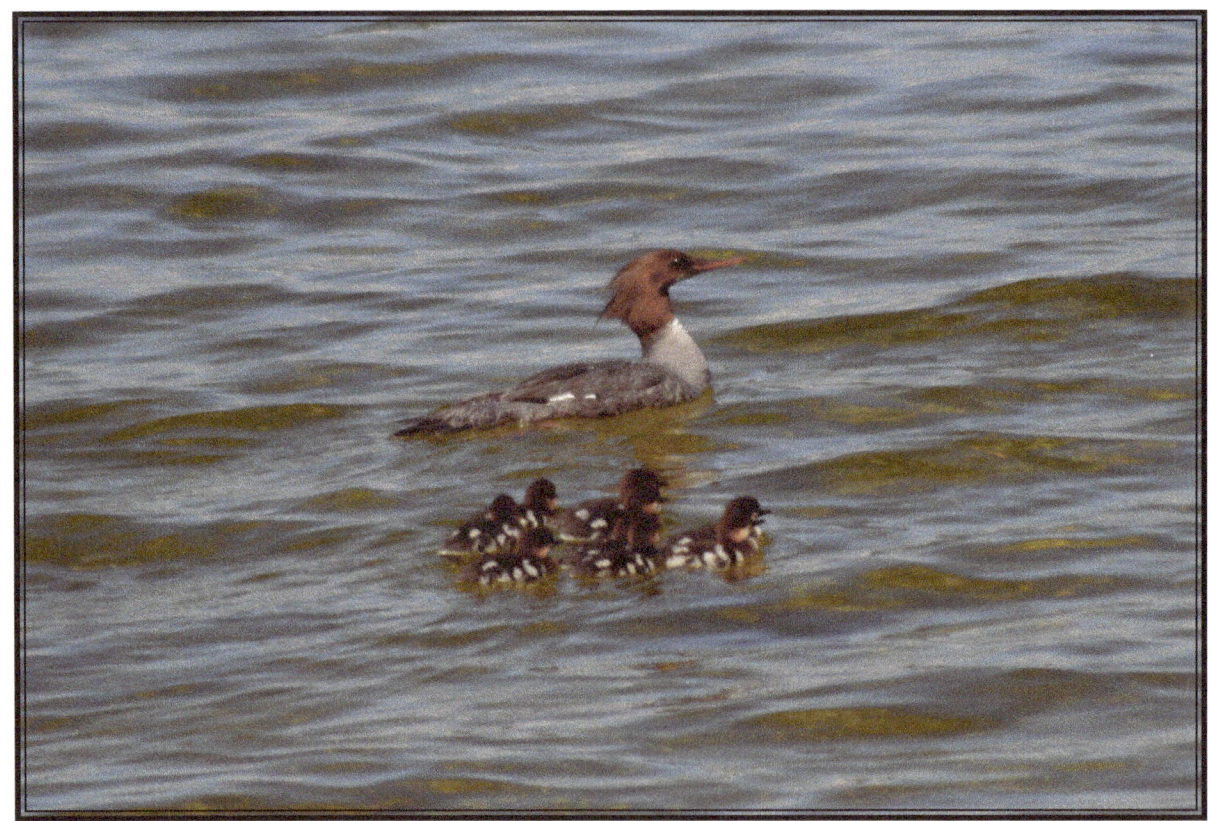

# The Common Goldeneye

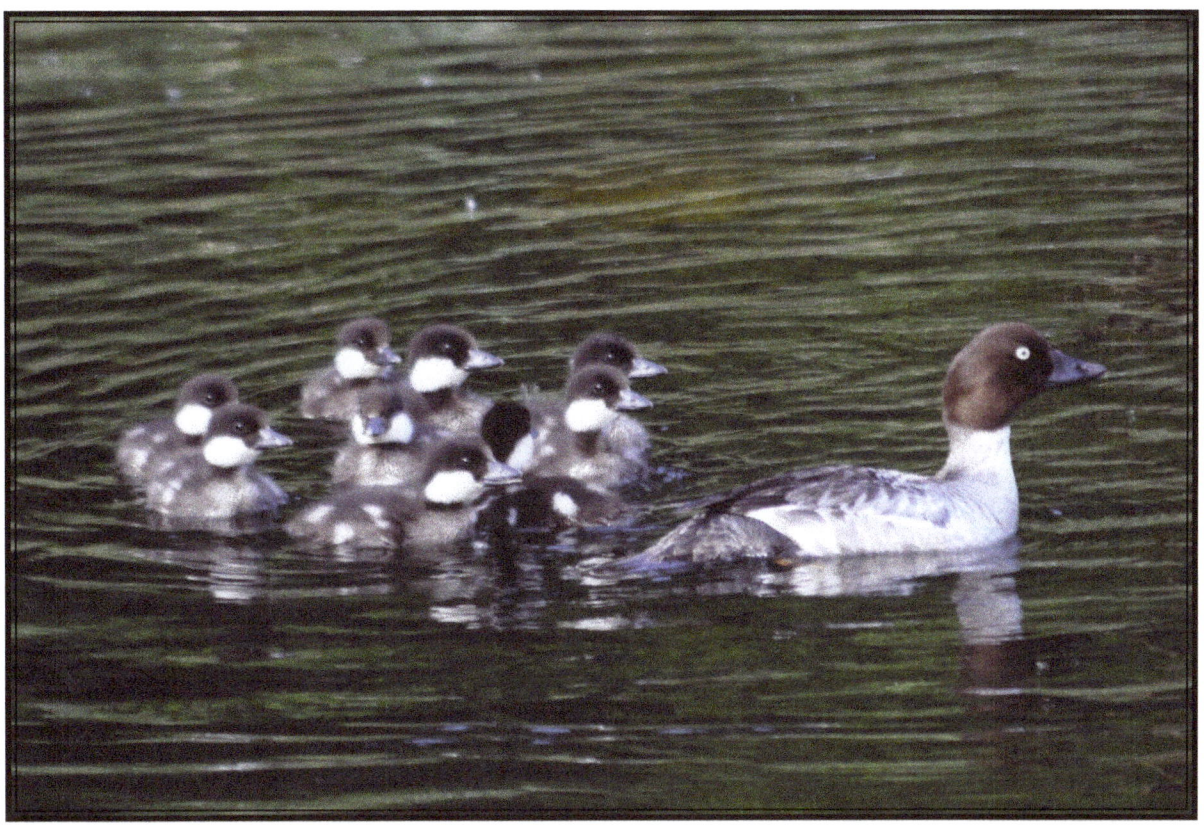

# The Yellow-Bellied Sapsucker

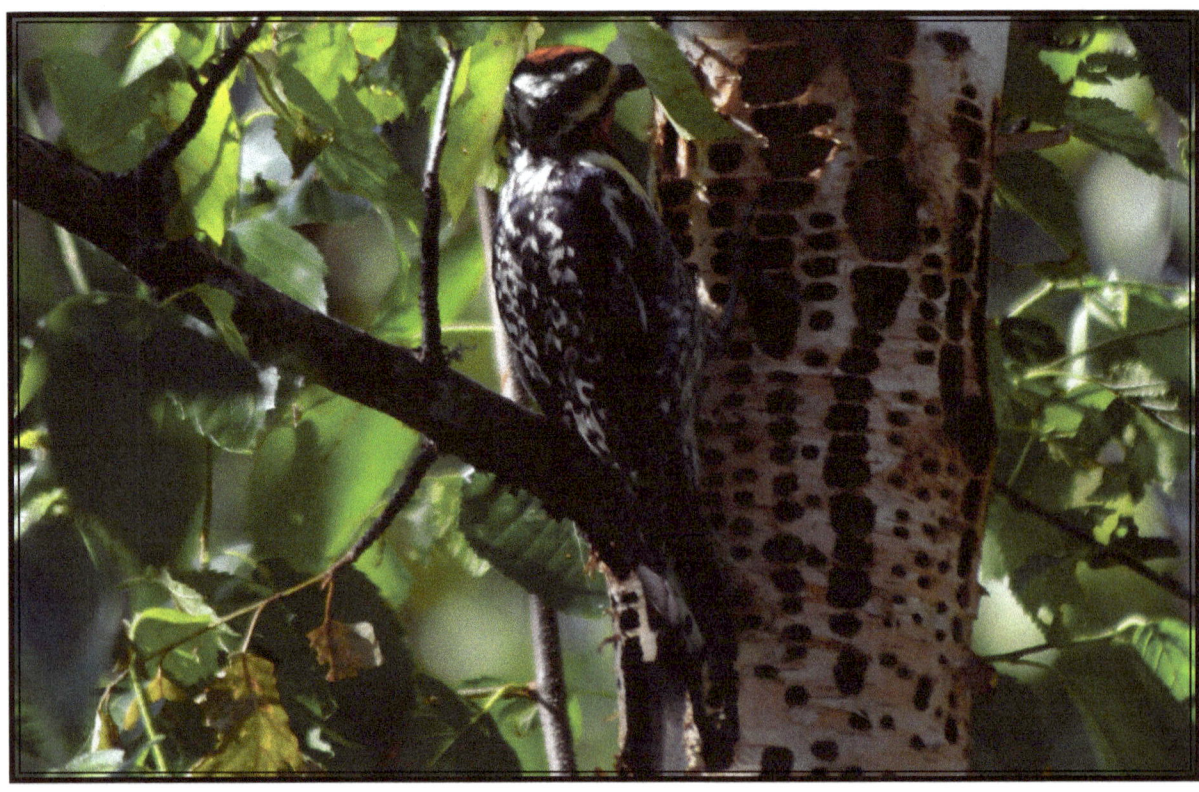

# The Elk

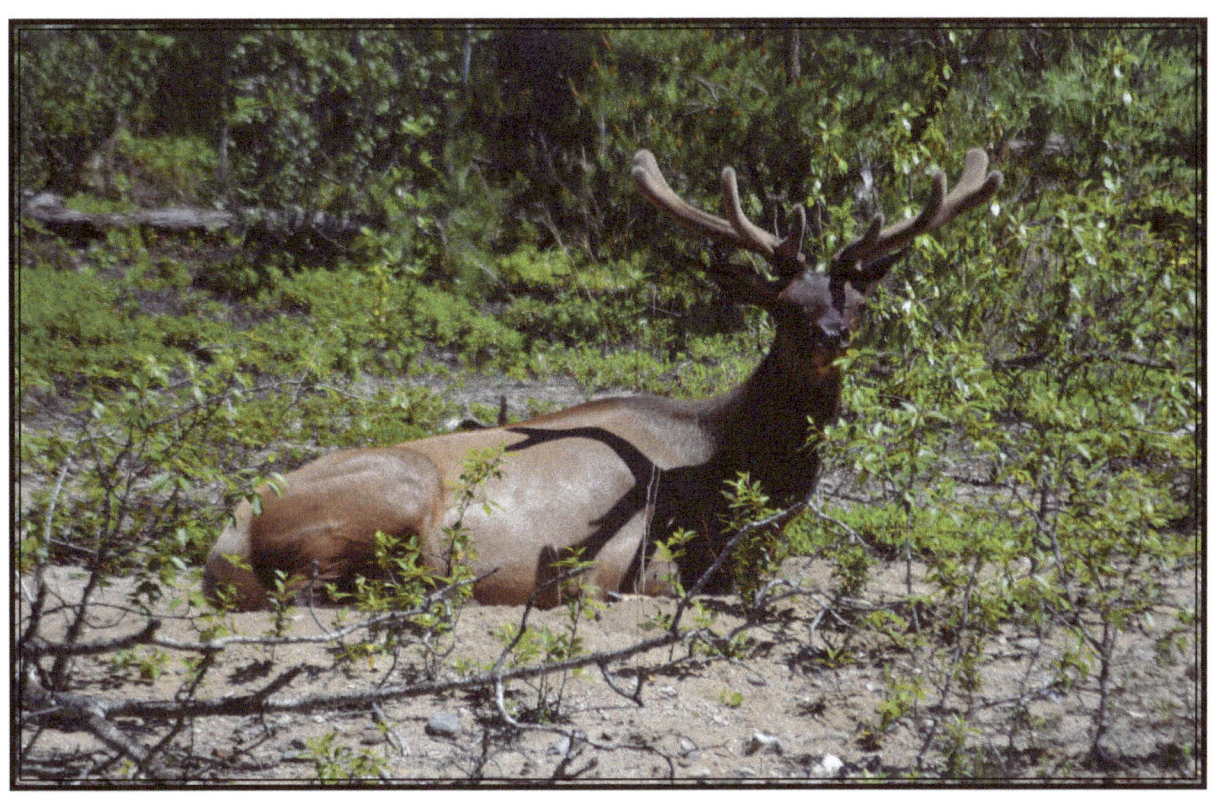

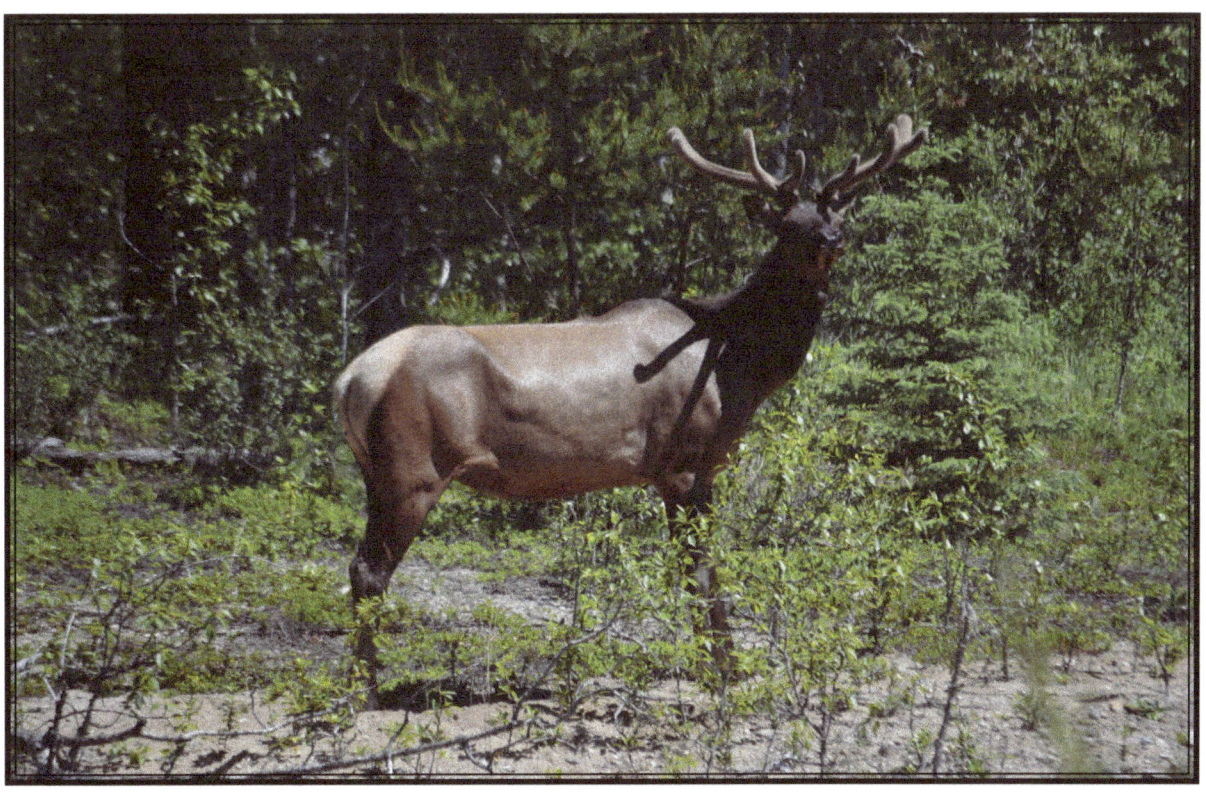

*Flowers*

Another thing that caught my eye when I went back to the park the following year was the amount of flowers that I saw. It was incredible to see the forest covered with flowers, just like a mat.

A couple of example of this was the bunchberry. Last year when I saw bunchberry, I would see many flowers, but this year, I saw a number of bunchberries that made a floral arrangement. It made for a beautiful photo. I also saw another example of this with lady's slippers.

I would see a lady's slipper here and there, but this year I was able to get a picture of twenty lady's slippers in just one bunch.

Not only did I see so many flowers, but I was surprised to find another eighteen different flowers that I did not see the previous year.

Yes, I have quickly learned that each year can be exciting because of the variety of flowers that can be seen, especially when you are looking for them.

Can't wait till next year to see what new and amazing flowers that I can find.

# The Bunchberry

# The Lady's Slippers

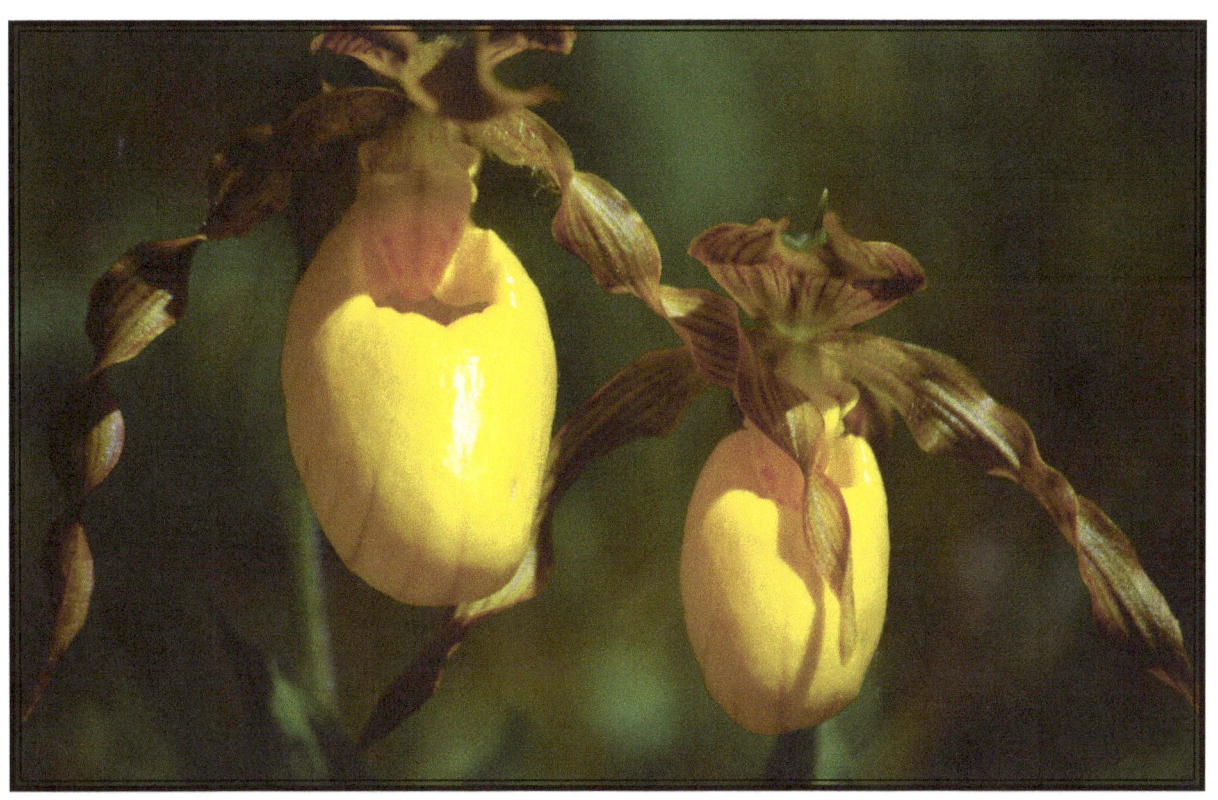

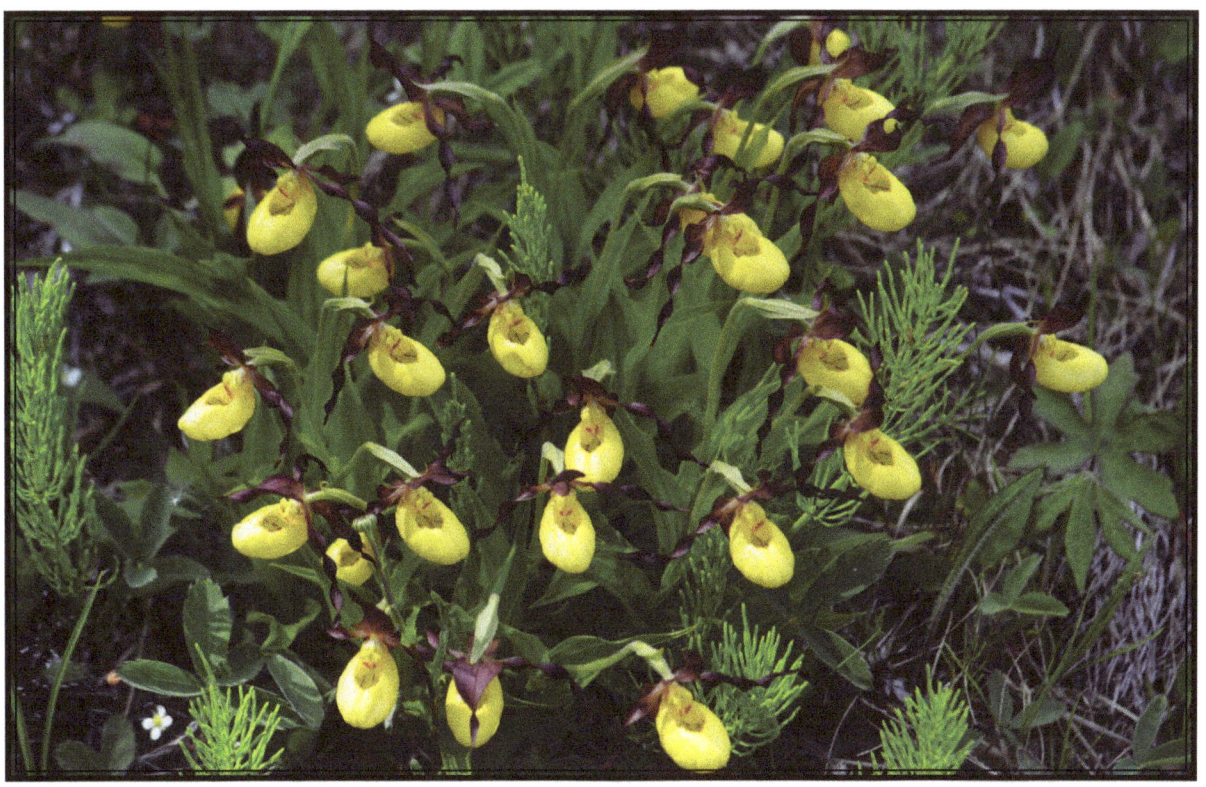

# The Smooth Wild Strawberry

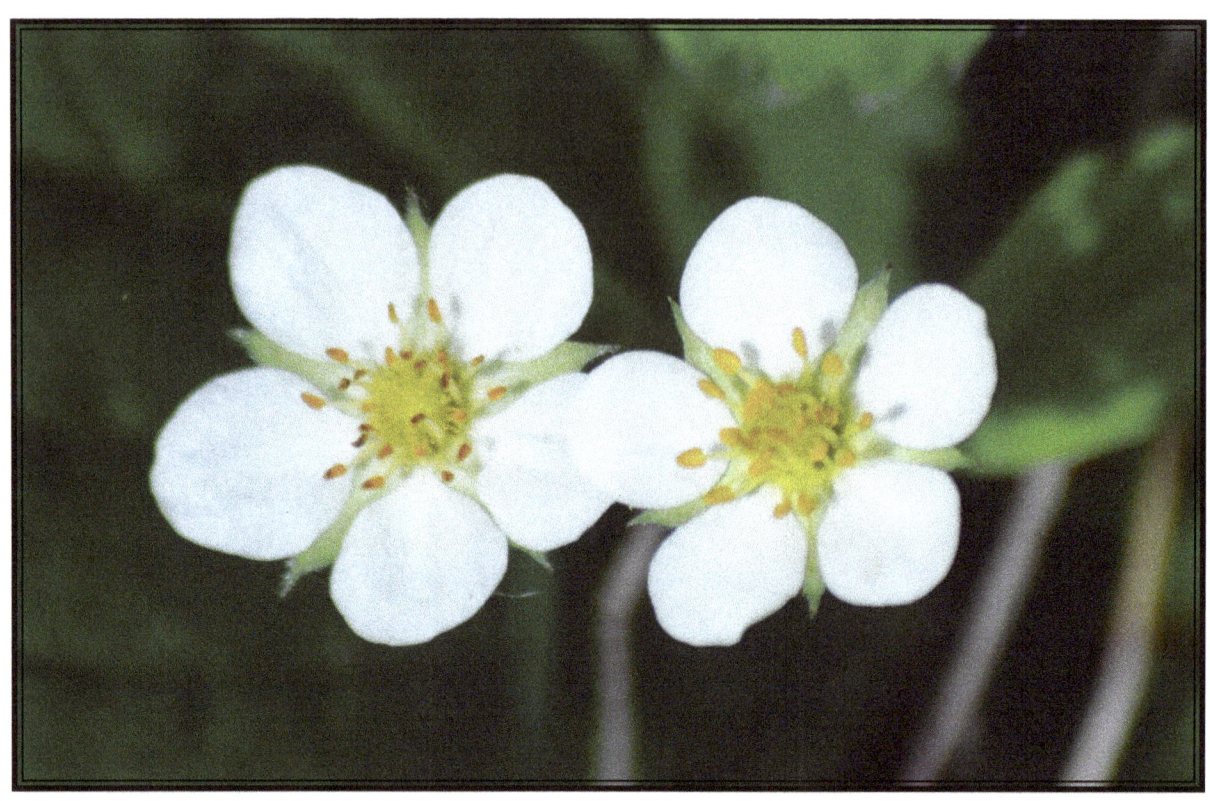

# The Wild Rose

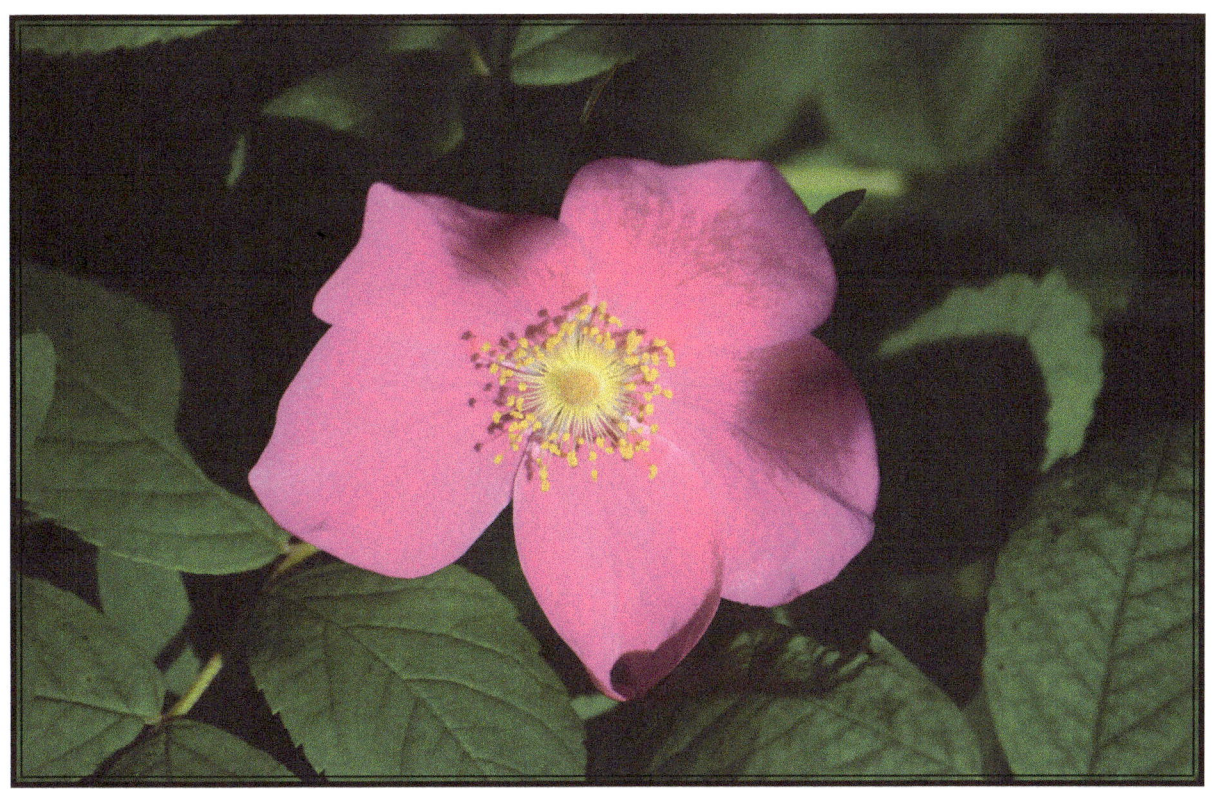

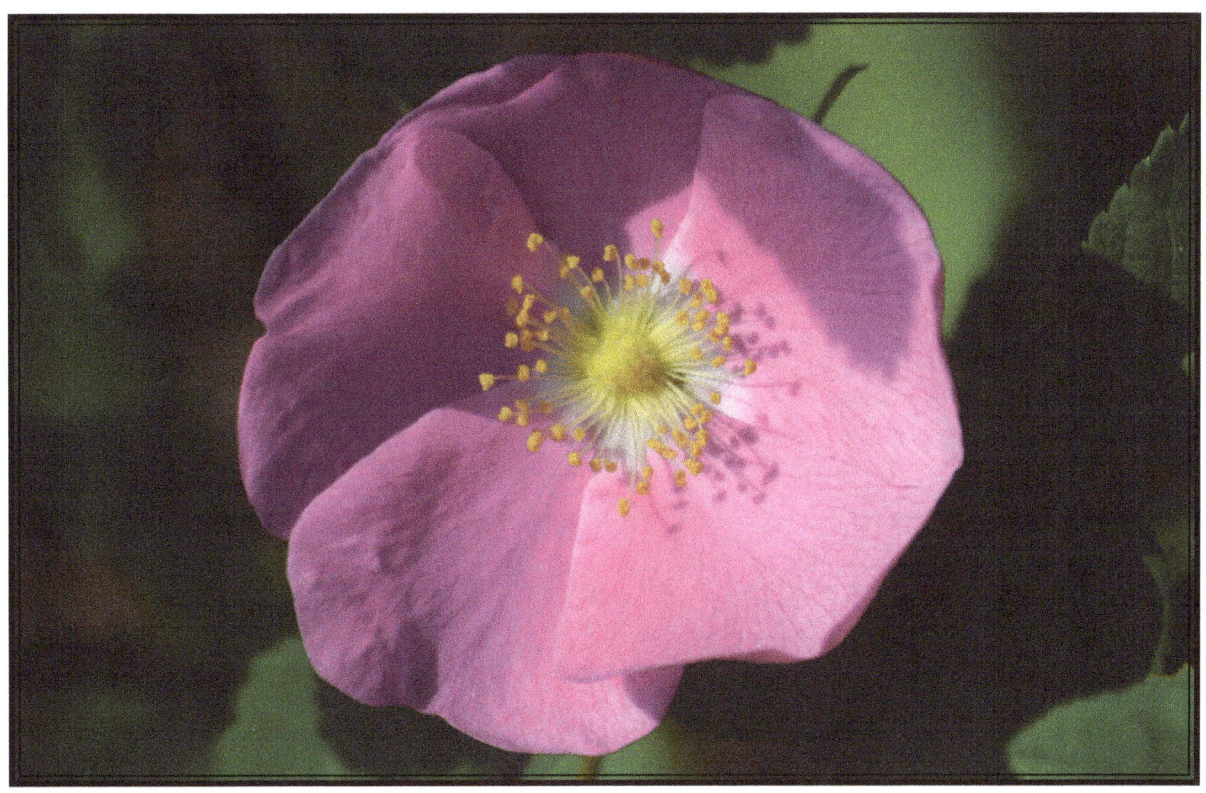

# The Ferns

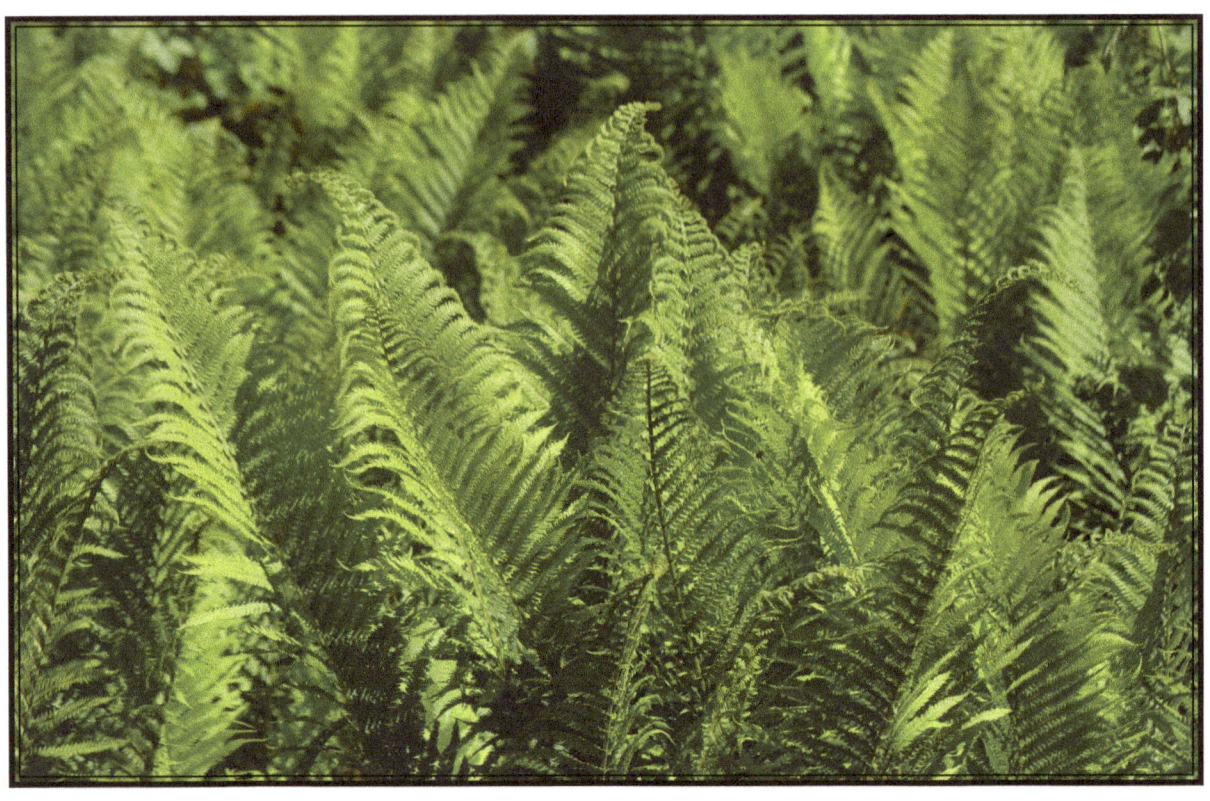

# The Mealy Primrose

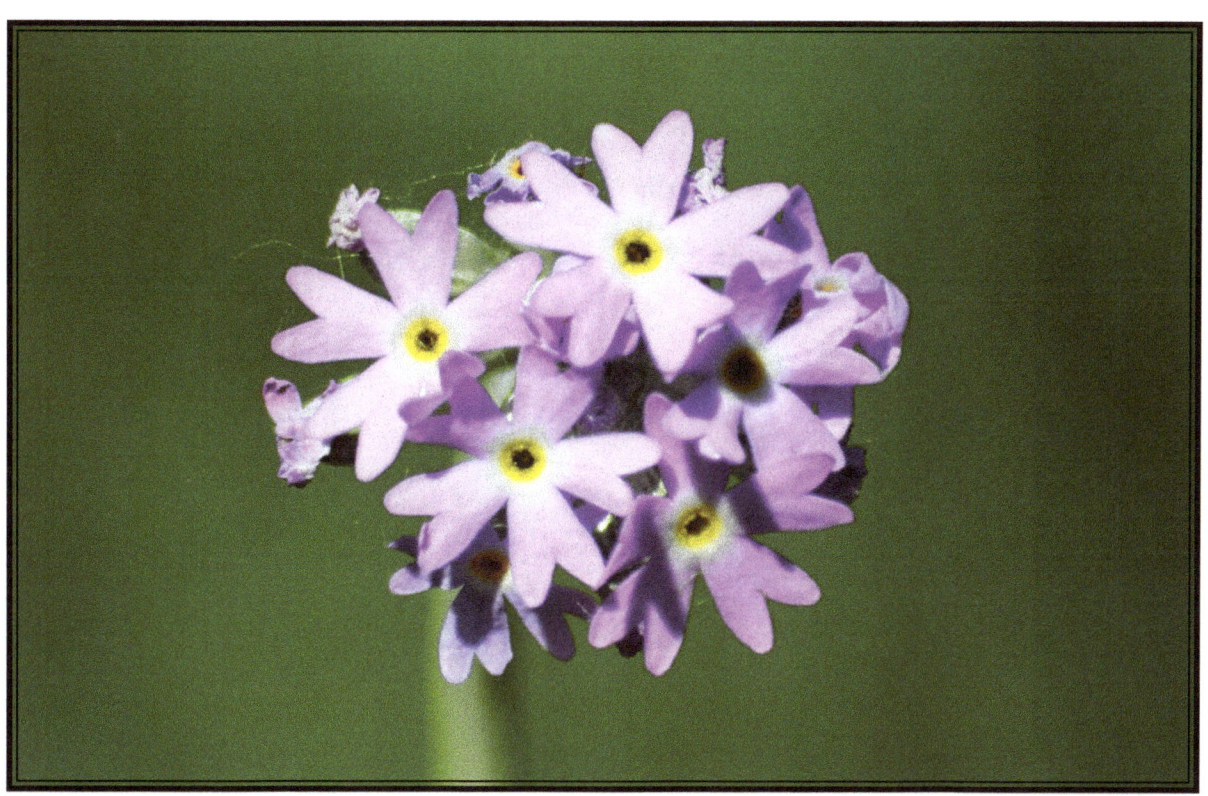

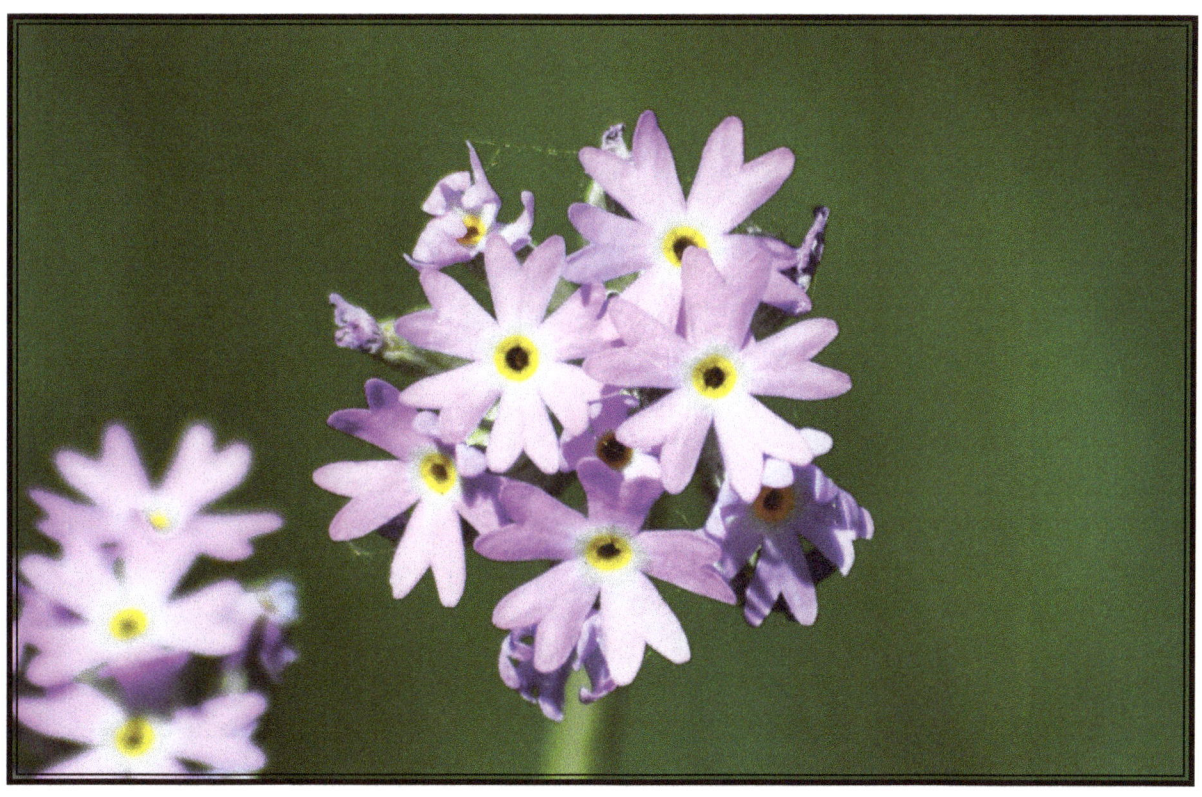

# The Water Arum or Wild Calla

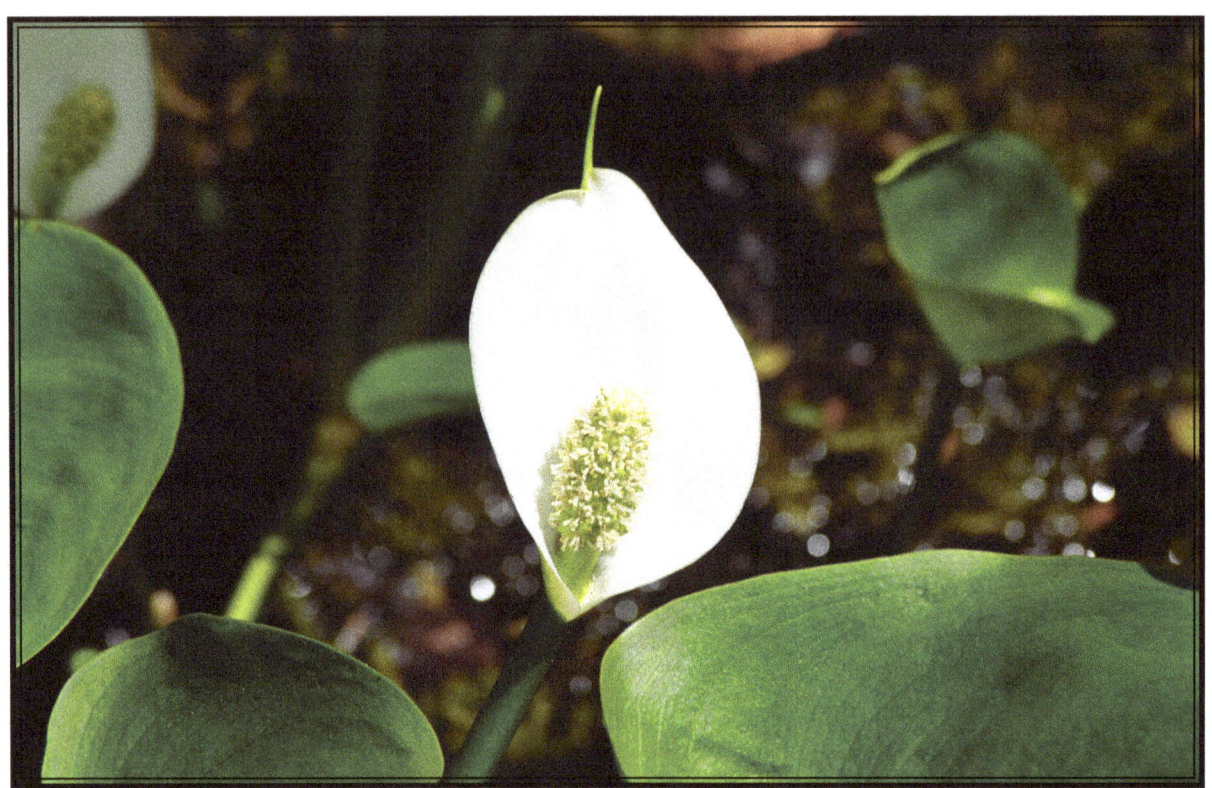

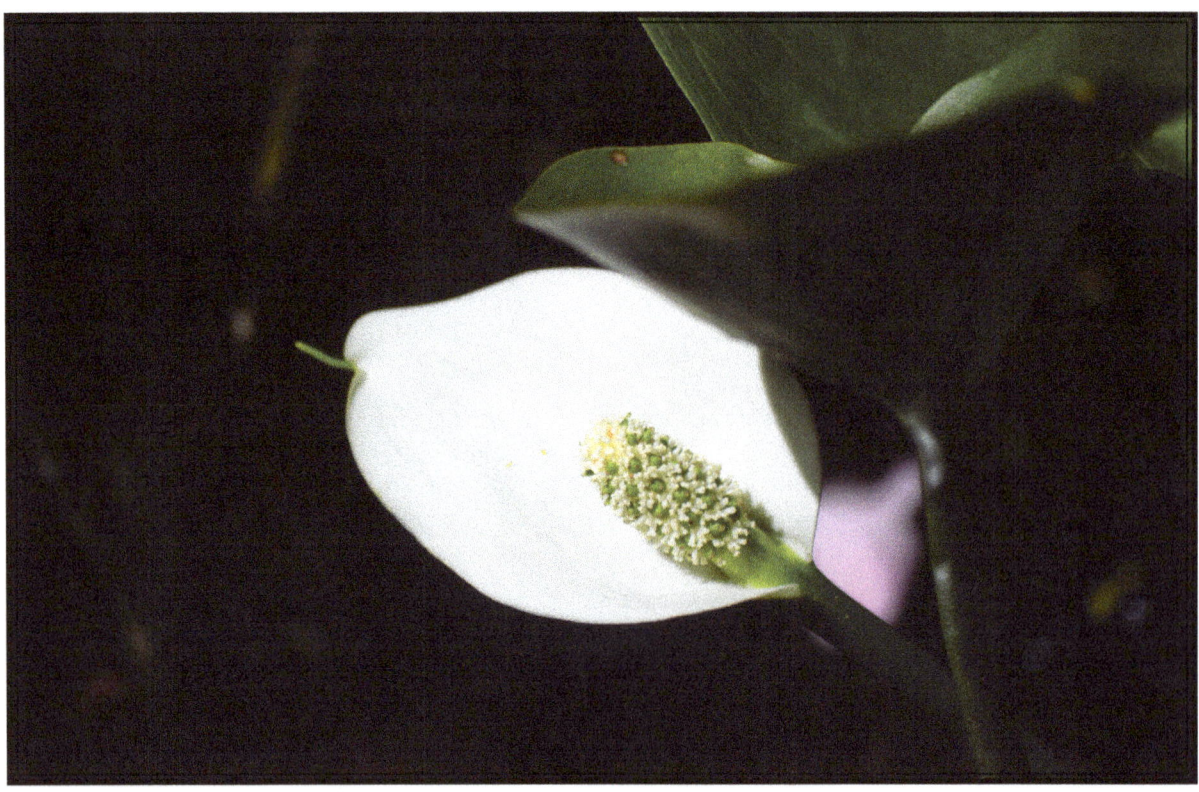

# The Twinflower

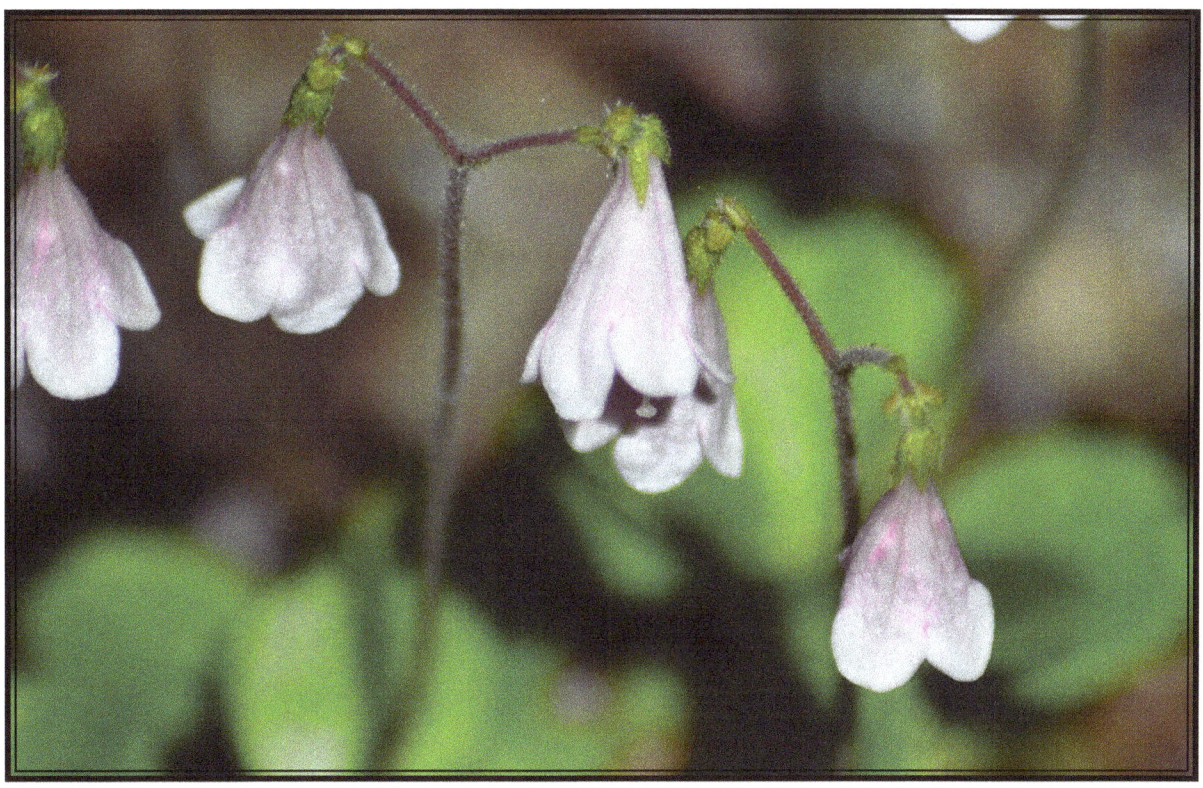

# The Bluebells

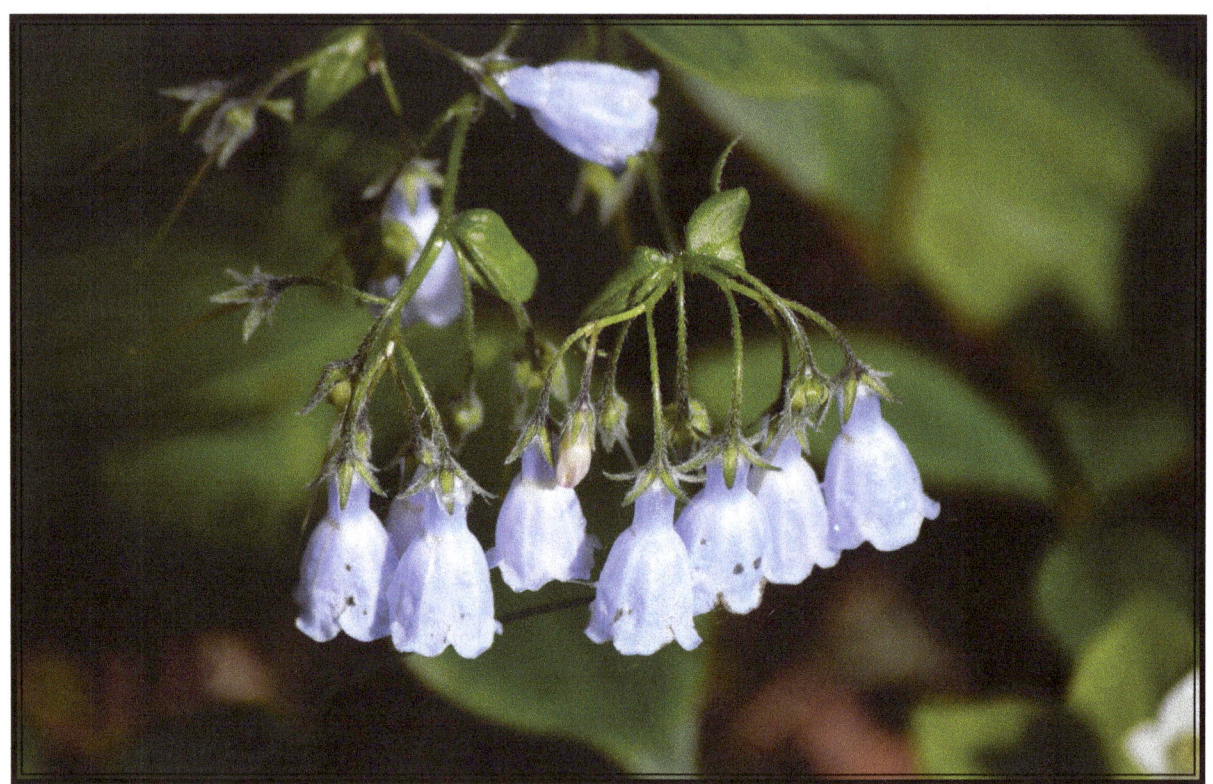

# The Prairie Buttercup

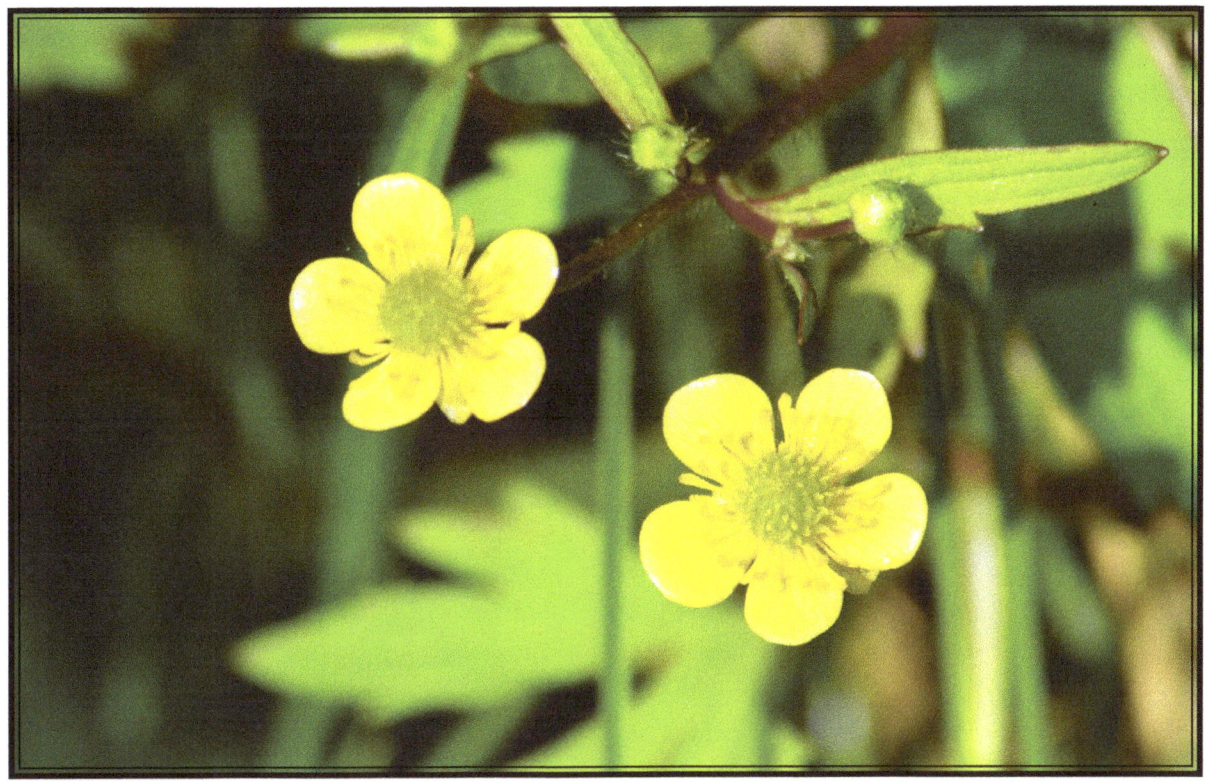

# The Common Silverweed

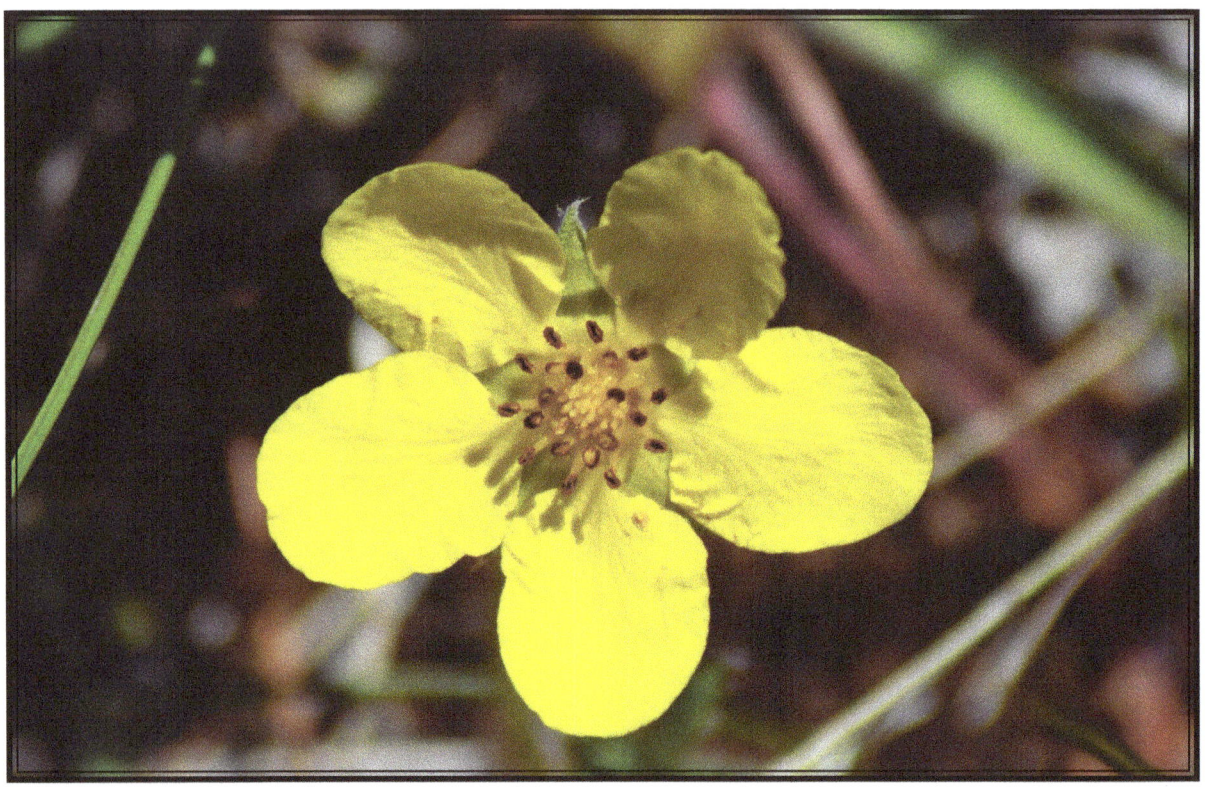

# The Spreading Dogbane

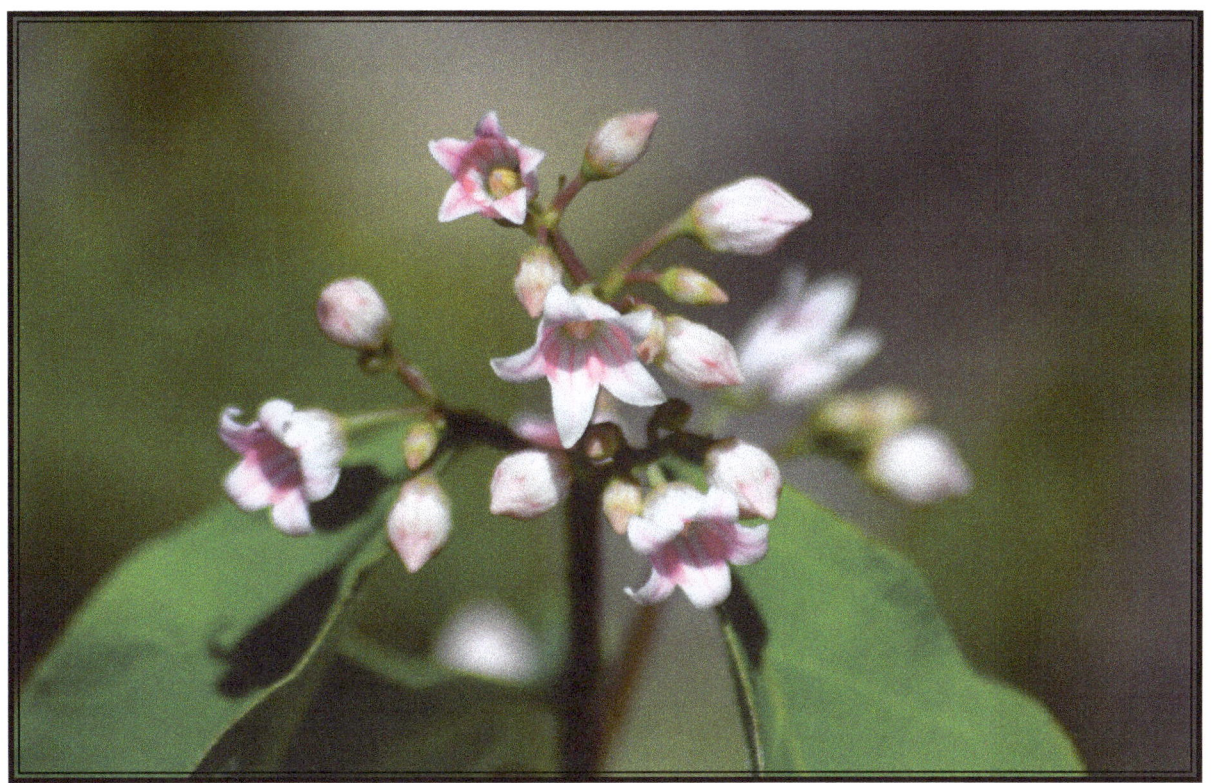

# The Round-Leaved Orchis

# The Canada Anemone

# The Red-Osier Dogwood

# The Scorpionweed

# The Marsh Skullcap

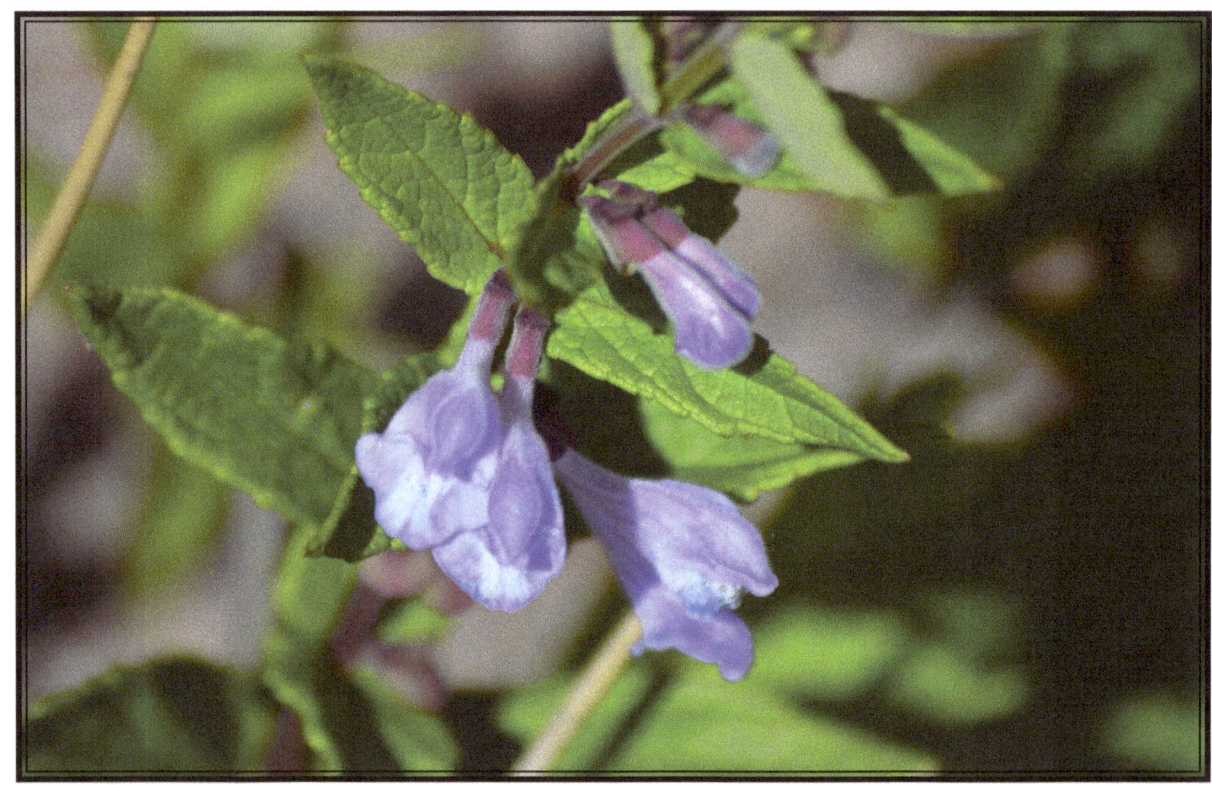

# The Common or Swamp Buttercup

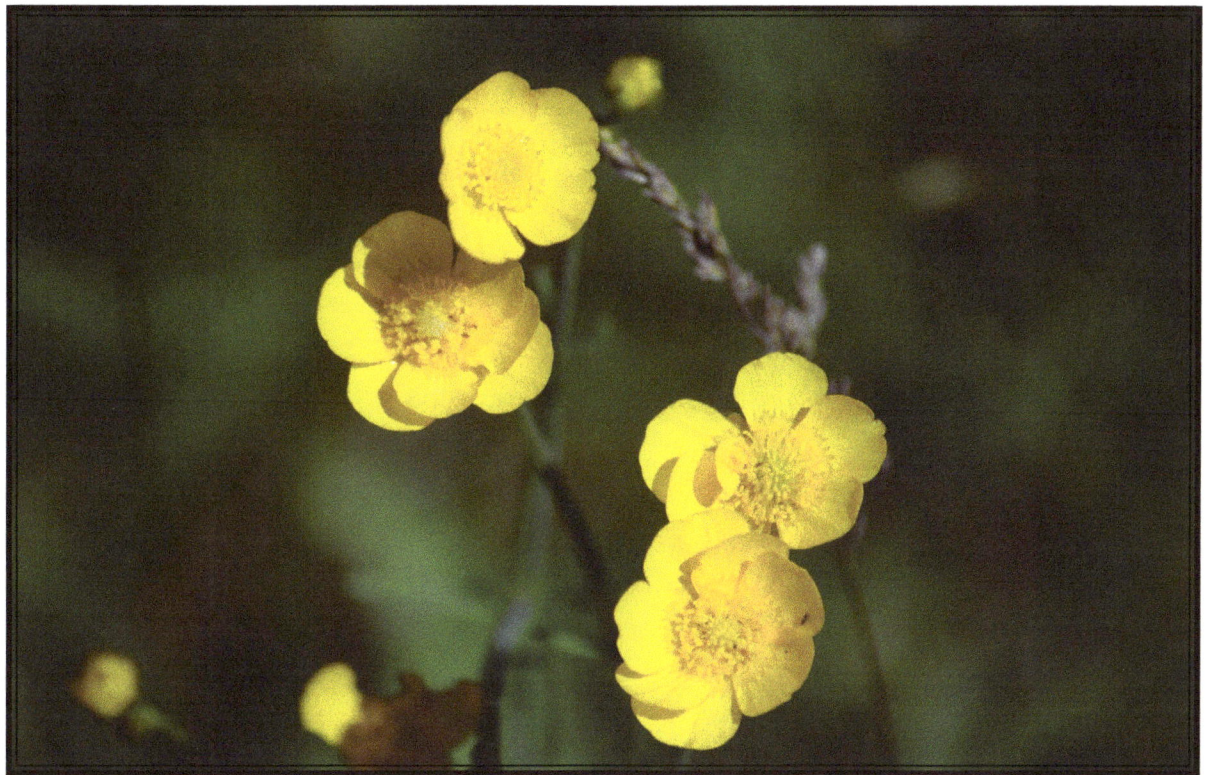

# The Honeysuckle

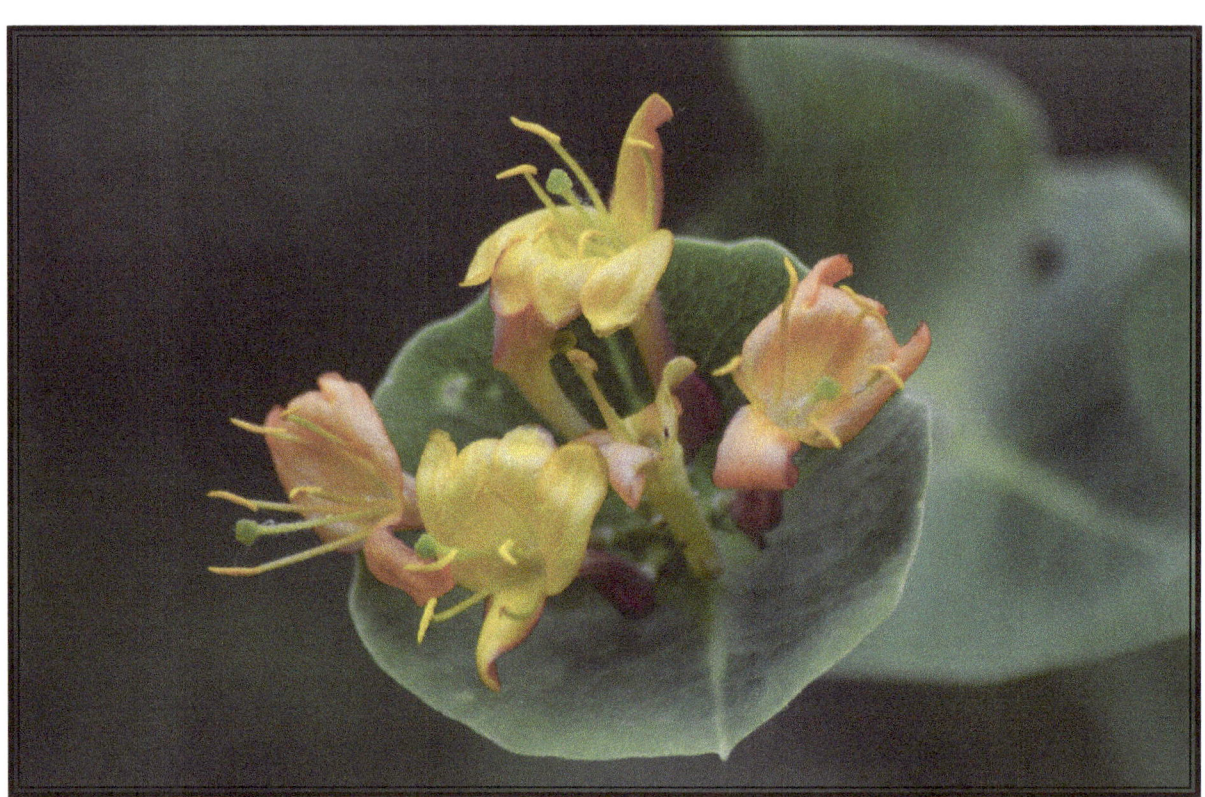

# The Wild Chamomile

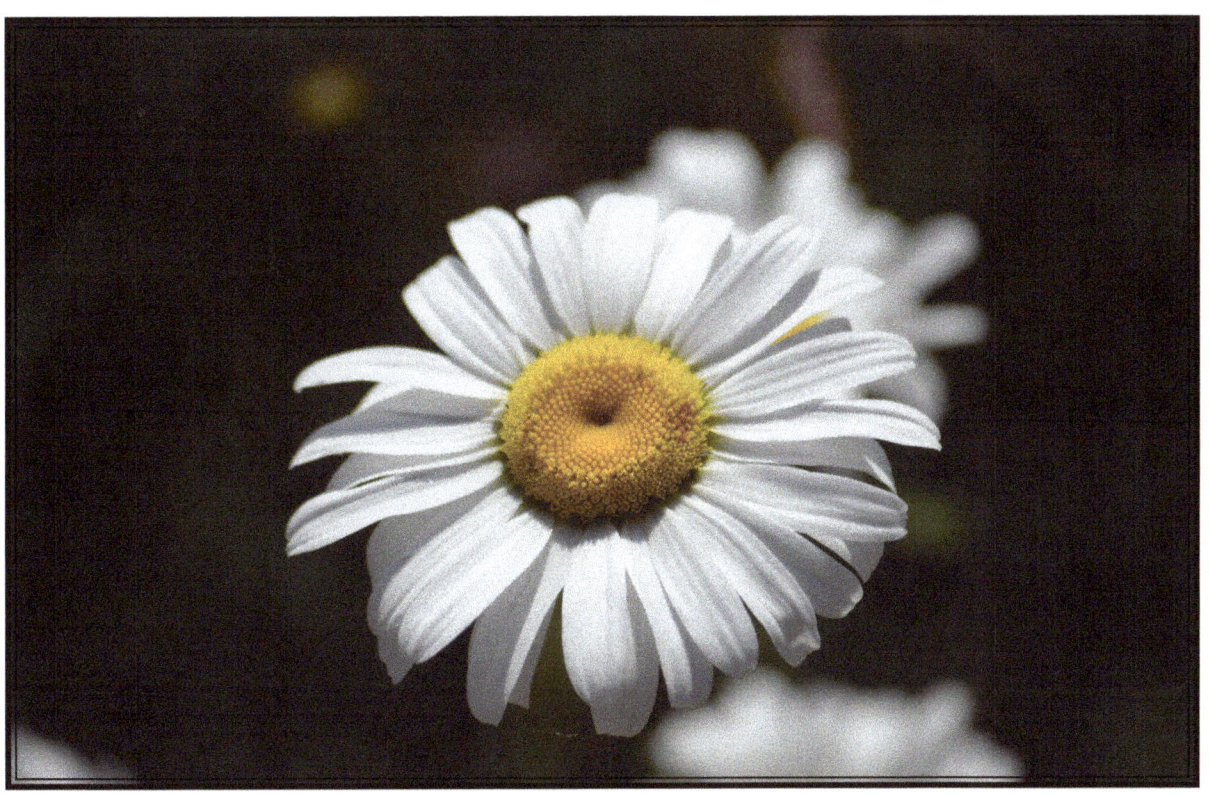

# The Tufted Loosestrife

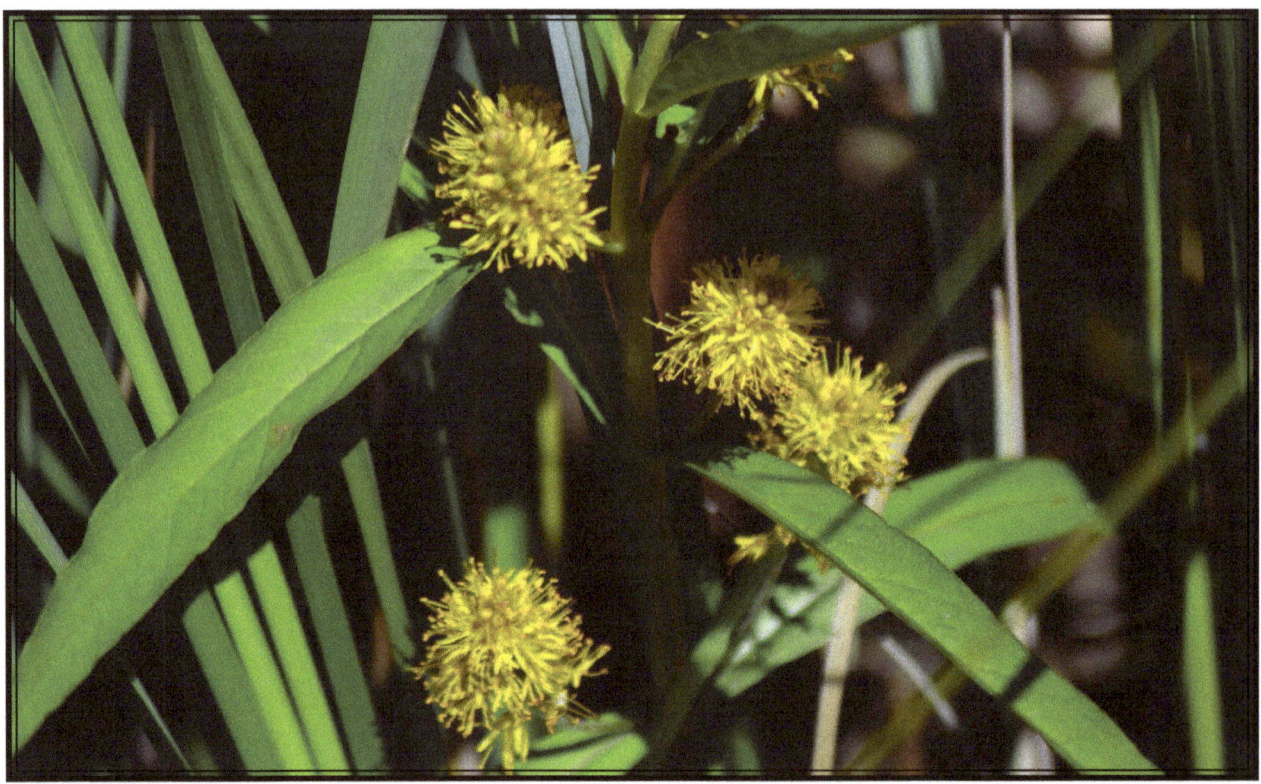

When I visit the park, I can never get enough photographs of black bears and common loons. This year was a very special year for me because of the amazing photographs that I was able to take of these incredible wildlife.

I was especially privileged to be able to get some amazing pictures of the common loon. What certainly helped me was the fact that I was able to get so close to them. I noticed that they came by the water-break in order to catch the fish that swam between it and the dock. One day I happened to be walking and noticed the common loon swimming around there, so I hide myself behind the light that is on the end of the water-break. I was thrilled and amazed that it swam only four or five feet from where I was standing. WOW!

Since the photographs that I was able to get was so much better than the photographs that I was able to get last year that I had to put them in my book. The common loon surely made these pictures truly amazing.

I also was able to take some amazing photographs of a black bear that I saw at the park. I was able to photograph him in about the same area as the pictures that I took of the two cubs with its mother.

Could this be one of those cubs?

The black bear that I was able to photograph this year looks like it could be a year old, in my opinion. This would be pretty special if this is indeed the case, if not, I still had to put him in my book. ENJOY these amazing animals, the common loon and the black bear.

# The Common Loon

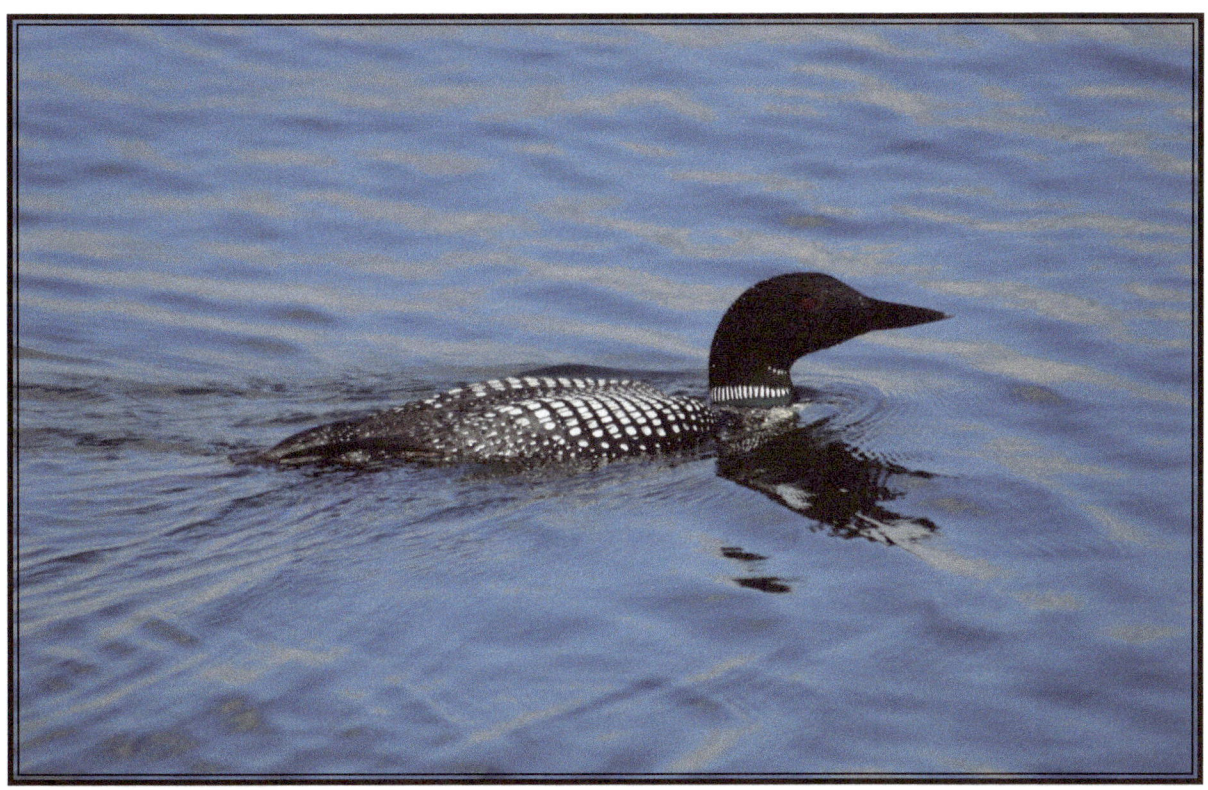

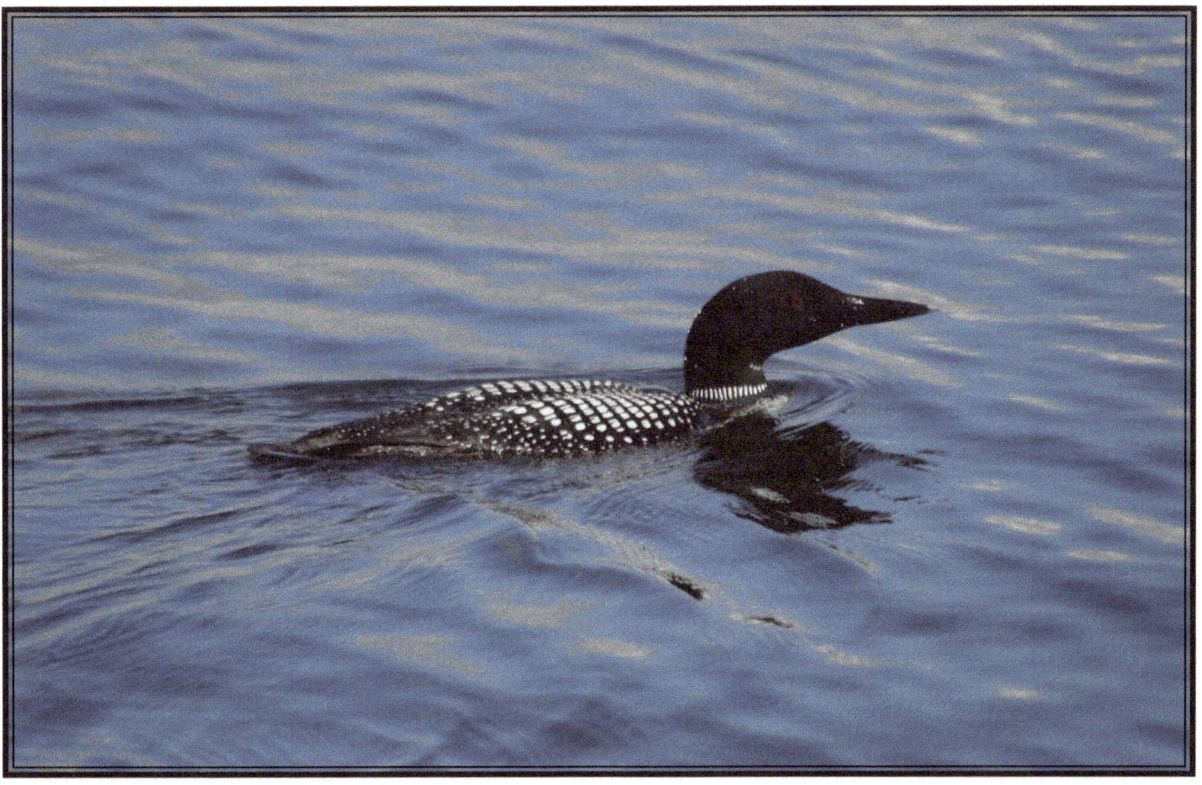

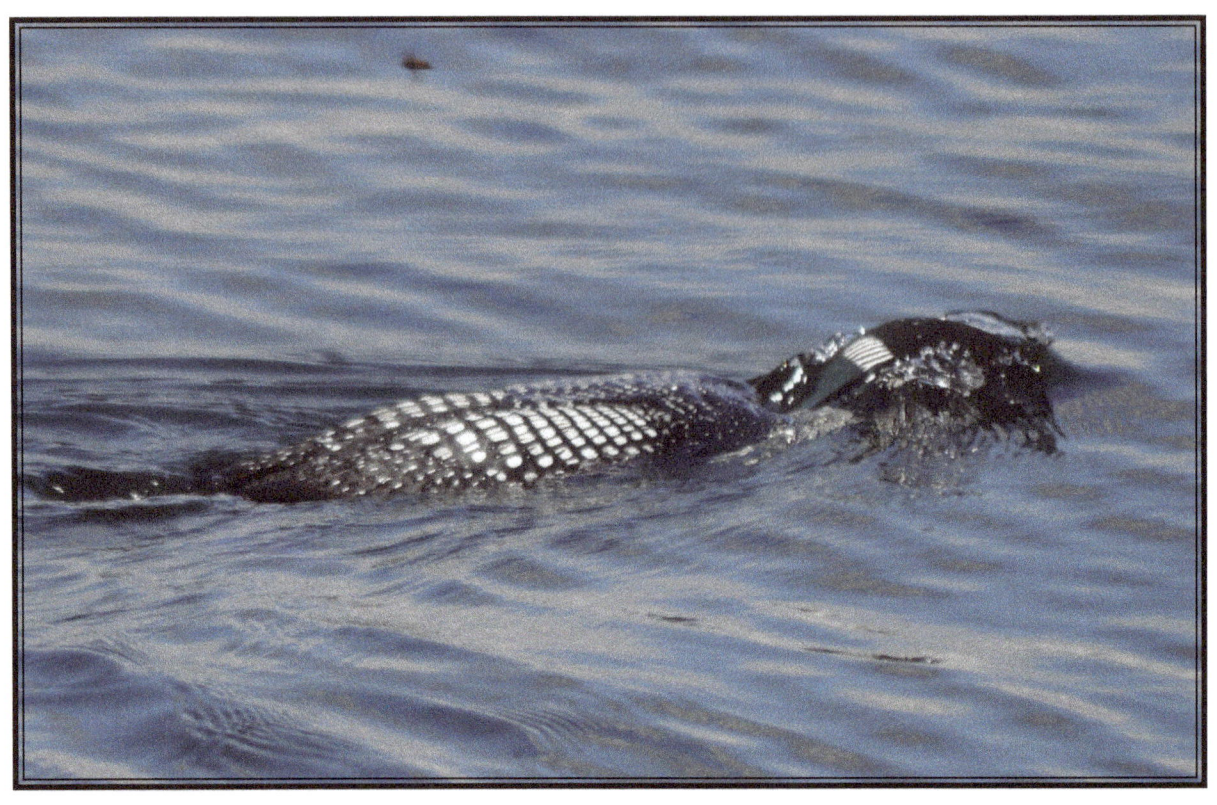

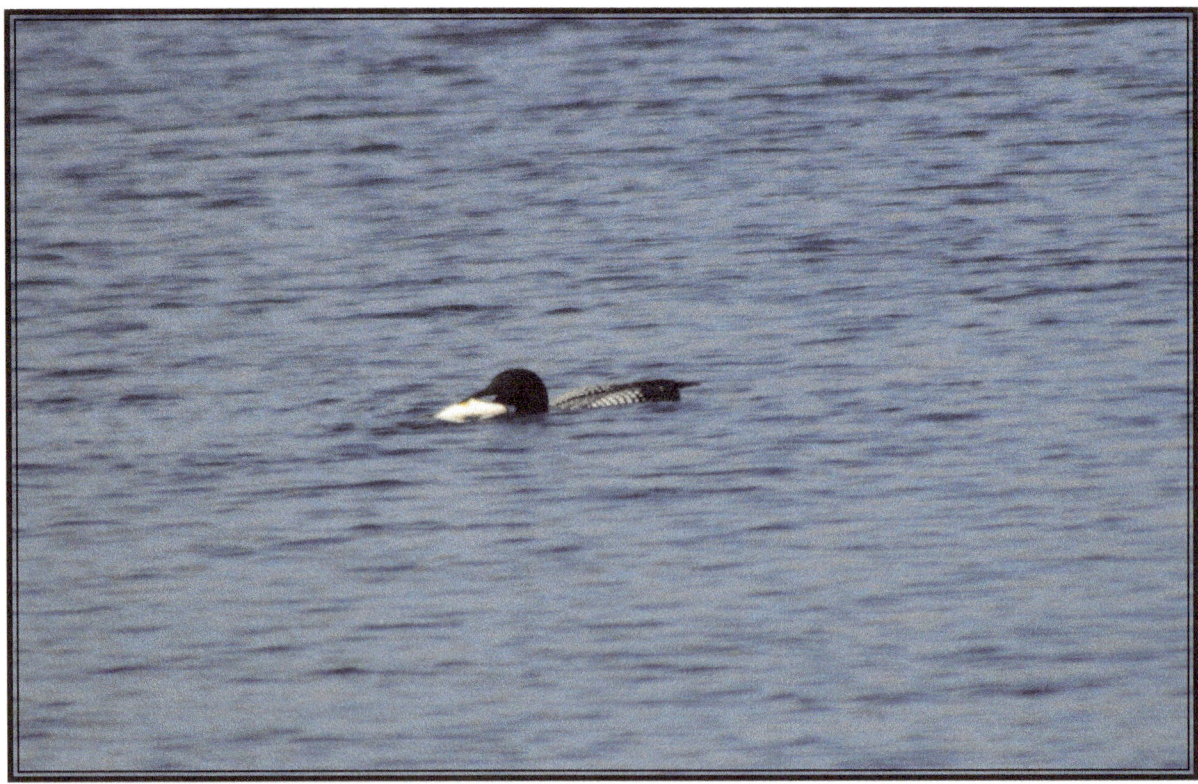

# The Black Bear

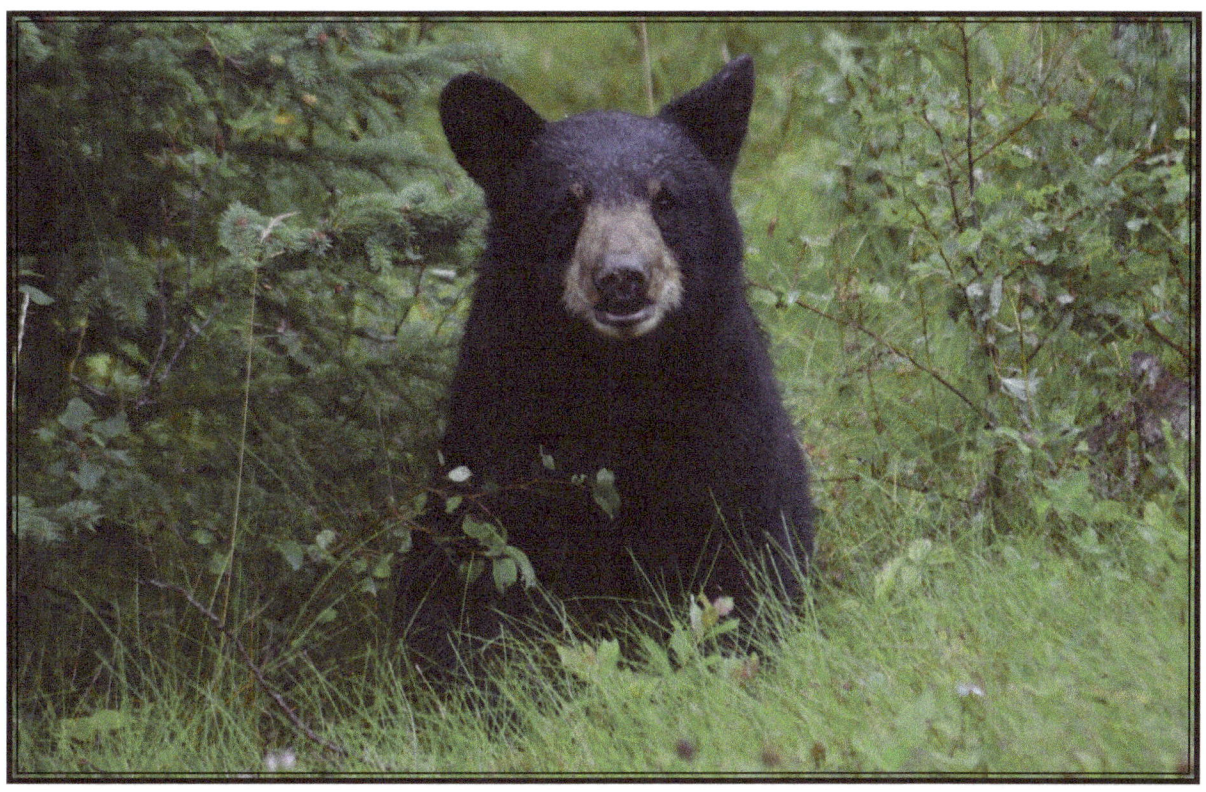

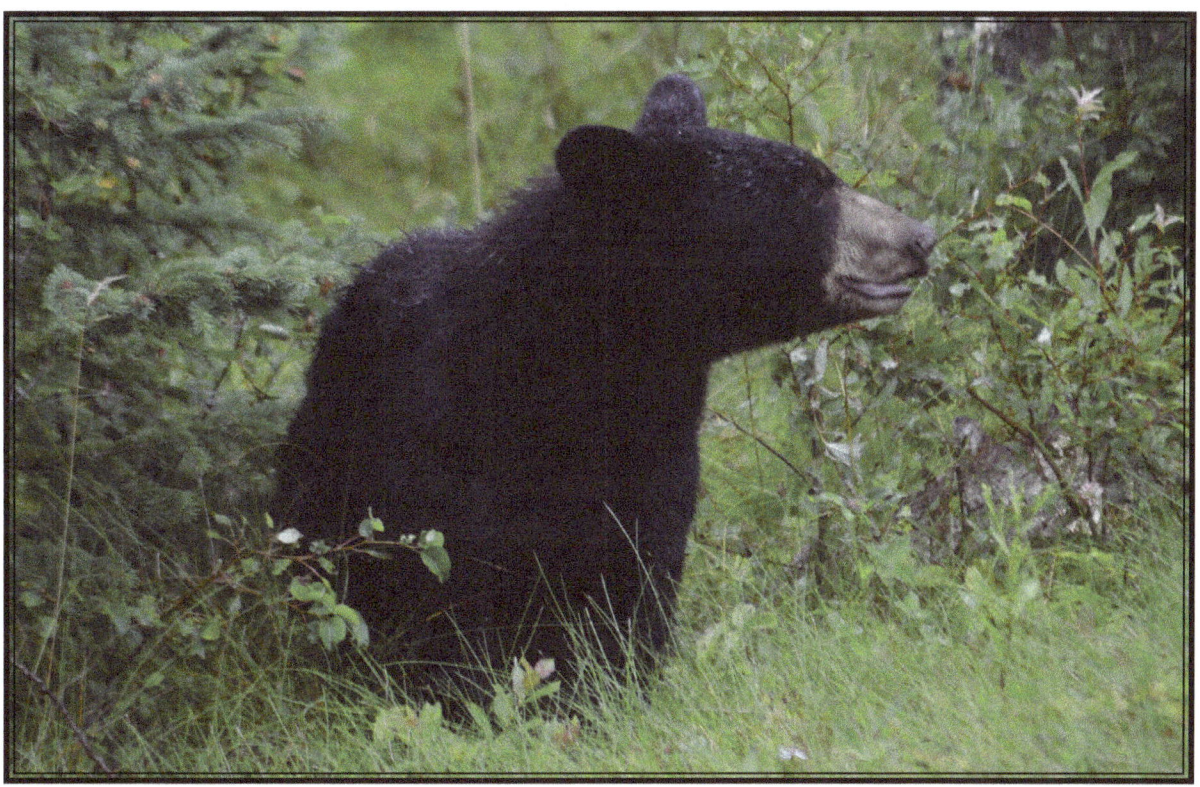

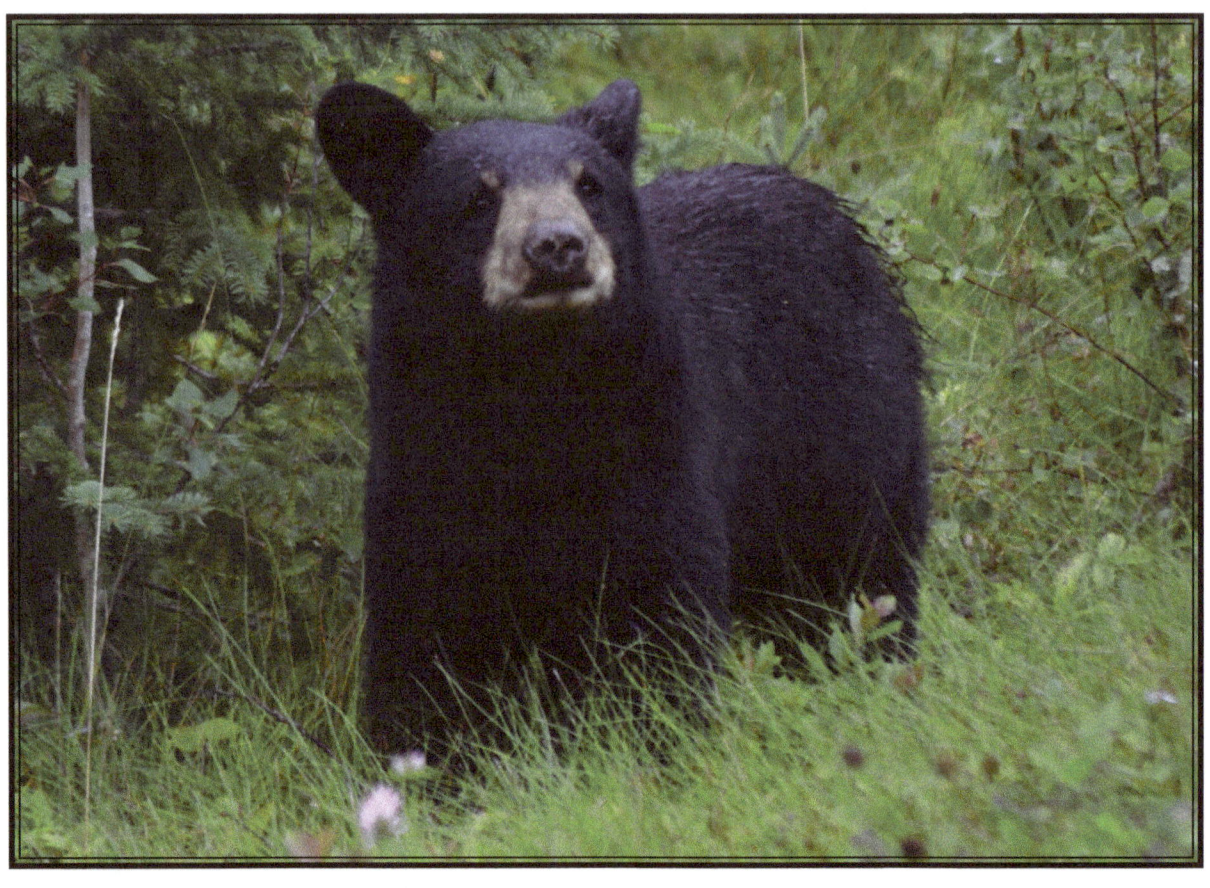

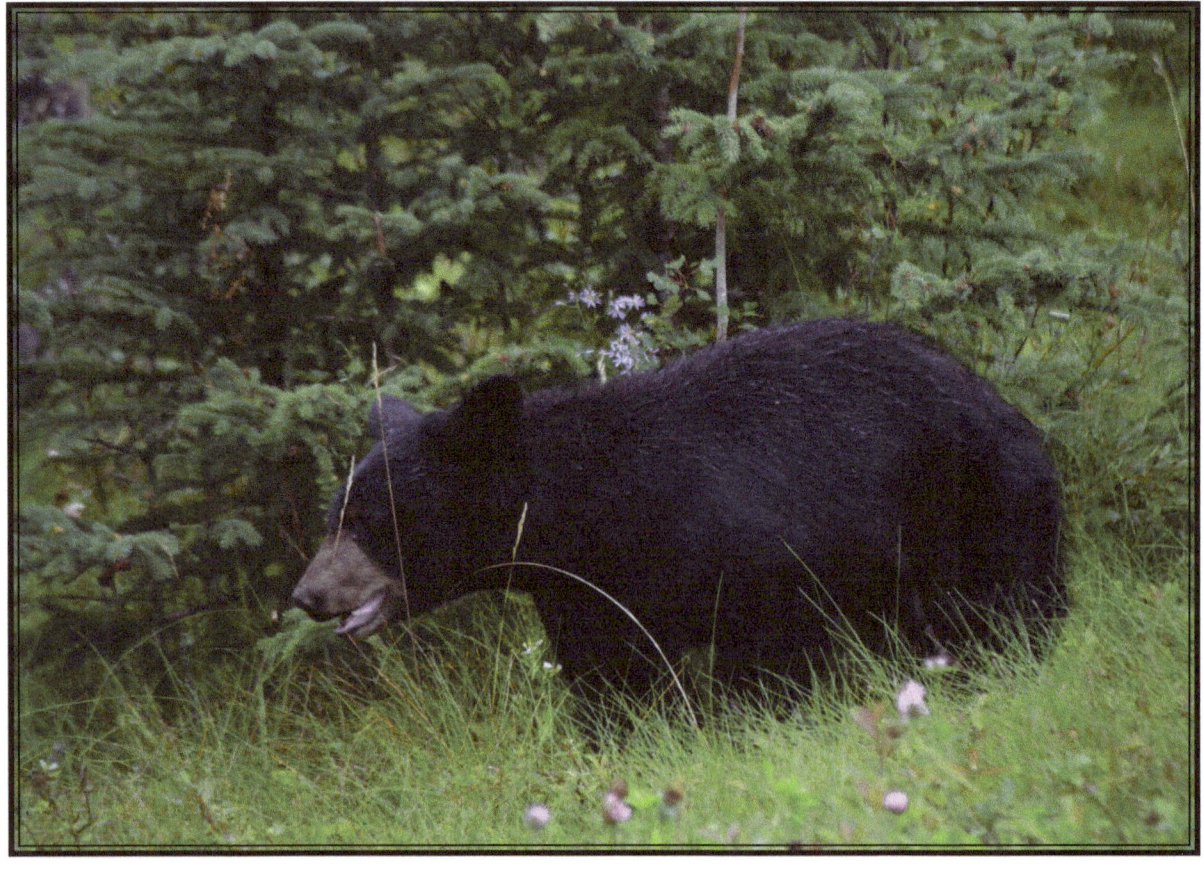

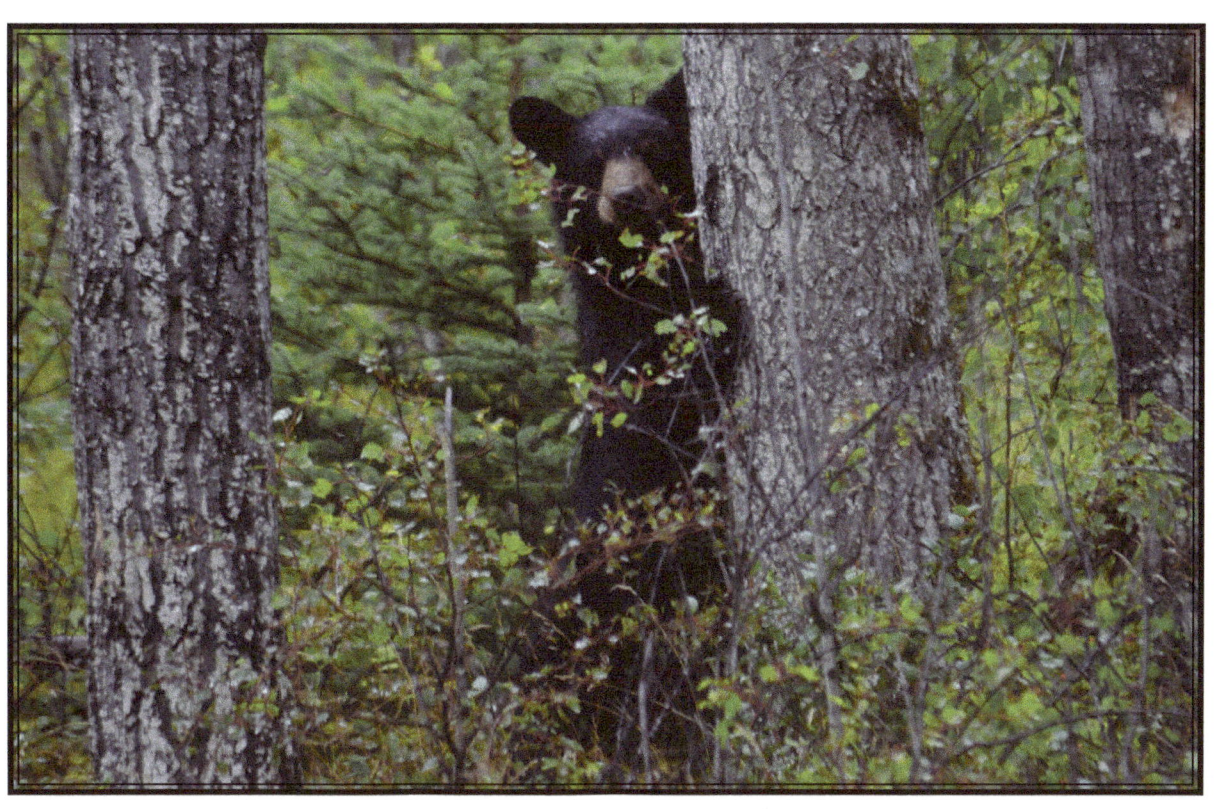

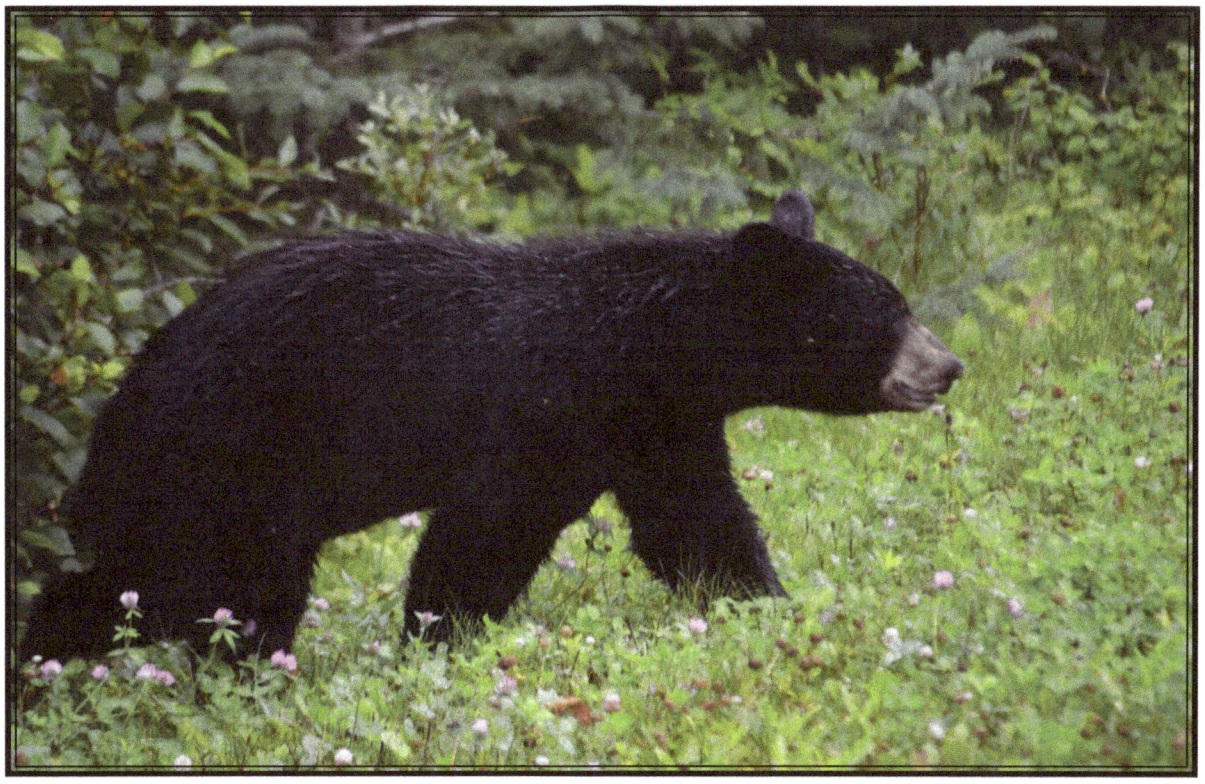

"I WONDER IF THE GUY WITH THE CAMERA
WANTS TO RACE – I GUESS NOT."

Even though my holiday was very short, it was amazing what I was able to see and photograph. Since the adventure will always continue, it makes me wonder what new and exciting things will I be able to enjoy when I visit the park the following year.

Maybe I will be able to see a blonde bear that I have heard so much about – that's a black bear that has a dye job. Now that would be terrific to be able to get a photograph of him. One thing that I am surprised that I have yet to see in the park are critters – such as a rabbit, porcupine, but what I really would like to get is a picture of a raccoon.

Yes, there is always something to look forward to in the park, something that will make my next stay so magical and special. I am filled with anticipation for what next year will bring. I hope that I will be able to stay longer so that I can enjoy the full beauty that the park has to offer. One thing that will be a must is to canoe down a river, the Kingsmere River or the Waskesiu River so that I will be able to find a moose as well, maybe with a calf, now that would make for a fantastic photograph.

But with sadness another year passes, with so many amazing memories that I will always cherish. Yes, it is amazing that taking up a hobby that was supposed to just give me something to do and was also inexpensive (hahaha!) it has certainly been rewarding to enjoy.

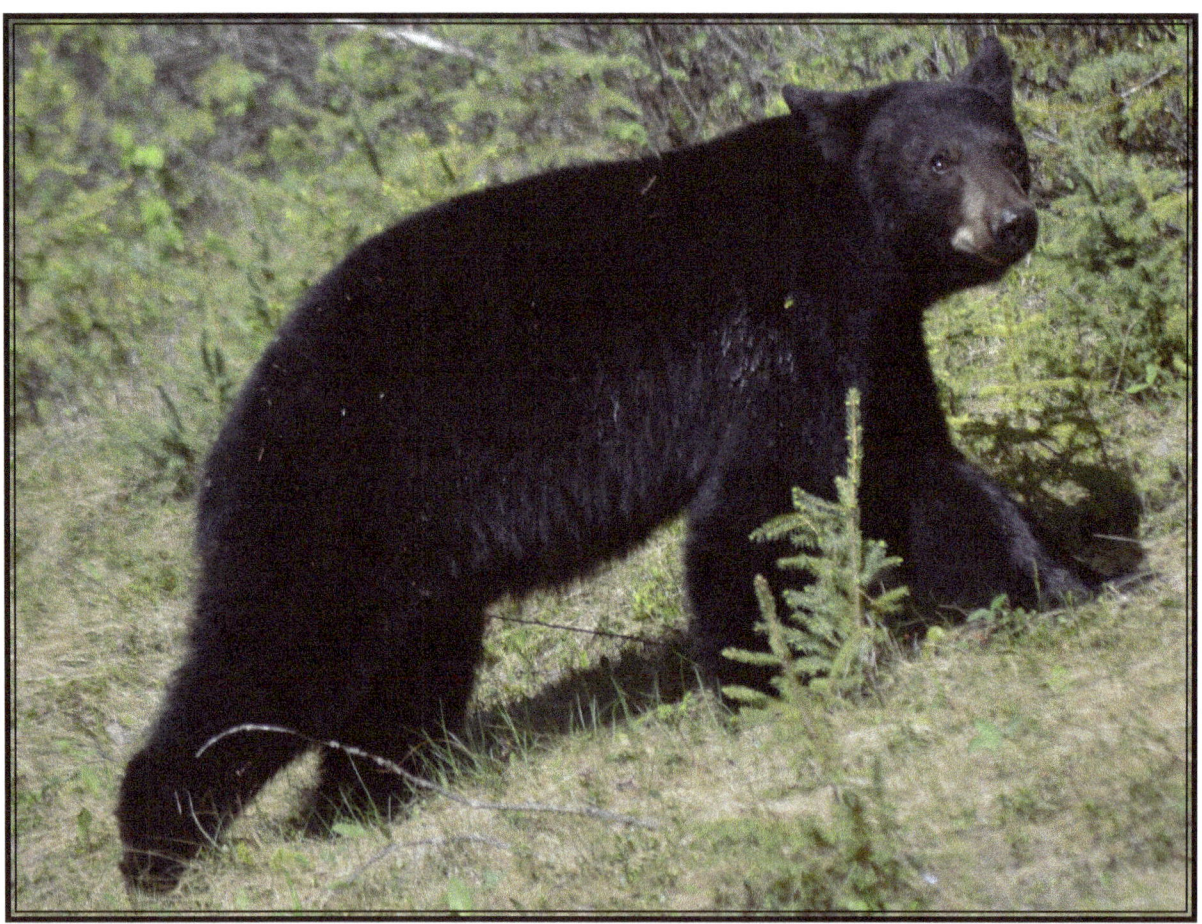

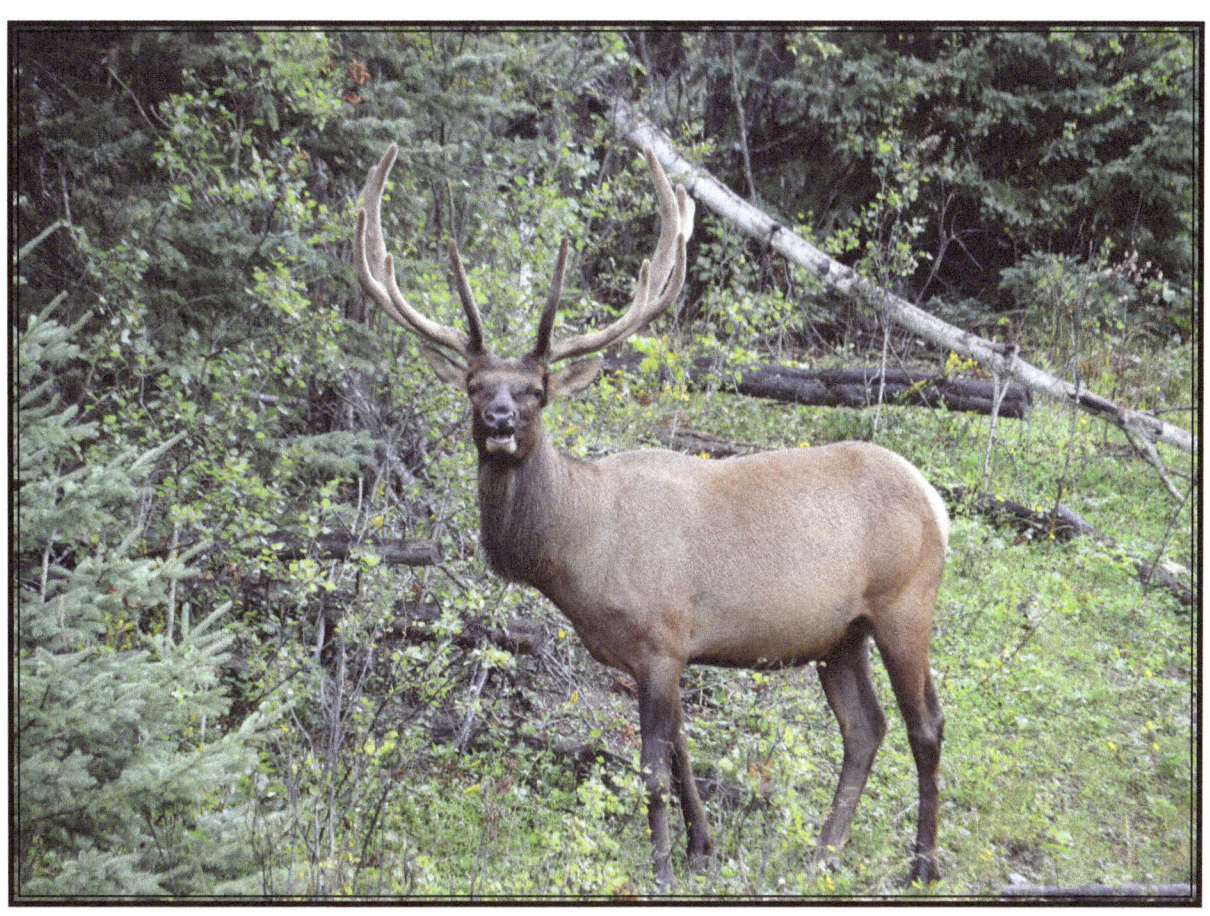